TRIBAL ART

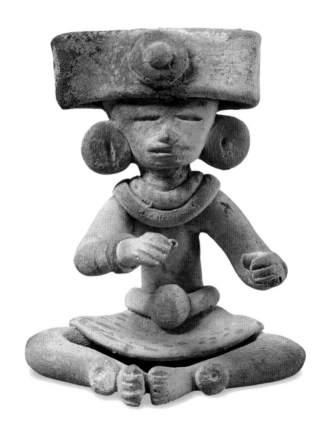

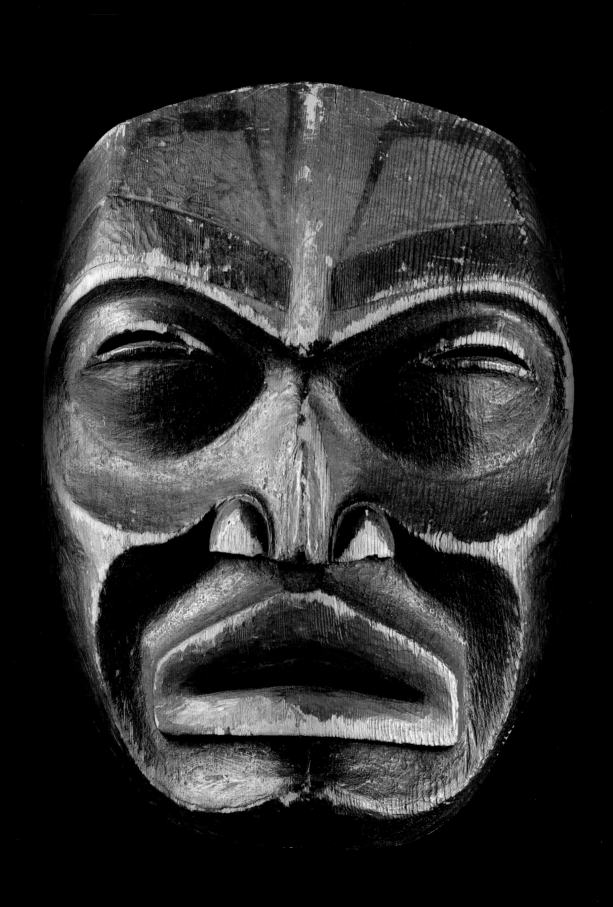

Previous page: *Teotihuacan figure, p.194*

Tlingit mask, p.155

TRIBAL ART

JUDITH MILLER
with Philip Keith and Jim Haas

Photography by Graham Rae

LONDON, NEW YORK,
MUNICH, MELBOURNE, DELHI

A joint production from **DK** and
THE PRICE GUIDE COMPANY

DORLING KINDERSLEY LIMITED
Senior Editor Dawn Henderson
Senior Art Editor Mandy Earey
Designer Katie Eke
DTP, Reproduction, and Design
Adam Walker
Managing Editor Julie Oughton
Managing Art Editor Heather McCarry
U.S. Editor Christine Heilman
Cartographer David Roberts
Production Elizabeth Warman

THE PRICE GUIDE COMPANY LIMITED
Publishing Manager Julie Brooke
Managing Editor Claire Smith
Editorial Assistants Megan Watson,
Sandra Lange, and Dan Dunlavey
Digital Image Coordinator Ellen Sinclair
Chief Contributor John Wainwright
Photographers Graham Rae and
Douglas Sandberg

First American Edition, 2006

Published in the United States by
DK Publishing, Inc., 375 Hudson Street
New York, NY 10014

The Price Guide Company (UK) Ltd
Studio 21, Waterside
44–48 Wharf Road, London N1 7UX
info@thepriceguidecompany.com

06 07 08 09 10 10 9 8 7 6 5 4 3 2 1

ISBN-13: 978-0-7566-1884-1
ISBN-10: 0-7566-1884-3

DK books are available at special discounts for bulk
purchases for sales promotions, premiums, fund-raising,
or educational use. For details, contact: DK Publishing
Special Markets, 375 Hudson Street, New York, NY 10014
or SpecialSales@dk.com

Color reproduction by Colourscan, Singapore
Printed and bound by SNP Leefung, China

Discover more at
www.dk.com

Contents

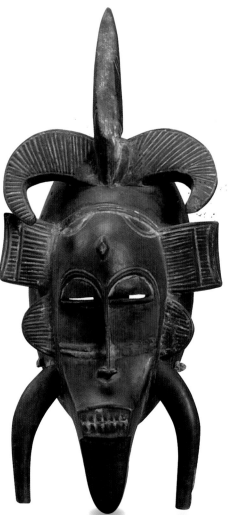

Senufo kpeliye mask, p.28

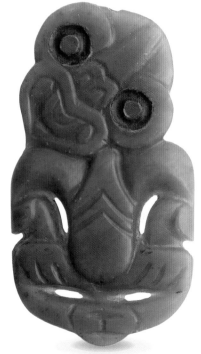

Maori hei tiki, p.108

The Americas 140

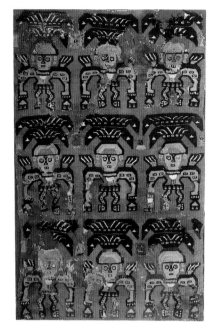

Chimu textile, p.216

Appendices 226

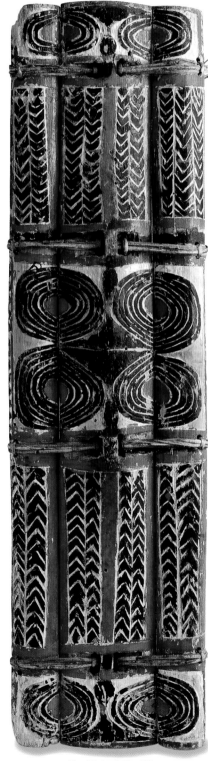

New Britain shield p.135

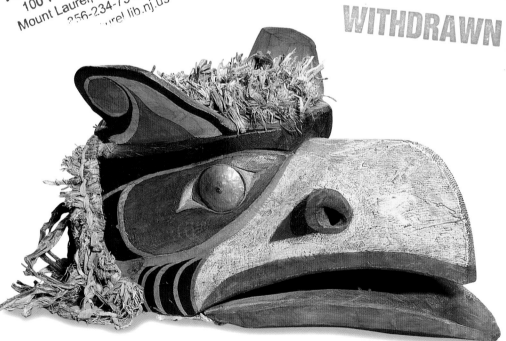

Kwakiutl bird mask, p.156

How to use this book

Tribal Art is divided into nine chapters under three main sections: Africa (West, Central, and East and South Africa); Oceania (Australia and Southeast Asian Islands, Polynesia and Micronesia, and Melanesia); and the Americas (North, Middle, and South America). Each section opens with an overview and a look at some of the key elements of the culture of that part of the world. Each chapter has an introduction to the region, including a map to identify the whereabouts of the most important tribes. This is followed by profiles of the key art-producing countries or areas within that region, with examples of their work. Sidebars provide an at-a-glance list of key facts relating to the area, including a list of key tribes where relevant. "Closer Look" boxes highlight pieces of special interest. Each item is concisely described and provided with its measurements, an up-to-date price, and a date of production.

Key Facts
Lists important information about the art of the region, including a list of tribes, where relevant.

Profile Information
Gives a fascinating insight into the artwork of the country or region. Also highlights the characteristics of the work and offers advice on what to look for when collecting.

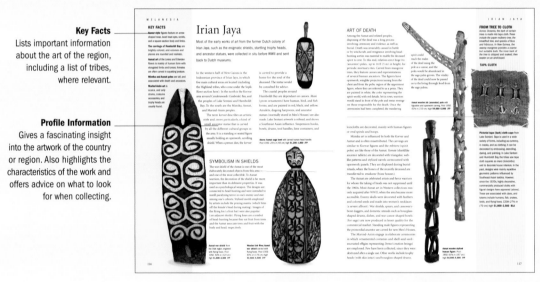

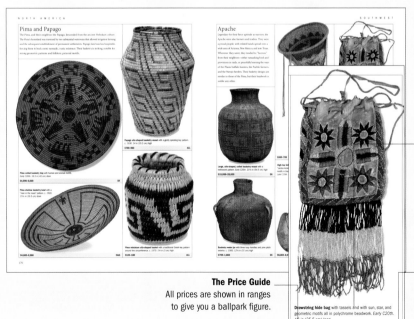

The Caption
Describes the piece, including the tribe attribution (unless a section is dedicated to a particular tribe or group under a heading).

The Price Guide
All prices are shown in ranges to give you a ballpark figure.

The Source Code
Most items in the book were specially photographed at an auction house, dealer, antiques market, or private collection. Each source is credited here. See pp.229–30 for full listings.

Foreword

In recent years, I have seen more and more tribal art at shows, fairs, auctions, and in dealer's shops, and like many people before me, have been entranced by it. Tribal art has a stunning visual appeal, and yet it is the people and culture that created it that fascinates us. Yet there seems to be very little information available to set the items in context. This book will change that.

In the 18th and 19th centuries, European explorers returned home with artifacts that shed a fascinating light on the way people from other cultures lived and what they believed. These pieces included everything from ceremonial works of art imbued with meaning to beautiful yet functional everyday objects. They inspired early 20th-century art and were fundamental in the establishment of the Cubist movement and seminal works by Georges Braque, Pablo Picasso, and Amedeo Modigliani.

Today, collectors seek similar inspiration from items that offer an intriguing glimpse into the lives of other peoples and other cultures. Some pieces reflect the beauty and simplicity of natural materials, such as smooth African wooden stools or chiseled pre-Columbian stone masks. Other work, including Navajo textiles and South African beadwork, celebrates riotous color and elaborate design. The emotional response to much of the work is central to its power. Ceremonial African masks represent an unfamiliar and perhaps mysterious society built on the importance of ritual and masquerade. Meanwhile, human skulls from Indonesia represent a head-hunting prowess shocking to some sensibilities.

Many pieces were functional or ceremonial, and it is the stories behind them that draws us to them. Each one reflects a piece of cultural history to be explored. The Nigerian Ibeji tribe, for example, had an unusually high occurrence of twins in their community, but many did not survive, and so a culture of making wooden figures for twin worship developed.

The dramatic impact of tribal art has made it popular with interior designers. Perhaps in a bid to escape the monotony of an often-commercialized Western effect, designers and enthusiasts are now looking to tribal art for bold shapes and colors that represent beautiful design as well as a glimpse into a different way of life.

If you—like a growing number of people—are as inspired by tribal art as I am, I hope you will find this book fascinating and enlightening.

Judith Miller.

Ifugao wooden spoon, p.93

What Is Tribal Art?

The many items of tribal art represented in this book are characterized by the importance of their meaning and function, although many are stunning in their visual appeal. We have used the overarching title of Tribal Art to define the ethnographic material culture of a great range of different peoples from Africa, Oceania, and the Americas over a substantial time scale. We have not included art related to any of the great world religions, so Buddhist, Hindu, and Christian sculpture, and Islamic decorative art do not appear.

The peoples who produce these items are enormously varied in geography and time scale. The ancient cultures of the Americas and some West African peoples are known only through archaeology, while in New Guinea and the Amazon, some isolated populations only recently made contact with the "white man" in the latter half of the 20th century. The common question "is it old?" has little meaning in the context of collecting objects of an ethnographic nature, since age is relative. Tlatilco figurines from Mexico date from around 1500 BCE, and all pre-Columbian artifacts predate 1521 CE (the arrival of

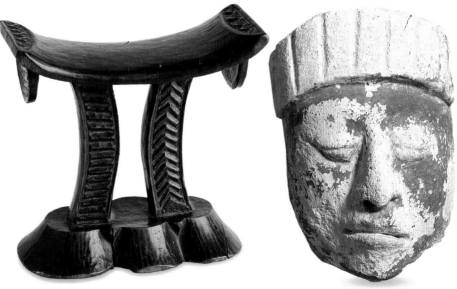

Prestige symbol of the Yoruba tribe, from Nigeria. *Mid-C20th. 33½ in (85 cm) high* **$500–700 OHA**

Carved wooden Shona tribe headrest, from Zimbabwe. *c. 1880. 6 in (15.5 cm) high* **$1,500–2,000 JBB**

Mayan stucco head, the serene face with headdress and traces of red paint. *550–950 CE. 9¼ in (23.5 cm) high* **$8,000–10,000 SK**

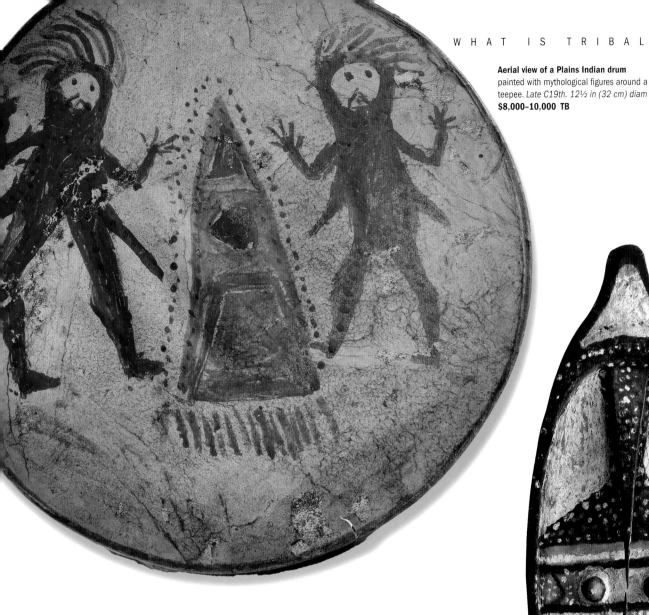

Aerial view of a Plains Indian drum
painted with mythological figures around a
teepee. *Late C19th. 12½ in (32 cm) diam*
$8,000–10,000 TB

Christopher Columbus). The Alaskan Okvik produced ivory carvings from

around 450 BCE to 100 CE, while many Polynesian artifacts were made before

1850. Most African carvings were collected from the late 19th century to the end

of the colonial period. Papuan objects tend to be early to late 20th century.

The items that appear in these pages fulfill myriad functions for the peoples

who produced them. In Africa and Oceania, we find great numbers of carved

wood masks, statues, weapons, and architectural elements. In pre-Columbian

America the archaeological record has preserved pottery, stone, and textile,

while in North America, buckskin clothing and basketry are widespread.

The question of authenticity is of great importance to collectors. For the

collector, a genuine item is something made by someone of that culture,

using traditional tools, and should have been used in a cultural context.

Ceremonial basket hook, designed to
lure and capture good spirits, from Upper
Sepik, Papua New Guinea. *Mid–late C20th.*
35¾ in (91 cm) long **$2,500–4,000 JYP**

Origins

Artist carvers and craftspeople used a wide variety of materials to produce the objects they needed for everyday and ritual use. These can be divided into three categories: materials from naturally occurring resources; those derived from wild or domestic animals; and imported materials manufactured by "outsiders."

Thus, virtually all cultures use certain species of tree and plant, and earth minerals such as clay, ocher, basalt, jade, obsidian, and precious metals. Skins from wild animals were treated to make clothing. Rare and valued materials such as feathers, quills, hair, ivory, bone, antlers, seashells, horn, coral, and seeds were often used as decoration. Cutting tools were made with teeth, stone, or seashells before the introduction of iron.

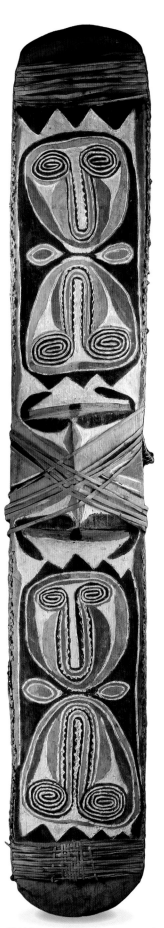

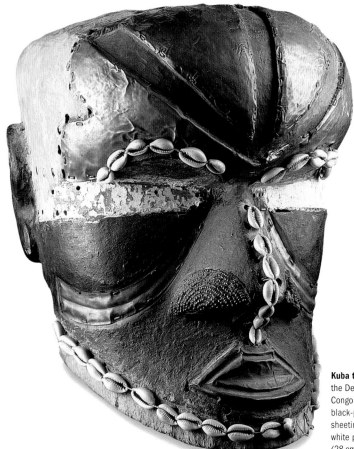

Kuba tribe helmet mask from the Democratic Republic of Congo. Carved in wood and black-painted, with copper sheeting, cowrie shells, and white pigment. *C20th. 11 in (28 cm) high* **$6,000–8,000 AP**

Wooden shield, from the Nakanai tribe of West New Britain, carved and painted with motifs and stylized faces. *Late C19th–early C20th. 77 in (195.5 cm) high* **$3,000–4,000 AP**

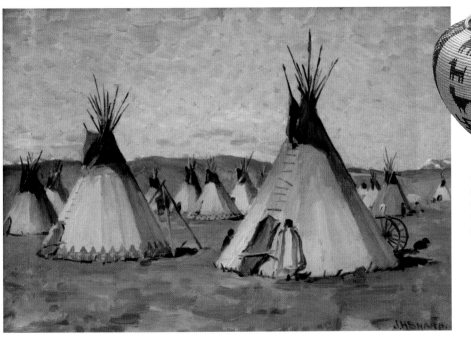

"**Blackfeet Teepees, Glacier Park, Montana,**" painted in oils on board by Joseph H. Sharp (1859-1953). *13½ in (34.5 cm) wide* **$120,000–150,000 RENO**

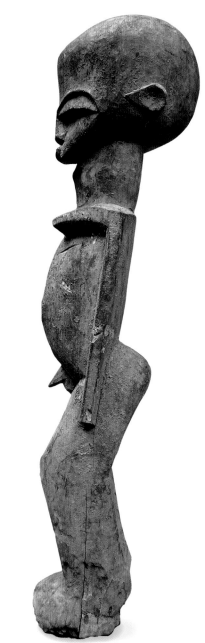

Yavapai Native American coiled basketry bowl by Minnie Stacey, of flat-bottomed, high-shouldered form with tightly woven zigzag motif panels alternating with predominantly figurative panels that include stylized humans and roosters. *c. 1935. 5½ in (14 cm) wide* **$25,000–40,000 SK**

The use of materials from the outside demonstrates the inventiveness and ingenuity of indigenous artists to recycle new materials. Czech glass beads were traded throughout Africa and North America, where beadwork became one of the most important art forms. English silk ribbons were unpicked and sewn into West African *kente* cloths or used by Woodlands Indians to ornament buckskin clothing. Brass upholstery tacks and mirror-glass were incorporated into Central African "fetish" figures, and brass faucets from British Colonial bathrooms were recast into Akan gold weights.

The lifestyle of each cultural group directly influences the nature and form of the items they produce. For example, nomadic pastoralists and hunter-gatherers manufacture only those items that can be easily carried from place to place.

Many items, such as ceremonial clothing, jewelry, and body ornaments, were made for high-ranking individuals and reinforced power or confirmed status. Stools were also important symbols of authority in Africa; in Polynesia, flywhisks were symbols of status, as were woven woolen blankets in the southwestern United States.

Carved wooden *bateba* figure embodying a *thil* spirit, from the Lobi tribe of Burkina Faso. *Early C20th. 10¼ in (26 cm) high* **$800–1,200 OHA**

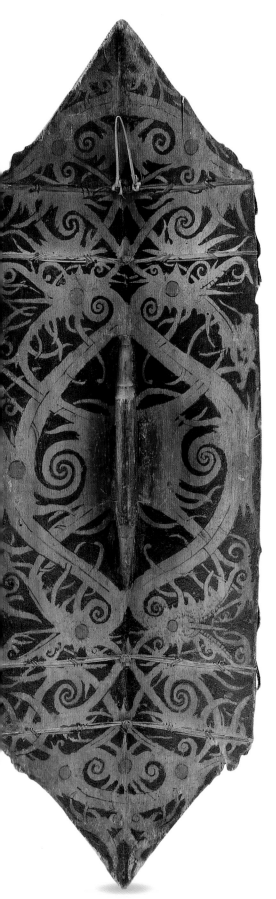

Rituals and Ceremonies

Virtually all material culture produced in traditional societies is connected in one way or another to the spirit world, via the means of ritual or ceremony. Most societies are animistic, believing that supernatural power resides in all elements of creation—humans, animals, plants, rocks, and rivers—and that this power can be harnessed via the appropriate ritual. Deceased ancestors or enemies retain this power and may become dangerous to the individual or community unless a carving or mask is created to provide a home for the roving soul. Polynesians and pre-Columbian cultures believed in a pantheon of gods and heroes, and striking images of these beings are often depicted as sculpture or on buildings.

Rituals take many forms, but all aim to influence supernatural forces for the benefit of the individual or society as a whole. Religious specialists performed ceremonies and guarded the secrets from the

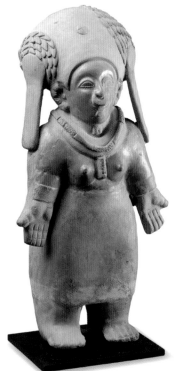

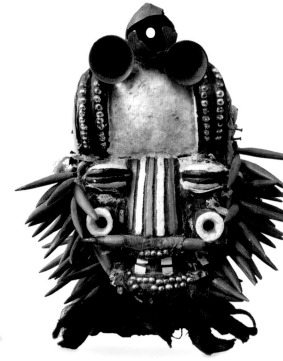

Carved wooden head-hunter's shield painted with scrolling shapes that form stylized faces, from the Dayak of Borneo. *Early C20th. 44 in (112 cm) high* **$3,000–5,000 WJT**

Jama-Coaque culture slip-painted pottery figure of a female, from the Manabi region of Ecuador. *500 BCE–500 CE. 13¾ in (35 cm) high* **$4,000–6,000 BLA**

Ceremonial pole mask with painted, vegetal, leather, and cowrie-shell decoration, from the Guerre tribe of Ivory Coast. *Mid-C20th. 13 in (33 cm) high* **$500–700 OHA**

uninitiated. In Africa, for example, powerful secret societies regulated the use of religious sculpture, which was used in ceremonies relating to the changes of the season and the desire to increase the fertility of families, livestock, and fields. The major transitions in social life, such as birth, puberty, marriage, and death, were marked with ceremonies—initiation, circumcision, and preservation of relics. Administration of law and order, execution, divination, and the fight against illness and witchcraft involved the use of masks and charms to frighten or harness supernatural spirits. Human sacrifice and cannibalism were regularly practiced in Melanesia. On occasions when the very survival of society was perceived to be at risk, these rituals were carried out on a massive scale.

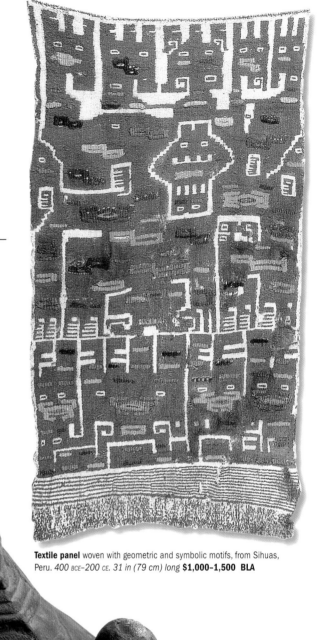

Textile panel woven with geometric and symbolic motifs, from Sihuas, Peru. *400 BCE–200 CE. 31 in (79 cm) long* **$1,000–1,500 BLA**

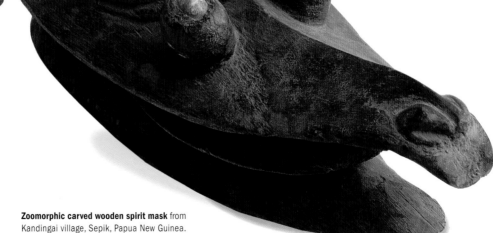

Three shrine figures from the Ada tribe of Togo and Ghana. *Mid-C20th. Tallest: 7 in (18 cm) high* **$70–150 (each) OHA**

Zoomorphic carved wooden spirit mask from Kandingai village, Sepik, Papua New Guinea. *Mid-late C20th. 13 in (33 cm) long* **$600–900 JYP**

Motifs and Symbols

Throughout the world, figures of humans or animals, plants or objects are incorporated into the decoration of artifacts. As we have discussed, the choice of design is not arbitrary, nor is it made on aesthetic values alone. Designs may be prescribed by cultural convention, but the choice of motif depends on its symbolic nature. The "squatting" figure motif occurs in many cultures and relates to ancestors and the notion of rebirth, by burial of the corpse in the fetal position. Wild animal motifs are designed to aid appropriation of their potent life force to the owner of the sculpture or mask. For example, Asmat warriors commission war shields incorporating fruit-bat motifs, because the fruit bat is associated with head-hunting— it consumes the fruit (head) from the tree (body)—and shields that carry this symbol are therefore thought to instill terror in the enemy.

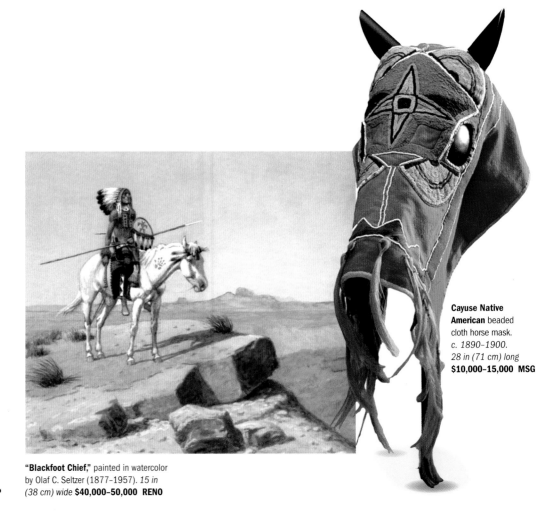

Cayuse Native American beaded cloth horse mask. *c. 1890–1900. 28 in (71 cm) long* **$10,000–15,000 MSG**

Carved and polychrome-painted wooden house board, from the Sepik River area of Papua New Guinea. *Mid-Late C20th. 100 in (250 cm) long* **$1,800–2,500 JYP**

"Blackfoot Chief," painted in watercolor by Olaf C. Seltzer (1877–1957). *15 in (38 cm) wide* **$40,000–50,000 RENO**

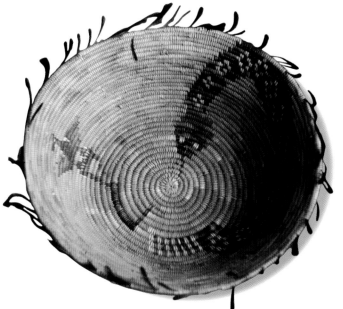

Mission basketry bowl with snake and pictorial decoration. *c. 1890–1910. 14 in (35.5 cm) diam* **$18,000–22,000 MSG**

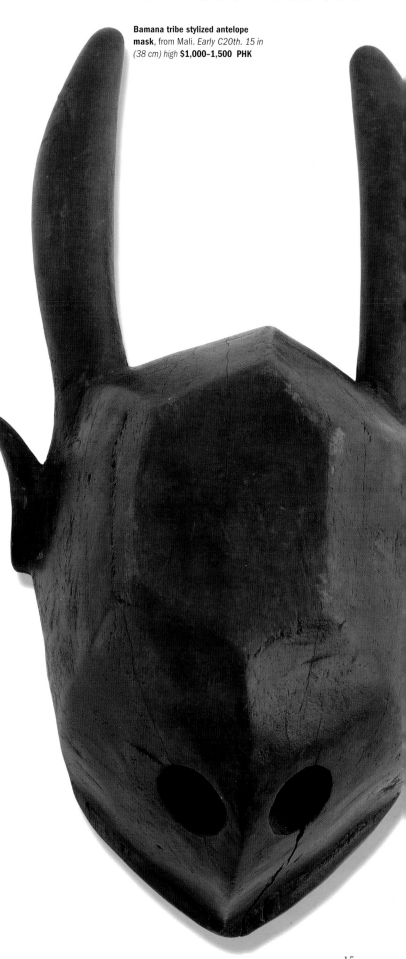

Bamana tribe stylized antelope mask, from Mali. *Early C20th. 15 in (38 cm) high* **$1,000–1,500 PHK**

Motifs are often abstracted to become geometric shapes that can be repeated to cover large areas. The Oceanic "crescent" shape is derived from the ocean-going canoe, while the New Guinea "hook" motif stems from the beak of the Southeast Asian hornbill bird, associated with the soul. For the Native American, the circle is of importance in medicine and originates from the shape of the sun.

The use of color to enhance artifacts is one of the most exciting aspects of tribal art. Paint and dyes can be produced from earth minerals, such as ocher and kaolin, while others come from insects or plants. Colors are used in symbolic ways, since specific colors are associated with ancestral spirits or deities—red is associated with the Yoruba god Shango, and Punu *mukudj* masks are white to symbolize the afterlife and spirits.

Movement and Influence

All societies change over time, including contemporary "traditional" societies. They were developing and adapting to environmental changes, economic pressures, and political influences well before the relatively recent impact of influences such as Islam, Christian missionaries, European traders, and colonial governments. In Polynesia, the combination of European disease, Christianity, and internal political pressure brought an end to traditional religion and art forms within only a century. Aboriginal Australians and American Indians were forced into reservations, and the Aztec and Inca cultures were destroyed by the Spanish conquistadors.

African cultures, on the whole, fared better under their colonial shackles, despite the devastating effects of slavery. As early as the

Polychrome-painted mask, from the Bozo tribe of Mali. *Mid-C20th. 47¼ in (120 cm) high* **$700–900 OHA**

Zuni Native American petitpoint pin in sterling silver set with round- and navette-cut turquoise cabochons. *c. 1940. 2¼ in (5.75 cm) diam* **$400–600 FS**

Eskimo polychrome stroud hanging by Jessie Oonark (1906–1985), decorated with embroidered and appliqué stylized figurative and geometric Eskimo imagery. *C20th. 57 in (145 cm) high* **$50,000–70,000 WAD**

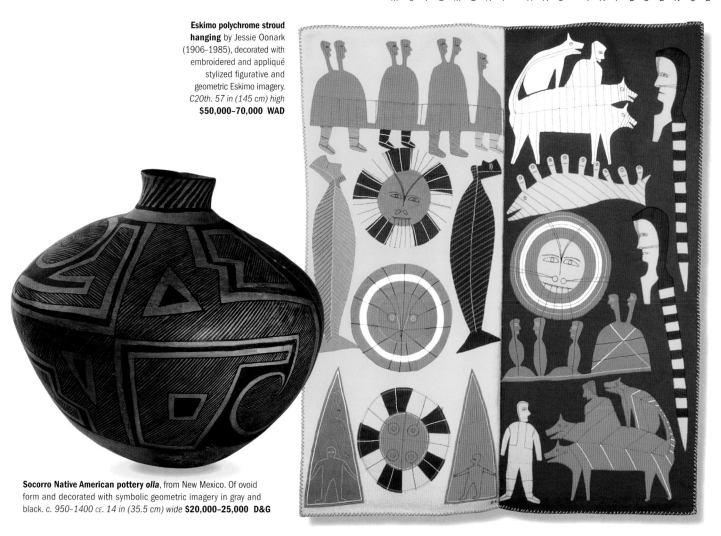

Socorro Native American pottery *olla*, from New Mexico. Of ovoid form and decorated with symbolic geometric imagery in gray and black. *c. 950–1400 CE. 14 in (35.5 cm) wide* **$20,000–25,000 D&G**

Melanesian wooden house post, of a male figure wearing European clothing, with remnants of black and white pigment. *Late C19th–early C20th. 34½ in (87.5 cm) high* **$2,500–3,000 SK**

15th and 16th centuries, ivory carvings and brass castings showing Portuguese figures were being produced in West Africa and crucifixes became emblems of Kongo chiefs. This fusion of native and European styles is regarded by academics as an important chapter in the history of non-Western art. This class of art includes the so-called "colonial carvings" that have become collectible in their own right. Styles and techniques diffuse from one culture to another via traditional trade relationships and are adapted along the way.

Stunned by its clarity of form and intensity of expression, many 20th-century European artists, such as Picasso, Gauguin, Matisse, and Klee, were influenced by the art of Africa, pre-Columbian Central America, and Oceania.

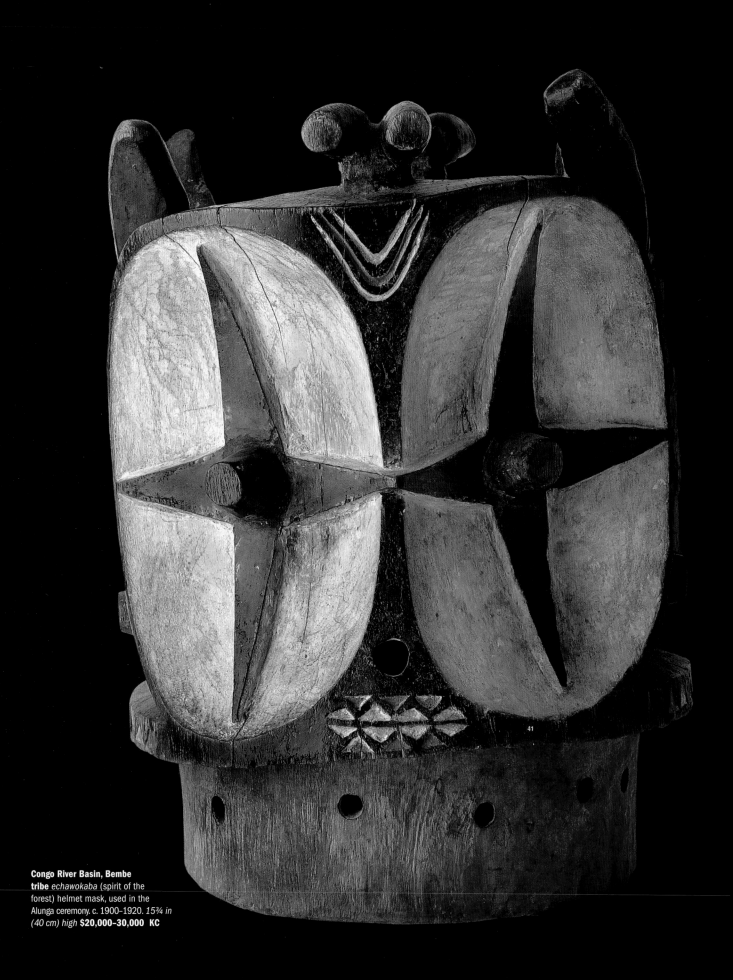

**Congo River Basin, Bembe
tribe** *echawokaba* (spirit of the
forest) helmet mask, used in the
Alunga ceremony. c. 1900–1920. *15¾ in
(40 cm) high* **$20,000–30,000 KC**

AFRICA

The course of 20th-century Western art was irreversibly and dramatically altered by African art.

The black arts of Africa have been described as shocking, sublime, bold, severe, dynamic, restrained, and expressive by connoisseurs in the West. These beautiful objects were created by enormously diverse cultures, across a continent inhabited by hundreds of millions of people—a product of not one, but many "Africas." Picasso little understood the religious nature of the African sculptures he collected. For him, the aesthetic qualities alone were overwhelming enough. We should not only look at, but also look into an object, to appreciate the cultural meaning of the work, and better understand the people who produced it.

Culture of Africa

Religion pervades all aspects of African culture, and access to the supernatural forces that control life is of vital religious importance. This might be achieved through the channel of a diviner, by carving and consecrating a statue, or by performing a masked ritual.

DIVINATION

Individuals who are understood to have a special affinity with the spirit world (they may have a predisposition for visions or vivid dreams) often become diviners. The diviner acts as an intermediary between the physical and metaphysical world, and is consulted by kings and commoners alike. He can determine the cause of illness, bad luck, theft, or other misfortune. He can also predict the success of hunting trips. And the most powerful can discover the identity of witches.

The method and apparatus of divination varies throughout Africa, but all are essentially oracular. The Yoruba cult of Ifa involves tappers, kola nuts, and boards covered with powder; the Kuba use a variety of friction instruments; the Chokwe use basketry trays and numerous small amulets; and the Venda employ bone tablets or float corn kernels on water-filled and engraved wooden dishes.

After the consultation, the diviner may prescribe a medicine for the client or advise that he or she perform a sacrifice. Whatever the outcome, the client usually leaves reassured, his or her questions answered. The widespread belief in the efficacy of divination should not be dismissed by Westerners. On the contrary, the techniques lead to sound psychological reasoning by the diviner. For example, the process enables decision-making and eliminates hesitation. Because the diviner-specialist is both experienced and divinely gifted, his diagnoses and predictions are respected.

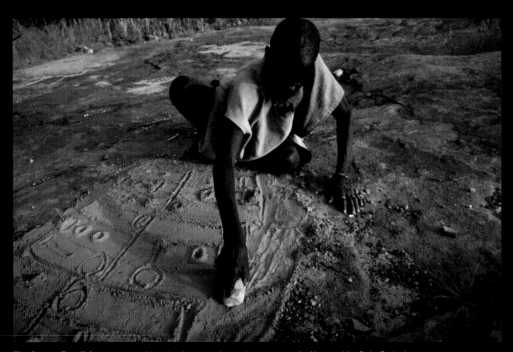

The Dogon Fox diviner uses markings in the ground to gain access to the Yuguru (the Pale Fox), the master of divination. He is the reincarnation of the cunning, impatient, and disruptive divine hero Ogo.

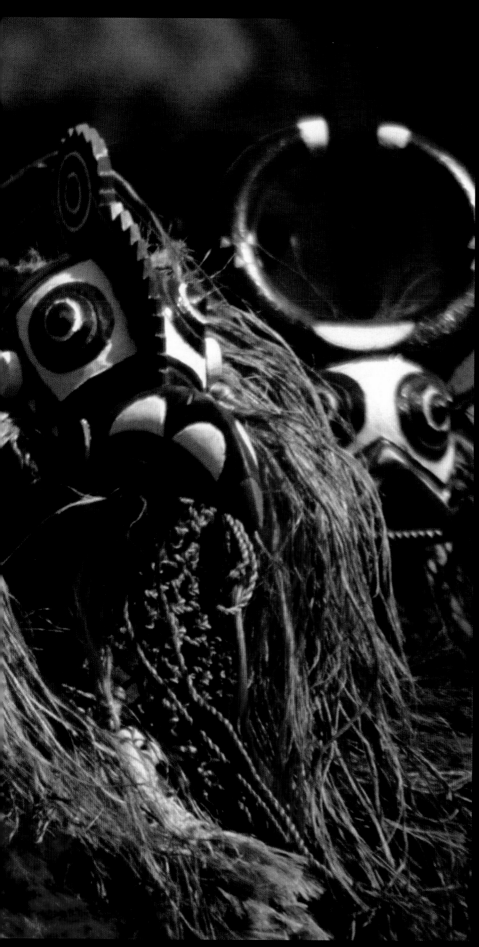

Bobo dancers from the Koudougou region of Burkina Faso wear animal masks used in group performances, at agricultural rituals in spring, and during the planting season. The dancers are concealed by their body costume and raffia fiber fringe.

MASQUERADE

The quintessential African cultural object is probably the mask. Viewed in the "sterile" atmosphere of a museum cabinet displayed on a stand, or hovering on the page of a book, most of the meaning is lost. We must remember that the mask is part of a set of rituals, which includes a concealing costume, pulsating music and drumbeats, flickering firelight, violent movement, and the reaction of the audience—the masquerade.

Masks are worn in one of three ways: as a crest above the head; conventionally, over the face or at a slant on the forehead; or over the head as a "helmet." Only face and helmet masks need be pierced for sight, as the other styles allow the dancer to see through a fiber fringe or fabric panels, attached to the perimeter of the mask by means of holes or nails, respectively. Masquerade performances occur for many different reasons, but are generally associated with secular or religious ceremonies; for example, in the context of sacred cults, male and female initiations, funerals, hunting, farming, detecting bad magic, apprehending witches, adjudicating disputes, and for entertainment. Masks become occupied by spirits during the ceremony only. Afterward, they are regarded as merely wooden "shells" and may be discarded. This is one reason why so many ended up in European collections in the 19th and early 20th centuries.

WEST AFRICA

With its rich and fabled history, large cultural diversity, and close proximity to Europe, West Africa—and its many tribes and peoples—has dominated the European academic and popular mind since the 15th century. There has long been great interest in the wide variety of wonderful artworks from this part of Africa.

The West African region is composed of two different geographical areas, the forests of the Guinea coast (Senegal to Cameroon) and the plains in the western and central Sudanese savanna (western Sahara to Chad). The economy of this region was influenced first by Islam via the ancient trans-Saharan trade routes in the north, and then by the European traders who arrived at the coast. Some of the earliest Western maritime contacts came from Portugal in the 15th century. The Portuguese advanced ever farther around the western coast of Africa in search of wealth, Christian converts, and allies to fight the invading Moors (Almoravides). Four centuries earlier, the Almoravides had set out from Senegal to conquer the Soninke kingdom in Ghana and convert it to Islam.

THE RISE OF TRADE

The history of West Africa is characterized by the expansion and contraction of successive militaristic empires. The natural metal resources of gold, copper, and iron also contributed to the formation of these states. They enabled the development of trade in gold, which brought enormous wealth and power to the rulers, who cast bronze sculptures to legitimize their kingship. The pressures of war and trade had severe consequences for millions of ordinary West Africans, who became an unwitting commodity in the miserable slave trade, which escalated in the 18th century and diminished in the 19th century.

The development of settled agriculture enabled the establishment of great empires such as the Soninke, Songai, and Mali in the savanna, and city-states such as Benin.

Wood and copper mask of elongated, tapering form with red woven fabric highlights, by the Marka tribe from western Mali. *C18th–C19th. 15 in (38 cm) high* **$7,000–10,000 JDB**

LANDSCAPE AND CULTURE
Climate and geography directly influence religious, military, and rural economic cultural practices. Rainfall steadily increases from north to south, creating a range of environments that sustain different plants and animals.

Right: The inhabitants of the coastal areas and river valleys, such as this area in Cameroon, are fishermen and farmers. The rainforest on either side of the Niger has poor soil.

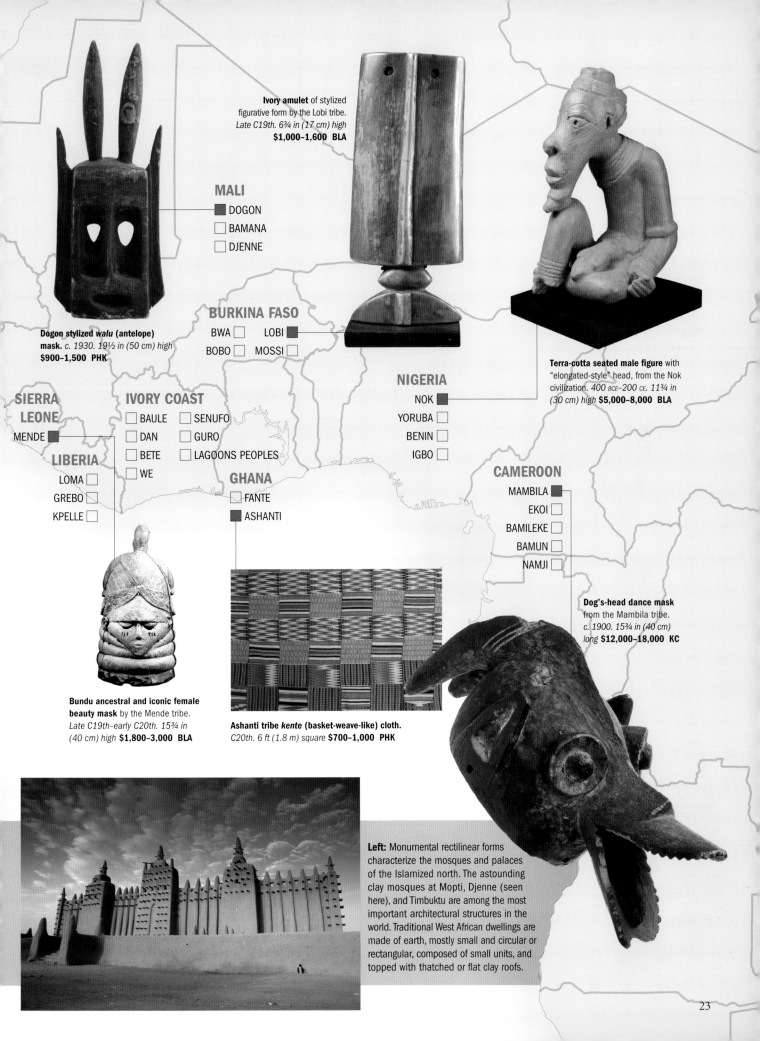

Ivory amulet of stylized figurative form by the Lobi tribe. *Late C19th. 6¾ in (17 cm) high* **$1,000–1,600 BLA**

MALI
- ■ DOGON
- ☐ BAMANA
- ☐ DJENNE

Dogon stylized *walu* (antelope) mask. *c. 1930. 19½ in (50 cm) high* **$900–1,500 PHK**

BURKINA FASO
- BWA ☐ LOBI ■
- BOBO ☐ MOSSI ☐

SIERRA LEONE
- MENDE ■

IVORY COAST
- ☐ BAULE ☐ SENUFO
- ☐ DAN ☐ GURO
- ☐ BETE ☐ LAGOONS PEOPLES
- ☐ WE

LIBERIA
- LOMA ☐
- GREBO ☐
- KPELLE ☐

GHANA
- ☐ FANTE
- ■ ASHANTI

NIGERIA
- NOK ■
- YORUBA ☐
- BENIN ☐
- IGBO ☐

Terra-cotta seated male figure with "elongated-style" head, from the Nok civilization. *400 BCE–200 CE. 11¾ in (30 cm) high* **$5,000–8,000 BLA**

CAMEROON
- MAMBILA ■
- EKOI ☐
- BAMILEKE ☐
- BAMUN ☐
- NAMJI ☐

Dog's-head dance mask from the Mambila tribe. *c. 1900. 15¾ in (40 cm) long* **$12,000–18,000 KC**

Bundu ancestral and iconic female beauty mask by the Mende tribe. *Late C19th–early C20th. 15¾ in (40 cm) high* **$1,800–3,000 BLA**

Ashanti tribe *kente* (basket-weave-like) cloth. *C20th. 6 ft (1.8 m) square* **$700–1,000 PHK**

Left: Monumental rectilinear forms characterize the mosques and palaces of the Islamized north. The astounding clay mosques at Mopti, Djenne (seen here), and Timbuktu are among the most important architectural structures in the world. Traditional West African dwellings are made of earth, mostly small and circular or rectangular, composed of small units, and topped with thatched or flat clay roofs.

23

Guinea and Sierra Leone

The most refined fusion of African craft and Portuguese design emerged during the 15th century in southern Sierra Leone, producing vessels stately enough to grace the tables of the courts of Europe.

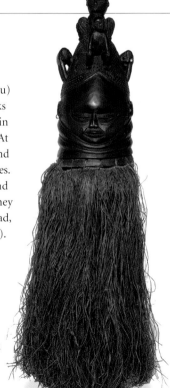

To the far west of the Guinea coast region are the ethnic groups of Guinea-Bissau, Guinea, and coastal Sierra Leone.

Two of the largest masks in Africa are used by the Nalu and Baga of Guinea—namely, the *banda* and *nimba* masks, respectively. The *banda* is a broad, oval human facemask with antelope, crocodile, and chameleon features, and is worn horizontally on the head during male initiations. The *nimba* weighs up to 130 lb (60 kg) and is a type of "bust" mask, supported on the shoulders of the dancer, and appears at rice harvest time. The Baga also carve medicine-spirit headdresses, *a-Tshol* (altar sculptures), and drums. Unusually, Baga drums have sculpted supports, often depicting horses and female figures, which refer to power and female dominance. They are played during important Simo ceremonies such as funerals. (These drums are rare in West Africa, as the traditional drum is cylindrical in form.) Most dramatic are the 6½–10-ft- (2–3-m-) high *basonyi* snake emblems, which appear in spouse pairs to fight a duel signaling the beginning of the boys' initiation festivities.

Today, the dominant group are the Mende, famous for their *sowei* (helmet masks), and female figure sculptures called *minsere*, which are also carved by the neighboring Temne.

Above: Mende tribe wooden stool with a monopod support carved with a human head and torso. *C20th. 15 in (38 cm) high* **$500–900 S&K**

HELMET MASKS

Helmet masks are produced by the Mende, Vai, and Gola, and most are used in connection with the Sande (or Bundu) women's society. This is the only documented use of masks by women in sub-Saharan Africa. The Sande is involved in the initiation of girls and their preparation for marriage. At the end of the rituals, a spirit appears wearing the mask and carrying a whip to drive away malevolent spirits and witches. Masks are painted black and polished with palm oil, and are worn with long raffia-fiber fringes and costumes. They are carved with qualities reflecting beauty (high forehead, elaborate coiffure), and prosperity (multiple neck rolls).

Left: *Sowei* (Mende tribe helmet mask), possibly carved by Mustafa Ado Dassama, incorporating the heads of King George V and Queen Mary. *1936. 17 in (43 cm) high* **$3,000–7,000 AP**

A CARVED HELMET MASK WITH GRASS SKIRT ATTACHED

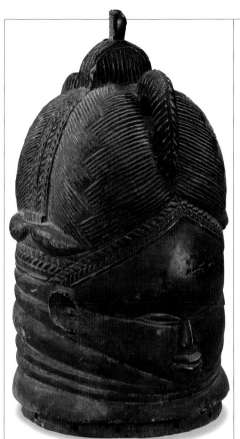

Vai tribe helmet mask with typically elaborate braided and backswept coiffure. *C20th. 15¾ in (40 cm) high*

$500–900 **S&K**

Sowei **(Mende helmet mask)** topped with a Sande society tortoise motif. *Late C19th–early C20th. 15¾ in (40 cm) high*

$1,000–1,500 **BLA**

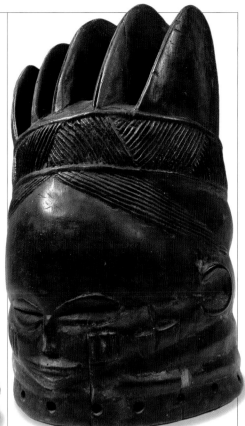

Sowei **(Mende helmet mask)** with ridged coiffure. *C20th. 13¾ in (35 cm) high*

$400–600 **SWO**

THE ANCIENT SAPI

The ancestors of present-day Mel-speaking groups in southern Sierra Leone were the Sapi. They produced the so-called Afro-Portuguese ivory carvings originating from Sherbro Island, and exported to the courts of Europe from the 15th to the mid-16th century. The carvings are exceedingly rare and include elaborate salt-cellars, spoons, and oliphants (side-blown trumpets), carved to European designs. Similar steatite carvings (*nomoli* figures and *mahen yafe* heads) are thought to be associated with Sapi aristocracy, and Mende chiefs or Poro society elders use them in divination. The Sapi were invaded by the northern Mani, who put an end to these carving traditions during the 16th and 17th centuries.

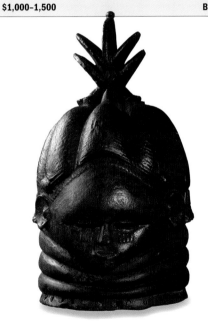

Sowei **(Mende helmet mask)**, from the Sande society. *Late C19th–early C20th. 15¾ in (40 cm) high*

$2,000–3,000 **BLA**

Carved wooden *a-Tshol* sculpture, from the Baga tribe. *Late C19th–early C20th. 11½ in (29.5 cm) high*

$600–1,000 **BLA**

Rare ancient Sapi carved oliphant (trumpet), with one damaged end. *C16th. 18 in (46 cm) long*

$9,000–12,000 **PHK**

25

KEY FACTS

Tribes of the area include Loma, Kpelle, Bassa, Grebo, Guro, Yaure, Baule, Lagoons peoples, Dan, Bete, We (Guere and Wobe), and Senufo.

The terrain here is mostly flat with undulating plains. There is a mountainous region in the northwest.

This is an agricultural region and the close relationship between the people and their land is reflected in religious ceremonies and art.

One of the key festivals is the *Fêtes des Masques* (Festival of Masks), held to venerate the *du* (forest spirits). Dancers wear masks embodying these spirits and dance in competitions.

Below: **Bete warrior's mask**, from Ivory Coast. Provenance: Ex Emerson Fowler collection. *C20th. 11 in (28 cm) high*
$9,000–11,000 JDB

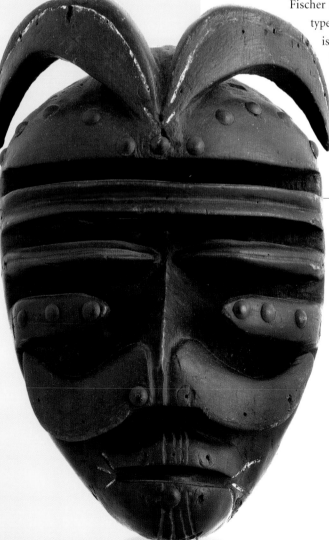

Liberia and Ivory Coast

The artwork in this area ranges from mysterious, encrusted Senufo zoomorphic masks to polished, concave-faced Dan entertainment masks. The Senufo make elegant diviner's figures and the Baule produce beautiful, carved spirit wives.

The Cavalla River Basin in western Liberia is one of the most prolific art-producing areas on the Guinea Coast. Around ten distinct ethnic groups are found here, including the 350,000 Mande-speaking Dan. A vast array of wood and bronze masks, sculpture, and ethnographic items are used by the Dan. However, it is the mask that predominates. German academic Eberhard Fischer identified almost 140 types. The form of the masks is broadly categorized by "male" or "female" attributes. Feminine-type masks are often oval, with slit-pierced eyes, and engraved detail. The masculine-type masks are more boldly carved, with larger, angular shapes, tubular eyes, and bulbous foreheads, and sometimes with animal furs. Individuals and clans, rather than secret societies, own Dan masks. Miniature charms in the form of masks are highly collectible as they copy the wide variety of facemasks used in dances by the Dan. Farther eastward on the Ivory Coast is home to several tribes, including the 1.5 million Senufo who inhabit the savanna to the north. Their style of art shows the influence of Voltaic groups such as the Dogon and Bamana of Mali.

Above: **Carved wooden, stylized male figure** from the Dan tribe. *Late C19th–early C20th. 10 in (25.5 cm) high*
$1,200–2,000 BLA

BETE MASKS

The Bete are a group of around 200,000 Kru-speaking agriculturalists from southwest Ivory Coast. They adapted the use of masks from their We neighbors not earlier than the first part of the 20th century. Only Bete near the cities of Daloa and Issia use these highly stylized masks. They are carved with domed foreheads and a series of horizontal lobes, which extend over the cheeks and eyes, and join to the nostrils. They may be studded with upholstery tacks. In the past, warriors danced them before battle, but nowadays they are used by dance societies—for example, in the popular Ivory Coast stilt dance.

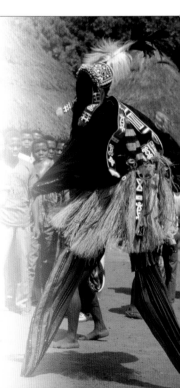

STILT DANCER, IVORY COAST

FIGURINES

There are two types of this Baule figurative sculpture. *Asie usu* sculpture represents bush spirits. Spirit mediums called *komien* (singular *komyen*) display these carvings during divination rituals to please the disgruntled *asie usu* spirits. *Blolo* figures represent spirit spouses, either *bian* (male) or *bla* (female). They are similar to *asie usu*, but with cleaned and polished surfaces. They are carved for spouses of the "other world," who were left behind at birth. Bad dreams are believed to indicate the need to consecrate an altar and make offerings to carved male or female figures.

Left: Carved wooden female figure from the Baule tribe, representing a *Blolo* (a spouse from the spirit world). *C20th. 12¾ in (32.5 cm) high* **$900–1,400 S&K**

Right: Baule tribe anthropomorphic *asie usu* spirit figure, in the form of a seated female. *Late C19th. 13 in (33 cm) high* **$3,600–6,000 BLA**

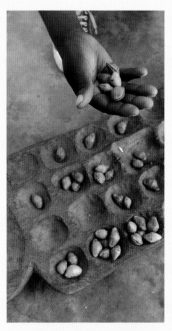
Sculpture is made mostly for the Poro male initiation society. Pieces include facemasks, small divination figures, agricultural trophy staffs, large *pombibele* (rhythm pounders), which sound out the beat in dances, and large *kasingele* (bird statues), which are displayed on the ground or paraded above the head. Small items of furniture are also made and are popular with American interior decorators. The sculpture of the Baule, who are part of the Akan family of tribes, is also very well known. It is popular among Western collectors, perhaps due to its realism and attention to minute detail. Carvers also produce delightful miniature works of art in the form of combs, slingshots, gong hammers, and heddle pulleys for the weaving looms. Gold ornaments and gold-leaf-covered regalia are made for courtiers.

Around the wetland region in southeastern Ivory Coast are the Lagoons peoples—they include the Kulango, Attie, Ebrie, Abron, and Ligbi. Their artwork reflects the influences across the region, including Akan.

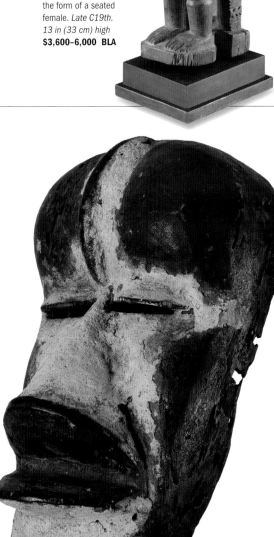

Left: Dan mask with angular features *C20th. 9½ in (24.5 cm) high* **$11,000–15,000 PC**

Senufo

The most recognizable Senufo masks are Kpeliye, characterized by oval faces, T-shaped noses, perimeter flanges of horns, wings, and crests. They may have pierced eyes and are worn at a slant on the forehead, with the dancer peering through the costume below the mask. Other masks represent animals, such as warthogs. They may incorporate some elements of animals (jaws, teeth, ears, and horns), as in the fire-spitter mask. Human figure carvings are produced in differing sizes but share strong stylistic similarities, with sagittal crest coiffures, heart-shaped faces with semicircular eyes, and hands held to the waist.

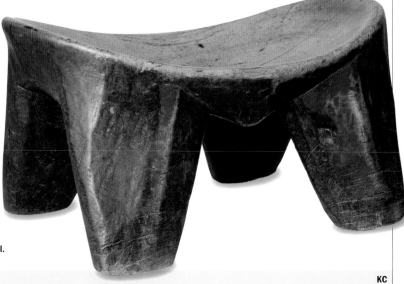

Carved wooden stylized warthog mask. *Early C20th. 21¼ in (54 cm) high*

$3,600–6,000 BLA

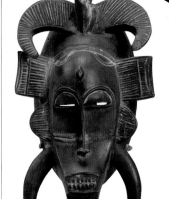

Kpeliye tusked, horned, and dark-patinated stylized animal mask used in Poro society ceremonies. *1920. 14½ in (37 cm) high*

$9,000–12,000 SK

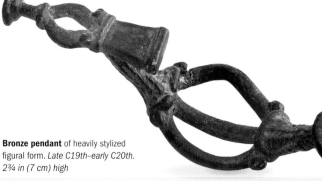

Bronze pendant of heavily stylized figural form. *Late C19th–early C20th. 2¾ in (7 cm) high*

$2,500–4,000 PC

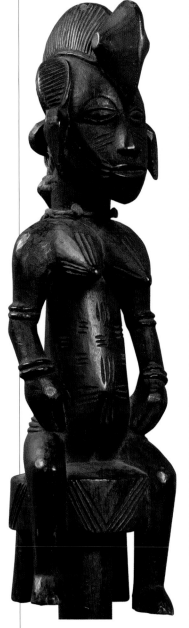

Female figural top of a carved wooden cane awarded to productive farmers. *Late C19th–early C20th. 45 in (114 cm) high*

$1,000–1,600 BLA

Senufo furniture has simple forms, mostly derived from animal imagery.

Four-legged carved wooden stool. *c. 1900. 16½ in (42 cm) long*

$360–600 KC

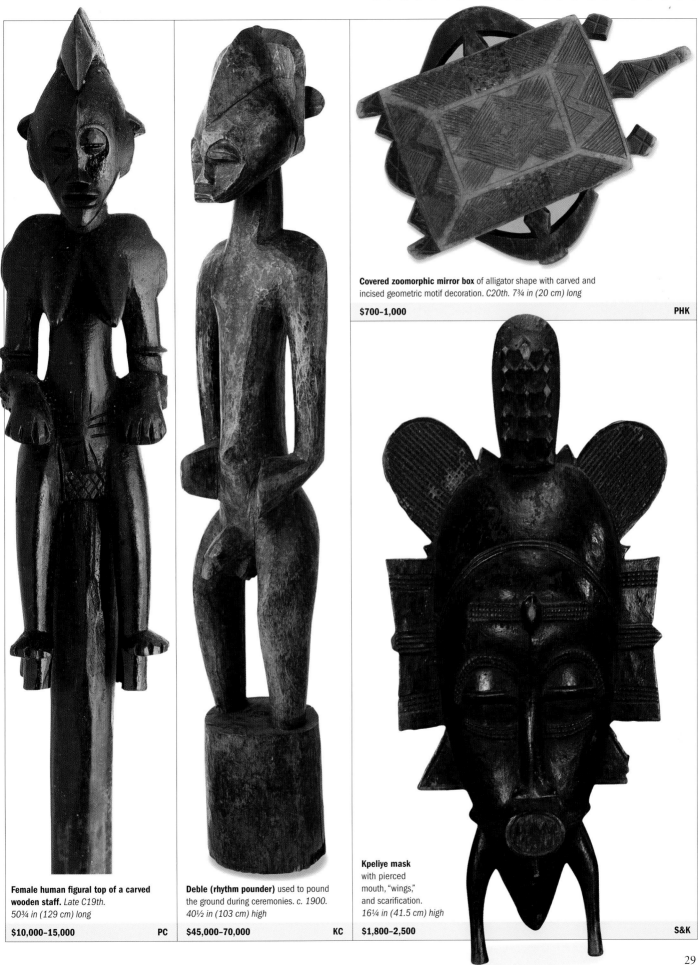

Covered zoomorphic mirror box of alligator shape with carved and incised geometric motif decoration. *C20th. 7¾ in (20 cm) long*

$700–1,000 PHK

Female human figural top of a carved wooden staff. *Late C19th. 50¾ in (129 cm) long*

$10,000–15,000 PC

Deble (rhythm pounder) used to pound the ground during ceremonies. *c. 1900. 40½ in (103 cm) high*

$45,000–70,000 KC

Kpeliye mask with pierced mouth, "wings," and scarification. *16¼ in (41.5 cm) high*

$1,800–2,500 S&K

Dan

Dan masks are worn with full costumes covering the body. The masks have different functions. The *deangle* mask, for example, has a shallow, domed forehead with median ridge, slit eyes with a kaolin, painted horizontal strip, and a cowrie shell fiber cap. It becomes the guardian and intermediary of the uncircumcised boy's initiation camp. Carved figures known as *lu me* (wooden people) are rare, and are usually female. They are portraits of the preferred wife of the chief, and confer prestige to their owners. Early male figures are especially rare.

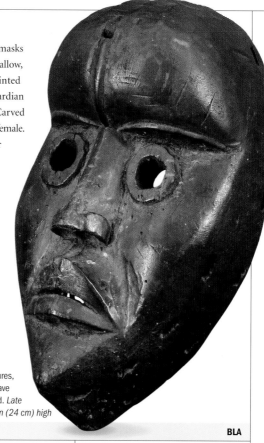

Facemask with Dan features, including a pointed concave face and domed forehead. *Late C19th–early C20th. 9½ in (24 cm) high*

$700–900　　　　BLA

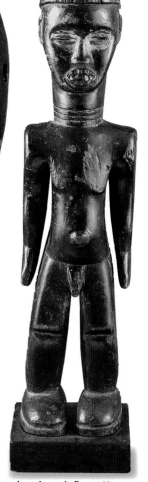

Carved wooden male figure with arms characteristically resting at the sides. *Late C19th–early C20th. 17¾ in (45 cm) high*

$1,500–2,000　　　　BLA

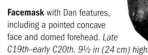
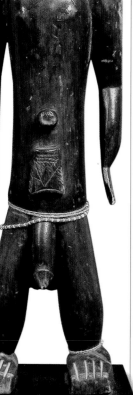

Carved wooden male figure with a conical helmet and beaded jewelry. *Late C19th. 21 in (53 cm) high*

$3,000–4,500　　　　BLA

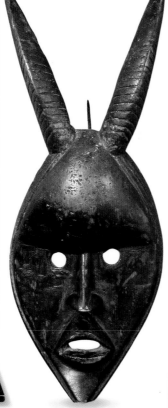

Carved wooden zoomorphic mask with concave face, bulging forehead, and horns. *Late C19th. 15¾ in (40 cm) high*

$2,200–4,000　　　　BLA

Carved wooden mask with a dark patina, pierced eyes, and protruding mouth. *Late C19th–early C20th. 9¼ in (23.5 cm) high*

$500–900　　　　SK

Deangle mask with slit, kaolined eyes and rolled fiber, cowrie shell, and trade bead attachments. *C20th. 10½ in (27 cm) high*

$1,000–1,500　　　　SK

A CLOSER LOOK

Gaegon masks are performance masks. All masks are known as *gle* (mask spirits) because the costume-mask-dancer triumvirate actually becomes the *du* (forest spirit); they are not merely possessed by it. Artists are only occasionally commissioned to carve masks, as preferred masks are used again and again, and may be adapted to perform different functions. The Gaegon mask is principally used for singing and entertainment during the village festivals that were common occurrences until the 1960s. It has been suggested that they were used during executions of criminals in the past. Today, dances are performed for tourists. **Below left: Gaegon mask** without monkey fur. *Late C19th–early C20th. 9¾ in (24.5 cm) high* **$1,800–3,000 BLA**. **Below right: Horned mask** with cloth-covered face and feather beard. *Early C20th. 12½ in (32 cm) high* **$3,000–4,500 BLA**

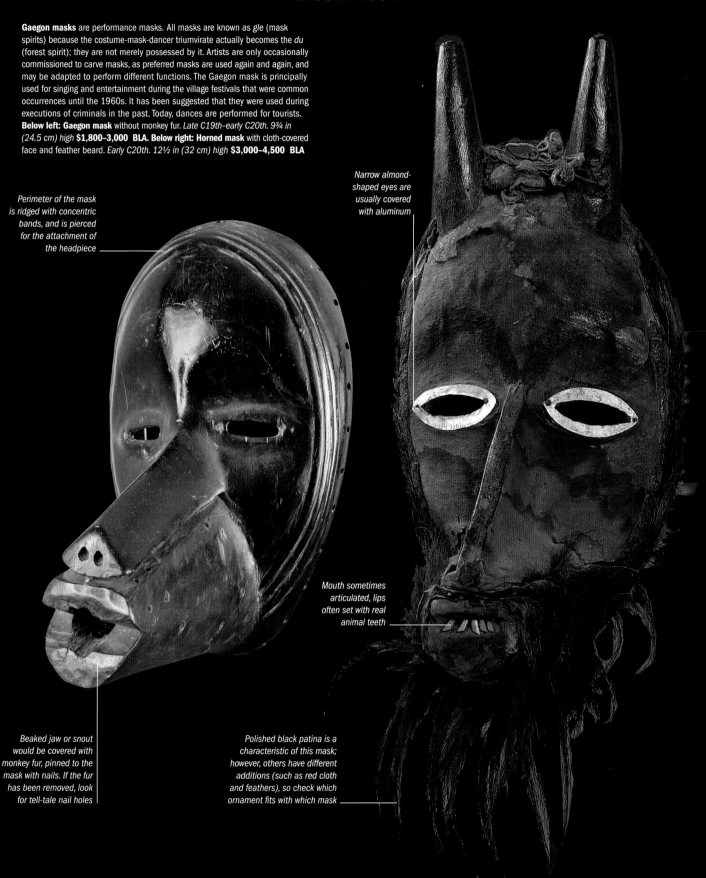

Perimeter of the mask is ridged with concentric bands, and is pierced for the attachment of the headpiece

Narrow almond-shaped eyes are usually covered with aluminum

Mouth sometimes articulated, lips often set with real animal teeth

Beaked jaw or snout would be covered with monkey fur, pinned to the mask with nails. If the fur has been removed, look for tell-tale nail holes

Polished black patina is a characteristic of this mask; however, others have different additions (such as red cloth and feathers), so check which ornament fits with which mask

Baule

One of the oldest dances performed by the Baule uses small facemasks, called *mblo*. The masks portray ordinary human characters and wild animals. One of these is the buffalo, the hunting of which is mimicked by boys and youths who carry off the dancer at the end of the performance. Lost-wax gold maskettes were made by Baule smiths in the 19th century to ornament the hairstyles of dignitaries. Nowadays, gold jewelry is used to adorn carved facemasks. Baule figurines are highly collectible. Look for a characteristic patina on *asie usu* figures resulting from their having been anointed with chicken blood and eggs.

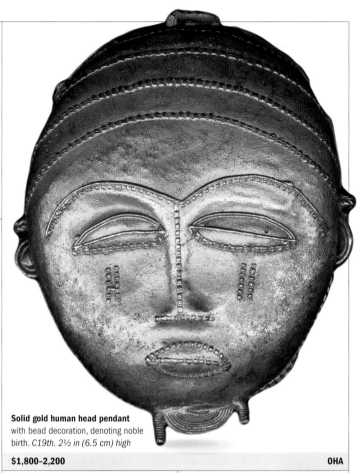

Solid gold human head pendant
with bead decoration, denoting noble birth. *C19th. 2½ in (6.5 cm) high*

$1,800–2,200 **OHA**

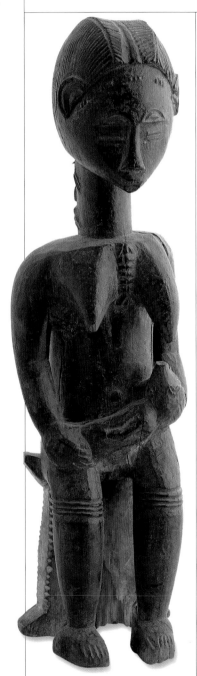

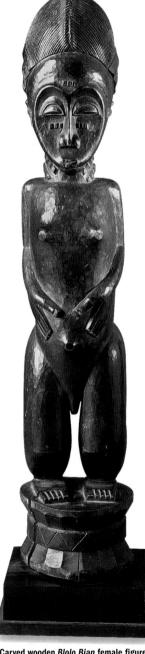

Maternity *asie usu* figure. Provenance: John Christopherson, artist (1921–1996) *19¼ in (49 cm) high*

$3,000–5,000 **PHK**

Carved wooden *Blolo Bian* female figure symbolizing a spouse from the spirit world. *Late C19th–early C20th. 19 in (48 cm) high*

$9,000–12,000 **BLA**

Carved wooden, black-patinated *djimini* dance mask with typical T-shaped nose. *Late C19th–early C20th. 9¾ in (25 cm) high*

$15,000–25,000 **BLA**

Zoomorphic carved wooden hammer used as a musical instrument. *Late C19th–early C20th. 10¾ in (27.5 cm) high*

$180–350 **BLA**

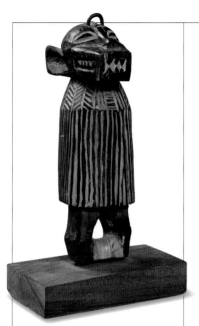

Carved wooden heddle pulley, associated with a blacksmith cult. *Late C19th–early C20th.* 5¾ in (14.5 cm) high

$1,200–1,800 BLA

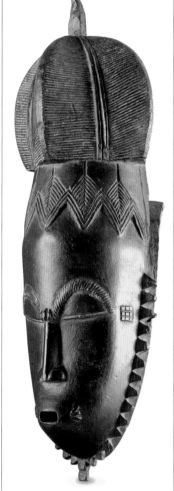

Carved wooden festival mask with an elaborate coiffure and raised scarification. *Late C19th–early C20th.* 17 in (43 cm) high

$6,000–9,000 BLA

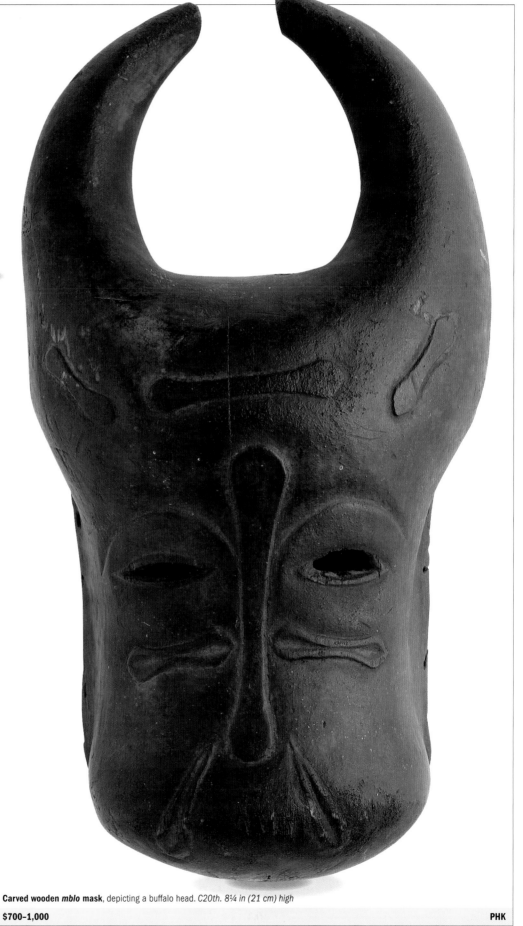

Carved wooden *mblo* mask, depicting a buffalo head. *C20th.* 8¼ in (21 cm) high

$700–1,000 PHK

KEY FACTS

Tribes include Ashanti (or Asante), Ewe, Fante, Moba, and archaic Komaland.

The humid, tropical climate is conducive to the growth of an array of plants, flowers, and trees. The wealth of color is reflected in the bright patterns of Ewe *kente* cloth.

Natural resources include lumber and gold. Sculpted brass weights measure out this precious commodity and are highly collectible.

The country is chiefly agricultural and cocoa production is key to the economy.

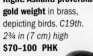

Right: Ashanti proverbial gold weight in brass, depicting birds. *C19th.* *2¾ in (7 cm) high* **$70–100 PHK**

Ghana

In the late 15th century, Portuguese sailors returned to Lisbon with astounding tales of kingdoms ruled by kings dripping in gold. Centuries later, during the colonial era, Ghana became known as "the Gold Coast."

Ghana has a strong identity despite European influences, and one tribe dominates. The Ashanti influence over other Twi-speaking tribes (the Akan family) is felt in the south and west into the Ivory Coast. From 1701, the first *ashantihene* (Ashanti king) established a powerful empire with the capital at Kumasi. Before their last battle with the neighboring state of Denkyera, legend has it that a golden stool descended from heaven and inspired King Osei Tutu to victory. Ever since, stools have been symbols of royalty, unity, and political power. The golden stool contains the soul of the Ashanti and is never sat on or placed on the ground.

The carving of drums is universally important; some have elaborate anthropomorphic stems, while others are simply decorated with incised lines.

Textile weaving is found across West Africa, but the *kente* cloth woven in Bonwire is perhaps the most recognizable symbol of African heritage, and is used for the national dress of Ghana.

The most famous Ashanti sculptures are the *akua-ba* figures with their large disklike heads. Women and girls tuck the figures into their skirts in order to aid fertility, and to promote health during pregnancy.

The Fante are a neighboring Akan group. They carve *akua-ba* statuettes with rectangular heads in pale wood with scorched decoration. They are also known for their graphic Asafo company flags, popular with interior decorators.

Above: Ashanti kuduo brass storage vessel, with a figurative scene cover and bands of geometric and floral motifs to the body. *C20th. 9 in (23 cm) high* **$700–1,000 RTC**

GOLD WEIGHTS

Brass weights for measuring gold dust are cast by all Akan groups using the lost-wax method, and can be categorized by type and date. Early weights (1400–1720) tend to be geometric with notched edges, the surfaces decorated with designs in low relief. Others are figurative or representational and tend to date from a later period (1720–1930). These may depict hunters, soldiers, domestic activities, weapons, or proverbs. For example, a porcupine figure, with its many spines, is a metaphor for the strength of the all-conquering Ashanti army. Weights are especially collectible because of their charm and diversity.

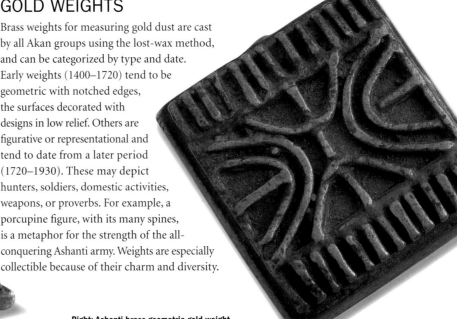

Right: Ashanti brass geometric gold weight. *1400–1700. 1¼ in (3 cm) high* **$70–100 PHK**

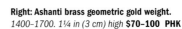

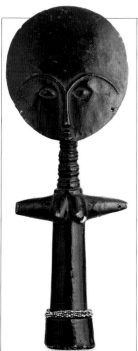

Ashanti carved wooden *akua-ba* female fertility doll. *C20th. 15 in (38 cm) high*

$2,200–4,000 **PC**

Ashanti carved wooden male figure (damaged). *Late C19th–early C20th. 8 in (20 cm)*

$1,500–2,000 **BLA**

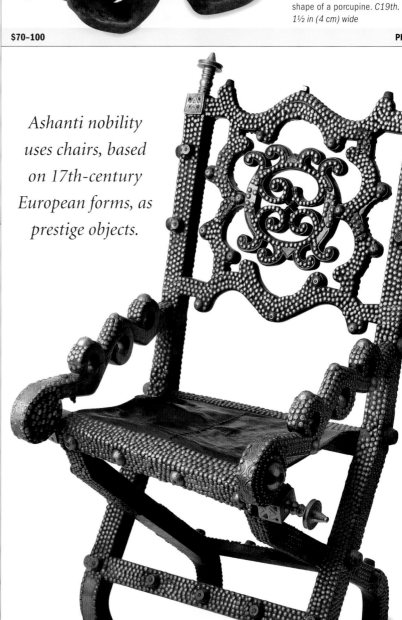

Ashanti brass gold weight in the shape of a porcupine. *C19th. 1½ in (4 cm) wide*

$70–100 **PHK**

Ashanti nobility uses chairs, based on 17th-century European forms, as prestige objects.

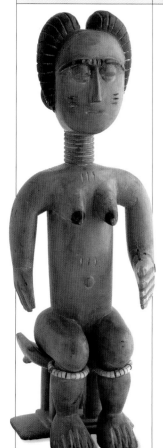

Ashanti Akan wooden fertility figure, seated on a typical stool. *17¾ in (45 cm) high*

$1,000–1,500 **PHK**

Fante carved wooden *akua-ba* doll with stylized rectangular head. *Early C20th. 11¾ in (30 cm) high*

$3,000–4,500 **PC**

Ashanti *acron kromfi* chair, in wood, brass, and leather. *Early C19th. 42½ in (108 cm) high*

$14,000–20,000 **AC**

KEY FACTS

Tribes include the Dogon, Bamana (or Bambara), Marka, Bozo, and Tuareg.

Inland Mali has a dry, tropical climate, with the mighty Niger River flowing northeast into central Mali before turning south.

The majority of the population is Muslim. The mud mosques found in this region represent some of the most striking African architecture.

Mali is an agricultural area and the importance of grain is seen in the decoration of granary doors, with elaborate carving and locks.

In the 13th–16th centuries several great empires developed in Mali with capitals in Kaarta and Segou.

Mali

Mali is a melting pot of influences. It is a region of nomads and farmers, Islam and animism. The peoples' grim history as slaves and slave traders has influenced art toward abstraction, with severe straight lines and angles.

The traditional art of Mali includes masks and figural sculpture, as well as archaeological material (such as terra cotta and bronze from the Djenne culture) and is dominated by two groups, the Dogon and the Bamana.

A MERGING OF INFLUENCES

The 250,000 Dogon inhabit the inhospitable Badiagara cliffs and surrounding plateau and valleys. The area is south of the fabled city of Timbuktu and untouched by the influence of Islam. The Tellem people, who were displaced by the Dogon in the 15th century, previously inhabited this land. They were forced to migrate east, where they became the ancestors of the Kurumba people. Tellem sculpture has been found in the burial caves in the cliffs. Tellem and Dogon characteristics are not easily distinguishable, often merging together in one piece. Figures with a thick encrusted patina of sacrificial material, such as chicken blood and millet beer (a Tellem trait), are often posed with arms stretched above the head, a gesture associated with Nommo, one of eight Dogon mythical ancestor twins. Dogon figural sculpture is closely related to religious rituals in which ancestors are venerated. Artists are influenced by style

Above: Wooden face mask with a dark brown patina, made by Bamana carvers. *Early C20th.* *11 in (28 cm) high* **$900–1,500 BLA**

MASQUERADE

Dogon masks can be grouped into categories according to material (wood or fiber), subject (human or abstract), and character (predator or quarry). Many masks are carved with two vertical slots into which eyeholes are cut, a form that echoes the architecture of the mud mosques of Djenne, Mopti, and Goundam (*see p.23*). The *kanaga* mask is probably the most recognized, with its beaklike mouth and "cross of Lorraine" crest. The crocodile mask has an encrusted patina and protects from the avenging spirits of slain crocodiles. Among the Bamana, the most well-known male societies are the Komo, who use masks with terrifying gaping jaws, encrusted with sinister, thick, sacrificial patinas, and the Tji Wara agricultural cult, who use Roan antelope headdresses (*see p.41*), popular in European collections.

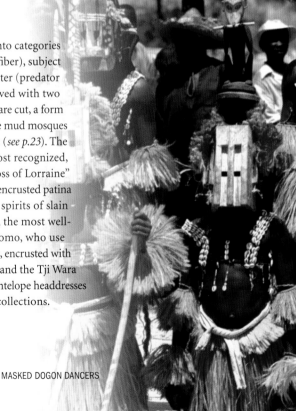

MASKED DOGON DANCERS

Left: Dogon stylized crocodile mask, carved in wood, with thick encrusted patina. *Late C19th–early C20th. 14½ in (37 cm) high* **$90,000–120,000 PC**

DJENNE ART

Terra-cotta sculpture and bronze work dating from the 11th to 17th centuries have been excavated from the site of Djenne-Djenno. Little is known of the pieces' use, because the context in which they were found has been destroyed. The bronze castings include pendants and bracelets, which can also be seen modeled on the terra-cotta figures. These are decorated with a variety of designs, including serpents, human heads, and full figures. The sculpture is unlike most other traditional African art, as the figures are sculpted in dramatic, asymmetrical postures.

Left: Djenne-style bronze cuff with human heads in relief and verdigris patina. *C16th. 2¾ in (7 cm) wide*
$10,000–15,000 PL

SYMBOLS

Many motifs are symbolic of a myth, animal, or spirit. Dogon granaries have doors carved with crocodiles, or rows of male and female twins symbolizing fertility. They often form five tiers representing the first five mythical generations of the clan.

DOOR LOCKS

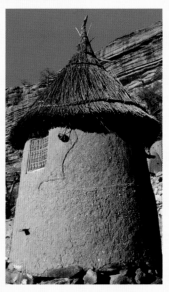

Locks are popular with collectors and are found in Bamana and Dogon society in many different styles. They are simply the bolt cases found on the wooden doors adorning granaries (*see above*). Locks are bridal gifts, the action of the bolt through the lock symbolic of the sexual act. Bamana locks are carved as male figures, while those of the Dogon may be surmounted with ancestors or horses.

conventions of the workshop, the location, and dialect group. A great variety can be found, making it difficult to identify the ancestor for whom the sculpture was carved.

VARIATIONS ACROSS A TRIBE

The Mande-speaking Bamana have a population of 2.5 million and are the largest group in Mali. Huge stylistic differences can be found among this group, with variations in surface and patina, and degree of naturalism or abstraction. Recent scholarship has identified homogenous carving styles, named according to the region in which the style is found.

Figural sculptures are found among the southern Bamana, where they are used in the context of Jo and Gwan initiation societies. Also of note are the disturbing and powerful *boliw* (singular, *boli*) of the Bamana. These are quadrupedal, hump-backed altar figures, with thick, sacrificial patinas. They are associated with the Komo and Kore societies, and contain immense amounts of *nyama* (energy), which a priest can channel toward a malevolent sorcerer, for example. The sculpture of Brancusi bears a resemblance to these apotropaic (anti-evil) power figures, making them popular among collectors. Komo society

leaders also forge iron staffs, often depicting equestrian figures.

The blacksmith artists of the nomadic Tuareg also work with metal, creating elaborate copper, brass, and silver-inlaid keys for dowry chests, which double as veil weights.

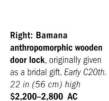

Right: Bamana anthropomorphic wooden door lock, originally given as a bridal gift. *Early C20th. 22 in (56 cm) high*
$2,200–2,800 AC

Dogon

Dogon figures have exaggerated breasts and shoulder blades. The line of the hair often continues that of the nose, and the chin is pointed or cylindrical. While ancestor statues are hidden, masks are displayed openly in mourning ceremonies. The ancestral Nommo spirit is portrayed with rain-beseeching arms, and his twin, Yasa, holds a container of rainwater on her head. A horse and rider are symbolic of the ark containing the first Nommo, with his eight child twins and all the animals on the earth. Dyougou Sirou, the incestuous son of the god Amma, is depicted covering his eyes in shame. Other items include door locks, necklaces, bronze pendants and rings, iron staffs, stools, ladders, and house posts.

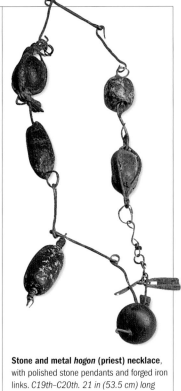

Carved and pierced wooden door lock, with an elaborate finial of a mounted *hogon* (priest). *Early C20th. 19 in (48 cm) high*

$1,000–1,600 BLA

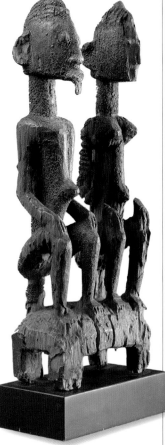

Stone and metal *hogon* (priest) necklace, with polished stone pendants and forged iron links. *C19th–C20th. 21 in (53.5 cm) long*

$500–700 SK

Carved wooden figure of incestuous Dyougou Sirou, covering his eyes in shame. *C19th. 11½ in (29 cm) high*

$1,000–1,600 BLA

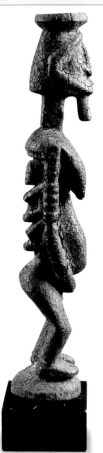

Carved wooden ancestor figure with a shallow receptacle on the head for libations. *Late C19th. 14 in (37.5 cm) high*

$3,000–4,500 BLA

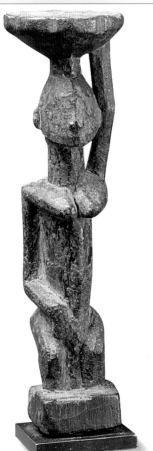

Carved wooden Yasa figure with a bowl on her head. *Late C19th–early C20th. 9½ in (24 cm) high*

$1,000–1,600 BLA

Pair of carved wooden, male and female, seated ancestor figures. *Late C19th. 27cm (10¾in) high*

£800–1,200 BLA

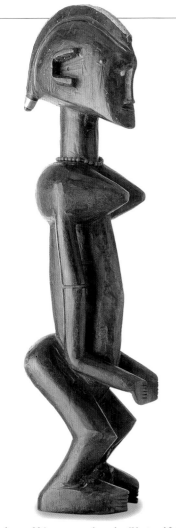

One of some 20 known carved wooden "Master of Ogol" -style figures from mythology. *c. 1930. 23¾ in (60 cm) high*

$3,000–5,000 **KC**

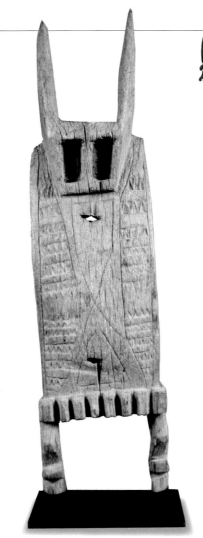

Carved wooden anthropomorphic door lock decorated with scarified and notched geometric motifs. *Late C19th. 19¾ in (50 cm) high*

$1,200–2,000 **BLA**

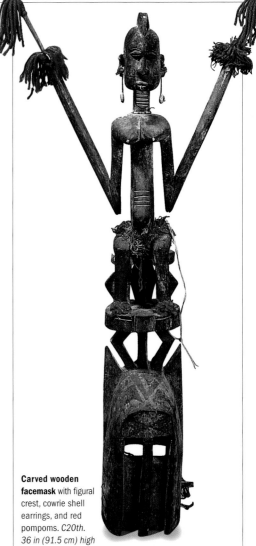

Carved wooden facemask with figural crest, cowrie shell earrings, and red pompoms. *C20th. 36 in (91.5 cm) high*

$400–600 **RTC**

Two *hogon* (priest) necklaces: the left with a stone pendant; the right with a quartz pendant and tongs. *C19th–C20th. 25 in (63.5 cm) long*

$300–500 **SK**

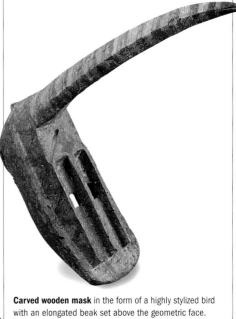

Carved wooden mask in the form of a highly stylized bird with an elongated beak set above the geometric face. *Late C19th–early C20th. 15¾ in (40 cm) high*

$4,000–5,000 **BLA**

Bamana

One of the regional carving styles used by the Bamana is the "Segou style," characterized by arrow-shaped noses, zigzag or triangular body decoration, flat faces, and paddlelike hands. In the south, "Bougouni style" has a more sensitive feel. Jo association sculptures, *nyeleni* (little ornaments), are always carved as standing nubile women, and are rendered with ideal attributes of a long neck and conical breasts. They act as insignia to the young male initiates. Gwan sculpture acts as a memorial for deceased twins of each gender (female *gwandusu*, male *guantigi*), and during ceremonies the figures are tended and sacrifices are made to them.

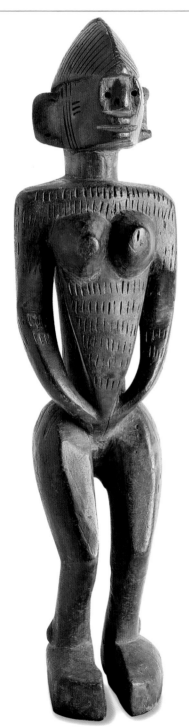

Carved wooden *gwandusu* female figure, with clasped hands. *c. 1910. 22¾ in (58 cm) high*

$1,600–2,000 JBB

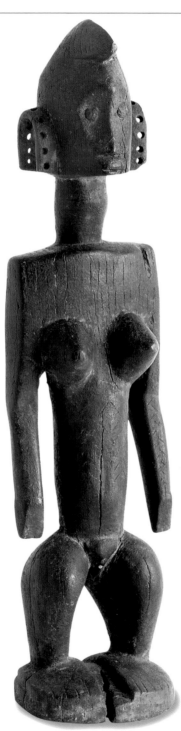

Carved wooden *gwandusu* female figure, with arms by its sides. *c. 1890. 20 in (51 cm) high*

$1,800–2,200 JBB

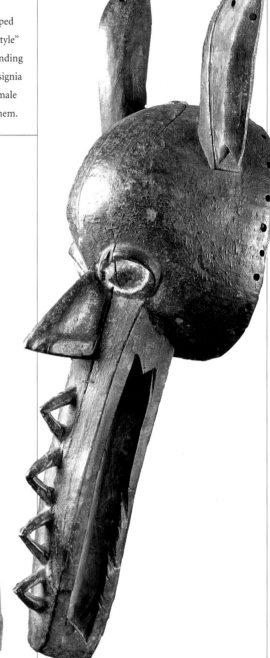

Wooden zoomorphic mask with an extended mouth and kaolined eyes. *Late C19th–early C20th. 24¾ in (63 cm) high*

$1,500–2,000 BLA

SHARED INFLUENCES

The masks of the Bamana tribe are very similar to those of other Mali tribes, such as the Marka, Bozo, and Malinke—but with significant distinctions. Marka masks (*see p.22*) resemble the crested designs used by the Bamana N'tomo society, but are covered with cloth and metal strips or sheets, with tresses to the sides. The masks of the Bozo are similar to Marka and Bamana masks, but are more rounded—often depicting buffalo. Malinke masks are more stylized and angular, and show Bamana traits as well as similarities to the work of the Senufo of the Ivory Coast (*see p.28*).

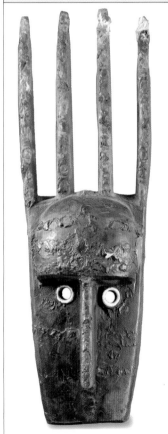

Segou-style figure with flat face, arrow-shaped nose, and splayed hands. *Late C19th–early C20th. 24½ in (62 cm) high*

$3,000–4,500 **BLA**

A CLOSER LOOK

Antelope headdress. Members of the Tji-Wara society wear headdresses that are carved in pairs and depict Roan dage (antelope). The antelope symbolizes farming prowess and, by extension, sexual potency. The headdress is danced at harvest time, and at the beginning of the rainy season, to encourage the farmers in their labors. The successful farmer can claim the best bride and provide food for the bride's family with most certainty. *Early C20th. 54 in (137 cm) high* **$30,000–45,000 PL**

Powerful curved horns and erect ears suggest physical strength and alertness—ideal attributes of the farmer

Openwork zigzag motifs on the curved neck symbolize the course of the sun across the sky

The nose and earlobe are pierced for red cloth ornaments

The square base is pierced with holes to attach a woven basketry cap

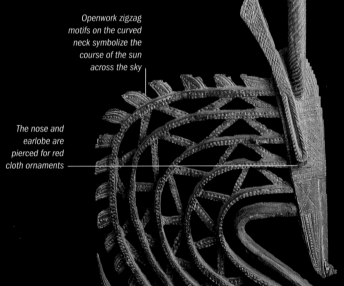

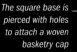

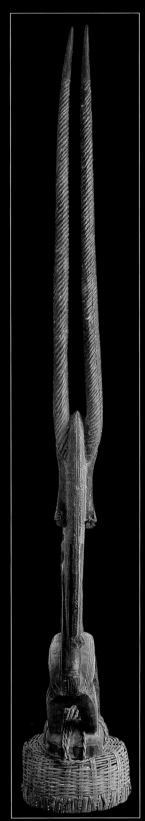

DETAIL FROM FRONT, SHOWING THE NARROWNESS OF THE PIECE

N'tomo society dance mask with characteristic comblike structure. *Late C19th–early C20th. 21¼ in (54 cm) high*

$4,500–6,000 **BLA**

KEY FACTS

Tribes include the Bwa, Bobo, Mossi, Lobi, Kurumna, and Tusyan.

Burkina Faso lies inland in the southern part of the sub-Saharan belt of savanna known as Western Sudan.

The dusty plains reach top temperatures from February onward. By then the harvest is complete and the farmers have time for social and ceremonial activities.

Light, pliable wood known as cotton tree is used for mask-making. Its lightweight quality is particularly important for the tall Bwa masks worn in ceremonies.

Burkina Faso

The tribes of Burkina Faso are renowned for their dramatic panel-shaped and brightly colored abstract masks. A small number of tribes also produce austere, realistic figurative sculptures.

There are around 60 different subgroups of peoples in this area. Most produce masks for ceremonies, often worn with a costume. The Bwa number around 300,000 and inhabit the area around the Black Volta River bend. Most have animist beliefs, attributing conscious life to sacred objects. In the south, they produce *nwantanta* (plank) masks. These can be up to 6½ ft (2 m) long and are used in domestic ceremonies. They depict creatures such as butterflies, antelopes, and birds and feature rectilinear motifs signifying myths. The Bwa believe that these masks become inhabited by supernatural clan spirits, who protect the owner's family from harm. Other masks are made from leaves and fibers.

The 250,000 Lobi live to the southwest, straddling the border with Ivory Coast. Their dances are performed without masks. Instead, artists produce *bateba* figures (*see below*), carve three-legged stools ornamented with human heads, and make wedge-cut ladders.

The 100,000 Bobo people live to the west of the Bwa and carve large zoomorphic and anthropomorphic helmet masks with painted decoration. Their work shows elements of Bamana realism as well as the abstract work of the Mossi. Mossi masks have oval or almond-shaped faces with supporting antlers, tall narrow plank superstructures, or figure crests.

Above: Mossi carved wooden figure with arms characteristically set apart from the body. *Mid–late C19th. 11¾ in (30 cm) high* **$6,000–10,000 BLA**

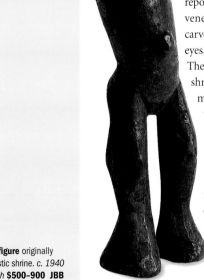

BATEBA FIGURES

The two types of *bateba* figures are used as repositories for the *thil* (supernatural spirits) venerated in Lobi culture. They are often carved with rounded heads and coffee-bean eyes, barrel torsos, and block feet and hands. The first type, *thil du*, is placed in household shrine rooms and anointed with sacrificial material to avert misfortune and ensure the goodwill of ancestors. Figures with splayed arms protect against dangerous *thil*. The second type is known as *duntundora* and can be over 20 in (50 cm) high. They are often carved from hard wood, with severe facial expressions. They are also placed in the Lobi shrine in times of distress and assume the anguish of the sufferer.

BATEBA FIGURES IN A SHRINE

Right: Thil spirit figure originally placed in a domestic shrine. *c. 1940 11 in (28 cm) high* **$500–900 JBB**

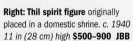

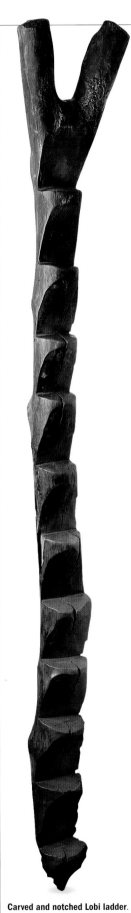

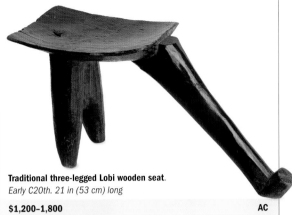

Traditional three-legged Lobi wooden seat.
Early C20th. 21 in (53 cm) long

$1,200–1,800 AC

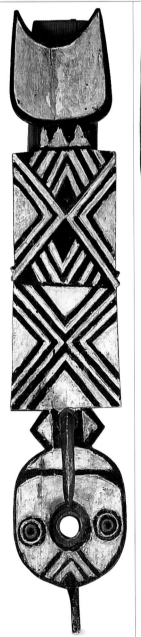

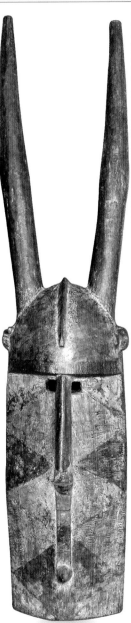

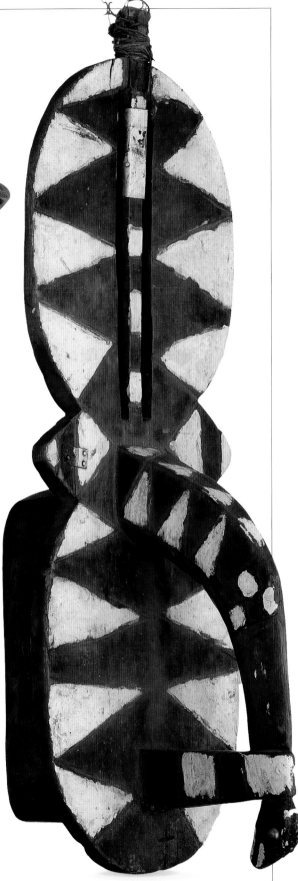

Carved and notched Lobi ladder.
Early C20th. 84 in (213 cm) long

$1,600–2,000 JDB

Nwantana painted plank mask
with stylized bird head, by the Bwa
people. *C20th. 61 in (155 cm) high*

$300–700 RTC

Bobo tribe zoomorphic mask
with horned cap and red and
white paint. *Late C19th–early
C20th. 50½ in (128 cm) high*

$10,000–16,000 BLA

Stylized Bwa plank mask with polychrome painted motifs.
C20th. 21¾ in (55 cm) high

$2,200–3,000 AC

Tribes in the north include the Nupe, Hausa, Dakakari, Nok, Afo, Jukun, Wurkun, Tiv, Chamba, Mumuye, Koro, Mama, and Bura. In the southeast (including the Niger delta and Cross River region) are the Igbo, Igala, Idoma, Urhobo, Ibibio, Annang, Oron, Eket, Ogoni, Efik, Mbembe, and Ekoi. In the southwest are the Yoruba, Bini, and Edo.

Traded copper and brass from Portuguese merchants encouraged artistic production in casting centers such as Benin.

Ancient terra-cotta sculpture has been found in archaeological sites at Nok, Ife, Dakakari, and Owo.

Coastal tribes such as the Ijo, who are fishermen as well as farmers, carve unusual horizontal masks depicting aquatic animals.

Nigeria

Nigeria is the largest African coastal country and, with around 100 million citizens, the most populous country on the continent. The cultural and artistic traditions of this vast area date back 2,000 years to the Nok terra-cotta.

The country is geographically divided along a north-to-south axis, based on rainfall and vegetation. In the northern region, savanna and desert allow the cultivation of millet, rice, and groundnuts. The tribes are dominated by the Hausa language and Islamic religion, but survive in their own leaderless communities resisting the cultural incursions of Islam. South of the convergence of the Benue and Niger Rivers, the forested region begins; this eventually becomes mangrove swamp on the coast. The major Nigerian cities are located in the predominantly Christian south. The area is dominated by the Igbo (also known as Ibo) and Yoruba peoples. Agriculture in the south includes cash crops of cocoa and rubber.

The Yoruba are the largest ethnic group in Africa and number around 15 million. Over a 300-year period, the transatlantic slave trade expropriated 25 million West Africans, of which only about 15 million even survived the journey. They were destined for the plantations of the European colonies in the New World. Despite the abolition of slavery in Europe by the 19th century, a further four million were transported in that century. Consequently, Yoruba traditions are practiced in many countries across the world, including Brazil, Trinidad, and Cuba.

Several powerful city-states emerged in Nigeria, producing now-rare works of art for

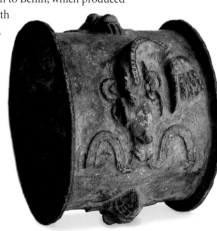

Above: **Carved wooden dance crest** with a white-painted naturalistic face, by the Idoma people. *Late C19th–early C20th. 14¼ in (36 cm) high* **$1,400–2,000 BLA**

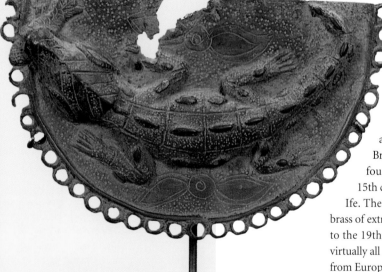

Above: **Benin bronze plaque** of demi-lune shape, with an alligator in relief. *C18th–C19th. 6½ in (16.5 cm) high* **$1,800–2,500 S&K**

METAL CASTINGS

Nigeria's metal castings are principally made from alloys of copper, mined in Niger as far back as 1000 BCE. Bronze artifacts from the 8th–10th centuries have been found in the lower Niger River area. Between the 12th and 15th centuries, brass castings developed among the Yoruba in Ife. The technology disseminated south to Benin, which produced brass of extremely high quality from the 15th to the 19th century. By the 19th century, virtually all Benin castings were made from European brass. Castings were made using the lost-wax technique: an object is modeled in clay, covered in wax, then covered again in clay. Once baked, the wax melts to reveal a cavity into which molten metal is poured.

Right: **Yoruba lost-wax** cast bronze bracelet. *C17th. 2¾ in (7 cm) high* **$5,000–9,000 PC**

COLONIAL FIGURES

Celebrated artist Thomas Ona Odulate produced carvings of British colonials for commercial sale. The style of the work is that of Ijebu-Ode, his home before he began carving in his Lagos studio in the 1940s. The pieces are painted with imported red and black ink, and shoe whitener. The figures are presented in their formal regalia, symbolic of the power institutions imposed on fellow Nigerians. The "characters" include The Clergyman (as seen here), The District Commissioner, The Doctor, and The Lawyer. Colonial figures are also carved by many other African tribes, including the Baule, Tsonga, Nguni, and Kamba.

Left: Pair of colonial figures, the religious male with kaolin pigment, carved by Yoruba artist Thomas Ona Odulate. *Mid-C20th. 10¼ in (26 cm) high* **$900–1,200 SK**

YORUBA DEITIES

The homogeneity of Yoruba art reflects the domination of various cults, whose ceremonies are practiced among all Yoruba people. These include the Ibeji twin cult, Epa, Egungun, and Gelede masquerades, Obgoni and Oshanyin metalwork cults, and Ifa divination.

PANTHEON OF GODS

Yoruba Ifa divination bowl "Agere Ifa." When Yoruba children are born, a *babalawo* (diviner) identifies the *orisha* (pantheon of gods) with which the child is associated. Sacrifices are subsequently made in domestic shrines. The most important *orisha* are Eshu (the trickster), Ogun (the god of iron and war), Shango (god of thunder and lightning), Obatala (the gentle god), Oshanyin (the god of herbalists), Oshun (the female god of water), and Oko (the god of farming). Olorun is the supreme being and there are no images of him. *C20th. 9 in (23 cm) high* **$9,000–12,000 PHK**

a period of over seven centuries. These include the spiritual center of the Yoruba at Ile-Ife (C11th–15th), Ijebu (C16th–18th), Owo (C13th–16th), and Oyo (C15–19th). The 20th century saw the advent of new political systems.

The Igbo and Niger Delta peoples live southeast of the Yoruba. The local autonomy of tribes in this area is reflected in the artworks. Many styles exist within each tribe, varying between villages. Moreover, the styles of different ethnic groups may be more closely related than styles within the same cultural group. For example, many Igbo and Idoma masks are almost indistinguishable. The Ekoi people live along the Cross River, in the far east of Nigeria and into Cameroon. The Nigerian Ekoi produce monolithic sculptures representing *akwanshi* (sacred chiefs). They range in size from 12 in (30 cm) to 6½ ft (2 m) and are thought to date from between the 16th and 19th centuries. (*See pp.52–55 for the Cameroon Ekoi.*)

In the northeast, the Mumuye, who live in the hills below the Benue River, make the most striking sculptures. The figures are elongated, with angular legs and arms (angled at the elbows) carved free of the sides and wrapped around the tubular torso. Coiffure may be a crest and the septum and earlobes are usually pierced in female figures. They are used for divination and healing, or act as guardians or status symbols for elders.

Right: Wooden shrine figure of a kneeling bowl-bearer. *Late C19th–early C20th. 14 in (35.5 cm) high* **$3,000–4,500 BLA**

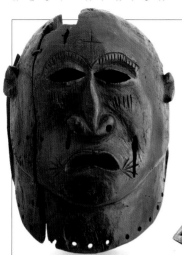

Rare carved wooden mask with an ancient patina, by the Tiv people. *C19th. 11 in (28 cm) high*

$9,000–14,000 **JDB**

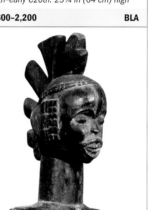

Ijo water spirit mask worn on the top of the head, so that the spirits can see it. *Late C19th–early C20th. 25¼ in (64 cm) high*

$1,600–2,200 **BLA**

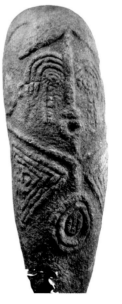

Carved and pigmented wooden figure with elongated features and overly large earlobes, from the Mumuye people. *Late C19th–early C20th. 45 in (114 cm) high*

$10,000–16,000 **BLA**

Yoruba woman's wrap, ikat-dyed in shades of indigo to produce a striped pattern. *Early C20th. 67 in (170 cm) long*

$1,400–1,800 **EFI**

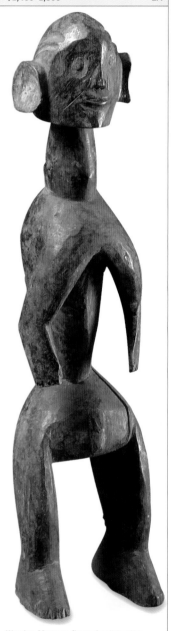

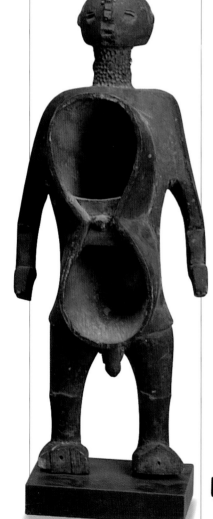

Wooden anthropomorphic drinking and pouring cup from the Koro people. *C20th. 24½ in (62 cm) high*

$27,000–36,000 **SK**

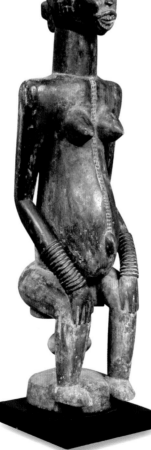

Ekwotame seated female wooden figure representative of Idoma tribe ancestors. *Late C19th–early C20th. 32 in (81 cm) high*

$10,000–16,000 **BLA**

Large carved stone *akwanshi* monolith representative of Ekoi tribe ancestors. *C16th–C19th. 42¼ in (107 cm) high*

$14,000–25,000 **BLA**

Wooden Mumuye figure for divination, apotropaic, and rain-making. *Late C19th–early C20th. 17¾ in (45 cm) high*

$1,800–2,500 **BLA**

Nok

Terra-cotta sculptures dating from 400 BCE to 200 CE were unearthed in the early 1940s near the town of Nok, on the Jos plateau in northern Nigeria. Unfortunately, illegal excavations ensued, so some of the sculpture on the international market may come from looted sites. There is variation in style among terra cotta found in Nok, Katsina, and Sokoto. Research continues to determine the relationship between this art, and its connections to the Yoruba, with whom there are obvious links. Because the archaeological context has been lost or damaged during the removal of the sculptures, their purpose is a matter of conjecture. Scholars have suggested that they are grave markers or lids to funerary urns.

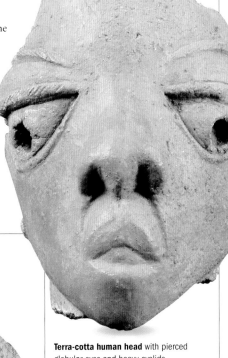

Terra-cotta human head with pierced globular eyes and heavy eyelids. *400 BCE–200 CE. 4¾ in (12 cm) high*

$1,200–1,800　　　　　　**BLA**

Terra-cotta female figure unusually complete and uncharacteristically standing. *400 BCE–200 CE. 32¼ in (82 cm) high*

$27,000–36,000　　　　　　**BLA**

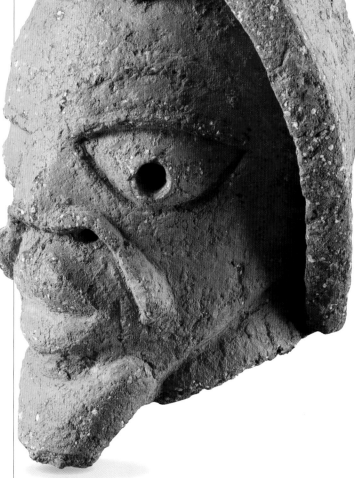

Terra-cotta male head with pierced globular eyes and curved lower lids. *1–400 CE. 7 in (18 cm) high*

$1,400–2,000　　　　　　**BLA**

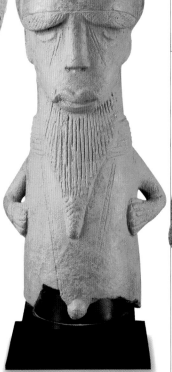

Terra-cotta figure with elongated face and overhanging eyebrows typical of the Sokoto area. *c. 400 BCE. 19¾ in (50 cm) high*

$7,000–12,000　　　　　　**BLA**

Terra-cotta human head with pierced eyes and elaborate coiffure. *400 BCE–200 CE. 8¼ in (21 cm) high*

$2,000–3,000　　　　　　**BLA**

Niger Delta

The Niger Delta peoples include the Igbo, known for marionettes, white-faced *mmwo* (maiden spirit) masks, *alusi* (tutelary deities), and *ikenga* (shrine figures). *Ikenga* are owned by household heads, and are used for protection, good luck, and strength. Ibibio, west of the Cross River, produce masks and figures with fleshy-looking articulated limbs, used in their Ekpo ancestor cult. Ekpo masks are either white "beautiful" masks or black "fierce" masks. The Idoma occupy the central area of the Benue state. They use *anjenu* (serene spirit figures) in ceremonies to ensure fertility and wealth. Dance crests carved with human heads and stylized fruit finials are used at funerals and harvest time.

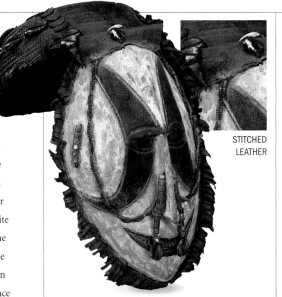

STITCHED LEATHER

Igbo mask with pigment, shell, raffia, and leather, from the Nri-Awka region. *C20th. 9½ in (24 cm) high*

$1,200–1,800 S&K

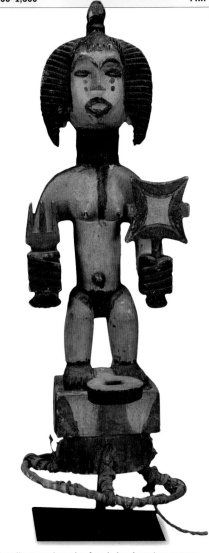

Carved wood Igbo mask of ovoid form, facial features defined with pigment. *C19th. 8¼ in (21 cm) high*

$900–1,500 PHK

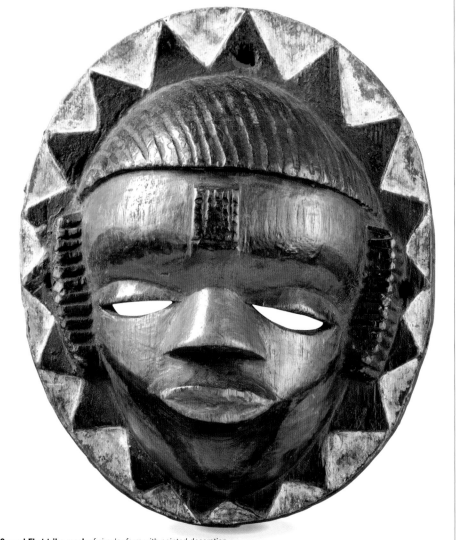

Carved Eket tribe mask of circular form with painted decoration. *Late C19th–early C20th. 6¼ in (16 cm) high*

$1,800–2,200 BLA

Igbo tribe carved wooden female head crest on a woven fiber base. *C20th. 21¾ in (55.25 cm) high*

$2,500–3,000 S&K

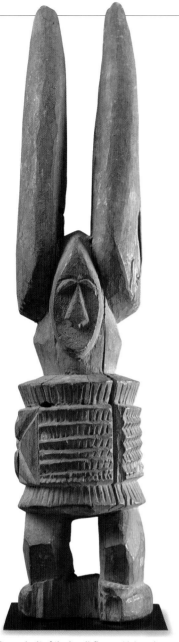

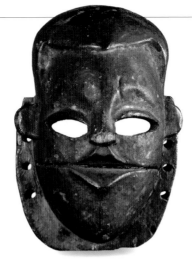

Characteristically small wooden human facemask from the Ogoni tribe. *Late C19th–early C20th. 6½ in (16.5 cm) high*

$400–700 **BLA**

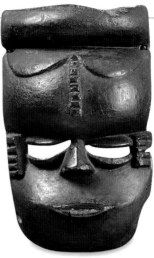

Ibibio tribe dance mask, with cicatrice scars on the forehead and beside the eyes. *C20th. 9 in (22.5 cm) high*

$900–1,500 **BLA**

Igbo Ikenga (cult of the hand) figure with large horns, symbolizing strength, power, and courage. *Late C19th–early C20th. 19¼ in (49 cm) high*

$500–900 **BLA**

IGBO COSTUME

Agbogho mmanwu dancers, who wear the *mmwo* mask, wear a tight-fitting costume (*see right*). Both the mask (not shown) and the costume represent an idealized notion of feminine beauty—the openwork crest represents an elaborate coiffure and the costume patterns represent female body decoration. The different pieces of colored cotton fabric are sewn together using the appliqué technique in a two-piece outfit. Both costume (body) and mask (head) must be seen together in order to understand the symbolism of the masquerade. Note the gloved hands, padded breasts, and umbilical hernia. Male dancers perform holding fans, whisks, or mirrors. They appear to depict not particular ancestors, but general female character types from the spirit world.

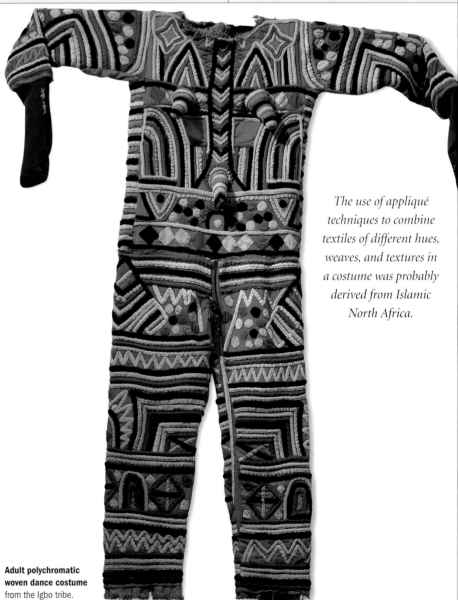

The use of appliqué techniques to combine textiles of different hues, weaves, and textures in a costume was probably derived from Islamic North Africa.

Adult polychromatic woven dance costume from the Igbo tribe. *c. 1960.*

$300–500 **EL**

Tribes in the west include the Tikar (including the Bamun, Kom, Babanki) and Bamileke (including the Bangwa, Batcham, Bagam, Menjo) in the Grasslands. In the north are the Fulani, Mambila, Kirdi, Namji, and Dowayo. In the forest and Nigerian borderlands and coast are the Ekoi, Ejagham, Keaka, Mbembe, and Duala.

Grasslands art reflects the secret institutions surrounding royalty. Bangwa royal portraits are extremely rare and dramatic pieces.

Nomadic Fulani produce artworks that can be carried easily, such as large gold earrings and carved bowls.

Duala art was greatly influenced by contact with European traders. Stools were carved for sale, and brightly painted ships' prows echoed Portuguese fishing boat design.

Cameroon

In the 1890s, Gustav Conrau acquired a sculpture of a woman from the Bangwa. He could never have imagined that almost a century later, the $3.4 million "Bangwa Queen" would become the most expensive work of African art ever to be sold.

The art of Cameroon can be divided into geographical groups. The Cameroon grassland in the west is a plateau known as the Grasslands, with scattered mountain peaks. Tribes here have quite a different artistic style from those who live in the far northern savanna region, in the dense forested area that borders Nigeria and the Cross River valley, and at the southern coast around Duala.

The tribes of the Grasslands region are organized in political groupings ranging from small chiefdoms to large kingdoms. Despite the fragmentary nature of the many hundreds of small societies, the art produced has great homogeneity. The sculpture and masks often portray humans, with wide almond eyes, semicircular ears, open mouths with carved teeth, fiber wigs, and beards. Zoomorphic motifs include spiders, snakes, crocodiles, and lizards. Animal masks include the elephant mask made from the beaded cloth of the Bamileke, and the buffalo helmet mask, which is the most powerful of all animal masks. A variety of other items are found in this region, such as large house posts and doors, beds, drums, carved ivory, and buffalo-horn drinking cups, reserved for chiefs. Brass pipe bowls, masks, and necklaces are also cast to a very high quality and the royal beaded stools and thrones are spectacular.

Two groups dominate the Grasslands: the 350,000 Tikar and the 700,000 Bamileke. The Tikar are composed of over 30 separate kingdoms, all of which trace their ancestry back to an original Tikar group 300 years ago.

Above: Grasslands carved horn drinking cup, ornamented with brass wire. 11¾ in (30 cm) long **$700–1,000 PHK**

CHIEFDOM

Each chiefdom is ruled by a Fon (chief or king) who is regarded as sacred, and whose influence overarches different ethnic communities. He is chosen by the *kwifon* (palace society) elders from among the royal clan. Royal statuary reinforces the image of the benevolent, prosperous, and bountiful leader. Among the Bamileke, commemorative images of the king and his queen (often nursing the infant heir) are carved when he is enthroned, and serve as reminders of the monarch and his dynasty when he is dead. The 11th King of the Bamun, Njoya, stands out as the most influential chief in the whole of Grasslands history.

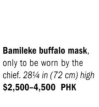

Bamileke buffalo mask, only to be worn by the chief. 28¼ in (72 cm) high **$2,500–4,500 PHK**

TRADITIONAL CHIEF DRESS IN NORTHEAST CAMEROON

Left: Carved wooden fertility doll with metal adornments and geometric features typical of the Namji. *C20th. 10¾ in (27 cm) high* **$700–1,200 BLA**

FERTILITY FIGURES

In northern Cameroon, delightfully stylized human figures are carved with narrow bodies and limbs, and small round heads. These can be found among the Dowayo and Namji. When unadorned, they are regarded as dolls for play. When they are ornamented with beadwork and cloth, however, they become empowered, and act as fertility figures, similar to the Ashanti and Fante *akua-ba* (doll). The Dowayo believe that the effectiveness of the carving to influence pregnancy depends chiefly on the artist's success with fathering children.

Left: Namji fertility doll with beads and cowrie shells. *C20th. 10¼ in (26 cm) high* **$1,500–1,800 EL**

The group collectively named Bamileke refer to themselves by the names of the 90 or so subtribes that make up the coalition. Their *mu po* (small figures representing pregnant women) are held during anti-witchcraft and healing ceremonies. Their palaces are constructed with lintels and posts carved with human figures; other figurative posts are planted to bar entrances to the building.

The Kirdi in the north fashion small objects in metal and leather for adornment, while the Mambila, who, like the Ekoi, straddle the Nigerian border, carve ancestor figures as receptacles to honor their fickle clan spirits, ensuring health, fertility, and prosperity. They are usually carved expressively, with a large triangular face, peg coiffure, almond eyes and mouth, bent arms, and powerful squat legs. They are regularly painted in red, white, and black, as are their masks of dogs, used in agricultural ceremonies.

SKIN

The skin of slaves or slain enemies was once stripped from the body, stretched, and used to cover the headdresses produced and used in various societies in Cameroon. Nowadays, however, untreated leopard or antelope skin is employed.

SKIN MASKS

Ekoi mask, with leopard skin and human skull, from Nigeria. Skin-covered masks and headdresses are used by most tribes in the Cross River area, both in Cameroon and Nigeria, including the Ekoi, Efik, Keaka, and Ejagham. Skin is stretched over a carved wooden base, stained with black and white details, cane or metal teeth are set in the open mouth, and the cranium is studded with pegs or applied with a human-hair wig. The mask is either set above a woven cap, or worn as a helmet. They came in various animal spirit forms, including antelope and crocodile masks with coiled horns; and in realistic human form with one to four faces. *Late C19th. 10¼ in (26 cm) high* **$25,000–30,000 PL**

Left: Ekoi mask, with antelope skin over a wooden base and human hair. *C20th. 12¼ in (31 cm) high* **$9,000–12,000 PL**

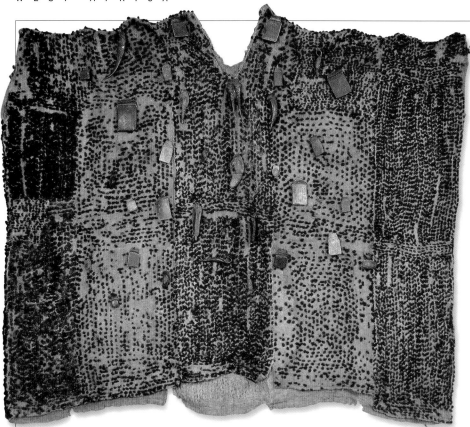

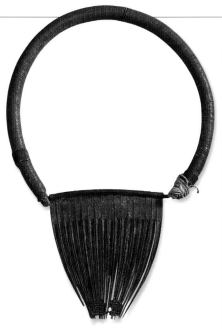

Metal and fiber "cache-sex" (modesty apron). *Late C19th.
6 in (15.5 cm) long*

$350–500 SK

Bamileke "boubou" garment made from woven and embroidered hemp. *Early C20th. 51¼ in (130 cm) high*

$1,400–2,000 BLA

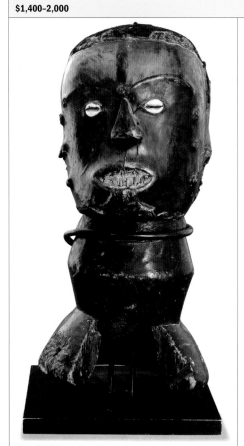

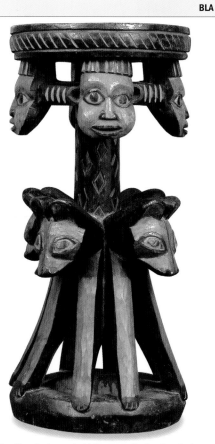

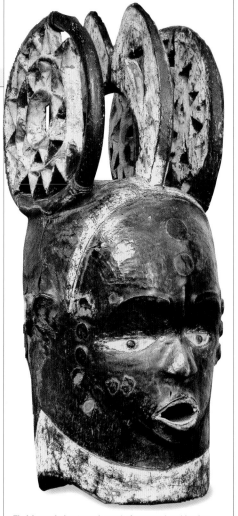

Ekoi ritual dance head in wood, paint, and bronze.
Late C19th. 14¼ in (36 cm) high

$900–1,800 BLA

Prestige stool carved with human and animal heads, from
the Bamileke. *Late C19th. 27¼ in (69 cm) high*

$1,400–2,000 BLA

Ekoi Janus helmet mask, made from wood and leather.
Late C19th. 23¼ in (59 cm) high

$7,000–12,000 BLA

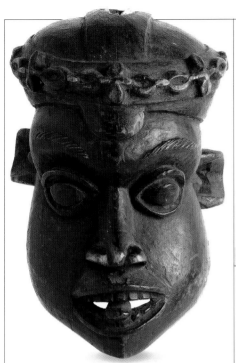

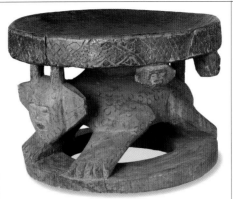

Bamileke prestige stool with animal carving. *C19th. 13 in (33 cm) high*

$2,500–4,500 KC

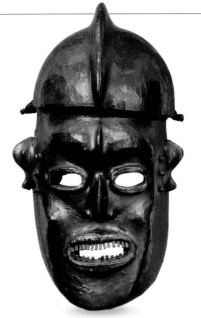

Large wooden Ejagham dance mask. *Late C19th–early C20th. 42¼ in (107 cm) high*

$3,000–4,500 BLA

Wood mask from the Grasslands region. *C19th. 16 in (41 cm) high*

$3,600–5,500 JBB

SEATING

A great variety of prestige stools and chairs are used by nobles in the Grasslands. The most elaborate thrones are reserved for the Fon (chief or king) and his queen. They are carved with human and animal symbols that embody the values of the culture, and legitimize the dynasty of the founding ancestor. Thrones with high backs are often not intended as seating, but as a display of power. The Bekom use them as pedestals for the bones of deceased former kings. Many are painted, but more often they are covered in a mosaic of cowrie shells and highly valuable colored glass beads imported from coastal ports far away. The stool below was made by the Babanki, a kingdom of the Tikar. The continuous frieze of standing and squatting figures probably refers to the king's dynastic lineage, reinforcing his legitimacy as ruler.

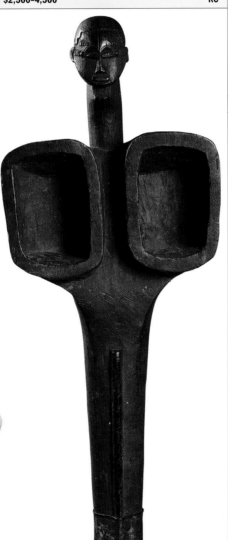

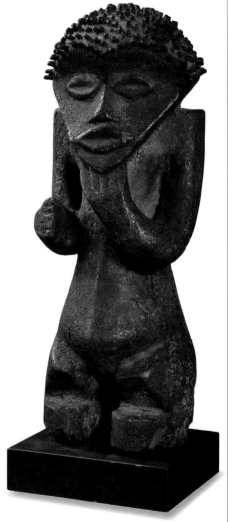

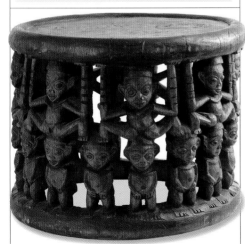

Babanki wooden dignitary's stool carved with two tiers of human figures. *C20th. 34 in (86 cm) diam*

$5,000–9,000 PHK

Wooden bellows carved by the Mbembe people in stylized human figurative form. *Early C20th. 31¼ in (79 cm) high*

$4,500–7,000 BLA

Carved wooden ancestral figure from the Mambila, with large head and peg coiffure. *c. 1900. 16¼ in (41 cm) high*

$10,000–18,000 BLA

CENTRAL AFRICA

Central African art is enormously varied due to the immense size of the region and the artistic richness of the cultures within it. There is a tendency toward naturalism in the masks and sculpture from this region, but there is also dramatically abstract work to be found here.

The heart of Africa consists of landlocked Central African Republic, the equatorial countries of Gabon and Equatorial Guinea, the Republic and Democratic Republic of Congo, and Angola in the south. Several kingdoms have developed here, including the Kongo on the Atlantic shores, the Kuba in the Kasai valley, and the Luba in the upper reaches of the Congo River. To the south is the loosely centralized society of the Lunda-Chokwe.

Both patrilineal and matrilineal kinship systems are found in this region, roughly dividing along a north to south axis. The type of lineage system determines the way artworks are commissioned and inherited, but has no influence on the type of object, nor the ritual context in which it is used. Of central importance to most peoples are the initiation rites, which occur at various periodic stages throughout the lives of men and women.

Compared to West African cultures, few artworks are truly for royalty—rather, the majority is associated with various kinds of sociopolitical leadership, from elders to chiefs.

MIGRATION AND ABSORPTION

The history of the region is characterized by continual migrations over a period of 2,000 years, during which newcomers and their customs were absorbed into existing groups. Portuguese ships first arrived at the mouth of the Congo in 1482 and converted the Kongo King to Christianity. Christian objects and motifs were assimilated and adapted to become chiefly insignia. Eventually, churches were built and ambassadors sent to Lisbon. The horrific practices of Belgian colonials and fortune hunters at the end of the 19th century inspired Joseph Conrad to pen *Heart of Darkness* in 1902. The Congo forests and river provide the backdrop for the story of humanity in the shadow of European imperialism.

The forest holds great symbolic meaning for these peoples, and the selection of a certain wood for sculpture is prescribed by the psychic nature of the tree.

Extremely rare wooden facemask with feather crest and a woven fabric neckpiece, from the Beembe society of the Congo. *Early C20th.* 13½ in (34 cm) high **$20,000–30,000 JDB**

LANDSCAPE AND CULTURE
The Central African landscape is inhabited along forested river valleys, dense tropical rainforest, and open forest and savanna. Almost all groups practice some form of agriculture, tend goats and sheep, and fish (as seen here in the Democratic Republic of Congo). Hunting game is an important social activity involving collective ceremonies.

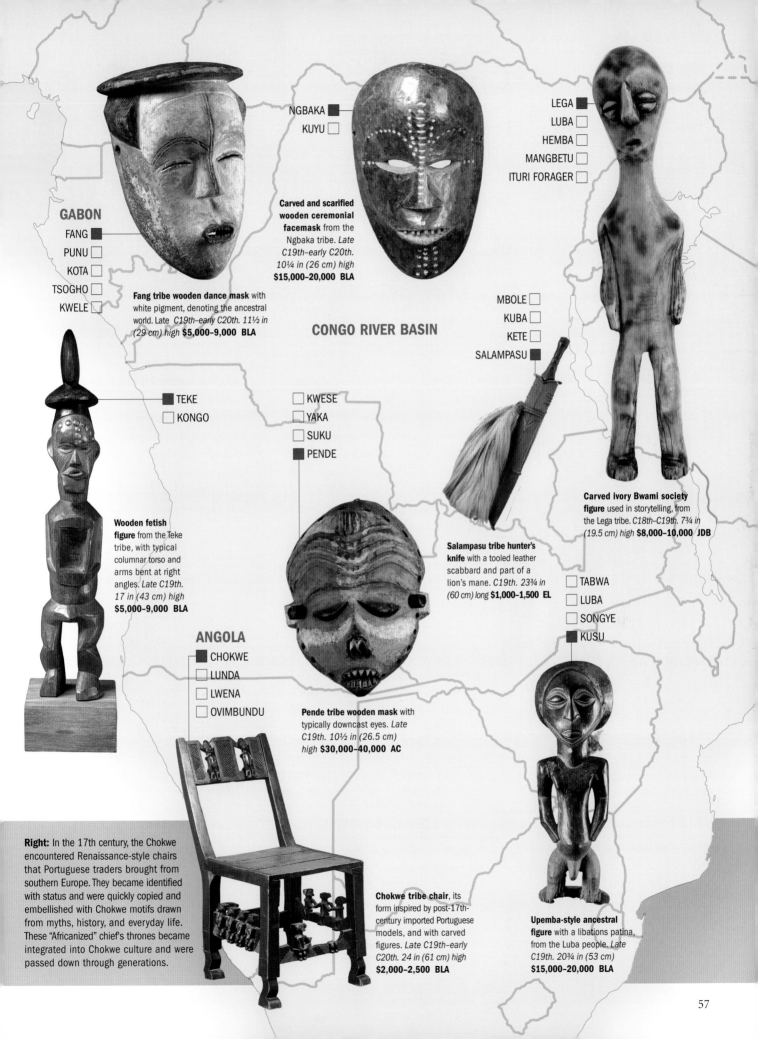

GABON
FANG ■
PUNU ☐
KOTA ☐
TSOGHO ☐
KWELE ☐

NGBAKA ■
KUYU ☐

LEGA ■
LUBA ☐
HEMBA ☐
MANGBETU ☐
ITURI FORAGER ☐

Carved and scarified wooden ceremonial facemask from the Ngbaka tribe. *Late C19th–early C20th. 10¼ in (26 cm) high* **$15,000–20,000 BLA**

CONGO RIVER BASIN

MBOLE ☐
KUBA ☐
KETE ☐
SALAMPASU ■

Fang tribe wooden dance mask with white pigment, denoting the ancestral world. *Late C19th–early C20th. 11½ in (29 cm) high* **$5,000–9,000 BLA**

TEKE ■
KONGO ☐

KWESE ☐
YAKA ☐
SUKU ☐
PENDE ■

Wooden fetish figure from the Teke tribe, with typical columnar torso and arms bent at right angles. *Late C19th. 17 in (43 cm) high* **$5,000–9,000 BLA**

Salampasu tribe hunter's knife with a tooled leather scabbard and part of a lion's mane. *C19th. 23¾ in (60 cm) long* **$1,000–1,500 EL**

Carved ivory Bwami society figure used in storytelling, from the Lega tribe. *C18th–C19th. 7¾ in (19.5 cm) high* **$8,000–10,000 JDB**

ANGOLA
CHOKWE ■
LUNDA ☐
LWENA ☐
OVIMBUNDU ☐

TABWA ☐
LUBA ☐
SONGYE ☐
KUSU ■

Pende tribe wooden mask with typically downcast eyes. *Late C19th. 10½ in (26.5 cm) high* **$30,000–40,000 AC**

Right: In the 17th century, the Chokwe encountered Renaissance-style chairs that Portuguese traders brought from southern Europe. They became identified with status and were quickly copied and embellished with Chokwe motifs drawn from myths, history, and everyday life. These "Africanized" chief's thrones became integrated into Chokwe culture and were passed down through generations.

Chokwe tribe chair, its form inspired by post-17th-century imported Portuguese models, and with carved figures. *Late C19th–early C20th. 24 in (61 cm) high* **$2,000–2,500 BLA**

Upemba-style ancestral figure with a libations patina, from the Luba people. *Late C19th. 20¾ in (53 cm) high* **$15,000–20,000 BLA**

KEY FACTS

Tribes include Fang, Kwele, Punu, Tsogho, Vuvi, Ambete, and Kota.

The rituals of initiation societies involve the use of symbols, mainly carved wood sculptures and masks, as well as authority emblems. They are centered on the propitiation of ancestral spirits and divination through the use of medicinal plants.

The traditional economy is dominated by hunting, fishing, and food gathering, while the sociopolitical structures are based on kinship.

Christian missionaries in Gabon in the 1930s influenced the artwork—reliquary guardians (*see below*) were no longer made after this decade.

Gabon

The reliquary guardians and masks of Gabon are regarded in the West as masterpieces of African art. Their astonishing forms were first appreciated in Modernist artistic circles in Europe at the beginning of the 20th century.

The inaccessibility of the rainforest, wet climate, and poor soil have largely precluded agricultural settlement in Gabon, and shifting communities establish themselves in the coastal valleys and in the Ogowe River Basin and its tributaries. Masks and sculptures made by tribes from across the region have become among the most sought-after and expensive in the Western art market, encouraging copies and fakes.

The Fang inhabit the northwest, Equatorial Guinea, and the very south of Cameroon. They maintain social cohesion via two societies, called So and Ngil, that cut across clan lineages. Both societies have masks associated with them. The Fang's three-legged stools and harps are used in initiation ceremonies. South of the Fang are the Tsogho, Punu, and Ambete. The Tsogho carve large flat masks painted white with a distinct double-arched brow.

They also carve red and white painted guardians for reliquary bundles. The Punu and other Ogowe River groups carve the white *okuyi*, representing the spirit of a beautiful maiden. These serene masks are worn by stilt-walking initiates and appear in the half-light of dawn or dusk. The Ambete are best known for their freestanding guardians whose hollow cavities contain ancestor relics.

The Kota occupy the eastern region, and make rare helmet masks. Their sculptural output is dominated by the variety of reliquary guardians they produce, rendered in a two-dimensional form. Other Kota items include stools and elegant bird-shaped knives.

Above: Punu tribe ancestral wooden mask with white pigmentation and a bifurcated coiffure. *Late C19th–early C20th. 8 in (20 cm) high* **$2,000–3,000 BLA**

RELIQUARY GUARDIANS

Both the Kota and Fang tribes stored the bones of ancestors in containers, which were surmounted by a carved figure guardian. The Fang *nlo byeri* (carved heads) and *eyema byeri* (standing or seated figures) were mounted on cylindrical bark boxes. There are many regional styles, but they generally share a set of features including a cylindrical torso, both hands holding a receptacle, bent legs with rounded buttocks and calves, a round head with heart-shaped face, and a pointed chin. The surface may have a desirable oily patina. Kota *ngulu* (guardians) are two dimensional and anthropomorphic, and are covered with sheets or strips of brass and copper. They are carved with stylized faces upon an open lozenge body, and are planted in a *mbulu* (woven basket).

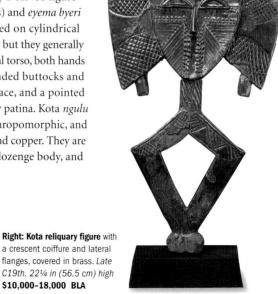

Left: Fang tribe male reliquary figure carved in wood and related to the Byeri cult. *Late C19th–early C20th. 19 in (48.5 cm) high* **$20,000–30,000 BLA**

Right: Kota reliquary figure with a crescent coiffure and lateral flanges, covered in brass. *Late C19th. 22¼ in (56.5 cm) high* **$10,000–18,000 BLA**

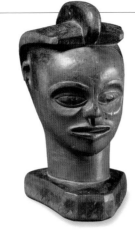

Carved wooden mask with ribbed coiffure and selective white pigment, from the Tsogho. *Early C20th. 10¼ in (26 cm) high*

$2,200–4,000　　　　　**BLA**

Fang tribe wooden head. *Late C19th–early C20th. 8 in (20 cm) high*

$3,000–4,500　　　　　**BLA**

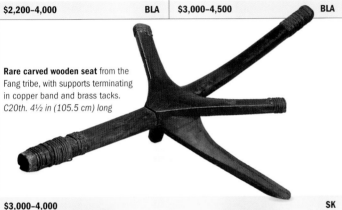

Rare carved wooden seat from the Fang tribe, with supports terminating in copper band and brass tacks. *C20th. 4½ in (105.5 cm) long*

$3,000–4,000　　　　　**SK**

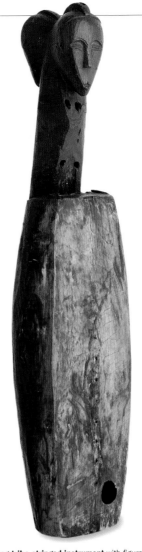

Fang tribe stringed instrument with figural headstock. *C19th. 22 in (56 cm) high*

$6,000–7,000　　　　　**JDB**

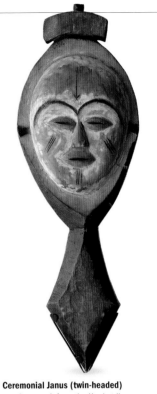

Ceremonial Janus (twin-headed) wooden wand, from the Kwele tribe. *c. 1910. 19 in (48 cm) high*

$10,000–15,000　　　　　**KC**

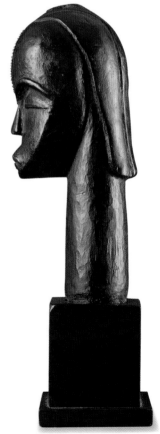

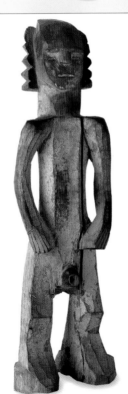

Tsogho reliquary bundle in the form of a human head and neck and a rope-bound body. *Early C20th. 14¼ in (36 cm) high*

$5,000–9,000　　　　　**BLA**

Carved wooden reliquary figure from the Ambete tribe. *C19th. 21¼ in (54 cm) high*

$80,000–100,000　　　　　**KC**

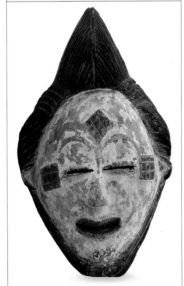

Punu tribe wooden mask with coiffure and pigmented face, including scarifications. *Late C19th. 15½ in (39 cm) high*

$12,000–16,000　　　　　**JDB**

Fang tribe Byeri cult wooden head, mounted on a plinth. *Late C19th–early C20th. 9 in (23 cm) high*

$20,000–30,000　　　　　**BLA**

KEY FACTS

Tribes include Kuyu, Teke, Kongo (Vili, Woyo, Yombe, Solongo, Beembe), Ngbaka Teke, Salampasu, Songye, Yaka, Pende, Lega, Kuba (Wongo, Lele, Bushoong, Ndengese), Suku, Tabwa, Mbala, Mbole, Lwalwa, Mangbetu, Luba, Hemba, Bembe, and Ituri Forager (Pygmy).

Portuguese sailors converted the Kongo King to Christianity in 1491. Locally made crucifixes then became status symbols.

Ivory was a major commodity in the 19th century. A tourist trade in carved tusks from the Loango region satisfied the European demand for "curios."

Lega Bwami society ivory paraphernalia is rare due to the Belgian colonial authority's mistrust of secret societies and the ban on the ivory trade.

Congo River Basin

The sublime sculpture of the Luba, Kuba, and Hemba shattered early 20th-century Western preconceptions about precolonial art. These cultural groups had been creating exceptional artworks long before the "civilizing" influence of the missionaries.

In the heart of Africa, the majestic Congo River drains a dense forest of 290,000 square miles (750,000 square kilometers). Its tributaries extend into the plains of the Uele, Kasai, and Shaba, and encompass a vast geographical area of almost 1.5 million square miles (4 million square kilometers). The People's Republic of Congo and the Democratic Republic of Congo are both included in this area. Each has changed its name since colonial times (they were known respectively as French Congo and Congo Brazzaville, then as Belgian Congo and Zaire); here we refer to the region as a whole called The Congo.

Throughout the region there are commonly held beliefs. Ancestor cults, witchcraft, nature spirits, and *nkisi* (spirit receptacles) have important roles in many communities. Perhaps because of their common Bantu origin, all Congo peoples believe in a single creator, of whom no images are made. Sculpture generally follows the human form, with the marks and designs on men and women's bodies also being carved on cult sculpture. These marks are regarded as beautiful and are simultaneously acknowledged as signs. The sculpture becomes a book of messages, readable only by the cult initiates (the ancestor figures of the Beembe, Lulua, and Luba are examples). Seclusion, circumcision, and ordeal mark initiation. Initiation masks among the Yaka, for example, are used as charms protecting the initiate from forest spirits and ensuring fertility later in life.

Above: Carved wooden Bwami society figure from the Lega tribe. *Early C20th. 14¼ in (36 cm) high* **$2,000–3,000 BLA**

MUSICAL INSTRUMENTS

The tribes of Central Africa play harps, finger pianos, drums, large slit gongs, whistles, and trumpets. Among the Yaka and neighboring peoples, *mukoku* (handheld slit gongs) are used in rituals performed by *nganga* (ritual specialists). This gong (*see left*) originates from the northern Yaka. The gong signals the *nganga*'s presence and provides the rhythm for his chants during *ngoombu* (divination). The neck of the gong would be encircled by a fiber loop threaded through a short baton. Typical features of northern Yaka gongs are semi-closed eyes, diminutive chin, pierced ears, and facial tear markings. *Mukoku* are multifunctional and can be used as containers to mix herbal medicines or as seats. Miniature gongs are used as charms.

Right: Carved wooden gong from the northern Yaka peoples, with carved human head and a coiffure. *C20th. 16¾ in (42.5 cm) high* **$1,000–1,500 FRE**

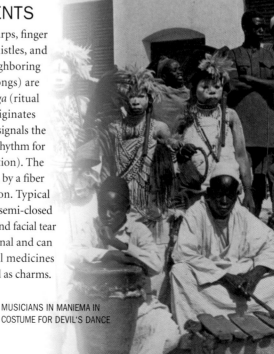

MUSICIANS IN MANIEMA IN COSTUME FOR DEVIL'S DANCE

ADORNING MASKS

Most wooden masks used in dance, ritual, or performance are part of a costume, which can mean anything from a whole body suit to merely fiber fringes. Masks are usually "dressed" with additional materials such as teeth, hair, bone, berries, metal, cloth, shell, or feathers. These adornments are essential in increasing the power of the mask. Indeed, the simple addition of a feather crest may activate it or help it to become possessed by a spirit. Without these additions, the mask would be regarded as "naked" or, even worse, "useless."

Left: Owl-form variation of a Kifwebe zoomorphic mask, from the Luba peoples. *C20th. 22½ in (57 cm) high* **$3,600–5,000 JDB**

Left: Horned wooden animal mask with raffia throat piece, from the Salampasu peoples. *Late C19th–early C20th. 22 in (56 cm) high* **$5,000–7,000 JDB**

Nganga (ritual specialists), who use a variety of empowered objects to foresee and determine solutions to physical or spiritual concerns, practice divination. Some of these divination *mankishi* are small and are used for the problems of individuals, while other larger figures are for the well-being of the entire community. Among the Kongo and Songye peoples, these community figures are magnificent expressions of awesome power.

Unlike the kingdoms of the Kuba and others, the precolonial Lega had no centralized political system, and were governed by the Bwami grade association—a voluntary society that upholds moral values. All Lega art is for Bwami—the small ivory objects serve as proverbs to illustrate Bwami principles of moderation,

respect, and moral and physical beauty, while the white painted *idumu* masks act as links to the ancestors of highly graded elite. *Mbole ofika* (carved figures of hanged criminals) are used by the Lilwa society during initiation ordeals to show the consequences of violating the law. Women of the Ituri Forest are responsible for all domestic activities, including painting on bark cloth prepared by men. They create designs associated with body art, which reflect the improvised, syncopated rhythms of their celebrated polyphonic singing.

Left: Yaka flywhisk, made from animal hair, with a wooden handle, copper bindings, and figural finial. *c. 1880. 21¼ in (54 cm) long* **$2,500–3,600 JBB**

RITUAL SPECIALISTS

Clients may engage a nganga *(ritual specialist) to settle disputes, protect from witchcraft, or promote fertility or health. The* nganga *commissions the carving of a sculpture and places a medicine-filled resin container on its abdomen. It is adorned with magical objects and becomes empowered.*

NKISI

Teke *nkisi* figure from the Democratic Republic of Congo. *Nkisi* are receptacles for spirits. They can be an animal or human sculpture, or merely a container. *Late C19th–early C20th. 13 in (33 cm) high* **$900–1,600 BLA**

Western Region

The Congo River flows southwest, dividing the Republic and the Democratic Republic of Congo. The tribes here were the first to meet the Portuguese traders of the Renaissance and, in the 19th century, bore the brunt of the exploitation of King Leopold's colonial "agents."

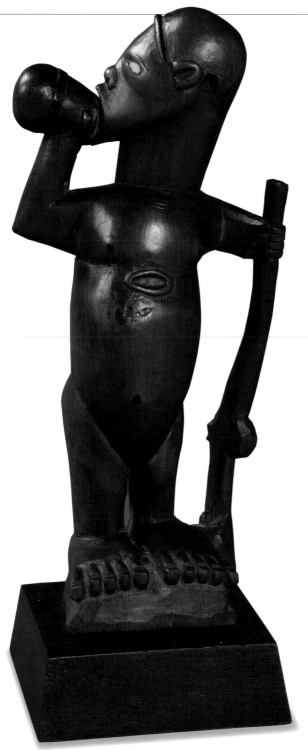

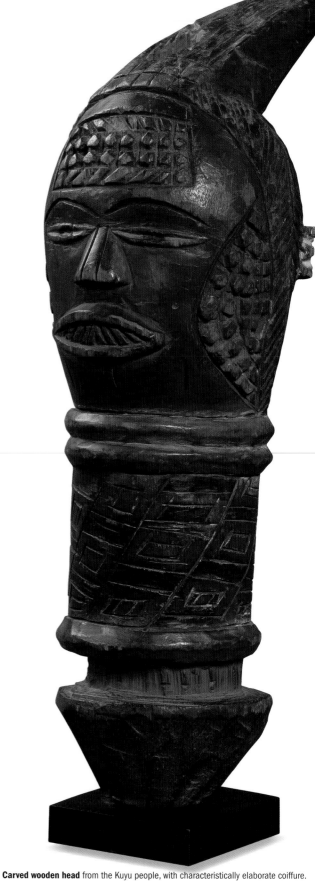

Carved wooden, ancestral hunting figure from the Beembe tribe. *Early C20th. 9 in (23 cm) high*

$1,200–2,000 BLA

Carved wooden head from the Kuyu people, with characteristically elaborate coiffure. Originally carried on a pole during ceremonies. *Late C19th. 15 in (38 cm) high*

$1,200–2,000 BLA

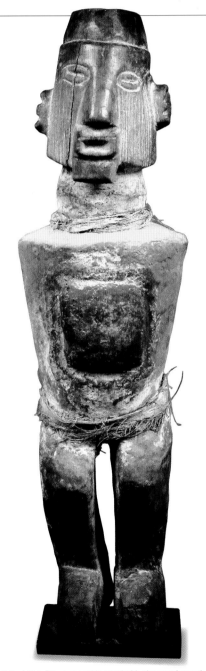

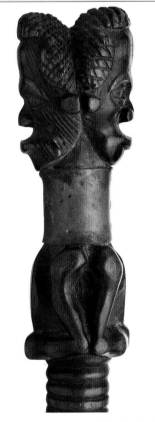

Teke

The Teke mainly live in the Republic of Congo and are best known for their wood figures applied with medicine bundles. They are seated or standing, usually with strict bilateral symmetry, and a cavity in the abdomen. The faces have lines representing *mbandjuala* (facial scarification). Those representing a deceased ancestor or chief are known as *butti*, and encased in a *bilongo* (clay cylinder) containing magical substances stained red with tukula powder. Because the torso is hidden beneath the *bilongo*, arms are rudimentarily carved or absent. The Teke also produce prestige items such as flywhisks and bronze necklets. Teke-Tsaayi *kidumu* masks are decorative disks with stylized features.

Teke ancestral *butti* figure with a slotted chest for magical substances. *Late C19th. 15½ in (39 cm) high*

$3,000–5,000 BLA

Ivory horn, elaborately carved with figures in deep relief by artists of the Vili (or Loango) tribe. *Late C18th–early C19th. 18¼ in (46 cm) long*

$2,000–3,000 BLA

Teke fetish figure carved in wood with pigment decoration and typical slightly bent legs and right-angled arms. *C20th. 13 in (33 cm) high*

$600–900 BLA

Carved wooden Janus (twin-headed) handle of a Bateke flywhisk. *Early C20th. 10½ in (27 cm) high*

$4,000–5,000 AC

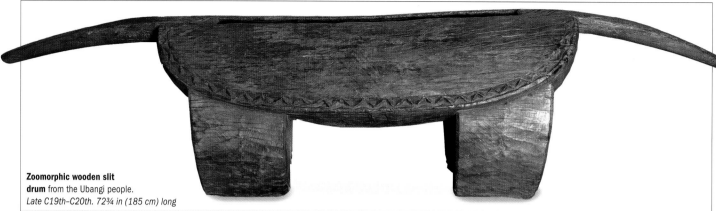

Zoomorphic wooden slit drum from the Ubangi people. *Late C19th–C20th. 72¾ in (185 cm) long*

$15,000–20,000

KC

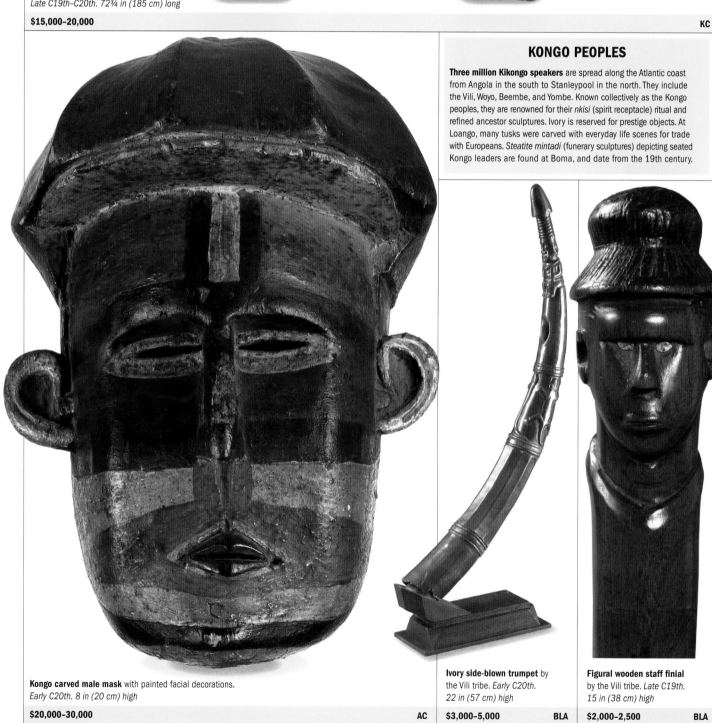

KONGO PEOPLES

Three million Kikongo speakers are spread along the Atlantic coast from Angola in the south to Stanleypool in the north. They include the Vili, Woyo, Beembe, and Yombe. Known collectively as the Kongo peoples, they are renowned for their *nkisi* (spirit receptacle) ritual and refined ancestor sculptures. Ivory is reserved for prestige objects. At Loango, many tusks were carved with everyday life scenes for trade with Europeans. *Steatite mintadi* (funerary sculptures) depicting seated Kongo leaders are found at Boma, and date from the 19th century.

Kongo carved male mask with painted facial decorations. *Early C20th. 8 in (20 cm) high*

$20,000–30,000

AC

Ivory side-blown trumpet by the Vili tribe. *Early C20th. 22 in (57 cm) high*

$3,000–5,000

BLA

Figural wooden staff finial by the Vili tribe. *Late C19th. 15 in (38 cm) high*

$2,000–2,500

BLA

Central Region

This region ranges from the Kwango and Ubangi rivers in the west to the Lomami and Snkuru Rivers in the east. The dense forest is home to nature spirits commemorated in Pende masks and regulated by Yaka fetishes. Kuba kings ruled over a stratified society, which produced a highly individual artistic style.

Ngbaka wooden backrest with geometric piercing. *c. 1875. 15¾ in (40 cm) long*

$900–1,500	JBB

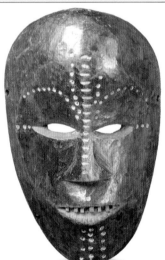

Ngbaka tribe wooden mask of typically scarified ovoid form. *Late C19th–early C20th. 10¼ in (26 cm) high*

$15,000–20,000	BLA

Geometric pattern *tapa* (bark) cloth, originally worn as a skirt, from the Uturi Foragers. *C20th. 34¾ in (88 cm) long*

$800–1,000	JDB

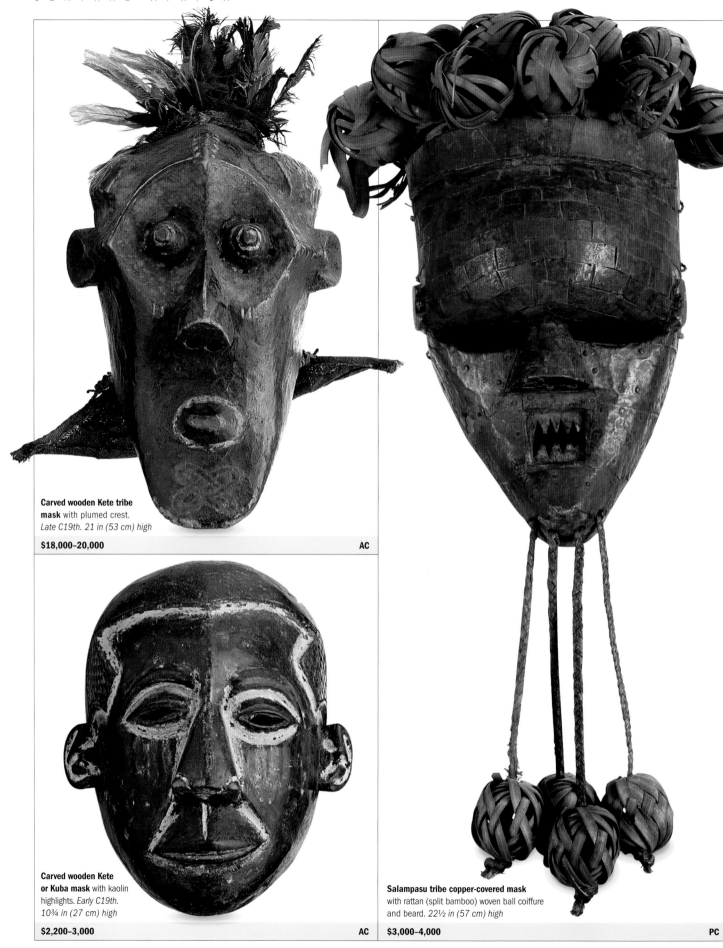

**Carved wooden Kete tribe
mask** with plumed crest.
Late C19th. 21 in (53 cm) high

$18,000–20,000 AC

**Carved wooden Kete
or Kuba mask** with kaolin
highlights. *Early C19th.
10¾ in (27 cm) high*

$2,200–3,000 AC

Salampasu tribe copper-covered mask
with rattan (split bamboo) woven ball coiffure
and beard. *22½ in (57 cm) high*

$3,000–4,000 PC

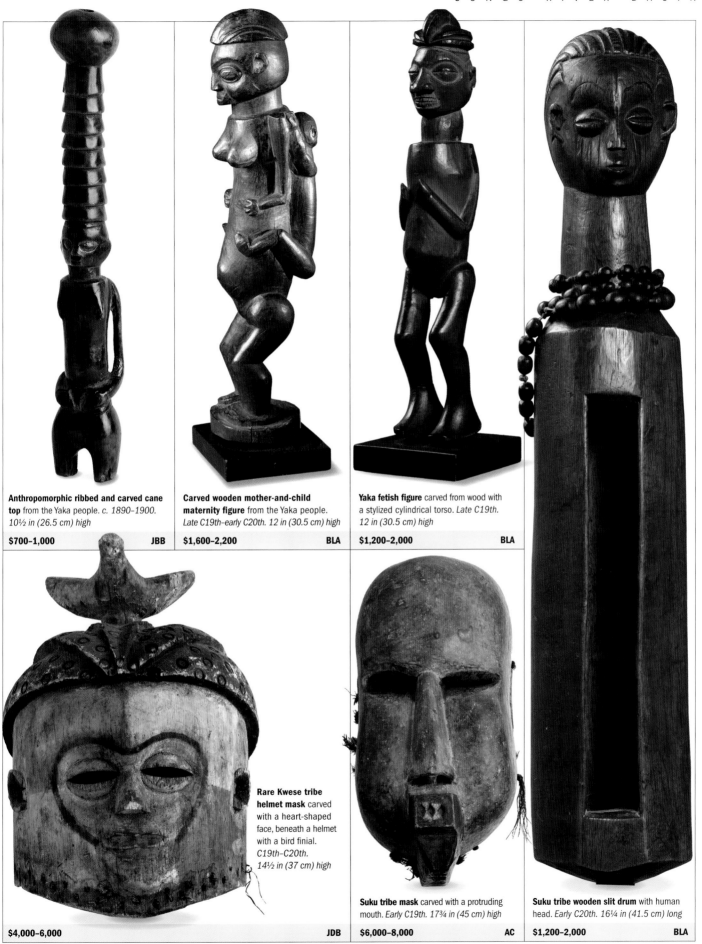

Anthropomorphic ribbed and carved cane top from the Yaka people. *c. 1890–1900. 10½ in (26.5 cm) high*

$700–1,000 JBB

Carved wooden mother-and-child maternity figure from the Yaka people. *Late C19th–early C20th. 12 in (30.5 cm) high*

$1,600–2,200 BLA

Yaka fetish figure carved from wood with a stylized cylindrical torso. *Late C19th. 12 in (30.5 cm) high*

$1,200–2,000 BLA

Rare Kwese tribe helmet mask carved with a heart-shaped face, beneath a helmet with a bird finial. *C19th–C20th. 14½ in (37 cm) high*

$4,000–6,000 JDB

Suku tribe mask carved with a protruding mouth. *Early C19th. 17¾ in (45 cm) high*

$6,000–8,000 AC

Suku tribe wooden slit drum with human head. *Early C20th. 16¼ in (41.5 cm) long*

$1,200–2,000 BLA

Kuba

The Kuba kingdom produced its best artwork at the height of its power in the second half of the 19th century. The federation embraces around 19 groups, including the Kete, and Bushoong, the ruling clan. The best-known carvings are the *ndop* portrait statues of Bushoong *nyimi* (kings), which are mostly in museums. Other figurative sculpture is rare, but masks are carved for use in religious ceremonies. They are multicolored, brightly painted, and beaded. Dynamic, geometric designs are seen in Bushoong textiles and beaded paraphernalia. Many Kuba tribes carve boxes and anthropomorphic palm wine cups, the finest of which are by Lele and Wongo artists.

Woven and polychrome-dyed vegetal fiber clothing pendant and two belts, each with beads and cowrie shells. *C20th. 49 in (124.5 cm) long*

$900–1,500 SK

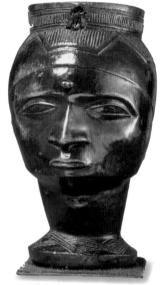

Anthropomorphic wooden palm wine cup, carved as a human head. *Late C19th. 8¼ in (21 cm) high*

$2,500–4,000 BLA

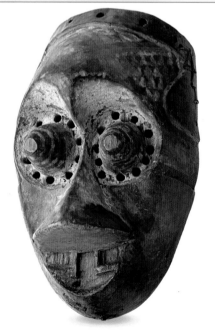

Carved wooden mask with characteristically large conical eyes. *c. 1900. 10¼ in (26 cm) high*

$15,000–20,000 KC

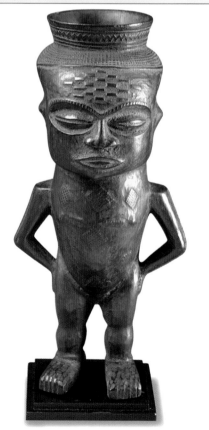

Bushoong anthropomorphic palm wine cup. *Early C20th. 9½ in (24 cm) high*

$1,000–1,600 BLA

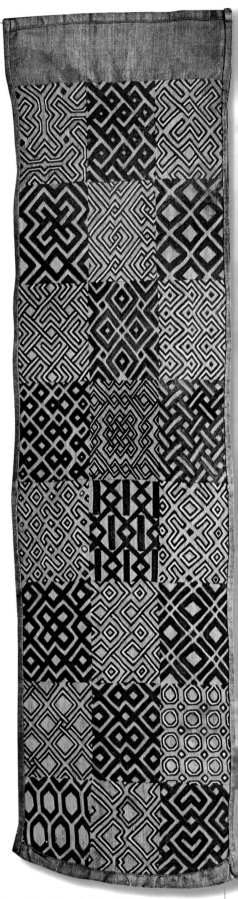

Geometric-patterned raffia skirt. *Early C20th. 51½ in (131 cm) long*

$2,200–3,000 JDB

Pende

The Pende settled on the Kwilu (West) and the Kasai (East) Rivers. Their masks include the *minganji* woven raffia masks, which represent ancestors, and the wooden *mbuya* village masks, which are characters from everyday life, with triangular faces, downcast eyes, upturned noses, and raffia coiffures. Some have long wooden beards, others distorted faces. Eastern Pende make masks called *giphogo*, including a helmet mask and a facemask with antelope-like horns. The *panya-ngombe* buffalo mask is a dance mask and an architectural ornament. Western Pende ivory *ikhoko* (amulets) corresponding to *mbuya* masks are highly collectible, leading to fakes.

Pende chiefs' houses were decorated with carved, figural lintels and uprights.

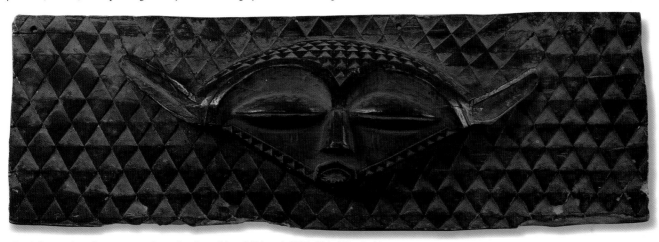

Carved and pigmented wooden *panya-ngombe* mask-wall panel. *Late C19th–early C20th. 29 in (74 cm) wide*

$4,500–6,000 BLA

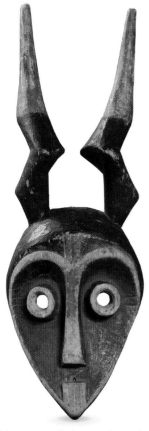

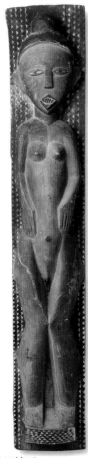

Elongated *panya-ngombe* dance mask
with typically slanted eyes and geometric decoration. *Mid-C20th. 6¾ in (17 cm) long*

$1,800–2,500 EL

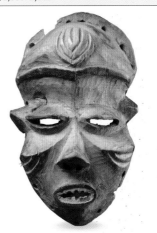

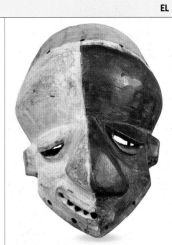

Giphogo zoomorphic dance mask, carved from wood and with selective pigmentation. *Early C20th. 17 in (43 cm) high*

$1,200–2,000 BLA

Wall panel carved with an elongated female figure. *c. 1930. 46 in (117 cm) long*

$4,4000–7,000 KC

Dance mask with carved cheekbone decoration and serrated teeth. *Early C20th. 9½ in (24 cm) high*

$600–900 BLA

Dance mask with asymmetrical facial features and coloring. *Early C20th. 10¼ in (26 cm) high*

$1,000–1,600 BLA

Eastern Region

Beyond the Lomami and Snkuru Rivers, to the great lakes that define the borders of east Africa, lies the eastern Congo region. Cultures here range from the diminutive Ituri Forager to the enigmatic Lega with their ivory Bwami carvings, the Songye with their abstract Kifwebe masks and the Luba and Hemba with their ancestor sculptures.

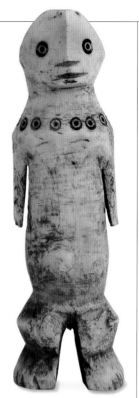

Lega tribe ancestral Bwami society figure carved from ivory. C20th. 7¾ in (19.5 cm) high

$3,000–5,000 JDB

Mangbetu tribe tapa mallet made of bone. C18th. 11½ in (29 cm) high

$9,000–11,000 PC

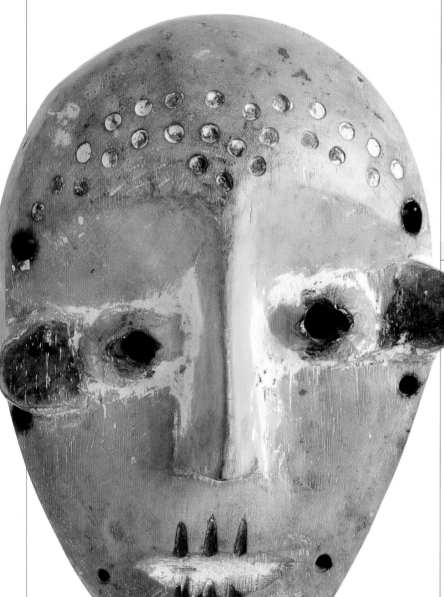

Lega tribe kaolin-detailed and pokerwork wooden mask with a typically linear nose. c. 1880. 4 in (10 cm) high

$15,000–20,000 JBB

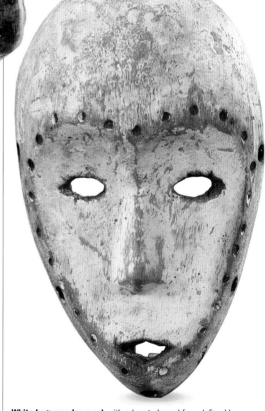

White Lega wooden mask with a heart-shaped face defined by circular piercings. Early C20th. 6 in (15 cm) high

$1,000–1,600 S&K

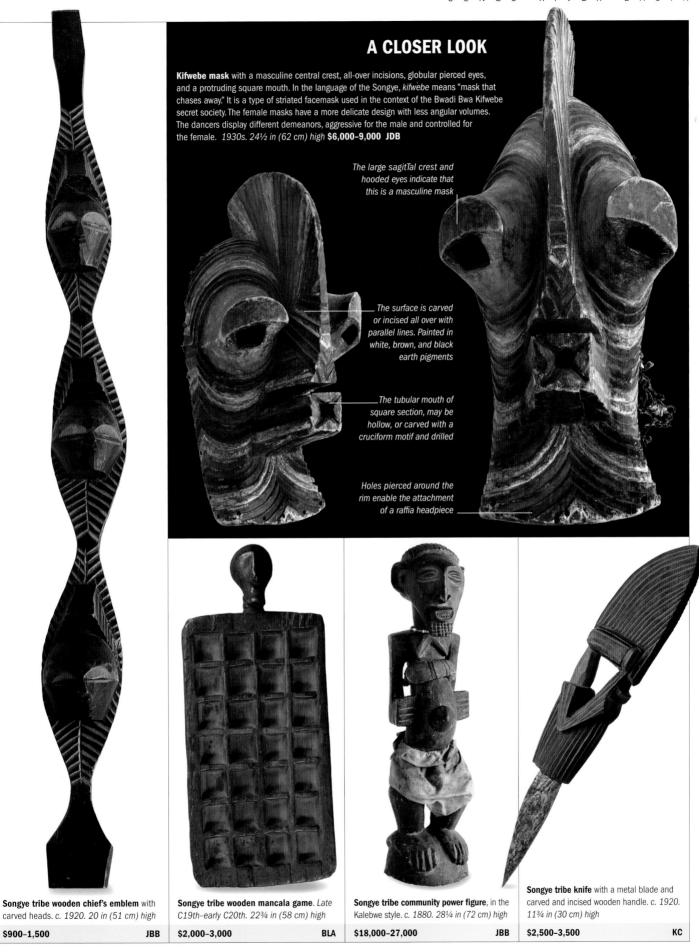

A CLOSER LOOK

Kifwebe mask with a masculine central crest, all-over incisions, globular pierced eyes, and a protruding square mouth. In the language of the Songye, *kifwebe* means "mask that chases away." It is a type of striated facemask used in the context of the Bwadi Bwa Kifwebe secret society. The female masks have a more delicate design with less angular volumes. The dancers display different demeanors, aggressive for the male and controlled for the female. *1930s. 24½ in (62 cm) high* **$6,000–9,000 JDB**

The large sagitTal crest and hooded eyes indicate that this is a masculine mask

The surface is carved or incised all over with parallel lines. Painted in white, brown, and black earth pigments

The tubular mouth of square section, may be hollow, or carved with a cruciform motif and drilled

Holes pierced around the rim enable the attachment of a raffia headpiece

Songye tribe wooden chief's emblem with carved heads. *c. 1920. 20 in (51 cm) high*

$900–1,500 JBB

Songye tribe wooden mancala game. *Late C19th–early C20th. 22¾ in (58 cm) high*

$2,000–3,000 BLA

Songye tribe community power figure, in the Kalebwe style. *c. 1880. 28¼ in (72 cm) high*

$18,000–27,000 JBB

Songye tribe knife with a metal blade and carved and incised wooden handle. *c. 1920. 11¾ in (30 cm) high*

$2,500–3,500 KC

71

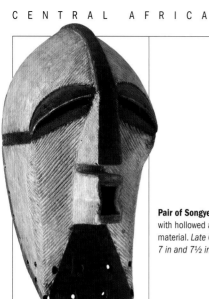

Songye tribe Kifwebe mask.
c. 1930. 16¼ in (41 cm) high

$10,000–16,000 **KC**

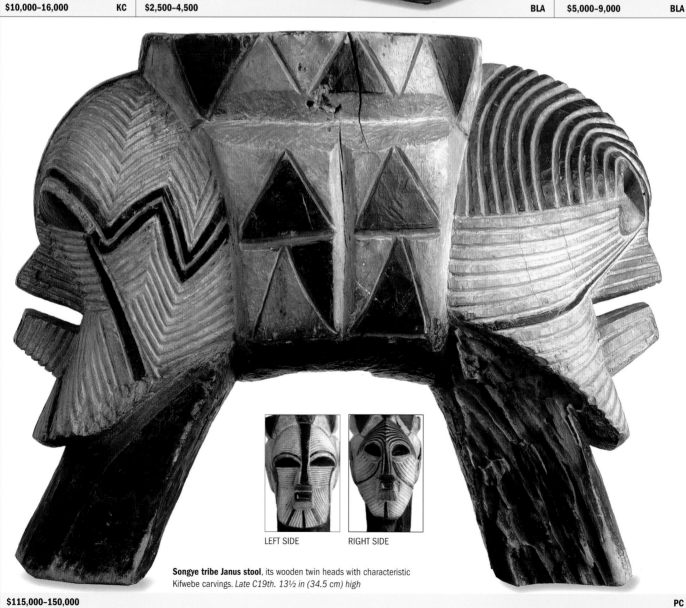

Pair of Songye tribe fetish figures
with hollowed abdomens for fetish
material. *Late C19th–early C20th.*
7 in and 7½ in (17.5 cm and 18 cm)

$2,500–4,500 **BLA**

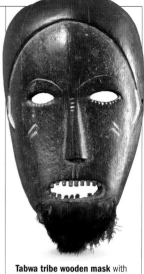

Tabwa tribe wooden mask with
open mouth, teeth, and animal-
hair beard. *Late C19th–early
C20th. 11¾ in (30 cm) high*

$5,000–9,000 **BLA**

LEFT SIDE RIGHT SIDE

Songye tribe Janus stool, its wooden twin heads with characteristic
Kifwebe carvings. *Late C19th. 13½ in (34.5 cm) high*

$115,000–150,000 **PC**

Luba and Hemba

In 1975, Francois Neyt identified a distinct Hemba style. Before this, most ancestor figures in Western museums and collections had been stylistically identified as originating in the Luba kingdom. Both carve magnificent commemorative sculptural portraits of deceased rulers, which share certain characteristics such as serene facial expressions and hands held to the distended abdomen. This lends emphasis to the importance of heredity. Although there are regional style variations, the figures are carved with generic characteristics. The depictions avoid individual distinguishing features in order to stress the continuity of the royal lineage, despite a succession of different rulers.

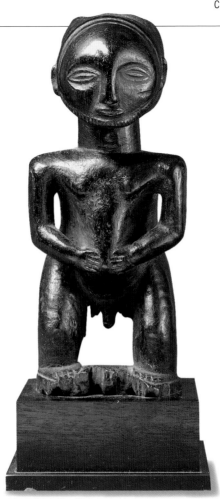

Carved wooden male figure from the Luba or Hemba tribe. *Late C20th. 8 in (20 cm) high*

$1,500–2,200 BLA

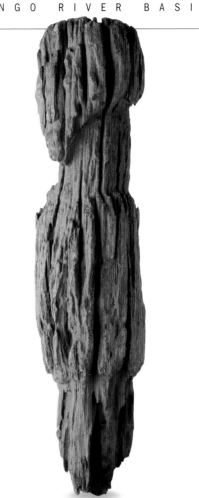

Hemba tribe mortuary post, carved in wood in human form, weather worn. *C19th. 24¾ in (63 cm) high*

$1,000–1,600 KC

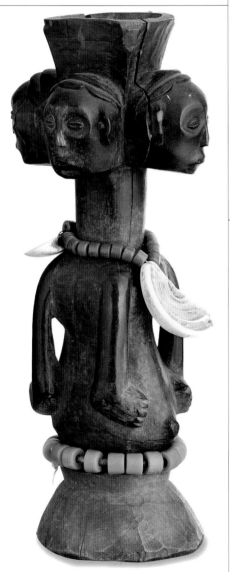

Four-headed Luba tribe figure, carved and with beads and stone pendant decoration. *Late C19th. 11 in (28 cm) high*

$5,000–8,000 AC

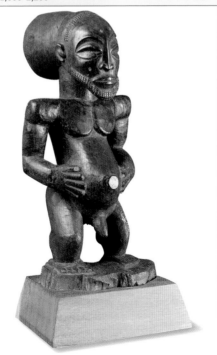

Carved wooden male ancestral figure from the Luba or Hemba tribe. *C20th. 12½ in (32 cm) high*

$7,000–14,000 BLA

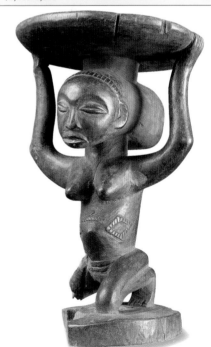

Anthropomorphic caryatid-like stool used by chiefs in Luba society. *Early C20th. 11¾ in (30 cm) high*

$1,500–2,200 BLA

KEY FACTS

Tribes include Chokwe, Ovimbundu, and Songo, who carve royal scepters of great beauty. The Lwena carve initiation figures and masks similar to the Chokwe. The Lunda did not develop an art style of their own, but imported Chokwe carvings for their own use.

Chokwe plastic arts decreased in quality after the collapse of the Luba Kingdom in the 19th century.

The Lwena have had a more peaceful history than the Chokwe and their art style reflects this: it is more rounded and less angular than the fierce Chokwe works.

Songo art often incorporates the images of oxen, the beast of burden preferred by traders of the 19th century.

Angola

The majority of art in Angola is created by the Chokwe, who trace their ancestry to the Luba in the Democratic Republic of Congo. They are renowned for masks adorned with fiber wigs, and with delicately carved coiffures and facial features.

The Lunda-Chokwe Empire was at its apogee during the 17th century. The Chokwe people had great skill as hunters and traders, first in ivory and later in rubber. By 1850 their wealth was such that they overthrew their Lunda masters.

The Chokwe make three kinds of statues that represent *mahamba* (lineage spirits), *wanga* (protective guardians), or *kaponya* (family ancestor portraits). The most famous figures are those of their founding ancestor, Chibinda Ilunga, a Luba prince who married a Lunda queen in the 15th century. The Chokwe are organized into chiefdoms, each ruled by a *mwanangana* (lord of the land). At each enthronement,

the chief is awarded a bracelet, a sword, a figural scepter, and a chair. He must wear the *cihongo* mask and the royal headdress during the ceremony.

Professional Chokwe *songi* (sculptors) pay particular attention to the hands, feet, and face of these works. Chokwe masks (*see below*) are very popular with collectors.

Ethnographic items also sought after include the elaborate chief's chairs fashioned after 18th-century Portuguese models, hunters' dog whistles, and snuff containers. These small items are reserved for the aristocracy and displayed suspended from the chief's spear. Ovimbundu tobacco pipes are also particularly collectible.

Above: Carved wooden *cihongo* male mask from the Chokwe tribe. *Late C19th. 8 in (20.5 cm) high* **$1,400–2,000 BLA**

MATERIALS FOR MASKS

Chokwe masks are made from a variety of materials, depending on the type of mask. The female *pwo* dance mask is carved wood or gourd with a long black thrummed fiber wig. It symbolizes an adult mother, and is carved with cicatrice tattoos. One such tattoo incorporates a cross motif, assimilated from the symbolism of the Portuguese monks of the 17th century. The other popular dance mask is called *cihongo*, characterized by a flat, projecting beard. Both usually carry metal earrings. The *cikungu* mask represents the ancestors of the chief and is composed of woven cloth and raffia stretched over a wicker frame, painted in black, white, and red.

Above: Chokwe female *pwo* mask, carved in wood with scarifications and vegetal hair. *Late C19th–early C20th. 10½ in (27 cm) high* **$6,000–9,500 BLA**

Left: Chokwe *pwo* wooden mask with raffia headpiece, used during circumcision ceremonies. *Late C19th–early C20th. 11¾ in (30 cm) high* **$8,000–12,000 BLA**

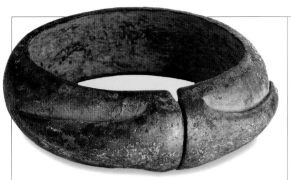

Bronze torque (necklace) from Lower Angola. *7 in (17.5 cm) diam*

$9,000–14,000 **PC**

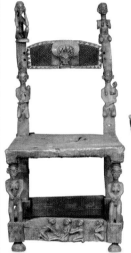

Chokwe chair with carved human figures. *Late C19th–early C20th. 48 in (122 cm)*

$1,600–2,200 **BLA**

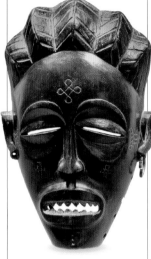

Wooden female *pwo* mask with a carved coiffure, from the Chokwe. *Late C19th. 8¾ in (22.5 cm) high*

$2,500–4,500 **BLA**

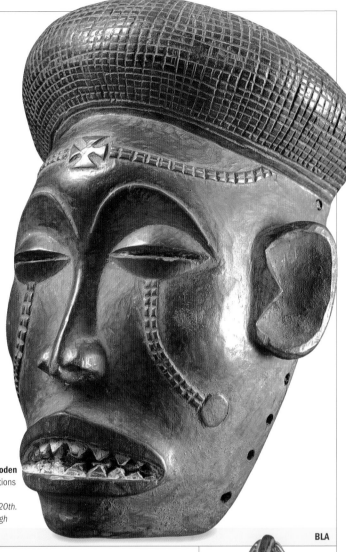

Chokwe carved wooden mask with scarifications and serrated teeth. *Late C19th–early C20th. 8½ in (21.5 cm) high*

$2,500–4,500 **BLA**

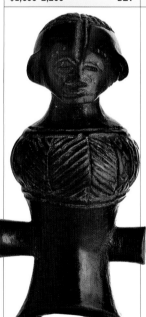

Anthropomorphic carved wooden whistle from the Chokwe. *Late C19th. 5¼ in (13 cm) high*

$3,000–4,000 **PC**

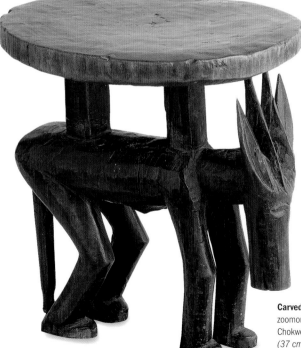

Carved wooden stool with zoomorphic base, from the Chokwe. *Early C20th. 14½ in (37 cm) high*

$10,000–15,000 **AC**

Anthropomorphic carved wooden scepter from the Chokwe. *Early C20th. 7¼ in (18.5 cm) high*

$500–900 **BLA**

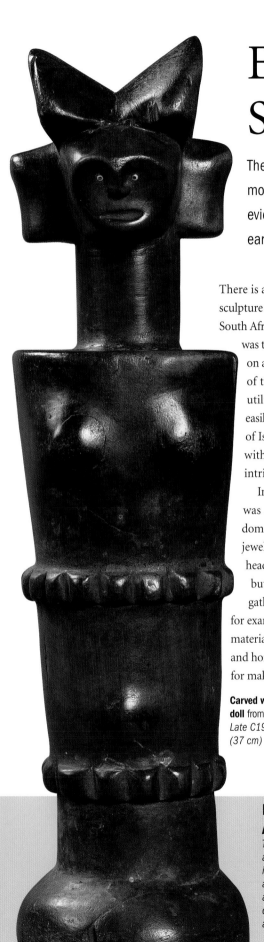

EAST AND SOUTH AFRICA

The present-day traditional societies in East and South Africa constitute the most diverse cultural region in Africa. This is also the region in which remarkable evidence of the earliest hominids has been unearthed (in Tanzania) as well as early human species (in Swartkrans and other sites in South Africa).

There is a relative paucity of freestanding sculpture and masks in societies in East and South African countries. One possible reason was the reliance of farming communities on a nomadic way of life for at least part of the year, where only portable and utilitarian objects could be transported easily. Another reason may be the influence of Islam (carried via ancient trading links with the Arab world), where there is an intrinsic intolerance of figurative art.

In the absence of ritual carvings, there was an explosion in the production of domestic utensils, such as tobacco pipes, jewelry, containers, stools, chairs, and headrests. Wood was the main material, but others were also used. The hunter-gatherer San of Namibia and Botswana, for example, use ostrich eggs as flasks. Other materials derived from cattle, such as leather and horn, are used in Kenya and South Africa for making clothing and personal possessions.

Carved wooden *mwana hiti* puberty doll from the Kwere tribe in Tanzania. *Late C19th–early C20th. 14½ in (37 cm) high* **$2,000–4,000 BLA**

The strong, "non-figurative" (Islamic) influence is felt most strongly along the Swahili coast. However, there are many exceptions to this trend, particularly inland and in the more remote regions. Two coastal Tanzanian tribes carve *mwana hiti* (small dolls), with simple cylindrical bodies. The Zaramo *mwana hiti* has a wheel-like head, while the Kwere carve a bifurcated coiffure. The Nyamwezi make ancestor figures, high-backed stools (carved in relief with male or female attributes), and staffs for chiefs. Figurative funerary posts are found across the eastern region, from Sudan and Ethiopia in the north (Bongo and Konso), through Kenya (Giriama) to Madagascar (Sakalava) in the south.

The Makonde of Tanzania and Mozambique carve helmet and body masks, staffs, drums, and sculptures for initiation ceremonies. Makonde masks are adorned with human hair and cicatrice-like beeswax decorations. In Zambia, Mbunda artists carve circumcision masks, and

LANDSCAPE AND CULTURE

The people of this vast region are chiefly pastoral. Crafted items had to be carried easily, and so artwork from this area includes beaded jewelry, decorated domestic utensils, and wonderful personal objects.

Left: In this pastoral landscape, cattle are of great importance as they equate to currency and, therefore, power and status. Cattle raiding was common in pre-colonial times and men trained to defend their herds from neighboring groups. The need to travel with herds in search of good pasture meant that most art was expressed in dance, music, and body decoration.

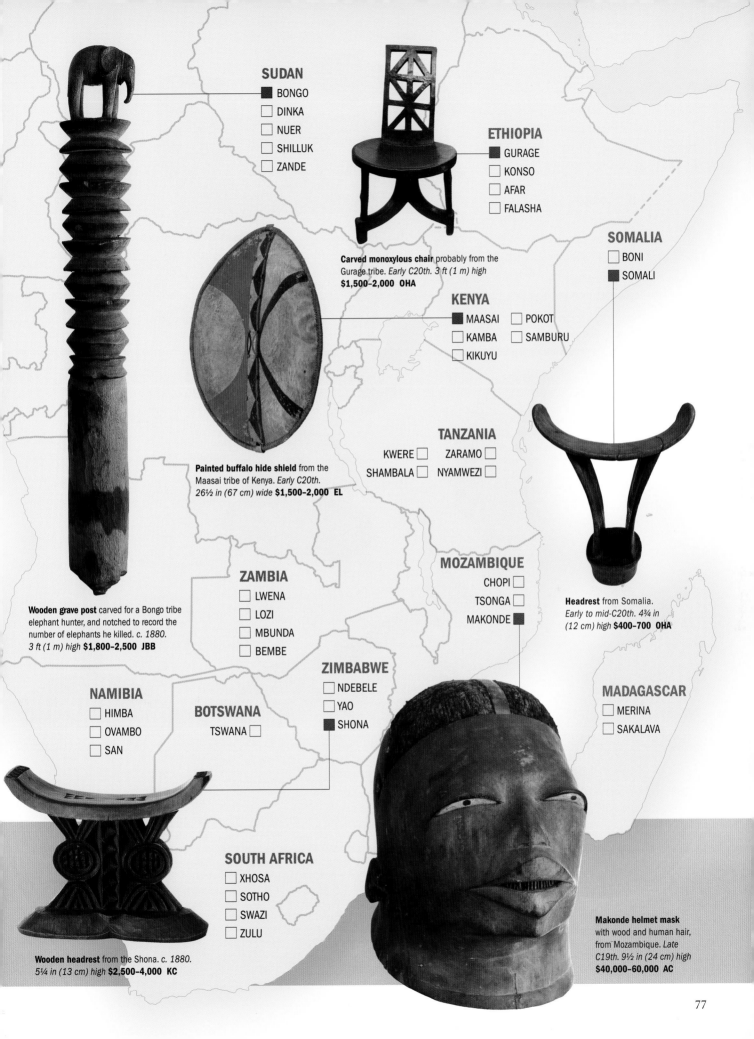

SUDAN
- ■ BONGO
- □ DINKA
- □ NUER
- □ SHILLUK
- □ ZANDE

ETHIOPIA
- ■ GURAGE
- □ KONSO
- □ AFAR
- □ FALASHA

Carved monoxylous chair probably from the Gurage tribe. *Early C20th. 3 ft (1 m) high* **$1,500–2,000 OHA**

SOMALIA
- □ BONI
- ■ SOMALI

KENYA
- ■ MAASAI
- □ KAMBA
- □ KIKUYU
- □ POKOT
- □ SAMBURU

Painted buffalo hide shield from the Maasai tribe of Kenya. *Early C20th. 26½ in (67 cm) wide* **$1,500–2,000 EL**

TANZANIA
- KWERE □
- SHAMBALA □
- ZARAMO □
- NYAMWEZI □

Wooden grave post carved for a Bongo tribe elephant hunter, and notched to record the number of elephants he killed. *c. 1880. 3 ft (1 m) high* **$1,800–2,500 JBB**

ZAMBIA
- □ LWENA
- □ LOZI
- □ MBUNDA
- □ BEMBE

MOZAMBIQUE
- CHOPI □
- TSONGA □
- MAKONDE ■

Headrest from Somalia. *Early to mid-C20th. 4¾ in (12 cm) high* **$400–700 OHA**

ZIMBABWE
- □ NDEBELE
- □ YAO
- ■ SHONA

NAMIBIA
- □ HIMBA
- □ OVAMBO
- □ SAN

BOTSWANA
- TSWANA □

MADAGASCAR
- □ MERINA
- □ SAKALAVA

SOUTH AFRICA
- □ XHOSA
- □ SOTHO
- □ SWAZI
- □ ZULU

Wooden headrest from the Shona. *c. 1880. 5¼ in (13 cm) high* **$2,500–4,000 KC**

Makonde helmet mask with wood and human hair, from Mozambique. *Late C19th. 9½ in (24 cm) high* **$40,000–60,000 AC**

have become assimilated with the Lozi (of the Rotse kingdom) who carve lidded bowls, handles, and knops with figures of animals or people in relief.

A number of enigmatic figures from the Yao and other groups in Malawi that were thought to have been made for the tourist market have recently been reexamined. It seems that many were in fact used as didactic aids in the initiation of young girls, where they portrayed ideals of beauty.

Headrests from the region range from simple branch-platforms (Rendille), to stylized human (Tsonga) and zoomorphic (Zulu and Nguni) forms. The Shona of Zimbabwe carve delicate rests, whose supports have concentric circles, openwork triangles, and lobed bases. These *nyora* (scar) designs refer to both ancestors and the guarantors of lineage, women.

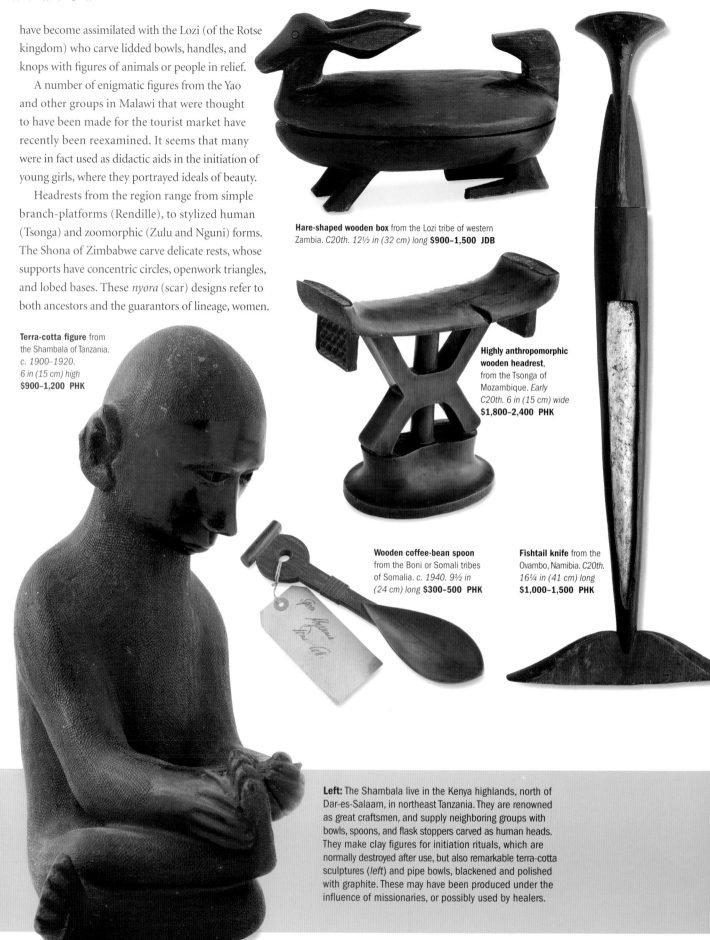

Hare-shaped wooden box from the Lozi tribe of western Zambia. *C20th. 12½ in (32 cm) long* **$900–1,500 JDB**

Terra-cotta figure from the Shambala of Tanzania. *c. 1900–1920. 6 in (15 cm) high* **$900–1,200 PHK**

Highly anthropomorphic wooden headrest, from the Tsonga of Mozambique. *Early C20th. 6 in (15 cm) wide* **$1,800–2,400 PHK**

Wooden coffee-bean spoon from the Boni or Somali tribes of Somalia. *c. 1940. 9½ in (24 cm) long* **$300–500 PHK**

Fishtail knife from the Ovambo, Namibia. *C20th. 16¼ in (41 cm) long* **$1,000–1,500 PHK**

Left: The Shambala live in the Kenya highlands, north of Dar-es-Salaam, in northeast Tanzania. They are renowned as great craftsmen, and supply neighboring groups with bowls, spoons, and flask stoppers carved as human heads. They make clay figures for initiation rituals, which are normally destroyed after use, but also remarkable terra-cotta sculptures (*left*) and pipe bowls, blackened and polished with graphite. These may have been produced under the influence of missionaries, or possibly used by healers.

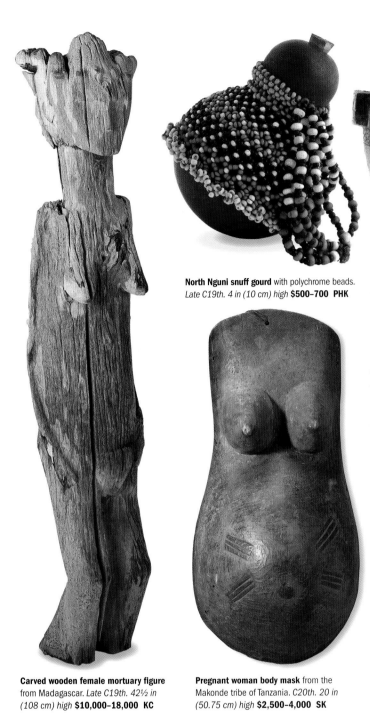

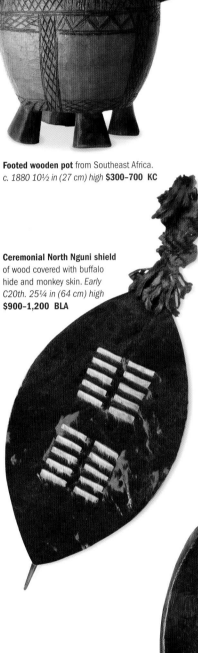

North Nguni snuff gourd with polychrome beads. *Late C19th. 4 in (10 cm) high* **$500–700 PHK**

Footed wooden pot from Southeast Africa. *c. 1880 10½ in (27 cm) high* **$300–700 KC**

Ceremonial North Nguni shield of wood covered with buffalo hide and monkey skin. *Early C20th. 25¼ in (64 cm) high* **$900–1,200 BLA**

Carved wooden female mortuary figure from Madagascar. *Late C19th. 42½ in (108 cm) high* **$10,000–18,000 KC**

Pregnant woman body mask from the Makonde tribe of Tanzania. *C20th. 20 in (50.75 cm) high* **$2,500–4,000 SK**

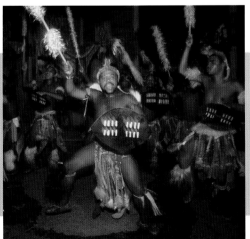

Left: The noble Zulu warrior with his *assegai* (stabbing spear) and *isihlangu* (regimental shield) is the embodiment of defiance in the face of overwhelming military might. Early in the 19th century, King Shaka united the various independent small chieftaincies of southwestern Africa, and turned circumcision schools into *amabutho* (age-grade regiments). This military organization became the basis of Zulu political, economic, and social control.

Wooden spoon with anthropomorphic handle, from the Tswana tribe of Botswana. *c. 1850. 11½ in (29 cm) high* **$8,000–12,000 KC**

79

Ethiopia

Ethiopia is the only African nation to avoid colonization (the Italians were only there for a very brief period around WWII). It is home to native populations of both orthodox Christian and Jewish faiths, and numerous "traditional" societies.

KEY FACTS

Tribes include the Gurage and Kaffa, the Kambatta, the Sidamo, Konso, Afar, Amhara, and the Jewish Falasha.

The people are mixed agriculturalists, tending fields and herding livestock. Groups tend to produce portable art, such as headrests.

Most groups carve stools, bowls, and other household utensils. Some are ornamented with Coptic designs, as the influence of orthodox Christianity extends beyond the religious centers in the highlands.

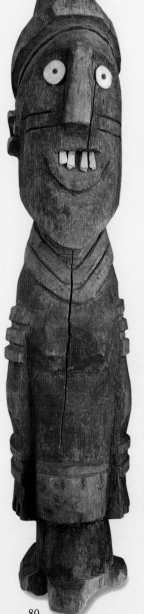

The non-Christian sculpture of Ethiopia includes a wide variety of ethnographic objects such as stools, chairs, and headrests (more accurately, neckrests). Almost all men (particularly herdsmen) use a headrest to keep their coiffures from being spoiled by sleeping on the ground and to use as a stool. The Gurage (Oromo) and Kaffa carve simple rests with bowed platforms and conical feet (or a single foot in the case of the Gurage). Sidamo rests are for women (the men have shaved heads, rather than coiffures that require protection) and are designed with a solid form since they do not need to be transported regularly. The Kambatta carve openwork headrests with incised line decoration. The Gurage and Galla also carve monoxylous, three-legged backstools with circular, dished seats, used during the installment of a new chief.

Many groups including the Issa and Afar (Danakil) make shields of animal hide, normally circular with a conical boss. The most elaborate are the prestigious presentational velvet- and metal-covered warrior shields of the Amhara.

Christianity in Ethiopia dates from 330 CE. Liturgical items date from the 5th century, when Syrian monks arrived. Some 17th-century brass processional crosses are still in use at Lalibela and Aksum, while others dating from the 13th century are found in a few Western museums.

Above: Wooden-framed Konso tribe shield with a zebra-skin covering. *Mid-C20th. 17 in (43 cm) high* **$700–1,000 OHA**

GRAVE MARKERS

Along with other groups in Sudan, Kenya, and Madagascar, the Konso make *waaga* (figurative grave markers). These are reserved for the highest members of the Gada male society. They are arranged in groups around the tomb of the deceased. The principal marker is centrally positioned, while those around it represent his wife, as well as emasculated slain enemies and animals. The principal post of each tomb is carved with a fierce expression and erect phallus, elaborate jewelry, and *kalaacha* (phallic) forehead ornament, as befits his status as hero and Gada member. When new, they are painted in red ocher, and have bone eyes and teeth, but after some time they become weathered and assume a ghostly appearance.

Left: Pair of Konso tribe male and female grave markers, in wood and bone. *Early C20th. Tallest: 20½ in (52 cm) high* **$1,200–1,800 PHK**

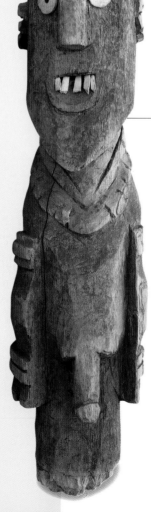

Right: Konso tribe grave marker in wood, with weathered surface. *C19th. 55½ in (141 cm) high* **$2,500–4,500 BLA**

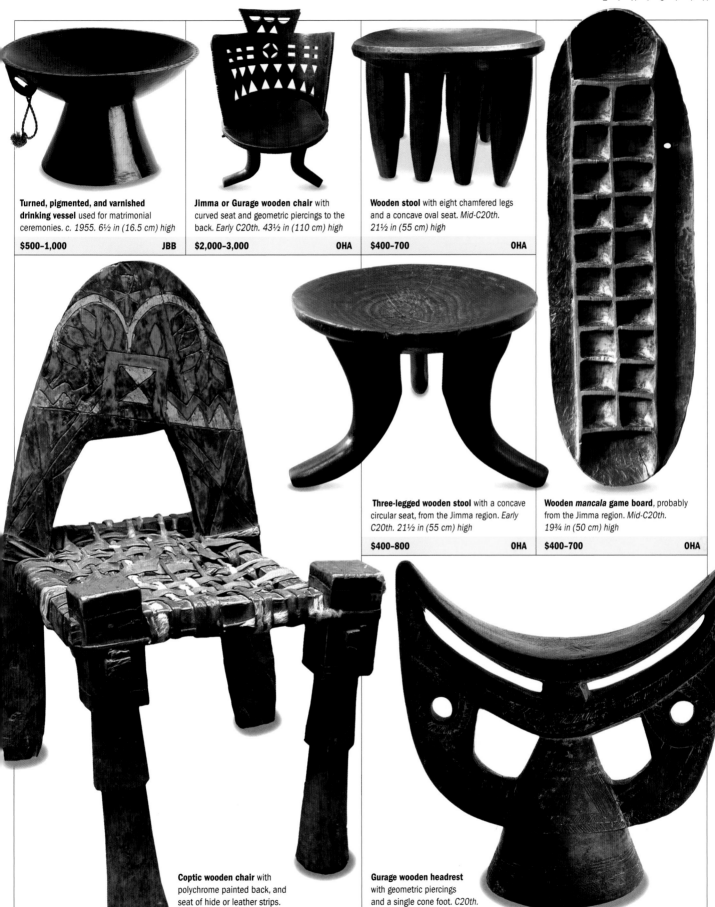

Turned, pigmented, and varnished drinking vessel used for matrimonial ceremonies. *c. 1955. 6½ in (16.5 cm) high*

$500–1,000　　　　**JBB**

Jimma or Gurage wooden chair with curved seat and geometric piercings to the back. *Early C20th. 43½ in (110 cm) high*

$2,000–3,000　　　　**OHA**

Wooden stool with eight chamfered legs and a concave oval seat. *Mid-C20th. 21½ in (55 cm) high*

$400–700　　　　**OHA**

Three-legged wooden stool with a concave circular seat, from the Jimma region. *Early C20th. 21½ in (55 cm) high*

$400–800　　　　**OHA**

Wooden *mancala* game board, probably from the Jimma region. *Mid-C20th. 19¾ in (50 cm) high*

$400–700　　　　**OHA**

Coptic wooden chair with polychrome painted back, and seat of hide or leather strips. *Mid-C20th. 27½ in (70 cm) high*

$500–800　　　　**OHA**

Gurage wooden headrest with geometric piercings and a single cone foot. *C20th. 7¾ in (20 cm) high*

$1,500–2,000　　　　**JDB**

Tribes include the Kamba, Kikuyu, Maasai, Karamajong, Giriama, and Pokot in Kenya; and the Somali and Boni in Somalia.

Somalia and Kenya are adjacent, coastal countries. Kenya's highland area is one of the most successful agricultural areas on the continent.

Arabic influence can be seen in architectural posts, doors, and trunks found around the port of Mombasa and islands of Lamu and Zanzibar.

The male Gohu society of Kenya is reserved for wealthy men who can make substantial financial contributions to the group. The society honors its dead by decorating their graves with a specially carved memorial statue.

Kenya and Somalia

The peoples of Kenya and Somalia are mostly nomadic. In keeping with their lifestyle, they create beautiful portable objects such as headrests, though their masks and figurative sculpture are very limited.

The Maasai of Kenya are a noble cattle-herding people. They make headrests, beaded jewelry, spears, almond-shaped hide shields, and horn armbands. They also produce small horn snuff bottles, with iron chains and beaded leather covers. The Kikuyu people's shields resemble Maasai designs, but tend to be more oval in form. Their carved wood initiation shields feature concentric zigzag bands and red, black, and white earth pigments.

The most prolific carvers in Kenya are the Kamba, who make small realistic figures with large earlobes, aluminum-studded eyes, and rounded features. Other carvings of *askaris* (native colonial troops) are occasionally found. The Kamba also carve traditional circular stools for elders, with three disklike feet and wirework decoration. More recent designs have bowed legs and geometric beadwork.

The Giriama are the largest subgroup of the Mijikenda, who live on the southeast coast of Kenya. They are one of the few tribes in this region who make sculpture. These *vigango* (ancestor posts) are generally vertical, flat, planklike pieces carved with triangular, rosette, and snake designs, surmounted by a circular or spherical head on a short neck. They are carved for the disgruntled spirits of deceased members of the Gohu society.

The Boni and Somali live on the border of Somalia and Ethiopia and are nomadic cattle herders. Both groups carve beautiful spoons for serving roasted coffee beans, and lightweight headrests, decorated with interwoven, Islamic-influenced, geometric designs.

Above: Kenyan (or possibly Sudanese) branch stool with a fine patina. *Late C19th. 14¼ in (36 cm) long* **$2,500–3,000 PC**

Horn bracelet from the nomadic Maasai tribe. *c. 1880. 7¼ in (18.5 cm) long* **$1,500–2,000 JBB**

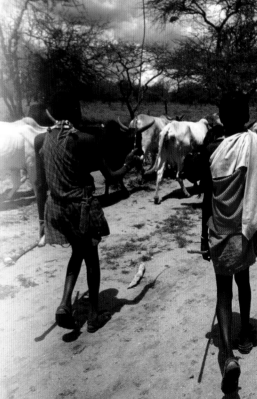

MAASAI CATTLE HERDERS

PASTORAL LIFESTYLES

Pastoralists need to transport their material culture with them. Beaded corsets and bundles of necklaces, ivory cuffs, coiled metal bracelets, and armbands are worn, and headrests, wrist knives, and throwing sticks are carried. For the people of northeastern Africa, cattle are an essential part of life. This is not to say that they rely entirely on cattle for food—many older men and women undertake basic subsistence activities in the semipermanent settlements not associated with the seasonal cattle camps. The importance is cultural. Cattle themselves are known by name, lineage can be recounted, and favorite animals are praised in song and dance. Their horns are encouraged to grow in desirable shapes and are dressed with tassels.

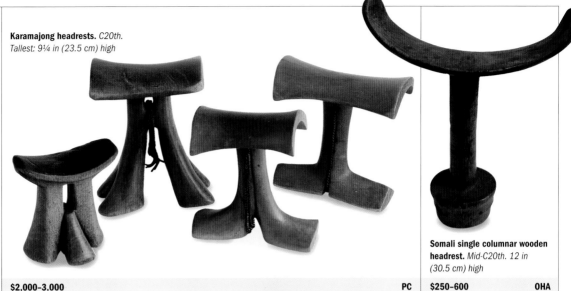

Karamajong headrests. *C20th.*
Tallest: 9¼ in (23.5 cm) high

$2,000–3,000 PC

Somali single columnar wooden headrest. *Mid-C20th. 12 in (30.5 cm) high*

$250–600 OHA

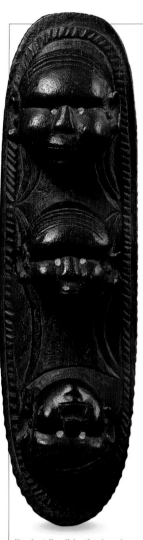

Kamba tribe divination board carved with three heads and inset with mother-of-pearl eyes. *Early C20th. 7 in (18 cm) high*

$300–500 BLA

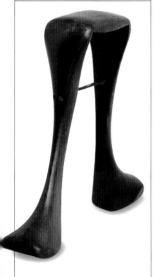

Twin-footed Kenyan karamajong headrest. *Late C19th. 9¼ in (23.5 cm) high*

$2,000–2,000 PC

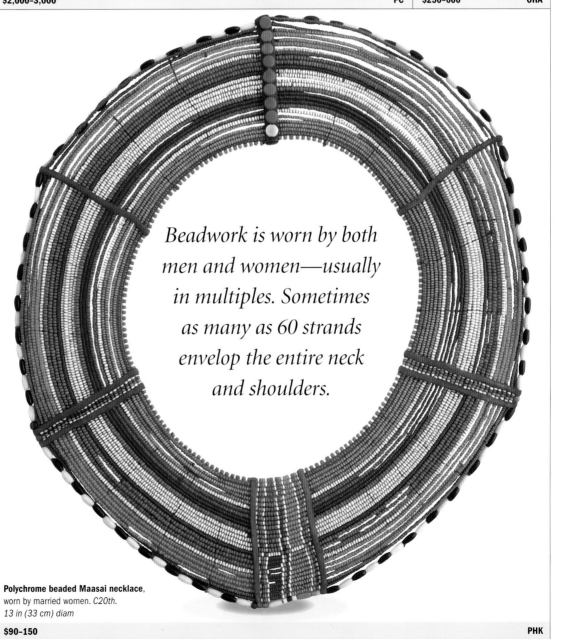

Beadwork is worn by both men and women—usually in multiples. Sometimes as many as 60 strands envelop the entire neck and shoulders.

Polychrome beaded Maasai necklace, worn by married women. *C20th. 13 in (33 cm) diam*

$90–150 PHK

South Africa

It is the military and political history of South Africa that has dominated the minds of Western observers. As a consequence, the rich material culture of this region has been largely overlooked until relatively recently.

KEY FACTS

Tribes include North Nguni (Zulu), South Nguni (including Xhosa), Swazi, Venda, North Sotho, Tswana (West Sotho), South Sotho, and Ndebele (Transvaal).

South Africa is made up of a large central plateau area with regions of hills at the coast. There is an abundance of natural resources, including gold and diamonds.

Many spears, shields, clubs, and staffs were collected during British military campaigns. In the past, much South African artwork was attributed incorrectly to the politically dominant Zulu tribe.

Movement between these nomadic tribes has been fluid, resulting in a crossover of ideas that can make precise attribution of individual pieces challenging.

Despite the lack of formal figurative sculpture, the arts of the peoples of South Africa are numerous and intriguing. Colonials and soldiers collected many items of domestic or military use in the 19th century, without concern for their true origin. The peoples they encountered followed their cattle over great distances during different seasons, and were not settled in one area. Therefore, items collected in Natal were simply categorized as "Zulu." However, recent scholarship has begun to reattribute items into the various ethnic groups that populate the country. For example, the Tsonga mainly live in southern Mozambique, but also migrated to different areas. They were required to send carved tributes to Chief Shaka in the early 19th century, as he united the area against the incursions of Dutch settlers. The Tsonga became known for their carving, and some moved to Natal, where they made figurative and zoomorphic staffs for Europeans and Zulu chiefs.

Colonial officers tried to make sense of the various pastoralist groups for administration purposes and settled on a classification along linguistic lines. Ethnologists adopted this system so that we now refer to Nguni- and Sotho-speaking people, for example. The Zulu are a confederacy of previously independent chieftaincies in Natal, which became united under Chief Shaka in the early 19th century, and are more correctly known as North Nguni.

Above: Rare North Nguni Janus-head wooden staff with a wirework handle. *C19th. 34¼ in (87 cm) long* **$3,000–5,000 PHK**

BEADWORK

Most southern African communities used beadwork to decorate clothing or to make jewelry. Glass beads were traded in this region by Arabs from the 11th to 16th centuries, and later by the Portuguese in exchange for food and livestock. Certain groups had a preference for particular sizes and colors—for example, the Cape Nguni favor red and the Ndebele, white. Both these colors are also associated with chieftaincy, particularly in the early 19th-century Zulu kingdoms, where the royal clan controlled beadwork distribution. Until recently, beadwork could be purchased for small sums, but as interest in the domestic arts of South Africa has risen, so have the prices.

Polychrome bead-and-cloth initiation doll from the Sotho tribe. *Late C19th. 3¼ in (8 cm) long* **$300–500 PHK**

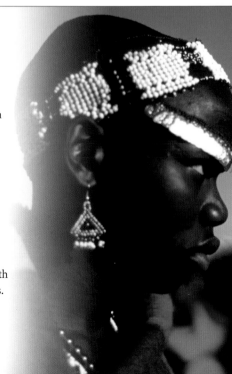

BEADWORK WORN IN NDEBELE WAR DANCE

A DIVERSE COLLECTING FIELD

A wide variety of ethnographic items are found in this country, which makes it an interesting region for new collectors to study. We find a huge range of *knobkerries* (clubs), hide shields with different regimental patterns, figurative and geometric staffs, beer pots, headrests, beadwork, and containers. Personal objects of great beauty are made of cow horn, metal, ivory and bone, textile, gut and hide, gourd, and wood. The multiple or "ambiguous" nature of southern African items has often been

noted. For example, *intshaza* are both snuff spoons and hair combs, and both essential personal implements for men and women. Many artifacts overtly or subtly refer to cattle, or, more importantly, the ownership of them. As with all pastoralist groups, cattle equates with wealth. A staff may be carved with a pair of horns, a headrest with four legs, or a snuff container carved from horn.

The social and spiritual importance of brewing and drinking beer led to the production of a variety of utensils and containers. They are most popular with collectors in the West. Pots used in the beer-making process are differentiated according to use. For example, *izimbiza* (brewing vats) are shaped differently from *izinkamba* (drinking pots). Some have burnished surfaces and raised or incised decorations. Elaborate oiled coiffures were kept clean by the use of headrests, and men and women also wore beadwork items. *Amashaza* (colorful earplugs) made from floor vinyl or plexiglass can be found mainly in KwaZulu-Natal.

North Nguni *ukhamba* (singular of *izinkamba*) beer pot in glazed clay with *amasumpa* markings. *c. 1930.* *11 in (28 cm) high* **$2,500–4,500 KC**

SYMBOLS

Some wooden items are decorated with motifs that are not merely decorative, but highly symbolic. One such motif is a body or facial scar, which is reserved for members of the ruling Zulu clan, and may refer to cattle wealth.

SCARIFICATION

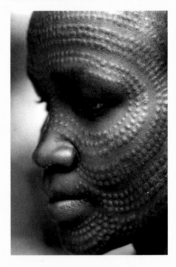

Called amasumpa (warts), these beauty marks are transposed onto objects such as *izigqiki* (headrests), *izingqoko* (meat dishes), *izinkamba* (beer pots), and *amathunga* (milk pails). They would have been used by high-status individuals, but in modern times such pieces form part of the marriage gift of a groom to his in-laws.

TOBACCO AND SNUFF

In this region, smoking tobacco and taking snuff are widespread, everyday social activities for both men and women. Both products are associated with the power and generosity of individuals and spirits. Finely carved pipes and *amashungu* (snuff containers) are very personal objects, since they are discreet, portable tokens of status. Snuff containers are worn as accessories, as are *intshengula* (snuff spoons) and *intshaza* (spoon-combs that double as hair ornaments). Zulu snuff was often a mixture of tobacco and *insangu* (marijuana) and would be taken before a debate to "clear the head," or when requesting fertility help from ancestors.

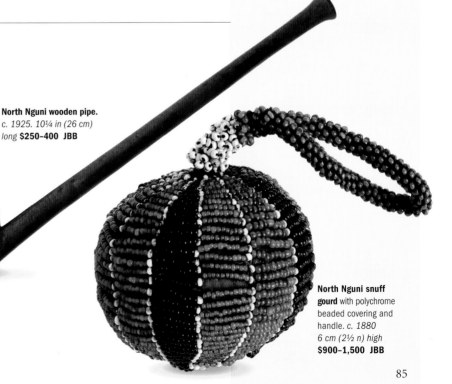

North Nguni wooden pipe. *c. 1925. 10¼ in (26 cm) long* **$250–400 JBB**

North Nguni snuff gourd with polychrome beaded covering and handle. *c. 1880* *6 cm (2½ n) high* **$900–1,500 JBB**

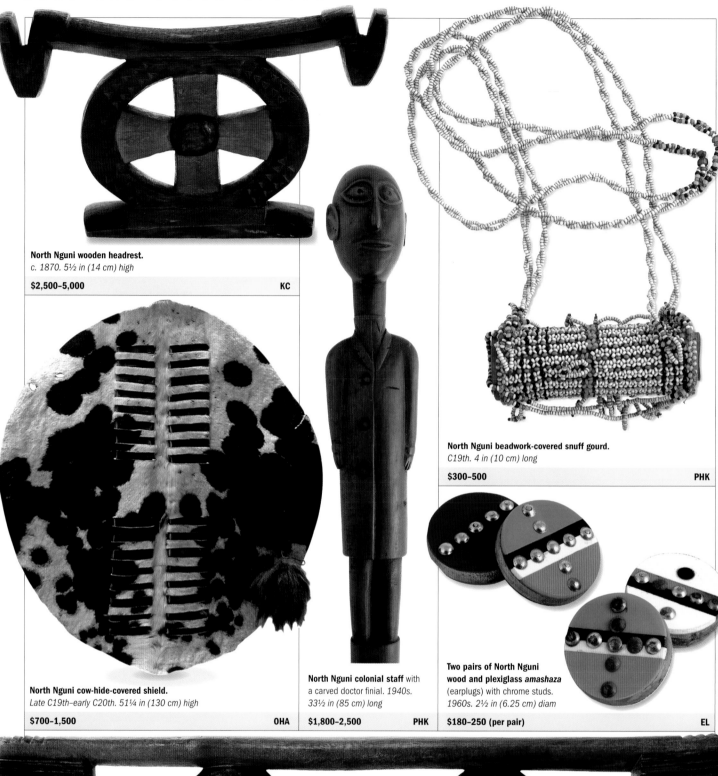

North Nguni wooden headrest.
c. 1870. 5½ in (14 cm) high

$2,500–5,000 KC

North Nguni beadwork-covered snuff gourd.
C19th. 4 in (10 cm) long

$300–500 PHK

North Nguni cow-hide-covered shield.
Late C19th–early C20th. 51¼ in (130 cm) high

$700–1,500 OHA

North Nguni colonial staff with
a carved doctor finial. *1940s.*
33½ in (85 cm) long

$1,800–2,500 PHK

**Two pairs of North Nguni
wood and plexiglass** *amashaza*
(earplugs) with chrome studs.
1960s. 2½ in (6.25 cm) diam

$180–250 (per pair) EL

North Nguni wooden headrest with arched central supports. *C19th. 28 in (71 cm) long*

$3,000–7,000 KC

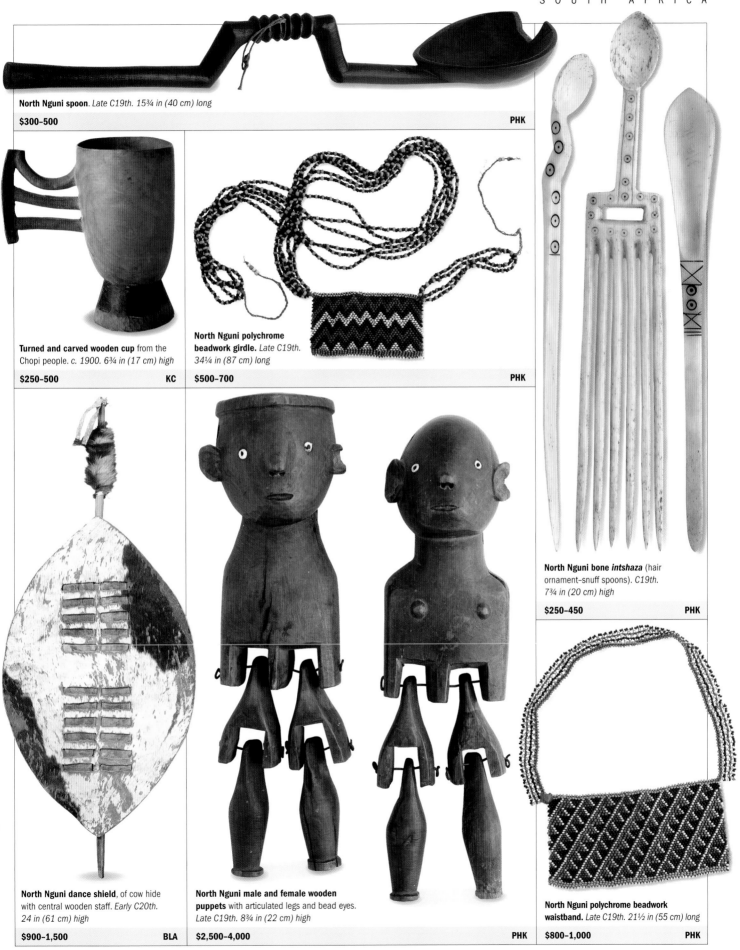

North Nguni spoon. *Late C19th. 15¾ in (40 cm) long*

$300–500
PHK

Turned and carved wooden cup from the Chopi people. *c. 1900. 6¾ in (17 cm) high*

$250–500
KC

North Nguni polychrome beadwork girdle. *Late C19th. 34¼ in (87 cm) long*

$500–700
PHK

North Nguni bone *intshaza* (hair ornament–snuff spoons). *C19th. 7¾ in (20 cm) high*

$250–450
PHK

North Nguni dance shield, of cow hide with central wooden staff. *Early C20th. 24 in (61 cm) high*

$900–1,500
BLA

North Nguni male and female wooden puppets with articulated legs and bead eyes. *Late C19th. 8¾ in (22 cm) high*

$2,500–4,000
PHK

North Nguni polychrome beadwork waistband. *Late C19th. 21½ in (55 cm) long*

$800–1,000
PHK

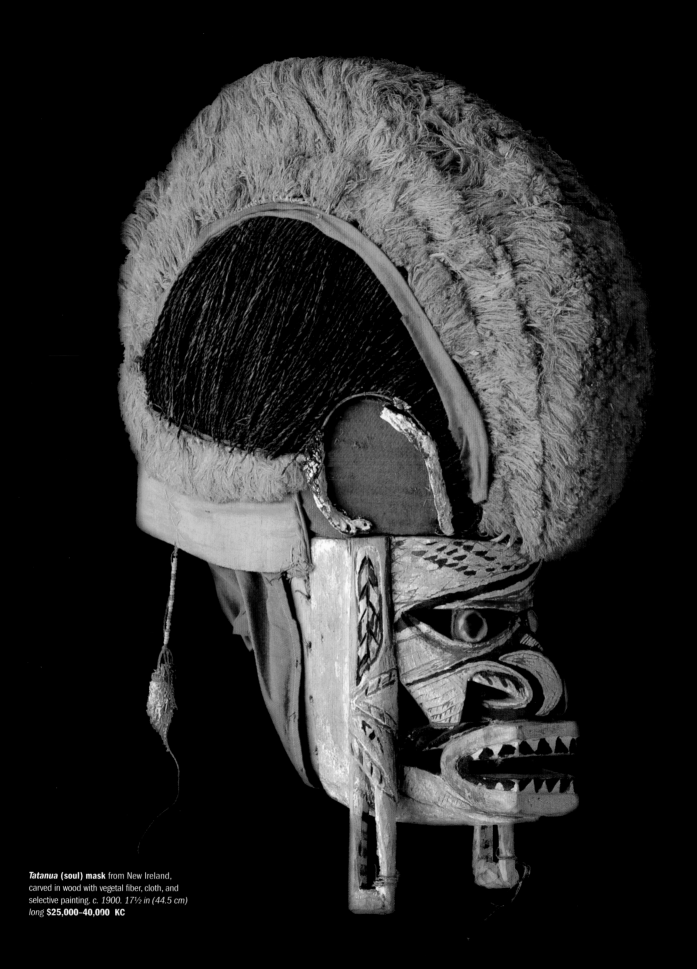

Tatanua **(soul) mask** from New Ireland, carved in wood with vegetal fiber, cloth, and selective painting. *c. 1900. 17½ in (44.5 cm) long* **$25,000–40,000 KC**

OCEANIA

Pacific art is a revelation that has captivated the imagination of aesthetes since Cook and Gauguin.

The Pacific Ocean covers about half of the world's surface, over which are scattered tens of thousands of islands, divided into Melanesia, Polynesia and Micronesia, Indonesia, the Philippines, and the continent of Australia. The art of Oceania appears complex and graphic, made to dazzle or inspire awe. Some pieces have surfaces entirely decorated with intricate designs, while others have a completely plain form. These contradictions make sense when we appreciate the purpose or function of an object, rather than seeing it purely as an artistic expression. Decoration enhances the efficacy of things; their beauty is often secondary.

Culture of Oceania

European contact caused great damage to many fragile Oceanic communities, particularly in Polynesia. However, resurgence in national pride and support from government has encouraged a flowering of traditional art forms and culture in parts of the region.

OCEAN LIFE

It has been said by scholars that Oceania was populated with the use of four fundamental artifacts: the adz, the fishhook, cordage (of sennit), and the canoe. Such was the importance of these (and other fundamental tools) that fine ceremonial examples were imbued with supernatural power and were highly prized as symbols of high status. All islanders and coastal peoples relied on the canoe for transportation, trade, and travel, since there were no pack animals prior to European contact. The simple dugout canoe was unstable, paddled or poled, and only suitable for calm water. Made from the trunk of a tree, it could be up to 80 ft (24 m) long, and so narrow that the crew had to stand.

Salt-water craft required more stability, and impressive sail-powered outrigger canoes were produced to cope with the waves and wind. These "workhorses" were used for most daily economic, subsistence activities on the islands, such as transportation and fishing. The most seaworthy vessels were the double-hulled war galleys of Fiji and New Caledonia, which could be over 100 ft (30 m) long, were capable of carrying several tons of cargo or 200 warriors, and had better sailing qualities than the European ships of the same period. The islanders of Oceania were very accomplished seamen and would embark on long voyages for trade, navigating by observing the currents, the wind direction, and the stars (which they mapped out on charts made of sticks).

Maori war canoes like these were built in 1990 to celebrate the 150th anniversary of the Treaty of Waitangi (the settlement between the Maori and the British). They symbolize strength and endurance, and act as a focus of Maori pride and *mana*.

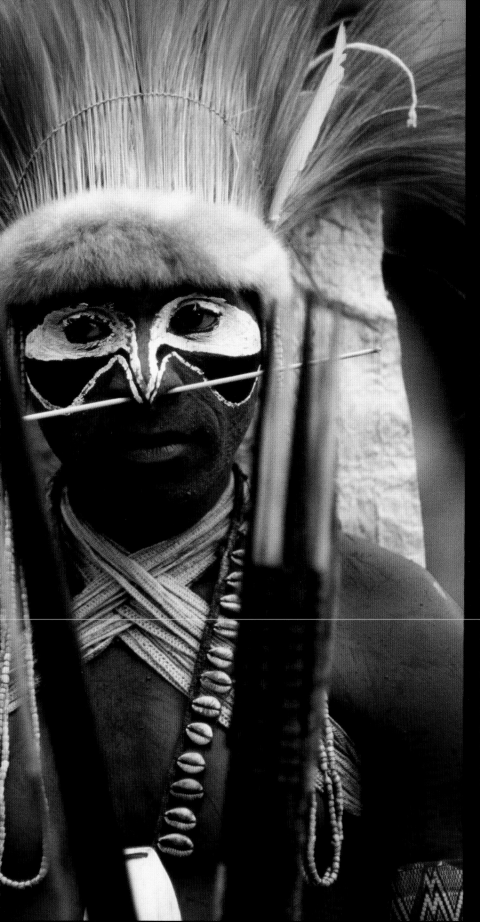

In the New Guinea Highlands, preparation for war and combat necessitated self-decoration and performance. Today, warriors still participate in musical performances, dances, and oration in their finery. They hold competitive feasts and festivals to commemorate national independence and historical missionary events.

WARFARE

A look at collections of artifacts from the Pacific immediately indicates the endemic nature of warfare in the region. Warriors used numerous clubs, spears, daggers, arrows, and shields. Most disputes occurred between neighboring clans or villages, and minor skirmishes between rivals were common. They often took the form of head-hunting raids to avenge blood feuds, the preferred method being by ambush or night attack. However, pitched battles were sometimes arranged on recognized fighting grounds, where a certain amount of "saber rattling" preceded brief exchanges, which could end in serious injury or fatality. Large-scale warfare did occur—for example in Fiji, where rival chiefs even employed Tongan mercenaries. It was very rare for an entire tribe to be annihilated, although the likelihood of mass mortality was dramatically increased after European contact and the introduction of guns. Not only did warfare become more lethal as a result, but also new reasons for conflict arose—rivals battled for control over the anchorages of ships and, by extension, the trade goods they carried. Some groups earned fearsome reputations as ferocious warriors, such as the Tongans, New Georgians, and Marind-Anim. Villages were defended by a range of measures, which included palisades, stockades, pits studded with bamboo spikes, earthworks, and moats. Platforms were erected in trees to act as lookout posts and bases for archers.

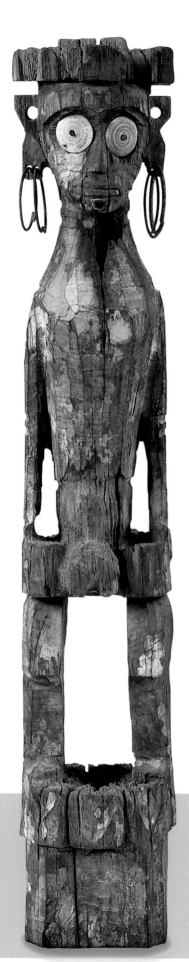

AUSTRALIA AND SOUTH EAST ASIAN ISLANDS

The rich arts of the widespread cultures of insular Southeast Asia and Australia are not as well known as those of the Pacific. But the wood and stone sculpture, textiles, and jewelry reveal a freshness and vitality unparalleled in the rest of the world.

The religious traditions of Buddhist, Islamic, and Hindu-Javanese art are well documented in the West, and many visitors have traveled to the great monuments and world heritage sites in Java, Bali, and Luzon. However, the indigenous arts of Taiwan, the Philippines, and the Indonesian archipelago have been largely ignored by museums until quite recently. Similarly, much has been made of the paintings of the Australian Aboriginal people, and there has been a welcome revitalization of painting by contemporary artists in acrylics and oils on canvas. However, the traditional material culture has been overlooked by many museums outside Australia.

The Southeast Asian islands may be widely dispersed but are linked through their shared Austronesian linguistic origin and ideology. They also share artistic motifs, which are inherited from the Dong-Son (500 BCE–100 CE), an ancient metalworking Vietnamese culture. Shared conceptions of life, death, and the cosmos developed, and were recounted in myth and represented in art styles as varied as those of the Pacific. Recurring motifs include boats, buffalo, trees, and birds. Artisans made contact with neighboring groups and technical skills sharpened. Accoutrements of authority were produced, which resulted in a diverse tradition of gold-working and textile-weaving.

Australia is different, however. The inhabitants were not influenced by the Dong-Son and do not speak an Austronesian language. The cultural history of the country was left to develop undisturbed (except for the occasional encounter with islanders from southern Southeast Asia) until the 18th and 19th centuries when European explorers and colonists arrived in large numbers. Aboriginal decorative motifs relate to the creation of Earth by ancestor giants, and appear in art in a variety of different forms—as abstract curvilinear patterns or as animal or quasi-human figures.

"Hampatong" ancestral guardian figure, carved in wood with shell eyes and iron earrings, from the Dayak people of Borneo (Kalimantan). *C19th. 38 in (96.5 cm) high*
$18,000–25,000 WJT

LANDSCAPE AND CULTURE
The landscape of insular Southeast Asia is mainly mountainous and volcanic, covered with thick tropical rainforest and fertile soils. The Australian landscape is both mountainous and desert, where nomadic bands are hunter-gatherers.

Right: In Southeast Asia, some tribes are semi-nomadic and derive food from hunting, fishing, and gathering forest products (*see Borneo forest, right*).

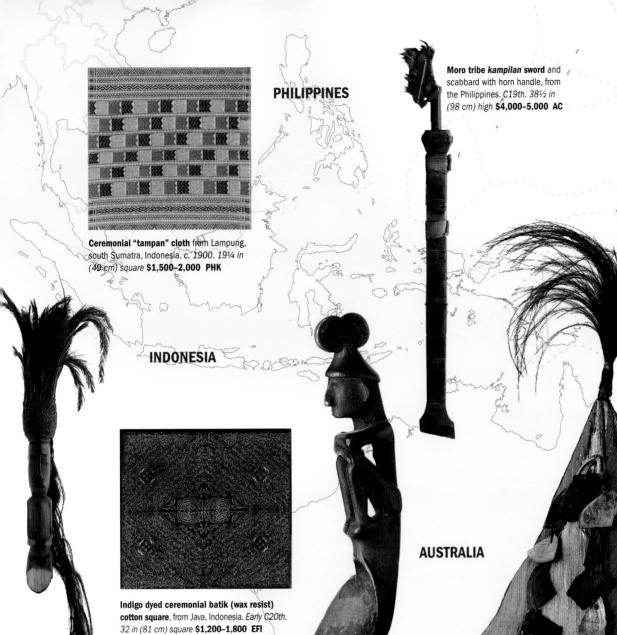

Ceremonial "tampan" cloth from Lampung, south Sumatra, Indonesia. c. 1900. 19¼ in (49 cm) square $1,500–2,000 PHK

PHILIPPINES

Moro tribe *kampilan* sword and scabbard with horn handle, from the Philippines. C19th. 38½ in (98 cm) high $4,000–5,000 AC

INDONESIA

Indigo dyed ceremonial batik (wax resist) cotton square, from Java, Indonesia. Early C20th. 32 in (81 cm) square $1,200–1,800 EFI

AUSTRALIA

Sorcerer's staff finial, from the Toba Batak of Sumatra, Indonesia. Early C20th. 16½ in (42 cm) high $700–1,000 PHK

Ifugao wooden spoon with human figurative handle, from the Philippines. C20th. 8 in (20 cm) long $5,000–7,000 PC

Aboriginal cloth, twine, shell, and feather hat, from Queensland, Australia. Early C20th. 18½ in (47 cm) high $700–1,000 KC

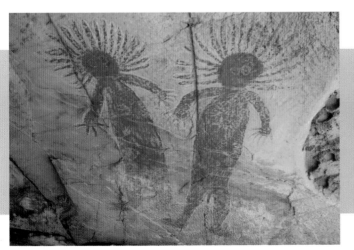

Left: Rock paintings are found in many Australian regions on the walls and ceilings of shallow caves, such as those shown here in the Northern Territory. Generally, the paintings refer to well-known myths and often depict human ancestors or supernatural figures or faces. The paintings are believed to be the work of the beings themselves. The drawings shown here depict Gangi Ngang—the first men of the local Mirriwung tribe.

Australia

Due to its isolation, Australia supported cultures that evolved virtually free from outside influence. It was almost uninterrupted for tens of millennia, until the arrival of the Europeans and settlement by the British in the 19th century.

KEY FACTS

The area of Australia is approximately equivalent to that of the United States, excluding Alaska.

There are three geographical zones: the west is a plateau broken up by small mountains and hills; the center is an area of low plains and dry desert; and the east is mountainous and rainy.

Artifacts are relatively simple, but engraved and/or painted with geometric designs that relate to ancestors.

Prices for Aboriginal art have increased sharply in recent years.

Right: Aboriginal wooden boomerang carved with a birdlike spike. *Late C19th. 26 in (66 cm) high* **$1,200–1,800 WJT**

Archaeological research has suggested that Australia was settled at least 40,000 years ago. Through time, the Aborigines developed a culture that was highly effective, despite the limited resources provided by the land. The environment was sparsely populated and a hunter-gatherer society emerged. Small bands of men wandered the land hunting kangaroo, opossum, and flightless birds, while women gathered tubers, small fruits, and insects. Women also made temporary shelters in which men maintained spiritual matters, through ceremony.

According to Aboriginal beliefs, creation occurred during a period known as "dreamtime," when giant semi-human and semi-animal beings roamed the earth, creating all known things, including light, fire, death, human rituals and laws, and life. When they had finished, they transformed themselves into the topographical features of the lands, such as rocks and waterholes. These ancestors were called "Dreamings" and are one of the dominant subjects expressed in Aborigine art today. They are represented as totems, by plants, animals, and by geographical features. These totems are believed to be the actual ancestors of the clan lineages. Ceremonies centered on the worship of these ancestors, who protected and provided for the group through their supernatural power. Sacred laws controlled the use of hunting grounds and maintained kinship ties through marriage, and youths were initiated into adulthood.

Above: Tiwi Aborigine funeral *tunga* (bark bag), from Melville Island. *Mid–Late C20th. 21¼ in (54 cm) high* **$900–1,500 JYP**

BOOMERANGS

The boomerang is synonymous with the Australian Aborigine, although throwing sticks in one form or another are used all over the world. The boomerang has a wide variety of uses. In arid central Australia, mobility of the group is of utmost importance, and individuals carry as little as possible. Here, the boomerang is an all-purpose tool used for digging, as a knife, hammer, or club, for making fire (by friction), for musical accompaniment, as well as for fighting and hunting. In other areas, such as coastal southern and western Australia, boomerang design evolved to solve different problems. Non-returning boomerangs were used as weapons, while wild fowl were hunted with the returning type.

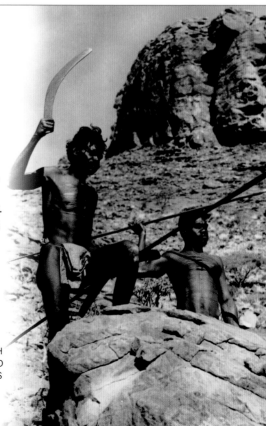

ABORIGINES WITH BOOMERANG AND WOODEN SPEARS

MATERIAL CULTURE

Hunter-gatherer societies in general produce a relatively small amount of material culture. In Australia, there is a large amount of rock painting and engraving, sand painting, and body decoration. The objects that commonly occur in collections include various hunting and fighting weapons, utensils, ritual carvings, and bark paintings, made with simple tools. Most are usually decorated with beautiful geometric engraved or painted designs in earth pigments.

Shields are very varied, and are among the most decorative items collected today. They were used to parry spear thrusts and arrows during fighting but, as with many boomerangs, often performed a multitude of other functions. The most decorative shields are those from Queensland, which are made from the buttress roots of fig trees. These are broad, oval, and slightly bent (adding to their charm), and painted with bold interlocking designs. *Wunda* shields of western Australia are painted and incised with parallel grooves in alternate colors. Murray River shields are delicate and rare. Other decorated weapons include the boomerang, *waddy* or *lilil* (types of club), and *woomera* (spear throwers). Utensils include knives with blades of stone (or, more recently, worked glass), various woven plant fiber bags, and *pitchi* or *coolamon* (wooden bowls that double as baby carriers).

Strips of eucalyptus bark were flattened and braced and used for temporary shelters in northern Australia (Groote Eylandt, Melville Island, and Arnhem Land). The insides of the shelters would be painted with a variety of ancestral designs, human forms, and animal totems in different regional styles, including the so-called X-ray style, depicting internal organs.

SACRED AMULETS

Every adult male owned a tjuringa, made of stone or wood and engraved with concentric circles and arcs. Tjuringas are highly sacred because they embody the totemic spirits of both the owner and the creator beings. They are displayed during initiation and rain-making ceremonies, then carefully stored away.

Aboriginal incised and ochered *tjuringa. C19th.* 6¾ in (17 cm) long
$1,800–3,000 PHK

BARK BAGS

The Tiwi of Bathurst and Melville Islands in the northern territory use a number of ritual objects in their Pukamani mortuary rites. For example, there are unusual carved memorial posts, which are positioned around the grave of the deceased. Participants wear bark armbands with feathered flanges, and store food in *tungas* (bark bags). After the ceremonies, the *tungas* are sometimes broken, or placed on top of the Pukamani poles. All of these objects are painted with beautiful rectilinear designs of cross-hatched panels or bands, in red, rare yellow ocher, and white (kaolin) on a dark ground made from manganese oxide.

Left: Tiwi Aborigine funeral
tunga (bark bag), from
Melville Island. *Mid–Late
C20th.* 17¾ in (45 cm) high
$900–1,500 JYP

MOTIFS INCLUDE FROGS, SNAKES, TURTLES, BIRDS, AND MOSQUITOES

Polychrome bark painting of lagoon wildlife, attributed to Mattijin of the Hunagem group, from Yirrkala. *1960s. 26½ in (67.25 cm) high*

$2,500–3,000 AP

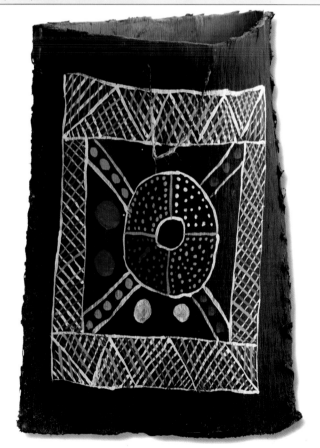

Tiwi Aborigine funeral *tunga* (bark bag), from Melville Island. *Mid-Late C20th. 20 in (51 cm) long*

$900–1,500 JYP

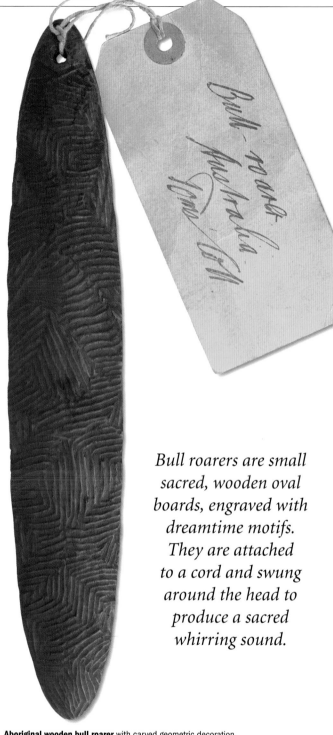

Bull roarers are small sacred, wooden oval boards, engraved with dreamtime motifs. They are attached to a cord and swung around the head to produce a sacred whirring sound.

Aboriginal wooden bull roarer with carved geometric decoration. *C19th. 11½ in (29.5 cm) long*

$300–500 PHK

LABELS

Some artifacts can occasionally be acquired with old labels still attached to them. In the absence of any provenance about where and when an item was collected, this is invaluable to both the modern collector and the academic. Some labels were attached by ethnographers or early explorers, and these are of considerable interest. Although some have been proven to be inaccurate—confusing cultures and locations, or misinterpreting the use of an item—this is still of historical interest. Certain museums or important collectors used their own number system or letter style, and recognizing these can be crucial in tracing the provenance of an item. Labels should never be removed.

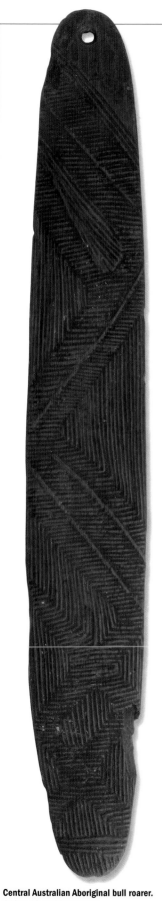

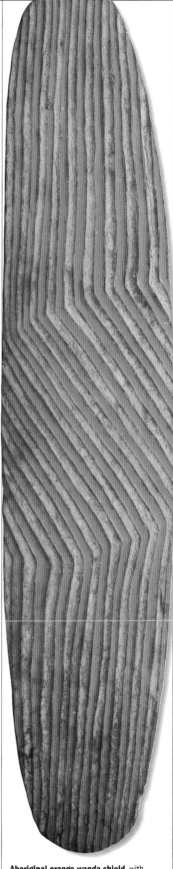

Central Australian Aboriginal bull roarer.
C19th. 13 in (33 cm) long

$300–500 **PHK**

Tiwi Aborigine carved and polychrome-pigmented Pukamani funeral ceremony pole.
Mid–Late C20th. 72½ in (184 cm) high

$5,000–7,000 **JYP**

Finely engraved wooden Aboriginal club.
C19th. 26 in (66 cm) long

$1,200–1,800 **WJT**

Aboriginal orange *wanda* shield, with zigzag pattern, from Western Australia.
C20th. 32¼ in (82 cm) high

$5,000–9,000 **PC**

Philippines

The tribal peoples of the Philippines struggled tenaciously against colonial and religious persecution for hundreds of years, in order to preserve their identities, their traditional values, and their rich arts.

Below: Seated *bulul* **figure**, carved in wood by the Ifugao people. *Early C20th.* *14¼ in (36 cm) high* **$1,800–2,500 BLA**

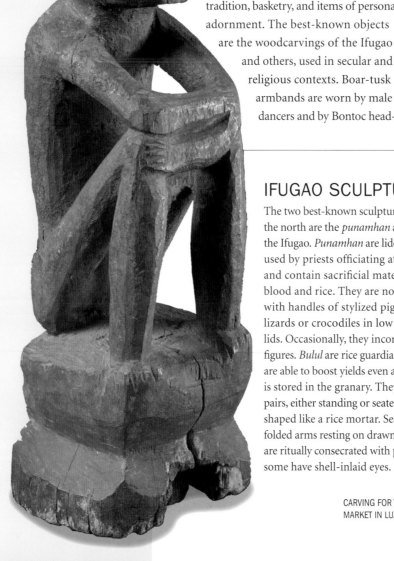

The Republic of Philippines is an archipelago of about 7,000 islands (of which only around 900 are inhabited) lying in the South China Sea, with a total land area about the size of the British Isles or Arizona. Of the 11 main islands, the largest are Luzon, in the north, and Mindanao, in the south.

The northern tribes of Luzon live in the mountains, where the landscape is characterized by spectacular rice terraces. A wide variety of art forms exist here, including a rich textile tradition, basketry, and items of personal adornment. The best-known objects are the woodcarvings of the Ifugao and others, used in secular and religious contexts. Boar-tusk armbands are worn by male dancers and by Bontoc head-hunters, and both women and men wear jewelry of gold, silver, bead, and shell. The handles of *pakko* (Ifugao spoons and ladles) are carved with figures, and take on a wonderful patina through use. They are very collectible.

In the Islamicized south, metalwork and weaving are highly developed, particularly in the highlands, and carvings on houses, boats, grave markers, and personal objects include triangles, plant, and rope-twist motifs. These designs are all referred to as *okir* motifs. Islam eschews animal and human images in art, although there are one or two exceptions among the Maranao.

Above: Wooden *pakko* **(spoon)** with a brass human figurative handle, from the Ifugao people. *C20th. 7 in (18 cm) long* **$12,000–20,000 PC**

IFUGAO SCULPTURE

The two best-known sculptural forms in the north are the *punamhan* and *bulul* of the Ifugao. *Punamhan* are lidded containers used by priests officiating at ceremonies, and contain sacrificial materials such as blood and rice. They are normally carved with handles of stylized pig's heads, with lizards or crocodiles in low relief on their lids. Occasionally, they incorporate human figures. *Bulul* are rice guardian deities, which are able to boost yields even after the harvest is stored in the granary. They are carved in pairs, either standing or seated, above a base shaped like a rice mortar. Seated *bulul* have folded arms resting on drawn-up knees. They are ritually consecrated with pig's blood, and some have shell-inlaid eyes.

CARVING FOR THE TOURIST MARKET IN LUZON

TRIBES AND BELIEFS

Indigenous tribal groups remain only in remote areas of the islands to the north, south, and west, while the rest of lowland Philippines was converted to Catholicism during the Spanish colonial period (from the 16th to the 19th century). Nine tribes, including the Isneg, Kalinga, Bontoc, Ifugao, and Ilongot, inhabit the mountains of northern Luzon. In the south, Islam has remained the dominant religion since its establishment in the 15th century, and the Muslim tribes that occupy western Mindanao and the Sulu archipelago include the Maranao, Tausug, Yakan, Bejau, Moro, and Samal. The Manobo, Mandaya, Bagobo, and T'boli are non-Muslim and non-Christian tribes who reside in Palawan, Mindoro, and eastern Mindanao.

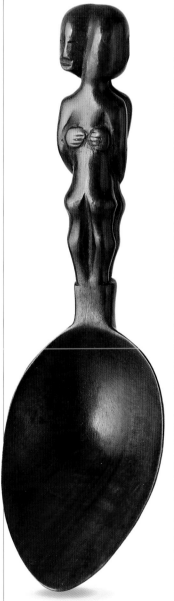

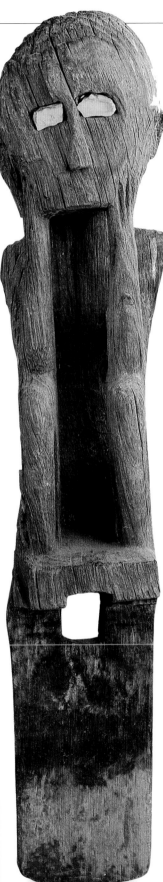

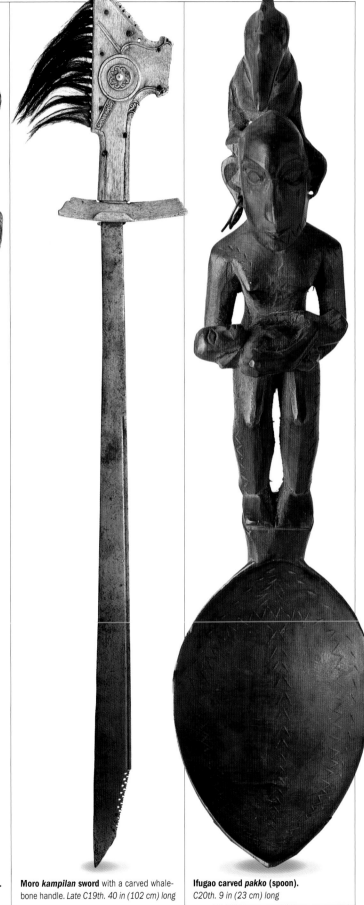

Ifugao carved *pakko* (spoon).
C20th. 7½ in (19 cm) long

$5,000–7,000 **PC**

Ifugao carved wooden seated *bulul* figure.
C20th. 18 in (47 cm) high

$10,000–12,000 **PC**

Moro *kampilan* sword with a carved whale-bone handle. *Late C19th. 40 in (102 cm) long*

$12,000–18,000 **AC**

Ifugao carved *pakko* (spoon).
C20th. 9 in (23 cm) long

$5,000–7,000 **PC**

Indonesia

The peoples of Indonesia are as enigmatic as their islands are dispersed. The motifs that decorate their artifacts can be understood more clearly when placed within the mythical contexts of these remarkable cultures.

KEY FACTS

Main peoples include Batak, Iban, Toraja, and the people of Nias, Mentawei, Flores, Sumba, Atauro, Timor, Lombok, Leti, and the Moluccas. The Dayak group includes Kenyah-Kayan, Bahau, and Bidayüh.

This archipelago of islands stretches between the Indian and Pacific Oceans and is mainly a tropical climate, with cooler areas in highland regions.

Gold jewelry is worn by men and women of high-ranking families to confirm their status to others.

Warfare and the taking of heads were important ways for men to acquire prestige.

Right: Dayak head-hunter's shield, in wood with inlaid human hair from enemy heads. *Early C20th.* *42 in (106.75 cm) high* **$9,000–12,000 WJT**

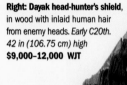

Imagery used across this archipelago includes the water buffalo, the fish, dog, shrimp, or lizard, as well as motifs familiar in Western art, such as the Tree of Life and the Soul Ship. These motifs are popularly woven into ritual textiles, an art form that is incredibly rich and often overlooked in favor of sculpture. Textiles are found throughout the islands and are very collectible, not only because of their graphic beauty, but also because they can be easily transported and displayed in Western interiors. Many weaving and dyeing techniques are used including warp *ikat* (in Sulawesi, Borneo, and Sumba) and supplementary weft embroidery (in the Lampung region of south Sumatra and

Timor). Equally, the wide variety of shields and swords is popular with collectors. In Java, courtiers of the Muslim sultans wear the ceremonial *kriss*, with its wavy iron blade. The hilts are finely carved from wood or ivory, or occasionally cast in gold and studded with precious stones.

Many Indonesian cultures construct large buildings decorated with architectural carvings. The Batak of Sumatra build their impressive houses with huge roof eaves and pairs of large carvings of *singa* (serpent-buffalo who inhabit the underworld); in Sulawesi, Toraja artists employ buffalo emblems in their architecture. In Borneo, longhouse beams, doors, and panels

Above: Wooden coffin fragment, carved as a stylized deity with large concave eyes, fangs, and protruding tongue. *C19th–C20th. 9½ in (24 cm) high* **$1,500–2,000 SK**

HEAD-HUNTING

Head-hunting took place in several islands, including Nias, Sumatra, and Timor. As late as the 1930s in Borneo, Iban warriors went on raids and participated in complex human sacrifice rituals. Warriors gradually acquired prestige, first participating in raids, and then moving on to leading successful bands of warriors. Although head-hunting is no longer practiced, the historic Gawai Amat cult is still celebrated today in a feast lasting seven days and nights. Among the Bidayüh, the heads of victims rested in the laps of women while prayers were said.

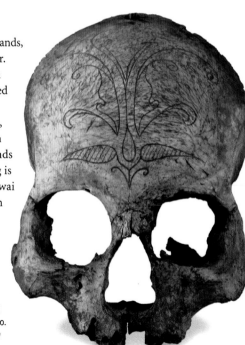

Right: Trophy skull with engraved decoration, from the Dayak of Borneo. *Early C20th. 6½ in (16.5 cm) high* **$4,000–7,000 WJT**

are carved or painted with *aso* (dog), *usang orang* (shrimp), and *hudoq* (ancestor spirit) motifs. These scrolling devices also decorate shields, beaded baby carriers, and jackets.

HONORING THE DEAD

Funerary sculptures are carved as memorials to the deceased. In Leti, they are conceived as seated figures and depicted with arms crossed and plumed topknots, with a weathered surface. The *adu zatua* of Nias are similar, but wear jewelry and tall crowns and have a polished patina. In Ataúru, pairs of small male and female statuettes with forward-curved limbs are hung from sacred hooks in each house. The Toraja carve life-like *tau-tau* figures for nobility, which are paraded during funerals and then ensconced in

cliff-galleries where the bodies are interred. The Dayak of Kalimantan erect *hampatong* (ancestor poles) beside their longhouses, surmounted with stylized human figures.

Near right: Hand-woven *lawon* (silk cloth), from Palambang, Sumatra. *Mid–Late C19th. 83½ in (210 cm) long* **$10,000–15,000 EFI**

Middle: One of a pair of Chinese silk *lawons*, from Palambang, Sumatra. *Early C20th. 66 in (155 cm) long* **$5,000–6,000 (the pair) EFI**

HAND-WOVEN SILKS

Textiles in Indonesia are predominantly woven from cotton, and decorated in different techniques. In Palambang, Sumatra, the lawon textile is woven from local silk, or imported from China along ancient trade routes.

LAWONS

Hand-woven, indigenous silk *lawon*, wax-resist dyed orange and red, from Palambang, Sumatra. *Lawons* are silk ceremonial scarves presented to married women. These particular examples are decorated in the *tritik* resist-dye technique, which originates in India and Central Asia. They have been compared to Rothko paintings, and are popular with collectors and interior designers in the US. *Mid–Late C19th. 78 in (198 cm) long* **$12,000–16,000 EFI**

THE RICE GOD

Rice is the staple food of groups like the Kenyah-Kayan of Borneo, who believe that it has a female spirit or "soul" that can be attacked by malevolent spirits. To protect this "rice soul" and ensure fertility in the field and home, men dance in *hudoq* (masks) and banana-leaf costumes to frighten away evil spirits during planting. *Hudoq* depict both human and animal forms, with menacing fangs, flange ears, and tendril-like motifs. They are repainted in red, black, and white on each occasion that they are used.

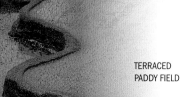

TERRACED
PADDY FIELD

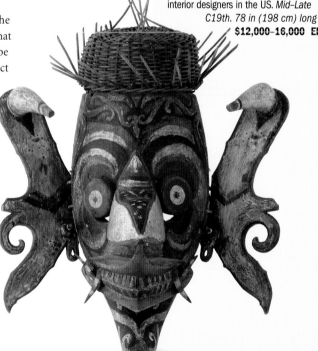

Right: Carved and painted wooden Dayak Hudoq mask, with attendant birds and a basketry hat. *Late C19th–early C20th. 20 in (50.75 cm) high* **$12,000–20,000 WJT**

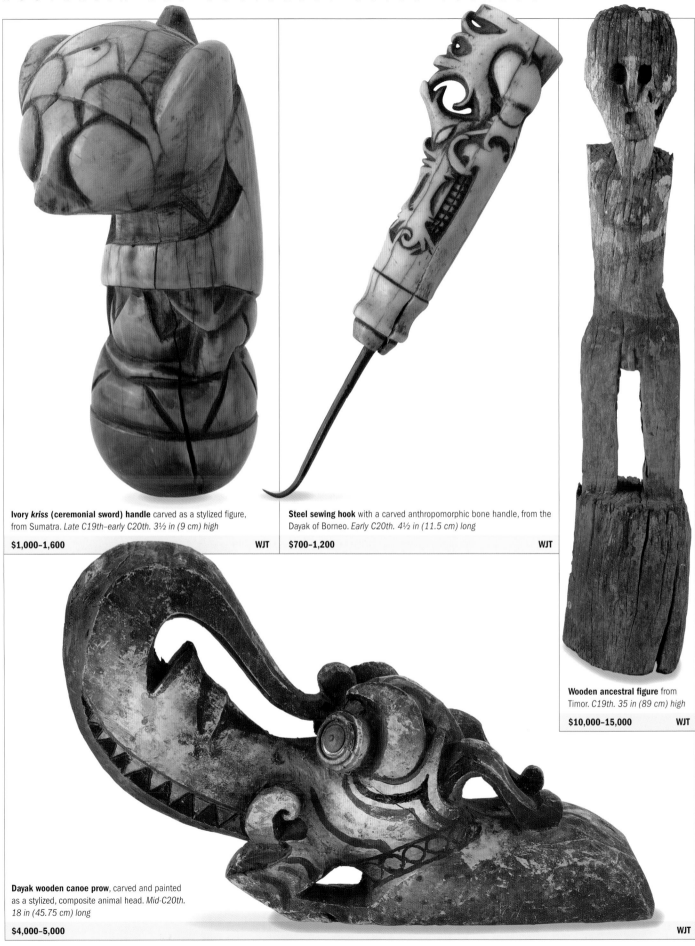

Ivory *kriss* (ceremonial sword) handle carved as a stylized figure, from Sumatra. *Late C19th–early C20th. 3½ in (9 cm) high*

$1,000–1,600 WJT

Steel sewing hook with a carved anthropomorphic bone handle, from the Dayak of Borneo. *Early C20th. 4½ in (11.5 cm) long*

$700–1,200 WJT

Wooden ancestral figure from Timor. *C19th. 35 in (89 cm) high*

$10,000–15,000 WJT

Dayak wooden canoe prow, carved and painted as a stylized, composite animal head. *Mid-C20th. 18 in (45.75 cm) long*

$4,000–5,000 WJT

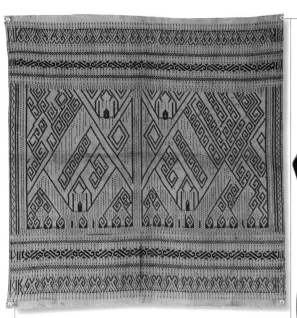

Ceremonial cloth woven with geometric patterns. *c. 1900.*
20 in (51 cm) wide

$180–400 SK

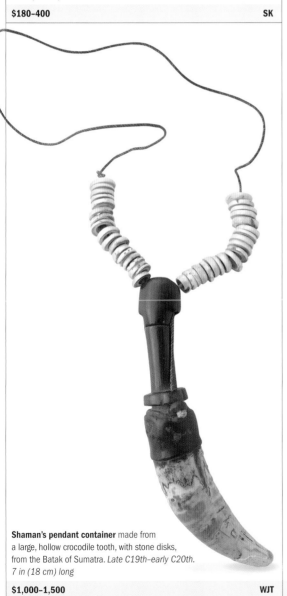

Shaman's pendant container made from
a large, hollow crocodile tooth, with stone disks,
from the Batak of Sumatra. *Late C19th–early C20th.*
7 in (18 cm) long

$1,000–1,500 WJT

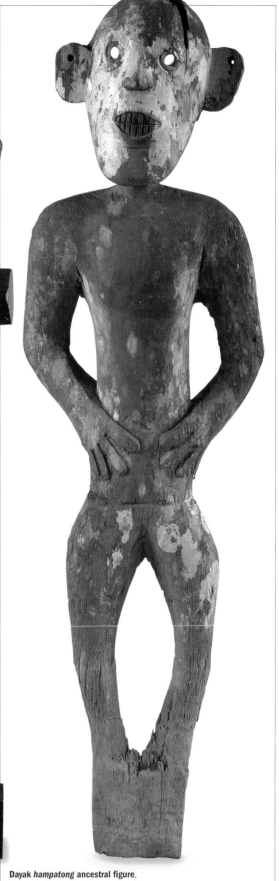

Wooden human figure from the
Nias Islands. *Late C19th–early
C20th. 13 in (33 cm) high*

$1,200–2,000 BLA

Dayak *hampatong* ancestral figure,
in wood with inlaid shell eyes.
C19th. 58 in (147.25 cm) high

$15,000–25,000 WJT

POLYNESIA AND MICRONESIA

Christian missionaries arriving on the islands of the South Seas encouraged converts to destroy temples and "idols," and whalers, merchants, and sandalwood traders exploited the natural resources. Today, dance and oral history are the only surviving art forms from this area.

Polynesia forms a geographical triangle with Easter Island, the Hawaiian Islands, and New Zealand at each corner. It includes Fiji, Tonga, Samoa, the Cook Islands, and French Polynesia (the Society Islands, Austral Islands, and Marquesas Islands). It was populated over a short period, between 1,000 BCE and 1,000 CE, which led to a cultural homogeneity that can be recognized in the art style from the area. Notwithstanding this, each of the islands has its own quite distinct art style. Micronesia consists of around 2,000 small islands belonging to four major groups—these are the Marianas, Carolines, Marshalls, and Kiribati.

In this region, society was strictly stratified according to rank, divided into a hierarchy of chiefs, nobles, commoners, and slaves. Status was inherited patrilineally in Polynesia, and matrilineally in Micronesia, and could not be altered. This social organization was reinforced by belief in two concepts, *mana* and *tapu*. *Mana* was the degree of prestige and power held by an individual by virtue of his birth. It could be enhanced or damaged by certain acts—for example, success or failure in battle.

Objects, too, possess *mana*, by association with their owners. In order to protect *mana* from "pollution," stringent rules were observed, called *tapu* (or "taboo"). The laws of *tapu* would, for example, regulate the amount of personal contact between two individuals with different amounts of *mana*: a slave could not even allow his shadow to fall across the path of a chief, let alone touch an object of his.

RELIGION AND ECONOMY

Polynesians venerated ancestors and believed in major deities, including Tangaroa (creator and sea god), Tu (war god), and Rongo (agriculture and peace god). Some carving represented both ancestors and deities, but many such works were destroyed by missionaries in the 19th century, so knowledge of them is based on only a handful of examples. Micronesians believed in ancestor and nature spirits.

In Polynesia, the traditional economy was based on fishing and horticulture (similar to Melanesia), but domestic chickens, dogs, and rats were also introduced. Pigs were also brought to some islands.

Wooden Sali club with crooked and bladed head, from Fiji. *C19th. 42½ in (108 cm) high*
$5,000–9,000 PHK

LANDSCAPE
The islands of the Pacific fall into three categories: "Continental" islands (such as New Zealand) and two types of "Oceanic" islands (which lie beyond the Andesite Line): the "volcanic" include Tahiti, Easter Island, and Hawaii, and "coral atolls," which form most of the Micronesian islands.

Right: Low-lying atolls, such as this one around Pisimwe island, Micronesia, provide virtually no natural resources apart from seafood and coral stone. Inhabitants use bone, shell, coral, and fiber for all their material culture.

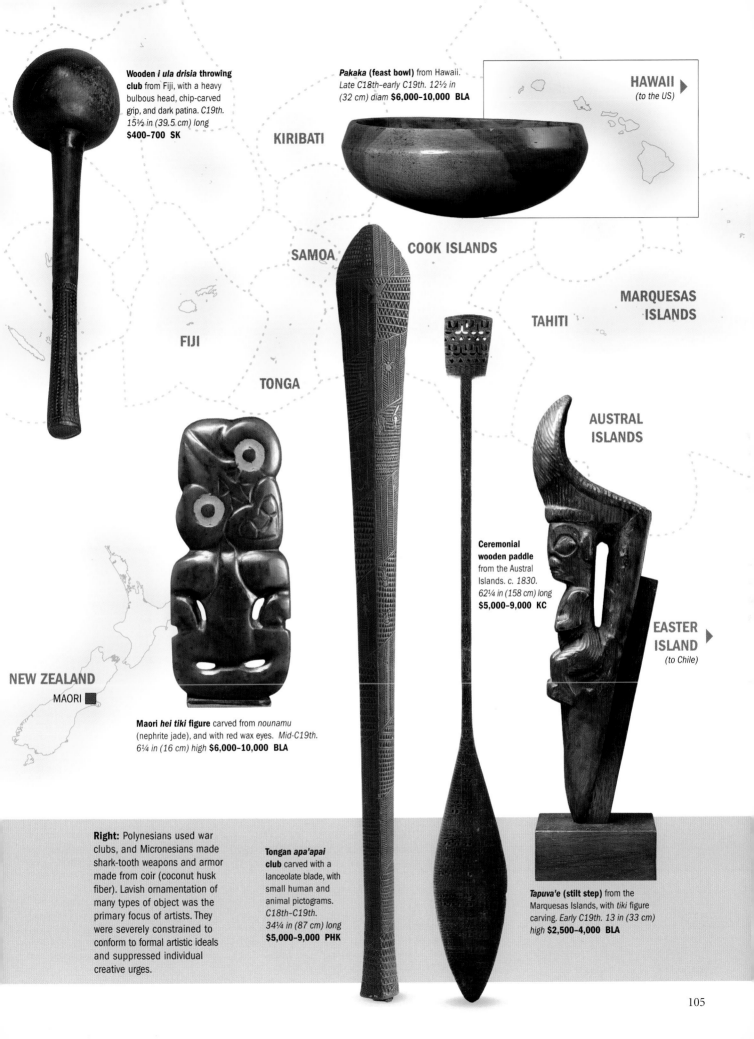

Wooden *i ula drisia* throwing club from Fiji, with a heavy bulbous head, chip-carved grip, and dark patina. *C19th.* 15½ in (39.5 cm) long **$400–700 SK**

***Pakaka* (feast bowl)** from Hawaii. Late C18th–early C19th. 12½ in (32 cm) diam **$6,000–10,000 BLA**

HAWAII ▶ (to the US)

KIRIBATI

SAMOA **COOK ISLANDS**

MARQUESAS ISLANDS

TAHITI

FIJI

AUSTRAL ISLANDS

TONGA

Ceremonial wooden paddle from the Austral Islands. *c. 1830.* 62¼ in (158 cm) long **$5,000–9,000 KC**

EASTER ISLAND ▶ (to Chile)

NEW ZEALAND

MAORI ■

Maori *hei tiki* figure carved from *nounamu* (nephrite jade), and with red wax eyes. *Mid-C19th.* 6¼ in (16 cm) high **$6,000–10,000 BLA**

Right: Polynesians used war clubs, and Micronesians made shark-tooth weapons and armor made from coir (coconut husk fiber). Lavish ornamentation of many types of object was the primary focus of artists. They were severely constrained to conform to formal artistic ideals and suppressed individual creative urges.

Tongan *apa'apai* club carved with a lanceolate blade, with small human and animal pictograms. *C18th–C19th.* 34¼ in (87 cm) long **$5,000–9,000 PHK**

***Tapuva'e* (stilt step)** from the Marquesas Islands, with *tiki* figure carving. *Early C19th.* 13 in (33 cm) high **$2,500–4,000 BLA**

Tapa was made across Polynesia, and the best came from the inner bark of the paper mulberry, and had many practical and ceremonial uses. Cloaks made of flax (Maori) and featherwork (Hawaii) were favored by chiefs and nobles. Micronesians wore little crafted clothing.

The traditional material culture of Polynesia exists only in private collections and museums, and was collected by early visitors and missionary societies in the 19th century. Polynesian artifacts in the art market are generally rare and expensive, and consist of implements. There are war clubs and stools of dramatic form, with beautiful surface patinas. Other items include ceremonial bowls and dishes for chiefs or priests, the finest of which are found in Fiji and Hawaii. Domestic implements are also collected, including pounders (*see below*) for preparing *poi* (a mash made from taro or breadfruit).

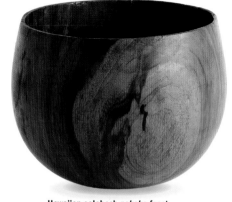

Hawaiian calabash *pakaka* feast-bowl. *C18th. 6½ in (16.5 cm) high* **$1,800–2,500 JBB**

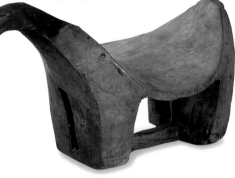

Wooden coconut grater (minus shell blade) from the Nukuoro Atoll, Caroline Islands. *C19th. 31½ in (80 cm) long* **$900–1,800 SK**

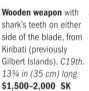
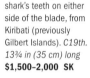

Wooden weapon with shark's teeth on either side of the blade, from Kiribati (previously Gilbert Islands). *C19th. 13¾ in (35 cm) long* **$1,500–2,000 SK**

Micronesian clamshell or coral beater, used as a bride price. *C19th. 11 in (28 cm) long* **$12,000–18,000 PM**

Tongan *apa'apai* club with lanceolate blade and geometric and figurative carving. *C19th. 39½ in (100 cm) high* **$5,000–9,000 SK**

CULTURE

Beautifying the body by means of injecting dye into the skin was widespread in Polynesia and parts of Micronesia. There has been a revival in recent times of Polynesians wearing traditional tattoos as an expression of nationalism, particularly in New Zealand, Samoa, and Tonga.

***Poi* pounder** from Truk Island, Micronesia. *Archaic. 6 in (15 cm) high* **$2,000–3,000 BLA**

Right: Maori chiefs wore intricate spiral facial tattoos, while full body tattoos occurred in the Australs, Cook, and Society Islands. The procedure, using comblike bone hammers, was excruciating and was an important characteristic element in many rites of passage. The picture on the right shows a modern, painted example of Maori facial tattoos.

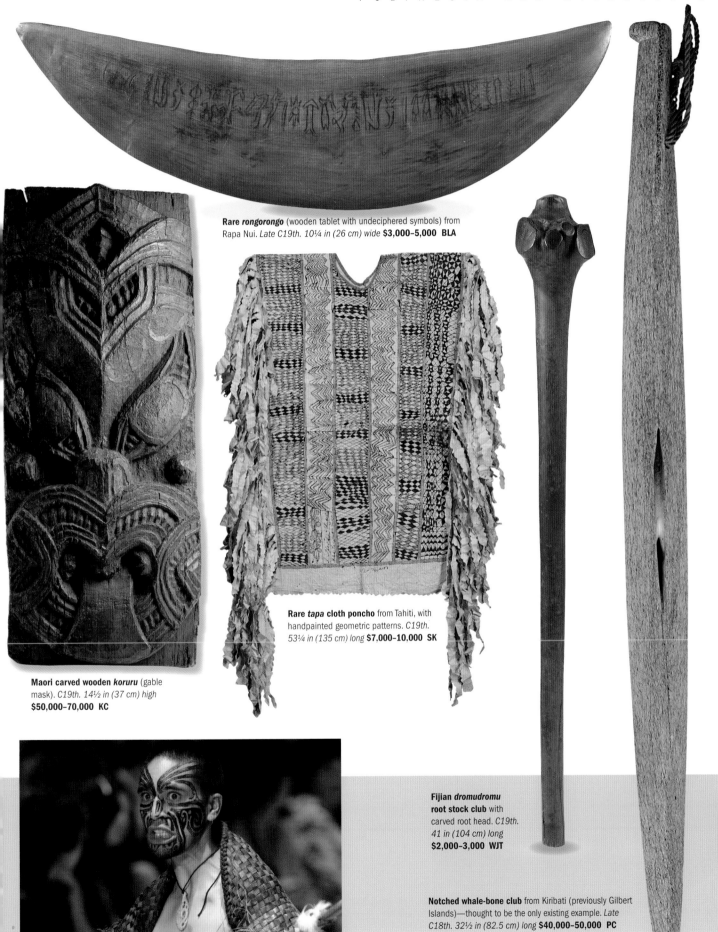

Rare *rongorongo* (wooden tablet with undeciphered symbols) from Rapa Nui. *Late C19th. 10¼ in (26 cm) wide* **$3,000–5,000 BLA**

Rare *tapa* cloth poncho from Tahiti, with handpainted geometric patterns. *C19th. 53¼ in (135 cm) long* **$7,000–10,000 SK**

Maori carved wooden *koruru* (gable mask). *C19th. 14½ in (37 cm) high* **$50,000–70,000 KC**

Fijian *dromudromu* root stock club with carved root head. *C19th. 41 in (104 cm) long* **$2,000–3,000 WJT**

Notched whale-bone club from Kiribati (previously Gilbert Islands)—thought to be the only existing example. *Late C18th. 32½ in (82.5 cm) long* **$40,000–50,000 PC**

107

New Zealand

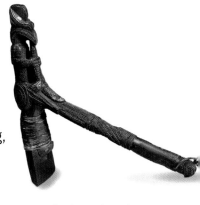

No other Polynesian people produced such a variety of art as the Maori. Their work includes stunning houses with painted and woven panels, flax and feather clothing, worked stone and bone, and exuberant wood carving.

In Maori culture, the overriding purpose of art was as an indicator of status. All kinds of implements carved from bone, ivory, wood, and stone were owned by individuals of rank. The elaborate canoes and meeting houses were a source of pride, and an expression of power and wealth for Maori tribes, in the same way that medieval cathedrals reflected the prosperity of European towns. Carvings are typically covered with an abundance of bold spirals carefully interspersed with *manaia* and *tiki* motifs. *Manaia* are mythical animal, bird, or human forms that have a reptilian character, while *tiki* are stylized humans.

The demeanor of the Maori warrior, as portrayed in the *haka* dance, is reflected in Maori carving: out-thrust tongue, *moka* (tattoo), wide-open eyes—often inlaid with *haliotis* (abalone) shell—and contorted posture. These features stress the fierce character of the ancestor.

The beautiful surface carving and patina of Maori weapons and *taonga* (highly prized personal objects) have attracted collectors and raised prices considerably. Some of the most popular works of art include: *kotiate, wahaika,* and *patu* (hand clubs); *taiaha, pouwhenua, hoeroa,* and *tewhatewha* (quarter staffs); *toki poutangata* (ceremonial adzes); *hei tiki* (pendants); and *wakahuia* (treasure boxes). Flutes, canoe prows and sterns, paddles and bailers, architectural panels, and gable masks are also sought after.

Above: Maori *toki poutangata* (adze) carved with a stylized human figure holding the tail of a lizard with inlaid *haliotis* (abalone) eyes. *Late C19th. 16½ in (42 cm) long* **$6,000–9,000 SK**

TIKI

The Maori *tiki* is a representation of a family ancestor, rather than of a god. The motif is rendered on almost all types of object, including the famous *hei tiki* (nephrite-jade neck pendants) worn by high-ranking men and women. These heirlooms were passed down the generations, increasing in *mana* (prestige) as they did so. Each would be given a name, and when removed from storage (in treasure boxes) they would be addressed by their name. *Pounamu* (nephrite jade) is only found on the South Island, and ranges in color from white-gray-green to blackish-green. It is so hard that it takes around five months to carve a single *hei tiki* using sandstone rasps and drills.

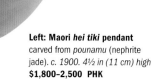

Left: Maori *hei tiki* pendant carved from *pounamu* (nephrite jade). *c. 1900. 4½ in (11 cm) high* **$1,800–2,500 PHK**

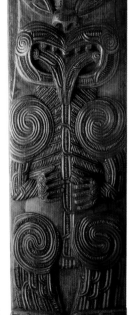

Right: Carved wooden Maori meeting house panel with a *tiki* figure. *c. 1870–1880. 71½ in (182 cm) high* **$30,000–70,000 KC**

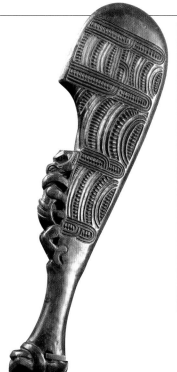

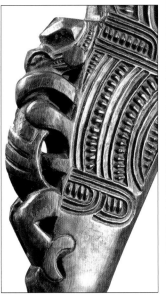

DETAIL SHOWING RAISED
TIKI ON THE HANDLE

Maori *wahaika* club carved from *toa* wood with carved and incised
geometric and figurative motifs. *Late C19th. 14½ in (37 cm) long*

$6,000–10,000 BLA

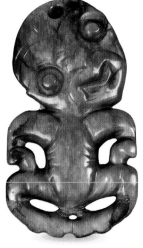

Maori carved jade *hei tiki* pendant.
C19th–C20th. 4 in (10 cm) high

$6,000–10,000 SK

Carved wooden *koruru* (gable mask)
from a Maori meeting house. *C19th.
37 in (94 cm) high*

$50,000–70,000 KC

Carved wood and metal Maori pipe made for the tourist trade.
Late C19th–early C20th. 6 in (15.25 cm) long

$900–1,800 WJT

Carved *raparapa* (end of a barge board) from King Tawhiao's
royal meeting house. *c. 1840. 64 in (162.5 cm) high*

$200,000–250,000 KC

KEY FACTS

Populations were decimated and culture ruined in both the Australs and Marquesas Islands, through disease and the activities of well-meaning missionaries and whalers.

Marquesas art is dominated by images of *Tiki*, the god of creation, and the characteristic treatment of the large, circular "goggle" eye. Combinations of rectilinear and curvilinear bas-relief designs are carved against blank spaces.

The most famous Austral sculpture is the figure of the god *A'a* from Rurutu, collected in 1821 by missionaries. It is displayed in the British Museum.

Austral and Marquesas Islands

It was the missionaries who saved some of the artifacts produced by the traditional cultures of these islands. Their new converts were so zealous in their faith that they destroyed much of the art representing their old culture and beliefs.

The Marquesas Islands of eastern Polynesia are high volcanic islands with deep terraced valleys. The most magnificent of all Polynesian war clubs are carved on the Marquesas Islands and are called *u'u*. They are highly sought after by collectors. They were used in combat and also valued as heirlooms, and were displayed as status symbols. Other items indicating high status were the carved fan handles of ivory and wood, decorated with two pairs of *tiki* figures back to back. *Ivi po'o* (small cylindrical toggles, made of the bones of enemies and carved with a *tiki*) were used to ornament shell trumpets, headbands, and drums, or were worn in warriors' hair.

The inhabitants of the central Polynesian Austral Islands were fierce warriors, and when metal tools were introduced in the late 18th century, they became great carvers. *Hoe* (ceremonial paddles) were produced in the 19th century in Ra'ivavae, for commercial purposes. A tour de force of surface carving, they are the most common Austral artifacts in the market today. Pre-1820 artifacts include drums, flywhisk handles, chief's stools, and necklaces, and can usually only be seen in museums.

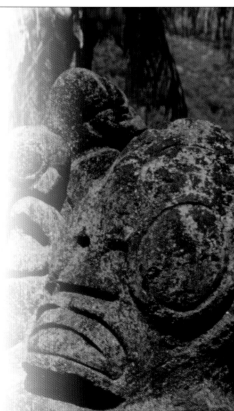

Above: Wooden stilt step carved with a *tiki*, from the Marquesas Islands. *Early C19th. 11½ in (29.5 cm) high* **$3,000–7,000 BLA**

Right: Stilt step from the Marquesas Islands, with a *tiki* carving. *Early C19th. 9¾ in (25 cm) high* **$5,000–9,000 BLA**

STILT STEPS

Stilt competitions were held in all Marquesas villages and were a favorite entertainment for adults and children as young as ten. Stilt poles were around 6½ ft (2 m) in length and wrapped in white *tapa*. Carved *tapuva'e* (steps) were lashed to the pole with colored *sennit* (woven coir cord). Formal contests involving racing and mock battles between tribal champions were held on *ma'ae* (paved stone enclosures) during important memorial festivals. Stilt steps were made by *tahuna vaeake* (specialist carvers) using hardwood cured in the mud of taro gardens. The form takes the shape of a number "7" with curved top, supported by a human figure, and decorated with parallel grooves.

TIKI SCULPTURE FROM A *MA'AE* (PAVED STONE ENCLOSURE)

A CLOSER LOOK

Rare Austral Islands necklaces like this one were mostly worn by women of "chiefly rank," and most were collected in Rurutu or Tubuai Island. The carved pendant symbols refer to (1) power, (2) wealth, and (3) lineage. The necklaces were made in the 18th and 19th centuries, before the demise of the traditional culture due to outside influences. *C18th. 22½ in (57 cm) long* **$300,000–400,000 WJT**

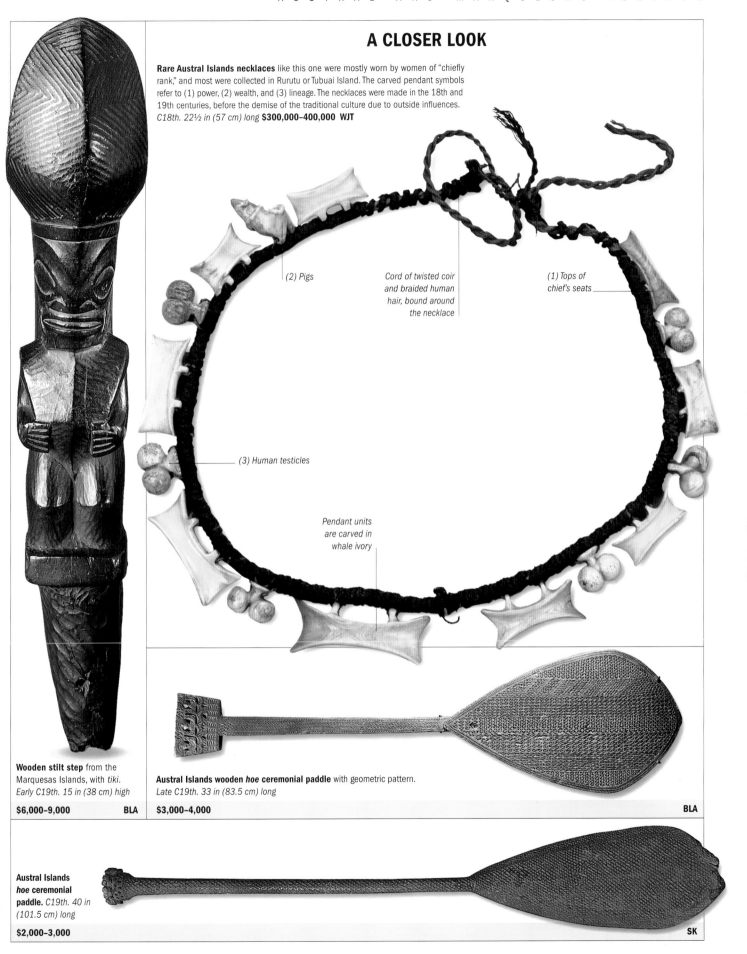

(2) Pigs

Cord of twisted coir and braided human hair, bound around the necklace

(1) Tops of chief's seats

(3) Human testicles

Pendant units are carved in whale ivory

Wooden stilt step from the Marquesas Islands, with *tiki*. *Early C19th. 15 in (38 cm) high*

$6,000–9,000 BLA

Austral Islands wooden *hoe* ceremonial paddle with geometric pattern. *Late C19th. 33 in (83.5 cm) long*

$3,000–4,000 BLA

Austral Islands *hoe* ceremonial paddle. *C19th. 40 in (101.5 cm) long*

$2,000–3,000 SK

KEY FACTS

Fiji consists of over 300 islands. The two main islands, Viti Levu and Vanua Levu, are mountainous with broad rivers and surrounded by reefs.

Captives of war were eaten, or kept prisoner and consumed at a later time.

***Tapa* (bark) cloth was worn by chiefs** and was also used as bedding or to partition areas within a house.

Fiji

The people of Fiji are racially and linguistically Melanesian, but culturally Polynesian, and their art forms are imbued with a spirit of refinement and power that is unequaled in the rest of Oceania.

The people of this island area were obliged to avenge insulted or killed kinsmen, and were inevitably in a more or less constant state of war, with an armory to go with it. The most common artifacts in Fijian collections are war clubs, and each had a different method of use. For example, *totokia* were two-handed "battle hammers" with a head shaped like the spiked pandanus fruit and were used in ambush and executions. During initiations, clubs would be passed between warriors and youths to transfer *mana* (prestige). Entire armies of regimented warriors fought battles involving as many as 15,000 men.

Marine ivory ornaments were highly prized by Fijian nobles. These included the *wasekaseka* and *waetsei* (split whale-tooth necklaces), the *civa*

vonovono (shell and ivory pectoral disk) worn by chiefs, and the *tabua* (whale-tooth pendants) worn by diplomats.

Although figurative sculpture is rare, human and animal motifs are often incorporated into ritual objects used by priests and chiefs, such as oil, food, and kava dishes. Kava (or *yaqona*) is an intoxicating drink consumed at rituals and before battles.

Tapa cloth designs were rectilinear, stenciled, and sometimes block-printed in black, with occasional red ocher details.

Fijian pottery is unique in Polynesia. Made by women, vessels were baked in open fires and glazed with pine resin while still hot.

Above: Wooden *i-ula-drisia* (throwing club) with carved handle, two inlaid teeth on the head, and a dark patina. *C19th. 14 in (35.5 cm) long* **$1,000–1,500 SK**

CANNIBALIST CULTURE

Cannibalism was practiced in several island groups in Polynesia and Melanesia, where it formed part of religious ritual associated with the worship of ancestors. However, in Fiji, human flesh was a normal part of the diet. Incessant wars raged between rival chiefs on the numerous islands, and these power-struggle battles provided the bodies for consumption. Chiefs and priests were imbued with so much *mana*, great care was taken to avoid touching potentially polluting food, and *i-culanibokola* (cannibal forks) would be used to consume human flesh. One chief is known to have eaten over 870 people in his lifetime.

Right: Large carved wooden *i-culanibokola* (cannibal fork), used by attendants to feed human flesh to priests. *C19th. 18 in (45.75 cm) long* **$4,000–9,000 WJT**

FIJIAN ISLANDS

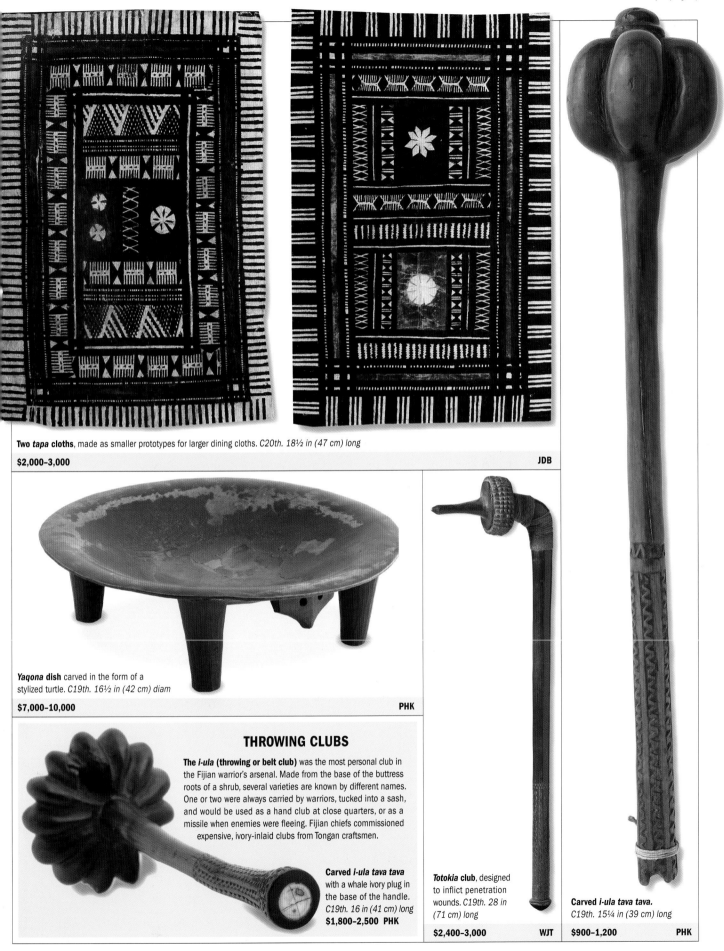

Two _tapa_ cloths, made as smaller prototypes for larger dining cloths. _C20th. 18½ in (47 cm) long_

$2,000–3,000

JDB

Yaqona dish carved in the form of a stylized turtle. _C19th. 16½ in (42 cm) diam_

$7,000–10,000

PHK

THROWING CLUBS

The _i-ula_ (**throwing or belt club**) was the most personal club in the Fijian warrior's arsenal. Made from the base of the buttress roots of a shrub, several varieties are known by different names. One or two were always carried by warriors, tucked into a sash, and would be used as a hand club at close quarters, or as a missile when enemies were fleeing. Fijian chiefs commissioned expensive, ivory-inlaid clubs from Tongan craftsmen.

Carved _i-ula tava tava_ with a whale ivory plug in the base of the handle. _C19th. 16 in (41 cm) long_
$1,800–2,500 PHK

Totokia club, designed to inflict penetration wounds. _C19th. 28 in (71 cm) long_

$2,400–3,000

WJT

Carved _i-ula tava tava._ _C19th. 15¼ in (39 cm) long_

$900–1,200

PHK

MELANESIA

Melanesia constitutes the largest and most populous area in the Pacific Ocean and was colonized by successive migrating groups. This led to a racial heterogeneity that is reflected in the large number of languages and great variety of art styles found across the region.

Melanesia was colonized from the west, beginning with New Guinea in around 3000 BCE, and spreading to the other islands from 3000 to 1500 BCE. The area called Melanesia is made up of Irian Jaya, Papua New Guinea, Vanuatu, New Caledonia, and the Solomon Islands.

Clothing was scanty or nonexistent, and involved simple loincloths or penis covers, and skirts. The traditional fabric was bark cloth (weaving being a recent introduction). Horticulture of subsistence crops is the norm, with taro and yam the staple. Wild coconuts, breadfruit, and sago are also gathered, and sweet potato, banana, sugar cane, and betel palm are grown (betel-chewing is popular throughout eastern Melanesia). Hunted wild and domestic animals include the cassowary, wallaby, bat, rat, pig, and dog.

Trade often requires arduous sea voyages by canoe, but is an essential economic activity. It enables ambitious men to gain wealth and status that is then proudly displayed during religious ceremonies and celebrations. Most communities are regulated through a men's society and the largest building in any village is the Men's House, a space for debate, as well as somewhere to store sacred objects.

SPIRITUAL BELIEFS
Masks and carvings are found all over Melanesia and represent ancestral ghosts or provide a home for them to inhabit. Funerary ceremonies are important to ensure spirits are suitably honored and safely dispatched to their final resting place. There is a widespread belief in the power of witchcraft to cause misfortune, illness, or death, and sorcerers are consulted to deflect malevolent attacks. Melanesians believe a spirit, often referred to as a "bush or nature" spirit, inhabits both animate and inanimate objects. They could be called upon to aid individuals in growing yams, fishing, or head-hunting raids, for example. In the past, warfare was endemic but small-scale, so a large variety of clubs, bows, arrows, and shields can be found.

The art of Melanesia is incredibly luxuriant and varied, with a vitality that borders on exuberance.

LANDSCAPE AND CULTURE
Social hierarchy is based on entrepreneurism, and leaders can increase their status by acquiring wealth. This can be achieved through exchange with partners on other islands, for example, in the ritual trading system known as the kula cycle.

Painted war shield from the Asmat people of North Citak, Irian Jaya.
Post-1950. 76¾ in (195 cm) high
$2,500–3,000 JYP

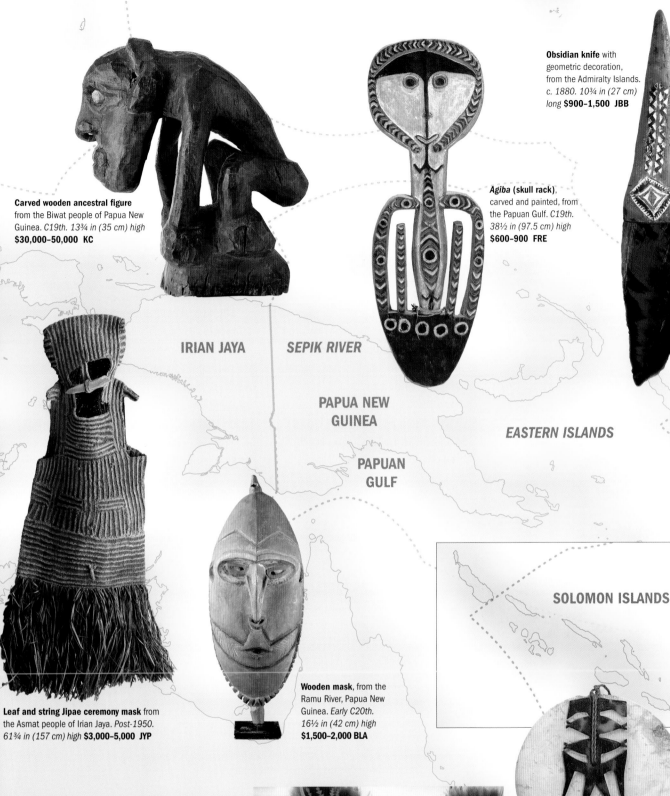

Carved wooden ancestral figure from the Biwat people of Papua New Guinea. *C19th. 13¾ in (35 cm) high* **$30,000–50,000 KC**

Obsidian knife with geometric decoration, from the Admiralty Islands. *c. 1880. 10¾ in (27 cm) long* **$900–1,500 JBB**

Agiba (skull rack), carved and painted, from the Papuan Gulf. *C19th. 38½ in (97.5 cm) high* **$600–900 FRE**

IRIAN JAYA

SEPIK RIVER

PAPUA NEW GUINEA

PAPUAN GULF

EASTERN ISLANDS

SOLOMON ISLANDS

Leaf and string Jipae ceremony mask from the Asmat people of Irian Jaya. *Post-1950.* *61¾ in (157 cm) high* **$3,000–5,000 JYP**

Wooden mask, from the Ramu River, Papua New Guinea. *Early C20th.* *16½ in (42 cm) high* **$1,500–2,000 BLA**

Clamshell *tema* pendant with a stylized frigate bird overlay in turtleshell, from Santa Cruz, Solomon Islands. *C20th. 3¾ in (9.5 cm) diam* **$900–1,500 SK**

Left: Melanesians have colonized the mountains, jungles, and river estuaries of New Guinea, as well as the islands of the western Pacific. They used the canoe for subsistence (as here in the Trobriand Islands), transportation, and warfare.

Right: Ceremonies are elaborate events controlled by men's societies to regulate political, religious, social, and economic functions. These Highlander tribesmen wear the typically ostentatious costume and body decoration of ceremony.

115

KEY FACTS

Korvar-style figures feature an arrow-shaped nose, bead inset eyes, scrolls, and a square-section body and limbs.

The carvings of Humboldt Bay are brightly colored, and volumes and planes are rounded and realistic.

Asmat art of the Lorenz and Eilanden Rivers is mainly of human form with elongated limbs and torsos; females are often carved in squatting posture.

Mimika and Asmat poles are tall, and associated with death and ancestors.

Marind-Anim art is scarce, and only drums, costume accessories, and trophy heads are usually found.

Irian Jaya

Most of the early works of art from the former Dutch colony of Irian Jaya, such as the enigmatic shields, startling trophy heads, and ancestor statues, were collected in situ before WWII and sent back to Dutch museums.

In the western half of New Guinea is the Indonesian province of Irian Jaya, in which five main cultural areas are located (excluding the Highland tribes, who come under the Sepik River section here). In the north is the Korvar area around Cenderawasih (Geelvink) Bay, and the peoples of Lake Sentani and Humboldt Bay. To the south are the Mimika, Asmat, and Marind-Anim peoples.

The term *korvar* describes an artistic style and, more particularly, a kind of small ancestor statue that is carved by all the different cultural groups in the area. It is a standing or seated figure usually holding an openwork, scrolling shield. When a person dies, the *korvar* is carved to provide a home for the soul of the deceased. The statue would be consulted for advice.

The coastal peoples around Humboldt Bay are dependant on canoes. *Mani* (prow ornaments) have human, bird, and fish forms, and are painted in red, black, and yellow. Amulets, dugong harpoons, and ancestor statues (normally stored in Men's Houses) are also made. Lake Sentani artwork is refined, and shows a Southeast Asian influence. Suspension hooks, bowls, drums, tool handles, lime containers, and

Above: Asmat sago bowl with carved human head handle. *Post-1950. 25½ in (65 cm) high* **$1,200–1,800 JYP**

SYMBOLISM IN SHIELDS

The war shield of the Asmat is one of the most elaborately decorated objects from this area—and one of the most collectible. To Asmat warriors, the decoration of the shield is far more important than its defensive properties. It was used as a psychological weapon. The designs are connected to head-hunting and were intended to instill paralyzing terror in one's enemy and awe among one's cohorts. Stylized motifs employed by artists include the praying mantis (which bites off the female's head during mating). Images of the flying fox (a fruit bat) were also popular (*see adjacent shields*). Flying foxes are a symbol of head-hunting because they eat fruit from trees and the Asmat associate trees and fruit with the body and head, respectively.

Asmat war shield from the Citak region, engraved with flying foxes. *Post-1950. 50¾ in (129 cm) high* **$1,800–2,500 JYP**

Wooden Unir River, Asmat war shield carved with flying foxes. *Post-1950. 69¼ in (176 cm) high* **$2,500–4,500 JYP**

ART OF DEATH

Among the Asmat and related peoples, disposing of the dead was a long process involving ceremony and violence, as well as burial. Death was invariably caused in battle or by witchcraft, and vengeance involving head-hunting sorties was essential to enable the deceased spirit to rest. To this end, relatives erect huge *bis* (ancestor) poles, up to 16 ft (5 m) in height, for periodic mortuary rites. Carved from mangrove trees, they feature canoes and representations of several human ancestors. The figures have openwork, winglike projections issuing from the chest and from the pubic region of the uppermost figure, where they are referred to as a penis. They are painted in white, the color representing the spirit world, with red details. Set in rows, warriors would stand in front of the pole and swear revenge on those responsible for the death. Once the ceremonies had been completed, the wandering spirit could reach the realm of the dead using the pole as a canoe, and the poles would be abandoned in the sago palm groves. The vitality of the dead could now be passed on to the living through food from the sago palms.

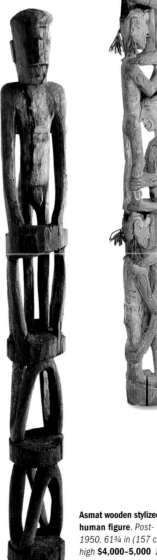

Asmat wooden *bis* (ancestor) pole with figurative and openwork carving. *Post-1950. 82¾ in (210 cm) high* **$4,000–5,000 JYP**

loincloths are decorated, mainly with human figures or oval spirals and hoops.

Mimika art is influenced by both the Korvar and Asmat and is often misattributed. The carvings are similar to Korvar figures and the *mbitoro* (spirit poles) are like those of the Asmat. *Yamate* (shieldlike ancestor tablets) are decorated with triangular, web-like patterns and stylized navels surmounted with openwork panels. They are displayed during burial rituals, when the bones of the recently deceased are transferred to *emakame* (bone houses).

The Asmat are celebrated artists and fierce warriors for whom the taking of heads was not suppressed until the 1960s. Most Asmat art in Western collections was only acquired after WWII, when the area became more accessible. Enemy skulls were decorated with feathers and colored seeds and made into women's necklaces (a severe affront). War shields, spears, and cassowary-bone daggers, and domestic utensils such as hourglass-shaped drums, dishes, and war-canoe-shaped bowls (for sago) are now produced in lesser quality for the commercial market. Standing male figures representing the primordial ancestor are carved for new Men's Houses.

The Marind-Anim engage in elaborate ceremonies in which ornamented costumes and shell-and-seed-encrusted effigies representing *Dema* (creation beings) are employed. Few have been collected, since they were destroyed after a single use. Other works include trophy heads (with skin intact) and hourglass-shaped drums.

Asmat wooden stylized human figure. *Post-1950. 61¾ in (157 cm) high* **$4,000–5,000 JYP**

FROM TREE TO CLOTH

Across Oceania, the bark of certain trees is made into tapa cloth. These include the paper mulberry tree, the breadfruit tree, and species of ficus and hibiscus. In New Guinea, the swamp mangrove provides a coarse but suitable bark. The inner bark of the tree is stripped and soaked, then beaten on an anvil-board.

TAPA CLOTH

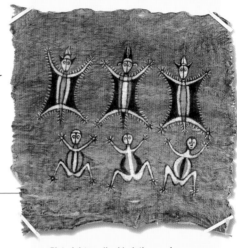

Pictorial *tapa* (bark) cloth cape from Lake Sentani. *Tapa* is used in a wide variety of forms, including as currency, in masks, and as clothing. It can be decorated by embossing, stenciling, dyeing, and painting. In Lake Sentani and Humboldt Bay, the tribes use tapa cloth squares as *maro* (loincloths) and to decorate house interiors. In the past, designs were mainly repetitive geometric patterns influenced by Southeast Asian textiles. However, since the 1920s, highly decorative, commercially produced cloths with figural designs have appeared (above). These are associated with clans, and totems include humans, fish, snakes, birds, and flying foxes. *C20th 27½ in (70 cm) high* **$1,800–2,500 BLA**

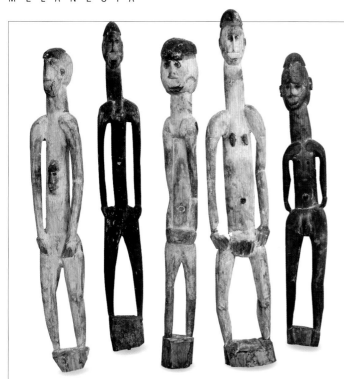

Five carved wooden human figures from the Asmat people.
Post-1950. Tallest: 48 in (122 cm) high

$2,500–3,000 **JYP**

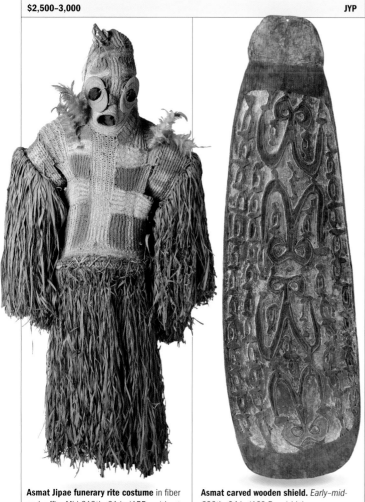

Asmat Jipae funerary rite costume in fiber
and raffia. *Mid-C19th. 61 in (155 cm) long*

$6,000–9,000 **WJT**

Asmat carved wooden shield. *Early–mid-
C20th. 64 in (162.5 cm) high*

$4,000–6,000 **WJT**

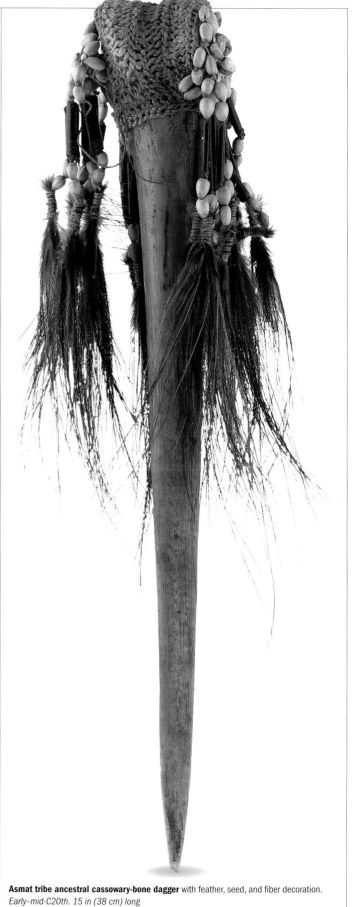

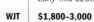

Asmat tribe ancestral cassowary-bone dagger with feather, seed, and fiber decoration.
Early–mid-C20th. 15 in (38 cm) long

$1,800–3,000 **WJT**

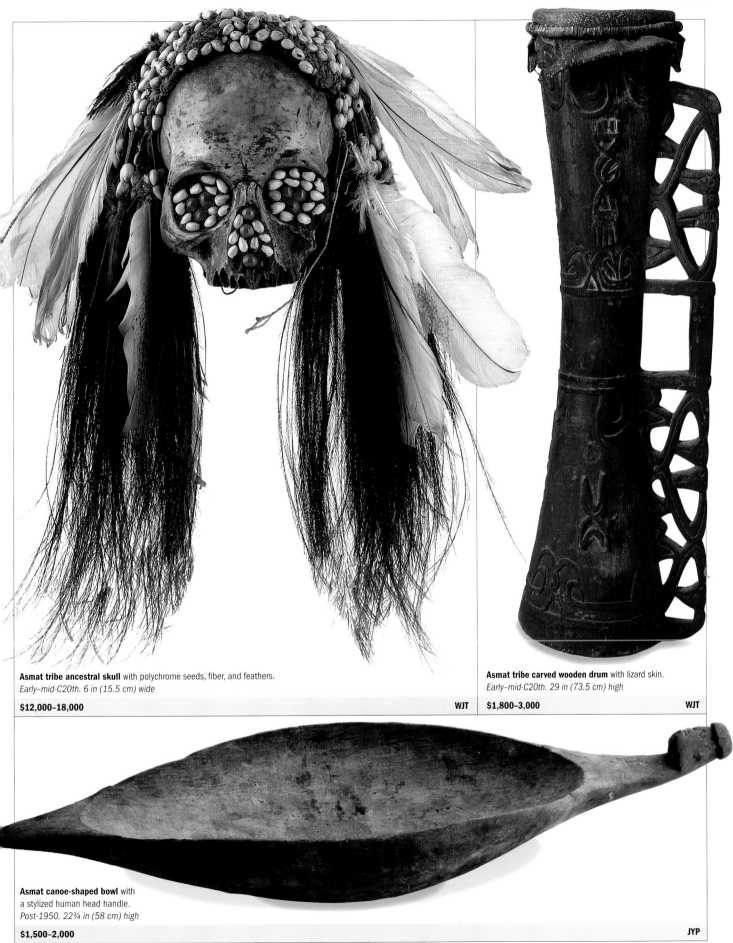

Asmat tribe ancestral skull with polychrome seeds, fiber, and feathers.
Early–mid-C20th. 6 in (15.5 cm) wide

$12,000–18,000 WJT

Asmat tribe carved wooden drum with lizard skin.
Early–mid-C20th. 29 in (73.5 cm) high

$1,800–3,000 WJT

Asmat canoe-shaped bowl with
a stylized human head handle.
Post-1950. 22¾ in (58 cm) high

$1,500–2,000 JYP

KEY FACTS

The human figure is transformed into a multitude of forms according to the culture—from the realistic ancestor carvings of the Biwat to the spirit hooks of the Bahinemo and Yimam.

Spirit Houses or Men's Houses are the dominant architectural feature in most villages, especially in the Middle Sepik region.

Every object, whether large or small, ritual or domestic, religious or secular, is decorated in some way.

Sepik River

The so-called "Nile" of New Guinea, the 700-mile (1,126-km) Sepik River and its tributaries are settled by many cultural groups, forming the most important cultural concentration in all of New Guinea, and perhaps Oceania.

More than just the setting of a great river, the Sepik is a region in which there is a recognizable style, despite its vast area and the many cultures that inhabit it. The region can be divided into three approximate sections, based on the course of the Sepik River and surrounding areas. The Lower Sepik, below Tambanum village, includes the Schouten Islands, Murik Lakes, Sepik and Ramu Deltas, and the Yuat and Keram tributaries. The Middle Sepik, between Tambanum and Ambunti villages, includes Chambri Lake, the Washkuk Hills, Prince Alexander and Hunstein mountains, Boiken plains, and the Blackwater and Karawari tributaries. And finally, the Upper Sepik and Highlands include the April River to the source of the Sepik, as well as the Torricelli Mountains and the May and Green tributaries.

REGIONAL DIFFERENCES IN ART

In the Lower Sepik region, human figures are squat and powerful, with a beaklike nose, and eyes carved in a slant. In some groups, the

Above: Iatmul house post fragment, from Middle Sepik, Papua New Guinea. *Post-1950. 48 in (122 cm) high* **$9,000–15,000 JYP**

HAUS TAMBARAN

This is the *pidgin* term for both the Spirit Houses and Men's Houses, where initiated men of certain clans meet. They are found in the Middle Sepik region and are huge imposing structures of 60 ft (18 m) high and 80 ft (24 m) long. They are constructed on two levels—the ground floor is for debating and passing time and the top floor is built to store sacred flutes and clan treasures (it may also have sleeping platforms for bachelors). Both stories are divided into clan areas, with separate hearths, slit drums, and stools. The house is the architectural expression of the primordial female body, and the gable masks, pillar, and beam carvings are references to ancient lineages.

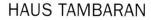

Left: Basket-woven and painted gable mask from Blackwater Lakes. *Post-1950. 41¼ in (105 cm) high* **$3,000–4,000 JYP**

THE INTERIOR OF A HAUS TAMBARAN

mouth and chin extend to join the navel. *Kundu* (hourglass-shaped drums), are found in this region, decorated with crocodile jaws carved at each end, representing the earth and the sky. Canoe prows also have crocodile heads and beaked spirit-guardians carved at each end. The "mosquito mask" of the Mambe on the north coast is used in hunting initiation ceremonies, and refers to the spirit *parak*. Painted bark cloth panels are found around Lake Sentani, but this art form is also known by the coastal peoples.

The Middle Sepik region is the smallest area within the three divisions, but many of the best-known groups live here. The Iatmul make long, shell-encrusted *Mei* ancestor masks, suspension hooks, and fine figurative stoppers for sacred clan flutes and lime containers. The hooked hunting spirit figures of the Yimam, Ewa, Korewori, and Bahinemo are particularly dramatic. Two- and three-dimensional carvings take the "hooked motif" (derived from the Southeast Asian hornbill bird) to the extreme. The Washkuk Hills peoples create some of the most colorful Sepik art. The Nukuma and Kwoma paint their yam harvest cane masks and carvings

in vivid colors; Abelam Spirit House facades are painted with tiers of *nggwal* spirit faces.

Fierce warriors from the Upper Sepik and Highlands region produce shields and other weapons, used in head-hunting raids to neighboring villages. The principal art form here, however, is in body decoration and costume, which is extremely elaborate, particularly among central Highlands people.

Mendi carved wooden shield, from the Southern Highlands. *Post-1950. 48 in (122 cm) high* **$1,500–2,000 JYP**

Painted wooden shield with Japanese Rising Sun, Highlands. *Mid-C20th. 64 in (163 cm) high* **$5,000–8,000 WJT**

HIGHLAND ENTRANCES

The *amoken* (cult houses in the Highlands) are relatively simple in comparison with the enormous Haus Tambaran of the Abelam, for example (*see opposite*). They are smaller constructions of around 100 square feet (10 square meters), and are raised on stilts, with gabled roofs. The facades are decorated with *amitung* (vertical boards), carved with symmetrical, curvilinear motifs, which appear to be anthropomorphic representations, rather than totemic. The tallest central board has a circular opening forming the entrance (*see left*). The buildings store ancestral relics and hunt trophies, arranged in symbolic patterns associated with ecology.

Carved wooden *amitung* (vertical door board) from Telefomin village, in the Highlands. *Post 1950. 86½ in (220 cm) high* **$6,000–8,000 JYP**

MEANING IN COLOR

Different peoples in the Sepik region and Highlands attribute different significance to color. Painted colors are derived from mineral and vegetable sources, and mainly include black, orange, red, and white.

SHIELDS

Carved wooden shield with painted decoration, from Mendi in the Southern Highlands. In the Highlands, painting on war shields is dramatically colorful. Research conducted by F. Barth (1975) concluded that, contrary to the denials of the Telefomin people, there was significance in the colors chosen for painting on shields, house boards, arrows, and hand-drums. Red represents "descent and the ancestors," and is smeared on bones and the faces of initiates. Black is for "male solidarity and seniority," and is derived from soot accumulated on the inside of Men's Houses. White represents "food, prosperity, and plenty," and is the color of taro flesh, mother's milk, pig fat, and shell (currency). *Post-1950. 56 in (142 cm) high* **$2,000–3,000 JYP**

Lower Sepik

The art of this region is characterized by the human figure motif, with certain distinctive attributes, such as the nose, which often has a pierced septum and is elongated into a beak. Curvilinear and triangular "toothed" motifs are found more on objects than on ancestor figures, particularly on the sides of canoes in coastal areas.

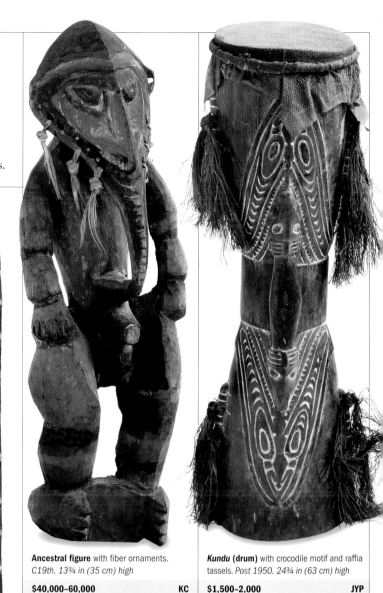

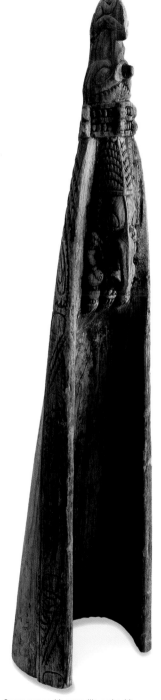

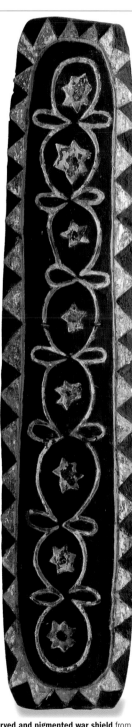

Ancestral figure with fiber ornaments. *C19th. 13¾ in (35 cm) high*

| $40,000–60,000 | KC |

Kundu (drum) with crocodile motif and raffia tassels. *Post 1950. 24¾ in (63 cm) high*

| $1,500–2,000 | JYP |

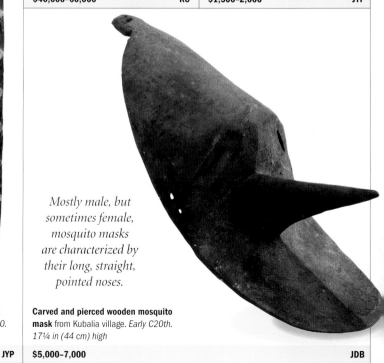

Mostly male, but sometimes female, mosquito masks are characterized by their long, straight, pointed noses.

Canoe prow with crocodile and spirit figure. *Post-1950. 65¼ in (166 cm) high*

| $2,500–3,000 | JYP |

Carved and pigmented war shield from Biwat village on the Yuat River. *Post-1950. 67¼ in (171 cm) high*

| $3,000–5,000 | JYP |

Carved and pierced wooden mosquito mask from Kubalia village. *Early C20th. 17¼ in (44 cm) high*

| $5,000–7,000 | JDB |

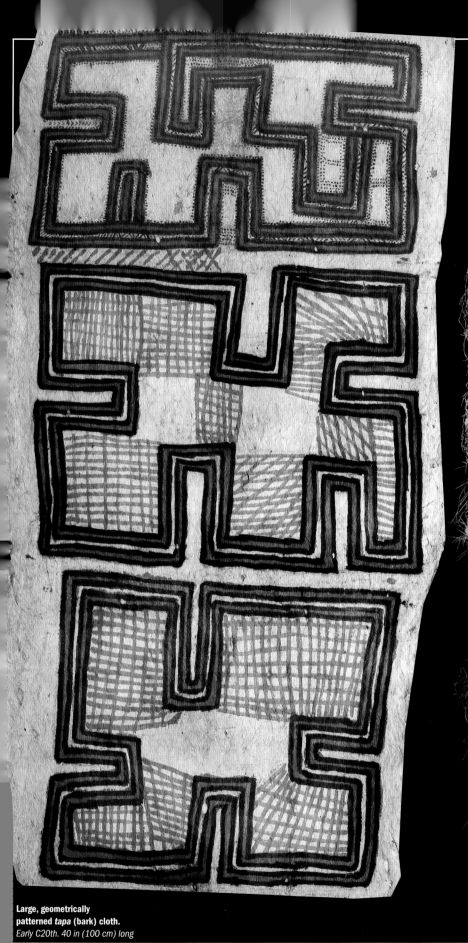

Large, geometrically patterned *tapa* (bark) cloth.
Early C20th. 40 in (100 cm) long

$5,000–7,000 JDB

Carved and pigmented mask with vegetal fiber hair from Tambanum village. *Post-1950. 41¾ in (106 cm) high*

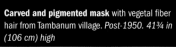

$2,000–3,000 JYP

Middle Sepik

This relatively small area is abundant with exuberant artistic expression. Surfaces are decorated with stylized human and animal forms representing spirits. Many objects relate to yam festivals and may be carved, potted, or woven in cane. The posts and facades of the great Spirit Houses are carved and painted. The buildings contain sacred objects, food hooks, and stools.

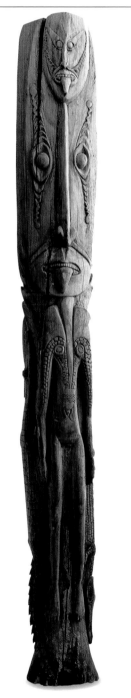

Ornamented ancestor post from Kandingai village. *Post-1950. 84¼ in (214 cm) high*

$8,000–10,000 **JYP**

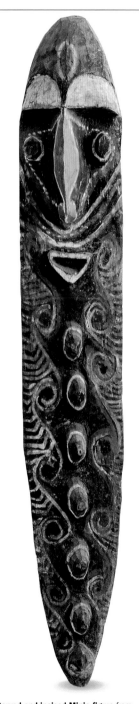

Carved and incised Minja figure from the Washkuk area. *Post-1950. 63 in (160 cm) high*

$2,500–3,000 **JYP**

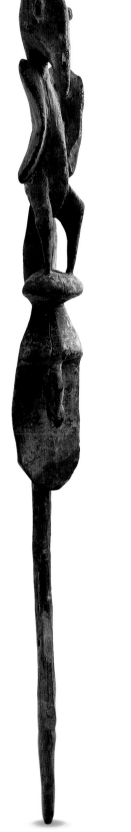

Carved Yena cult object from the Washkuk area. *Post-1950. 50½ in (128 cm) high*

$4,000–5,000 **JYP**

Ancestral cassowary-bone dagger with human figurative and geometric carvings. *Early C20th. 16 in (40.5 cm) long*

$1,800–3,000 **WJT**

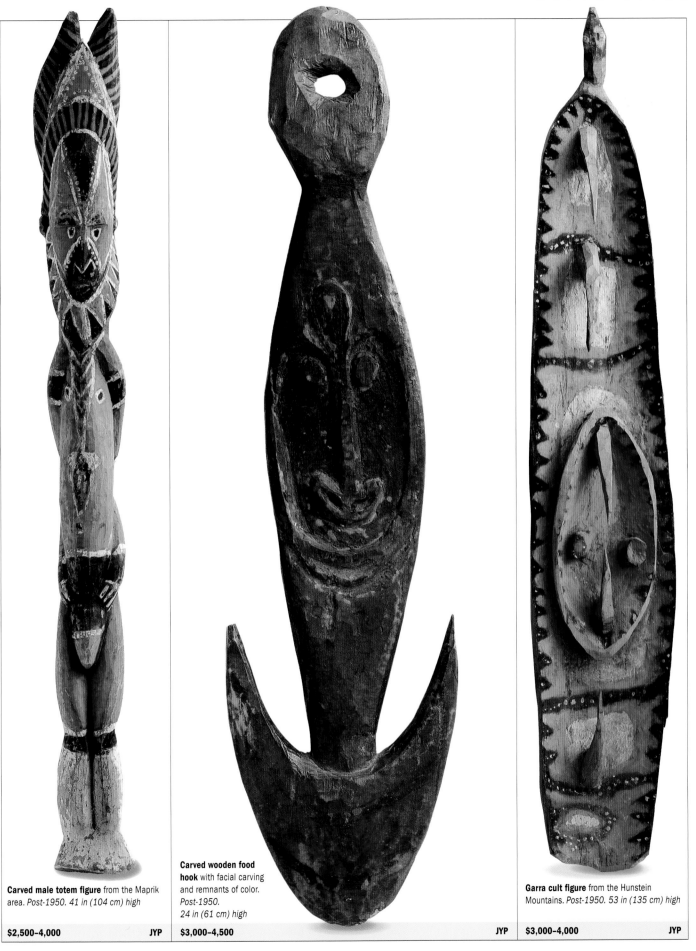

Carved male totem figure from the Maprik area. *Post-1950. 41 in (104 cm) high*

$2,500–4,000 **JYP**

Carved wooden food hook with facial carving and remnants of color. *Post-1950. 24 in (61 cm) high*

$3,000–4,500 **JYP**

Garra cult figure from the Hunstein Mountains. *Post-1950. 53 in (135 cm) high*

$3,000–4,000 **JYP**

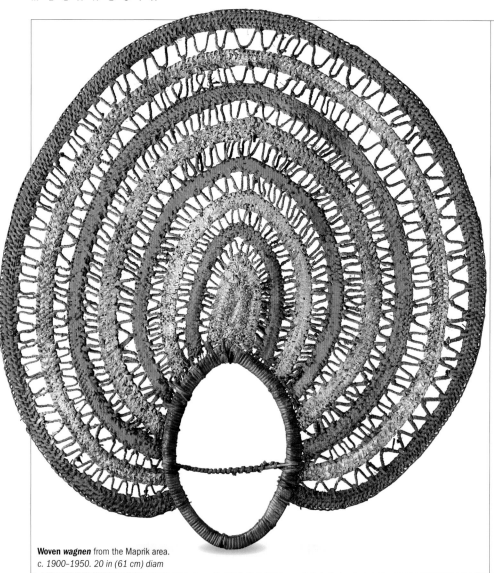

Woven *wagnen* from the Maprik area.
c. 1900–1950. 20 in (61 cm) diam

$1,000–1,500 KC

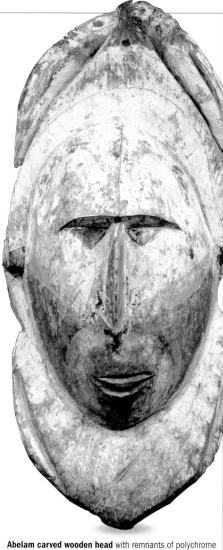

Abelam carved wooden head with remnants of polychrome
pigments. *Late C19th–early C20th. 22 in (56 cm) high*

$1,200–2,000 BLA

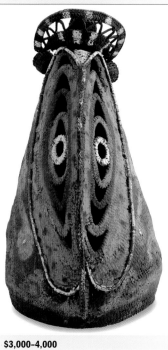

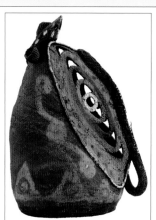

SIDE VIEW

Maprik area *baba* woven helmet
mask carved from a yam. *Post-1950.
19¼ in (49 cm) high*

$3,000–4,000 JYP

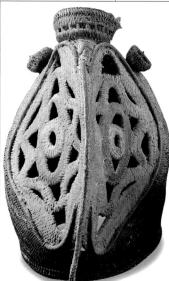

Baba helmet mask with polychrome
pigmentation, from the Maprik area.
Early C20th. 16½ in (42 cm) high

$1,500–2,500 BLA

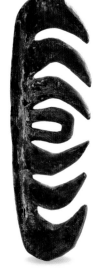

Hooked spirit figure from the Bahimeno
people of the Hunstein Mountains. *Post-
1950. 30¾ in (78 cm) high*

$3,000–5,000 JYP

A CLOSER LOOK

Yam cult Yena head from the Nukuma in the Washkuk area. The Nukuma and Kwoma live in the Washkuk Hills, north of the left bank of the middle Sepik River, where the yam harvest is a time of great celebration. Different carvings and figurative clay pots are produced for the three consecutive ceremonies—Yena-ma, Minja-ma, and Nogwi. *Post-1950. 45 in (114 cm) high*
$3,000–4,500 JYP

The spur is characteristic of Nukuma Yena cult figures, and may be ornamented

The stylized head above a tapering pole represents *sikilowas* (a man's soul or spirit)

Phallic noses relate to fertility

Nukuma Yena have a red face with white detail to the brows, eyes, and mouth. Often several layers of paint are found, indicating frequent reuse

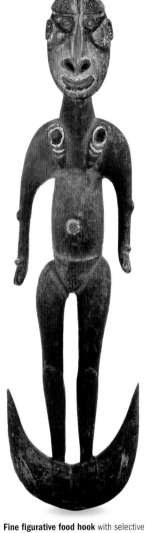

Yena cult head from the Washkuk area. *Post-1950. 39¼ in (100 cm) high*

$1,800–2,500	**JYP**

Fine figurative food hook with selective coloring. *c. 1900. 24¾ in (63 cm) high*

$25,000–45,000	**KC**

Carved and pierced headrest. *c. 1900. 6 in (15 cm) high*

$1,200–2,500	**KC**

Upper Sepik and Highlands

Weapons dominate the portable molded arts of this region, with each river or mountain area producing a different style of war shield. Spears, bows, and arrows are the common offensive weapons and all are decorated with carving, lime, and colored woven vegetable fibers. *Moka kina* are chest ornaments displayed by the Melpa people in the Waghi Valley. Along with pigs, they are exchanged during elaborate rituals and are signs of prestige.

Simbai shield with carved and painted geometric decoration. *C19th. 45 in (114.25 cm) high*

$5,000–7,000 **WJT**

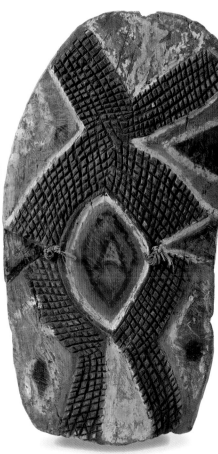

Simbai shield with chip-carved and painted decoration. *C19th. 37 in (94 cm) high*

$3,000–5,000 **WJT**

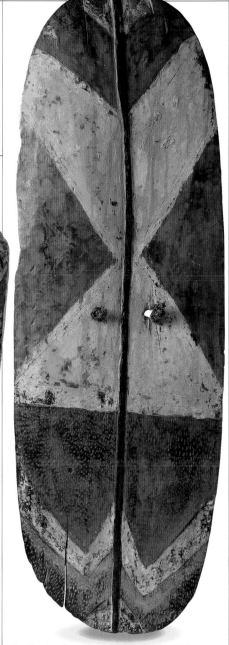

Mendi painted wooden war shield. *Early–mid-C20th. 48 in (122 cm) high*

$9,000–12,000 **WJT**

The ring is passed over the head of a fleeing enemy and a jerk drives the point into the nape of his neck.

Bamboo "man-catcher." *Early C20th. 74 in (188 cm) long*

$3,000–6,000 **WJT**

MODERN IMAGERY

The term "traditional" society can conjure up a picture of peoples frozen in time, but such societies do, in fact, evolve and are influenced to a degree by colonization and the creeping consumerism of the West. New Guinea societies are no different. In some areas, contemporary artists produce material for ritual reasons as well as for sale. They assimilate modern influences and transpose them onto traditional forms like war shields. They might be emblems from national flags (Japanese Rising Sun), logos from beer cans, or comic book heroes (see *below*). The reverse is found in urban New Guinea, where buses, buildings, and popular paintings using industrial paints and fabrics are decorated in culturally traditional styles.

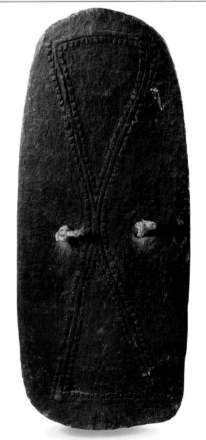

Moka kina (chest plate) with crescent shell and panel of bamboo bars, from the Melpa people. *c. 1950. 15 in (38 cm) diam*

$500–900 | **KC**

Painted shield with "Phantom" comic book and military license plate imagery. *Mid-C20th. 81 in (205.75 cm) high*

$7,000–10,000 | **WJT**

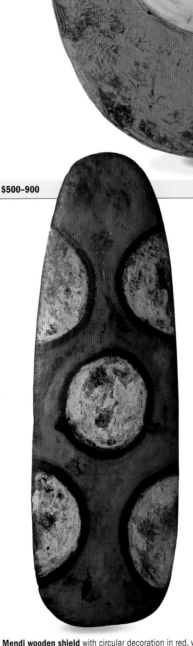

Mendi wooden shield with circular decoration in red, white, and black pigments. *Mid-C20th. 52 in (132 cm) high*

$9,000–12,000 | **WJT**

Carved Simbai shield. *C19th. 37 in (94 cm) high*

$5,000–7,000 | **WJT**

Weapons in this region include bows, clubs, and distinctive archer's shoulder shields with rectangular arm apertures.

***Tapa* (bark) cloth masks** are outlined with bent twigs. Woven rattan masks have beaks, and are boldly colored in white, red, black, and occasionally yellow earth pigments.

Ancestor boards are commonly found in Western collections, with occasional skull racks.

Personal objects are carved in dark woods and incised and in-filled with lime.

Papuan Gulf

There is an exuberance of two-dimensional surface decoration in the Papuan Gulf. The artists strive for bold curvilinear design and vivid color to ornament masks, shields, ancestor boards, and macabre skull racks.

The style region known as the Papuan Gulf encompasses the alluvial plains between the Fly River and Cape Possession. Although there are similarities to Sepik art, there is a distinct style.

The Kerewa live in the west and produce finely worked pieces typical of Papuan Gulf art including *agiba* skull racks (*see below*), woven rattan masks, and ancestral tablets called *gope* boards. These were produced by most Gulf peoples and kept in Men's Houses.

The people north of the Kerewa, between the Kikori River and Purari Delta, also produce *kwoi* (ancestor boards). Era River people produce *bioma* (cut-out ancestor carvings) with arms raised or curved down, possibly to suspend skulls.

The Elema live in the eastern region, where the Kovave initiations and the important Hevehe cyclical ceremonies dominate cultural life. The Hevehe concludes when the tall "sea-spirit daughter" masks exit the ceremonial house. Crest masks for the ceremonies are made from cane and painted bark cloth. The Elema also carve amulets from dwarf coconuts, incised with zigzags and porcine features, and in-filled with lime. Such *marupai* ward off ill health, increase wealth, and bring hunting success.

The Torres Straits is a separate style, but stylistically related to the art of the Kiwai at the mouth of the Fly River. Figurative art is only found in their arrowheads. Islanders also make amazing *warup* (drums), incised with zigzags, limed, and ornamented with shells and feathers.

Above: Carved *gope* ancestor board from the Elema people. *c. 1880. 39 in (100 cm) long* **$7,000–10,000 KC**

SKULL RACKS

Beautiful skull racks are found both along the Bamu River and in the Gulf of Papua, where they are called *agiba*, and are used to display the skulls of enemies. Sometimes bird and animal skulls are also mixed with human ones. The skulls have rattan loops threaded through the eye sockets and the loops are hooked over the two struts on either side of the central upright. The carving takes a two-dimensional form, and is a stylized human ancestor figure. In 1901, a single skull rack was recorded to display 700 individual skulls.

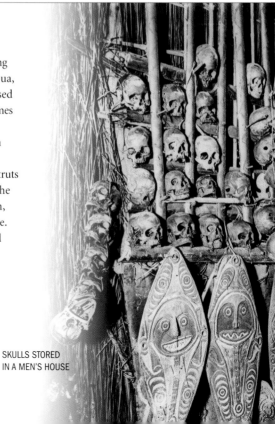

Wooden skull rack with carved and painted decoration, from Babaguima village. *Post-1950. 34 in (86 cm) high* **$3,000–5,000 JYP**

SKULLS STORED IN A MEN'S HOUSE

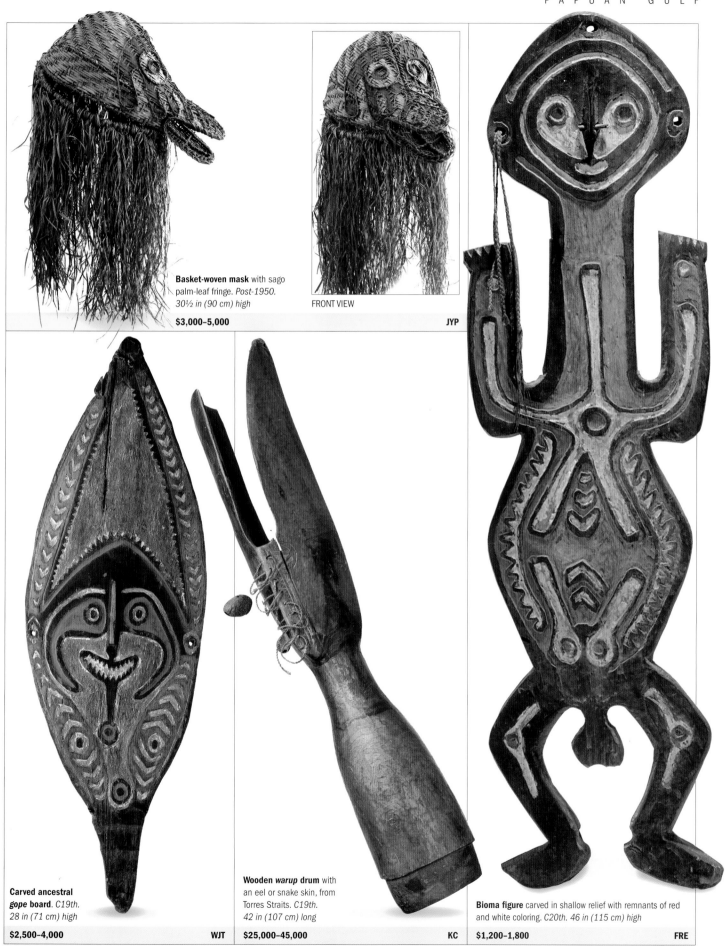

Basket-woven mask with sago palm-leaf fringe. *Post-1950.* *30½ in (90 cm) high*

FRONT VIEW

$3,000–5,000 JYP

Carved ancestral gope board. *C19th.* *28 in (71 cm) high*

$2,500–4,000 WJT

Wooden *warup* drum with an eel or snake skin, from Torres Straits. *C19th.* *42 in (107 cm) long*

$25,000–45,000 KC

Bioma figure carved in shallow relief with remnants of red and white coloring. *C20th. 46 in (115 cm) high*

$1,200–1,800 FRE

131

Massim art is centered on decoration on objects, rather than on sculpture or painting.

Admiralty Island sculpture is somewhat angular and vividly painted.

New Ireland art relates to ceremonies, and is complex and colorful.

Vanuatu figurative art is characterized by crosshatched planes and serrated edges. Tree fern is often used.

New Caledonia sculpture features a severe hooked nose with flared nostrils; architectural forms are carved with heads and lozenge patterns.

Overmodeling of skulls is found in New Caledonia, Vanuatu, New Ireland, and New Britain.

Clubs of widely differing forms are found throughout the region, and can often be assigned to individual islands.

Eastern Islands

The eastern Papuan shores and outlying Melanesian islands are colonized by seafaring peoples, whose cultures are as varied and distinct as their island groups.

In the far east of New Guinea is the Massim style province, which includes the Trobriand Islands. Artistic expression is secularized here. Painting is absent and sculpture is small, reduced to the handles of some delicate lime spatulae used for betel chewing (lime mortars were used by old men who had lost their teeth, to soften the betel nut for chewing). Canoe prows and dance boards exhibit the characteristic, interlocking stylized frigate bird beak motif approximating to a kind of extended guilloche scroll. Seafaring canoes are central to the Kula, a system of ritual exchange involving particular islands. They circulate *soulava* (necklaces) for *mwali* (armbands) in opposing directions around the Kula "ring."

To the north lies the Bismarck Archipelago, which includes the Admiralty Islands, New

Ireland, and New Britain. Admiralty sculpture has a distinct style and is more angular and rigid than work from the Sepik region. Deposits of obsidian were mined in this region and turned into spear and knife blades with ornamented handles. Unique war charms are also made, with feathers issuing from beneath a carved head. Just as in Tami and the Solomon Islands, these secular craftsmen were famous for their feast bowls (*see opposite*).

In New Ireland, the most important works of art relate to the Malangan, Uli, and Kulap funerary and initiation ceremonies. These ceremonies enable the soul of the deceased to be released to find the final resting place. The staging of a Malangan ceremony involves considerable expense. Both *tatanua* (masks)

Above: Massim society skirt board from the Trobriand Islands. *Post-1950. 22½ in (57 cm) long* **$2,500–3,500 JYP**

FIRE DANCE

In New Britain, the Baining people, who were driven into the interior by the Gunantuna (Tolai) in the 17th century, make spectacular cane and *tapa* masks. The *hareiga* is worn during daytime dances and the *maius* is worn during night dances. Three types of bizarre masks are utilized in these "circle of life" ceremonies, including the relatively small *kavat* mask (*left*). *Kavat* masks represent bush spirits and some types have an owl-like appearance. During the *maius* dances, they are used in both the spectacular fire dance and the snake dance, in which live snakes are handled.

Baining society fire dance *tapa* mask with a bamboo and reed framework, colored with berry dyes. *Post-1950. 33½ in (85 cm) high* **$1,800–2,500 JYP**

FIRE DANCING, NEW BRITAIN

FEAST BOWLS

Among islanders of Tami, in the Huon Gulf region of northeastern Papua New Guinea, a style of carving emerged that spread over the entire area. Their food bowls are either bird-shaped or of pointed oval form and made from a hard wood and polished with imported manganese or graphite, and tree sap. They are painted with ocher-rich soil and decorated with incised and lime-filled motifs. Motifs include serpents, bird's heads, fish, and human masks representing spirits. They are used in both secular and religious contexts, for meat and sago porridge. The bowls were traded as far as the Bismarck Archipelago. Tami carvers controlled their production, and "trademarks" can often be found on them.

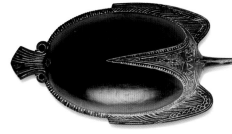

UNDERSIDE

Wooden Tami Islands feast bowl
carved with a stylized bird surround.
c. 1890. 22¾ in (58 cm) long
$2,000–3,000 JBB

and complicated openwork figurative carvings are required, incorporating a multitude of mythical human and animal motifs on the same carving. Kulap ceremonies involve carved chalk figures, and Uli carvings are used in conjunction with the exhumed skulls of the deceased.

The island of New Britain is home to such cultures as the Sulka, Baining, Gunantuna, Mengen, Arawe, Kilenge, and Nakanai. Despite contact with the Europeans since 1700, many cultures were unaffected until the early 1970s. In the Gazelle Peninsula, the large quantity of artwork includes the monumental *tapa*-covered masks of the Baining, conical Gununtuna masks, overmodeled human skulls, and red-pink pith masks for initiating Sulka youths. The war shields of the Sulka, Mengen, and Arawe are particularly striking.

The Vanuatu group of islands lies south of the Solomon Islands. Large wooden slit drums are found on Ambrym, carved with oval faces and saucer eyes. Tree fern is carved into stylized figures on Banks and Ambrym, and used in secret grade societies. On Malekula, fern is made into painted masks and *rabaramb* (mortuary figures). Domestic artifacts include carved dishes, wooden knives, and laplap pounders.

The Kanak people of New Caledonia carve *pwemwa* (water-spirit masks). In the northeast these have a hooked nose and flared nostrils, hair, and feathers. The entrances to Men's Houses are composed of wooden posts, of which the *jovo* (figurative door jambs representing ancestors) are the most impressive. Kanak chiefs owned beautiful *gi okono* (scepters of polished green serpentine disks).

LIME SPATULA

Trobriand Islands lime wood spatula with a pierced ring handle. Betel-chewing accessories include lime containers made from gourd or bamboo, and bone or wood spatulae. The plethora of highly collectible spatulae from the Massim district of eastern Papua New Guinea is particularly impressive. Finely carved examples have recently increased in value from less than a hundred dollars to several hundred. *Early C20th. 9½ in (24 cm) long* **$1,800–2,500 PHK**

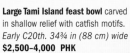

Large Tami Island feast bowl carved in shallow relief with catfish motifs. *Early C20th. 34¾ in (88 cm) wide* **$2,500–4,000 PHK**

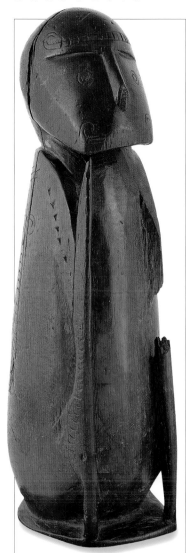

Carved wooden ancestral figure from the Trobriand Islands. *C19th. 16 in (40.5 cm) high*

$5,000–8,000 **WJT**

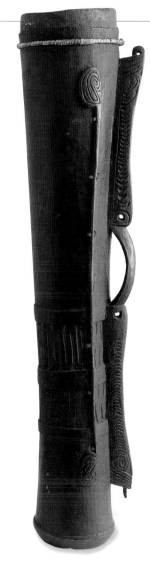

"Hourglass" drum from the D'Entrecastaux Islands. *Late C19th. 37¾ in (96 cm) high*

$900–1,500 **PHK**

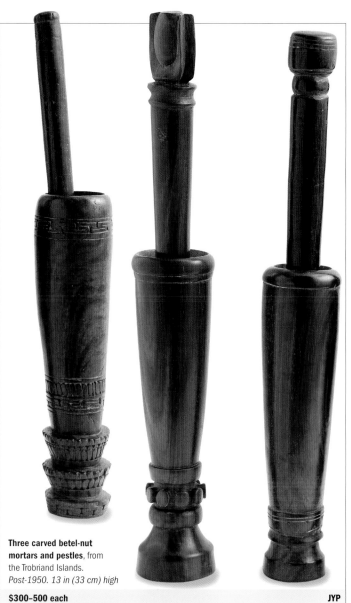

Three carved betel-nut mortars and pestles, from the Trobriand Islands. *Post-1950. 13 in (33 cm) high*

$300–500 each **JYP**

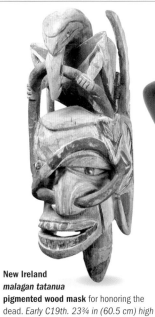

New Ireland *malagan tatanua* **pigmented wood mask** for honoring the dead. *Early C19th. 23¾ in (60.5 cm) high*

$20,000–30,000 **BLA**

"CLAPPER" HANDLES CAN BE USED LIKE CASTANETS

The huge range of handle designs makes lime spatulas very collectible. The spatula is used to add lime to a leaf-and-nut chewing mixture.

Lime spatula from the Trobriand Islands. *Late C19th. 9½ in (24 cm) long*

$1,800–2,500 **PHK**

A CLOSER LOOK

Arawe wooden war shield with geometric pattern decoration on the face and reverse in black, red, and white pigments. The Arawe live in southern New Britain, and are noted for skull binding. This process induces an elongated cranium and is almost unique in Melanesia. Their war shields are distinct in their construction and decoration.
Post-1950. 49¼ in (125 cm) high **$2,000–2,500 JYP**

Decoration on the front is frequently composed of panels containing incised coiled and zigzag motifs

The reverse is not engraved, and is painted differently, but is still composed of repeated designs within panels

Shields are always constructed with three vertical light wood planks of oval section, bound together with cane

The color palette is limited to black and white in older shields, sometimes with red in more recently made examples

KEY FACTS

In the northern islands, the red-black-white palette of colors predominates, while in the central islands, black is preferred, with inlaid white shell.

Acquiring prestige is of central importance for social advancement, and islanders engage in conspicuous displays of wealth.

Clubs are found throughout, some used as weapons, others in dances.

Skulls from the region are overmodeled with nut paste.

Solomon Islands

The islanders of the Solomon group are fierce head-hunters and skilled fishermen who revere ancestral and animal spirits. They strive to enhance their status by warfare and trade, using shell and feather currency.

The islands that make up the Solomon group can be divided into two style regions. In the north lie Buka and Bougainville, while to the south and the east, the islands include Choiseul, New Georgia, Santa Isabel, Guadalcanal, Malaita, San Cristobal, and Santa Cruz.

NORTHERN STYLES

In the north, the prevalent motif is the human figure, carved in low relief, usually squatting, and with raised arms. It appears on dance paddles, canoe hulls, slit gongs, and spoon handles. However, *koka* (dance shields), which were displayed during marriages, were decorated with propeller-like medallions. *Urar* (ancestor spirit) figures, presented during initiation, are scarce.

CENTRAL AND SOUTHERN AREAS

In the central Solomons, there is a large variety of small carvings, many of which are inlaid with small pieces of cut nautilus shell. The prows and sterns of the war canoes are particularly tall (over 10 ft or 3 m in some instances) and may also be shell-inlaid. The canoes are stored in beach shelters, which also serve as Men's Houses. Ancestral bones are kept in model canoes or beautiful bonito-shaped receptacles within the shelters. Other shell-inlaid objects include oval feast bowls (some over 3 ft or 1 m in length) and *wauri hau* (ceremonial batons with stone heads).

Above: *Kapkap* (worn around the head) with a filigree turtleshell overlay. *Late C19th–early C20th. 4½ in (11.5 cm) diam* **$1,200–2,000 BLA**

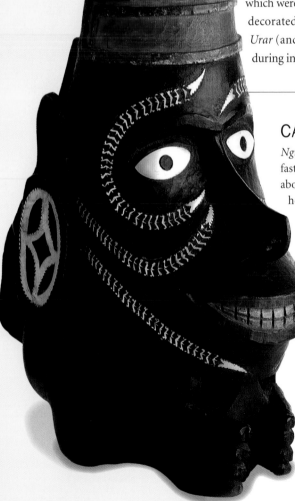

CANOE PROW ORNAMENTS

Nguzuguzu (or *toto isu*) canoe figureheads were fastened to the prows of *mon* (war canoes) just above the waterline. They depict a decapitated head and forearms with slanted prognathic features, decorated with inlaid shell plaques. They often hold a head or bird in their hands. Head-hunting was commonplace in the 19th century, and it has been suggested that these ornaments represent Kesoko, a head-hunting and fishing spirit, and were intended to frighten the enemy. They have been found mainly in Choiseul and New Georgia.

***Nguzuguzu* carved and painted wooden canoe prow ornament,** with shell inlay. *1880–1900. 13½ in (34 cm) high* **$18,000–30,000 KC**

CANOE BUILDING SHOWING *NGUZUGUZU*

ANIMAL IMAGERY

Animal motifs recur in Solomon Islands art, with the frigate bird often found on canoes, feast bowls, clubs, and jewelry. Frigate birds are significant for several reasons—they are esteemed for their aggressive nature (harassing other seabirds for food), they are large and impressive-looking, and they frequently shadow schools of bonito. Bonito fish are considered a manifestation of *tindalos* (deities), as are sharks. *Dafi* (crescent-shaped chest ornaments) from Malaita (*see right*) are often overlaid with turtleshell plaques depicting frigate birds. They are worn as talismans by Kwaio men on Malaita, especially when traveling by canoe. Other neck ornaments that feature animal imagery include the *laoniasi* (clamshell disk necklaces or pendants), which are engraved and stained with manganese pigment and are worn during ceremonies and used as currency.

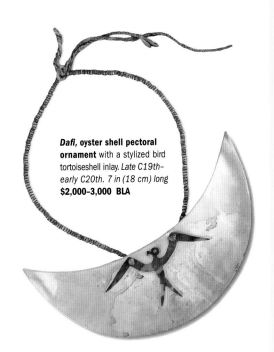

Dafi, **oyster shell pectoral ornament** with a stylized bird tortoiseshell inlay. *Late C19th–early C20th. 7 in (18 cm) long* **$2,000–3,000 BLA**

The men of the central Solomon Island region are preoccupied with fishing, hunting, warfare, and religious ceremonies. *Akaro* (ancestral spirits) are revered and the bones of important deceased men are either overmodeled or placed in reliquary containers. In some communities, chieftaincy can be attained through the acquired prestige of individuals, where success in warfare (and head-hunting), political skill, and wealth are prerequisite to social advancement. Clubs of various kinds are found in most, if not all, of the islands of the group. One elegant weapon, the *roromaraugi*, has an anthropomorphic handle and a curving head and is used for parrying spear thrusts. Shell-inlaid clubs were not used in battle, but are used as dance staffs. Small, elliptical wicker war shields were made in several central Solomon Islands, including New Georgia.

SANTA CRUZ ISLANDS

This southernmost group of islands has close affinity with Micronesian cultures. These islanders also wear shell disks called *tema*, which are worn around the neck. (These shell ornaments should not be confused with *kapkap*, as they have a different tortoiseshell

overlay design.) Painted, canoe-shaped dance wands are carried during *napa* ceremonies commemorating the maturation of children.

A unique form of currency is made on Ndende Island from the red feathers of the cardinal honeyeater bird. Many thousands of feathers are required to produce *tevau* (a single roll of money), which may be 30 ft (9 m) long. *Tevau* currency could be used to buy pigs or brides, or used to procure labor.

Comb, from Bougainville or Malaita. *Late C19th. 6½ in (17 cm) high* **$500–700 PHK**

ADORNMENT

Islanders display their wealth with jewelry made from shells of various types. Kapkap are clamshell disks overlaid with an openwork, turtleshell disk and were worn on a headband in the eastern Solomon Islands. Strings of small red, white, and black shell disks (arm and waist bands) were used as currency, to buy food or brides.

HAIR ORNAMENTATION

Particular attention was paid to the hair, and faa (shell palmwood combs) were made in the central and eastern Solomon Islands, decorated with inlays of shell. They were worn as dance ornaments, sold as curios, and traded to other Melanesian islands. Combs from Malaita were woven with yellow and red orchid split cane and are popular with collectors.

Two Malaita hair combs decorated with shell and resin. *Late C19th. 10½ in (27 cm) and 9½ in (24 cm) long* **$500–700 (each) PHK**

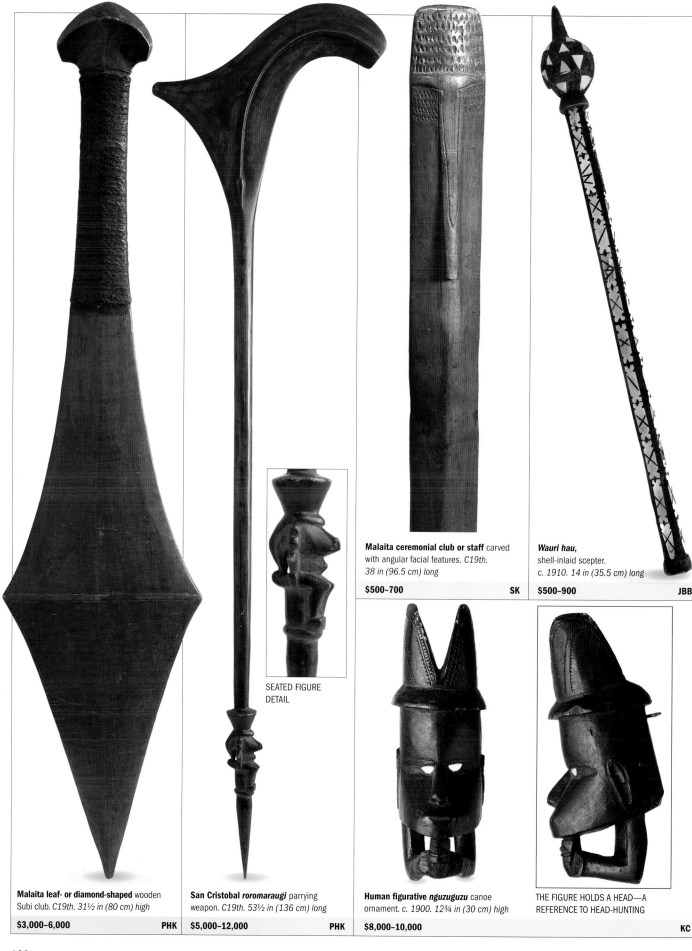

Malaita ceremonial club or staff carved
with angular facial features. *C19th.*
38 in (96.5 cm) long

$500–700 SK

Wauri hau,
shell-inlaid scepter.
c. 1910. 14 in (35.5 cm) long

$500–900 JBB

SEATED FIGURE
DETAIL

Malaita leaf- or diamond-shaped wooden
Subi club. *C19th. 31½ in (80 cm) high*

$3,000–6,000 PHK

San Cristobal *roromaraugi* parrying
weapon. *C19th. 53½ in (136 cm) long*

$5,000–12,000 PHK

Human figurative *nguzuguzu* canoe
ornament. *c. 1900. 12¾ in (30 cm) high*

$8,000–10,000

THE FIGURE HOLDS A HEAD—A
REFERENCE TO HEAD-HUNTING

KC

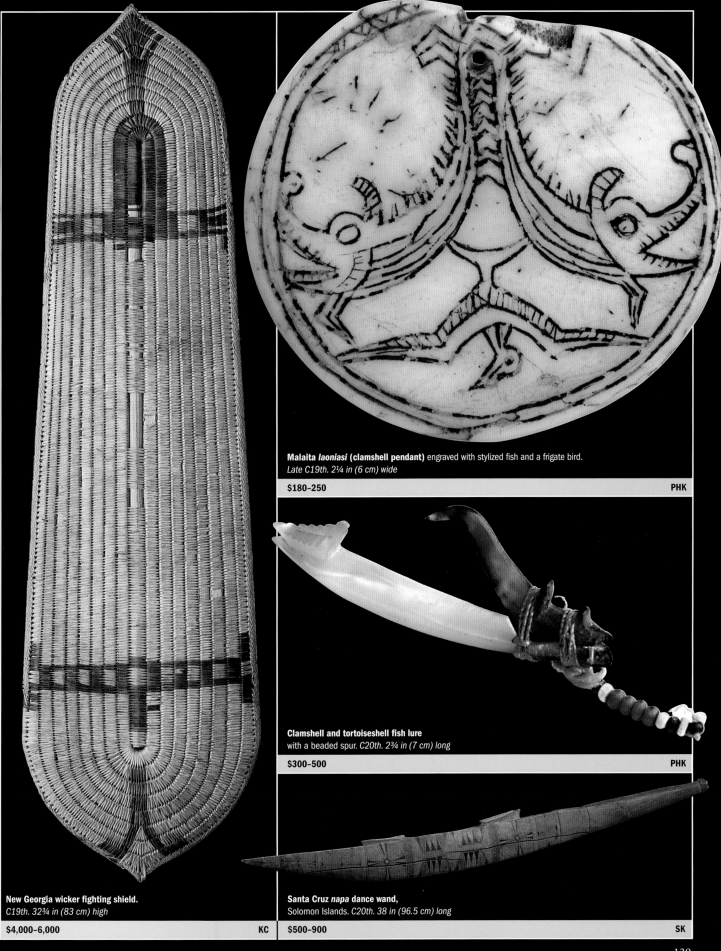

Malaita *laoniasi* (clamshell pendant) engraved with stylized fish and a frigate bird.
Late C19th. 2¼ in (6 cm) wide

$180–250 PHK

Clamshell and tortoiseshell fish lure
with a beaded spur. *C20th. 2¾ in (7 cm) long*

$300–500 PHK

New Georgia wicker fighting shield.
C19th. 32¾ in (83 cm) high

$4,000–6,000 KC

Santa Cruz *napa* dance wand,
Solomon Islands. *C20th. 38 in (96.5 cm) long*

$500–900 SK

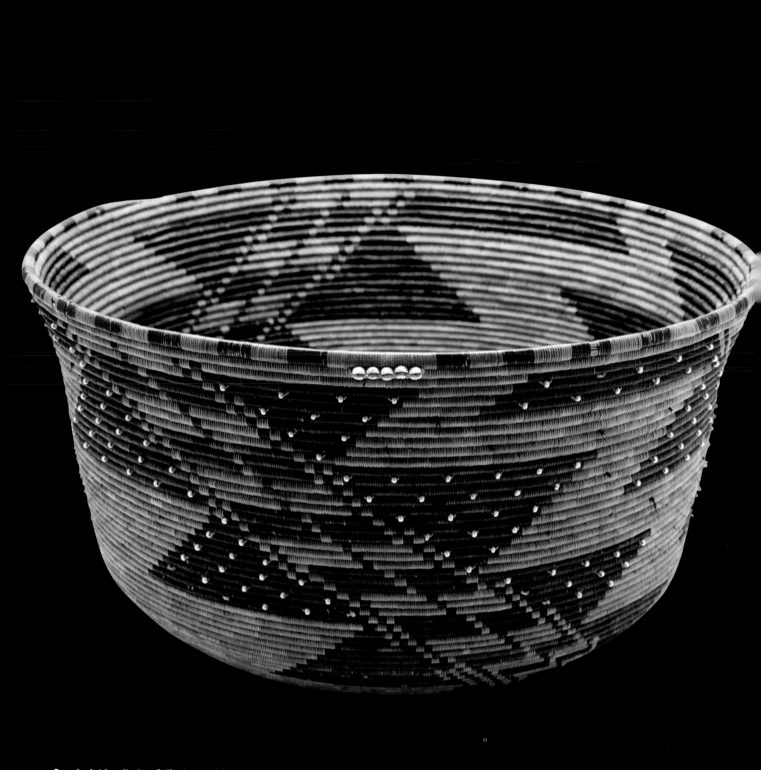

Pomo basket from Northern California, comprising
split sedge root and dyed cattail root on a willow
shoot foundation, with acorn woodpecker crest
feathers, valley quail topknots, clamshell disks,
and glass seed beads with cotton thread. *c. 1900.*
16 in (40.5 cm) diam **$25,000–30,000 FS**

THE AMERICAS

The art of the Americas is multifarious, from austere, majestic figurines to intricate, flamboyant textiles.

Europeans called it the New World, but Americans did not call themselves Americans—they were Seneca, Cherokee, Winnebago, Arapaho, Acoma, Apache, Navajo, Hupa, Cayuse, Tlingit, and Yupik; Olmec, Aztec, Zapotec, Mayan, Cocle, Quimbaya, Valdivia, Chavin, Inca, Paracas, and many more. Each of these cultures developed its own means of artistic expression. Religious or ceremonial occasions called for masks, shaman's rattles, and sculptures with magical qualities. Political events brought forth splendid garments and official regalia. For those secular moments of private interaction and entertainment, toys, smoking pipes, and the latest fashions all contributed to the face of Native America.

Culture of the Americas

Culture is never static. It evolves according to internal needs and external pressures. It may transform gradually or abruptly, as in the case of the Native Americans, whose lifestyles changed radically within 100 years of European contact.

PATRONAGE

Prior to contact with the Europeans, Native American groups had spread out across the North American continent. Each tribe was distinguished to the degree that their populace observed similar traditions, adhered to a shared belief system, and created a body of art and artifacts that acknowledged certain strictures following the style of their predecessors. A recognizable aesthetic developed within each group and became what the outside world calls "traditional art." The first patrons of these indigenous art forms were the people themselves. Ritual and secular functions required objects for use in such events. Other items were made for private use or personal adornment, and contributed to a larger body of work made for the people, by the people. Everything changed, however, with the arrival of the Europeans. As Native American cultures were subjugated and the old ways of life slowly died, the stimulus for the creation of artistic objects changed. Navajo blankets worn as garments evolved into rugs for non-Native American floors. Pottery vessels used to store grains or to carry water became curios for the tourist trade. Baskets that once held foodstuffs were now displayed on a mantelpiece as decorations. Curiously, this shift in motivation did not spell the doom of native art forms. Rather, collector patronage led to a creative flourish of new designs and styles in response to nontraditional tastes, and it saw to the preservation of skills that might otherwise have disappeared.

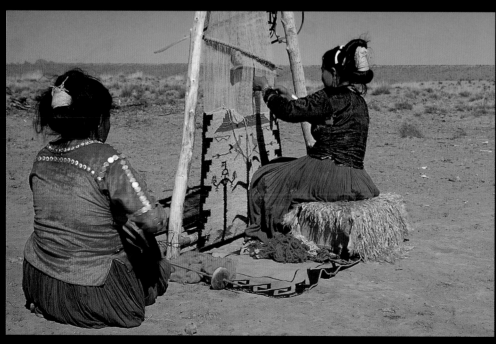

A Navajo weaver, seated at her loom.

The tomb of the Mayan ruler Pakal (reproduction at Museo Nacional de Antropologia, Mexico, shown left) was found hidden in a Palenque pyramid temple chamber in 1952. According to the archaeologist on site, it "...emerged a vision from a fairy tale, a fantastic, ethereal sight from another world."

AFTERLIFE

To the ancient cultures of Latin America, death was the dividing line between time spent in this world and an existence thereafter. They spent considerable time and effort preparing for what was to come. Among the Mayans, the Aztecs, the Incas, the Huaris, and other major powers, a high-status burial was an astounding display of ornate garments, jewelry, and even sacrificed human offerings. Royalty were interred in splendid architectural monuments that testified to their status. In West Mexico, where no major ruins have survived, shaft tombs were dug into the earth for the upper classes. Their underground burial chambers were filled with figurines and everyday objects made of clay, left to fulfill the dead person's every need. In southern Peru, a graveyard called the Paracas Necropolis, located in an almost rainless desert wasteland, was discovered to contain numerous mummies. Buried in a somewhat perfunctory manner, without markers above ground or protection below, the bodies nonetheless were wrapped in layers of remarkably luxurious textile shrouds. Fortunately for us, much has been preserved from these ancient cultures due to their burial practices. The preservation of these objects contributes to our understanding of early human societies and, in a way, allows them to live on—as was intended.

NORTH AMERICA

In every corner of this vast continent, cultures developed in response to a diverse range of natural challenges. Each established an equilibrium within their immediate environment that enabled them to survive. Their material culture reflected their needs, and they used local resources to create functional objects in an artful manner.

Over time, the encroachment of outsiders caused considerable change. As native populations were marginalized and left unable to control their own destinies, they turned to artistic production out of cultural pride and economic necessity.

On the Northwest Coast, a long-standing tradition of carved wood cult emblems, masks, and totems flourished in the 19th century. As cultural traditions came under pressure, a market for curios and collectibles helped to keep the art alive.

The "golden age of basketry" in California and the Plateau region was not some far-distant time when weavers pursued their craft for internal consumption. Rather, the art of basket-weaving reached its pinnacle in the first quarter of the 20th century. Designs grew more complex and technical standards improved with collector interest and patronage as the catalyst. People in the Southwest continued their age-old production of textiles, pottery, and baskets. But new forms and patterns entered the picture as sales to white people became increasingly common and instrumental in economic survival.

From the Great Plains to the eastern seaboard, people who had used porcupine quills, shells, and organic pigments for decorative use took to trade beads, store-bought paints, and non-native American tailoring for their garments and accessories. Eventually, beadwork items were made for both sale and use.

In every region of North America, the peoples' art evolved. The one constant was a link to time-honored traditions. Because of this fact, native American art, whether antique or contemporary, will always possess the indomitable soul of its makers.

American Indians and First Nations—names that are used to refer to a fantastic diversity of cultures and the true pioneers of the continent.

Sioux cradle, comprising polychrome glass seed beads and animal sinew, sewn onto hide. *c. 1880. 23 in (58.5 cm) long.* **$9,000–12,000 FS**

LANDSCAPE AND CULTURE
The people from this part of the world lived wherever the land would allow—in forests and prairies, deserts and tundra, flatlands and mountains, and on rivers, lakes, and seacoasts.

Right: The Rocky Mountains mark the western border of the Great Plains. Bison grazing nearby offer a glimpse of a bygone era in which they were a source of valuable material.

Eskimo model kayak in sealskin-over-wood with bone rigging, and a figure of a paddler. *C19th. 20½ in (52 cm) long* **$500–800 SK**

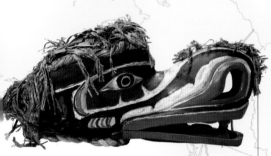

Kwakiutl crooked-beak Hamatsa bird monster mask, polychrome painted and with vegetal fiber hair. *c. 1910. 19 in (48.5 cm) long* **$30,000–50,000 M&D**

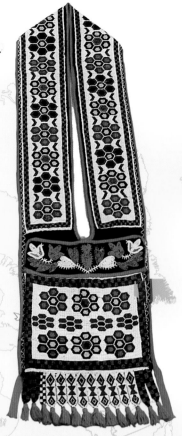

Cheyenne buffalo-hide teepee bag with polychrome bead, red-dyed horsehair, and tin cone decoration. *Late C19th. 19.5 in (9.5 cm) long* **$5,000–7,000 SK**

Ojibwa bandolier bag with polychrome wool and loom-beaded decoration on cotton cloth. *Late C19th. 35 in (89 cm) long* **$2,500–3,000 SK**

ARCTIC AND SUBARCTIC
- ■ ESKIMO
- ☐ ATHABASCAN

NORTHWEST COAST
BELLA BELLA ☐	KWAKIUTL ■
BELLA COOLA ☐	HAIDA ☐
NOOTKA ☐	TSIMSIAN ☐
MAKAH ☐	TLINGIT ☐

PLAINS
☐ ARAPAHO	■ CHEYENNE
☐ KIOWA	☐ BLACKFOOT
☐ HIDATSA	☐ SIOUX
☐ COMANCHE	☐ CROW
☐ CREE	

GREAT LAKES AND EASTERN WOODLANDS
MICMAC ☐	OJIBWA ■	SENECA ☐
WINNEBAGO ☐	HURON ☐	IROQUOIS ☐
POTAWATOMI ☐		

CALIFORNIA AND PLATEAU
MONO ☐	CAYUSE ☐
MISSION ☐	KLIKITAT ☐
POMO ☐	SALISH ☐
YOKUT ☐	CHINOOK ☐
HUPA ☐	NEZ PERCE ☐
PANAMINT ☐	YAKIMA ☐
MAIDU ☐	
KAROK ■	

SOUTHWEST
PAPAGO ☐	HOPI ☐
PIMA ☐	APACHE ☐
ANASAZI ☐	PUEBLO ■
NAVAJO ☐	

SOUTHEAST
☐ CADDOAN	☐ CREEK
☐ MISSISSIPPIAN	☐ CHICKASAW
☐ CHITIMACHA	☐ COUSHATTA
☐ CHEROKEE	
☐ SEMINOLE	
☐ CHOCTAW	

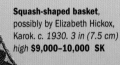

Squash-shaped basket, possibly by Elizabeth Hickox, Karok. *c. 1930. 3 in (7.5 cm) high* **$9,000–10,000 SK**

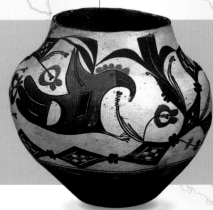

Acoma Pueblo *olla* painted in shades of brown and black with parrots and other traditional Acoma motifs. *Late C19th. 11 in (28 cm) high* **$30,000–40,000 SK**

KEY FACTS

Athabascan tribes include the Tanaina, Kutchin, Chipewyan, Northern Cree, and Naskapi; Eskimo peoples are grouped into Alaskan, Central, and Greenland divisions.

Athabascan and Eskimo lands are characterized by endless boreal forests, lakes, and rivers in the subarctic, giving way to a treeless tundra known as "the barren lands" and, ultimately, the icy regions of the far north.

The Athabascan peoples spoke an Algonquian tongue in the east and Athabascan dialects in the west; the Eskimo had their own unique language, spoken, with only minor variations, from Alaska all the way to Greenland.

Arctic and Subarctic

The Eskimo and Athabascan people of this region inhabited some of the harshest climates and most desolate territory on earth. The constant struggle to survive under such adverse conditions pervades the artwork from this region.

Despite the dual threats of starvation and cold (or perhaps because of them) the artistic objects from this part of the world were created in order to appease the spirits and the flesh.

A FIGHT FOR SURVIVAL

As a general rule, the Eskimo (or, in their language, Inuit) did not decorate the tools and implements that they used in their daily lives. Rather, elaboration of decorative detail was found in personal adornment and in ritual objects. Clothing was first and foremost practical, with garments sewn from the animal skins and furs that were readily available.

It was a woman's annual job, during the brief summer, to prepare a new set of clothing for her family that could withstand the rigors of winter. Appliqué patterns from seal or caribou skin were common, as were the use of fox, wolf, and dog fur for contrast and texture.

During ritual occasions, some Eskimo groups brought out masks designed to represent ancestral figures or members of the spirit world that influenced their daily lives. With no trees

Above: Pair of Athabascan sealskin boots with diamond-shaped motifs and fur trim. *Mid-C20th. 11 in (28 cm) high* **$180–450 ALL**

SUBSISTENCE

Managing to survive was always a challenge for most Eskimo groups, living in a land of frozen sea, ice, and little else. Despite the paucity of available resources, the Eskimo were able to ingeniously devise an array of tools that served almost every need. A typical assemblage might include a bow drill of ivory with a sealskin thong, an adz with bone handle and stone blade, an ivory arrow straightener, and harpoon sections of driftwood with sharpened walrus ivory points. Peculiar to the women were *ulus* (knives of crescentic slate blades) used for skinning, and sewing implements such as ivory needles and hollowed bone cases to contain them.

Above: Eskimo wooden utility box containing an *ulu* (knife), saw, bow drill, pipe, and kayak cleats. *Late C19th. Box: 17 in (43 cm) long* **$1,000–1,600 SK**

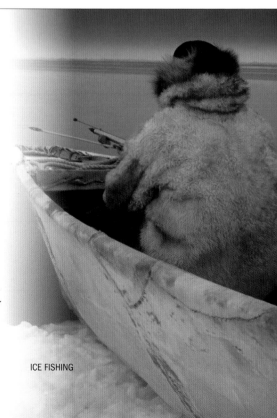

ICE FISHING

ART RENAISSANCE

Since the mid-20th century, the Canadian Eskimo have cultivated an art style that has brought much-needed income to their communities and wide praise of their aesthetic sensibilities. With government assistance in marketing, artists developed their own vision of "art for art's sake." They carved traditional media of stone, bone, and ivory but elaborated remarkably non-traditional depictions of the world around them. Individuals crafted their own unique styles, most particularly in drawing and printmaking, where free rein was given to the fertile imagination and wonderfully stylized creations of the artists.

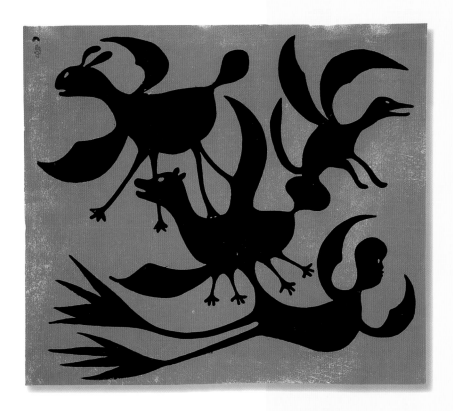

Right: Stonecut "Night Spirits" print by Eskimo artist Kenojuak Ashevak. *c. 1960. 24 in (61 cm) wide* **$10,000–15,000 WAD**

nearby, these were made of driftwood and adorned with feathers, animal teeth, and ivory ornaments. The Eskimo saw malevolent spirits as a constant menace in their perilous world, and the masks created to personify them were often terrifying to behold.

Talismans were carved in order to make direct contact with the life force of those animals upon which the people depended. A seal or caribou effigy might appear on special implements designed to reinforce the bond between human and animal brethren.

EUROPEAN INFLUENCES

For the Athabascan tribes, life was essentially a nomadic quest for food, at least until the arrival of Europeans and the subsequent market demand for animal pelts. Communities then formed around trading posts, and here the people were increasingly influenced by outsiders' goods and fashions. Tailored hide jackets in the European taste were festooned with glass beads or traditional porcupine-quill embroidery. Likewise, utilitarian containers of every sort bore time-honored, decorative patterns adapted to modern tastes and media.

Where the Athabascans lived in proximity to other cultures, they sometimes "borrowed" artifacts and made them their own. Masks similar to those of the Eskimo were occasionally used, and wood storage boxes and implements not unlike those of the Northwest Coast peoples were also found.

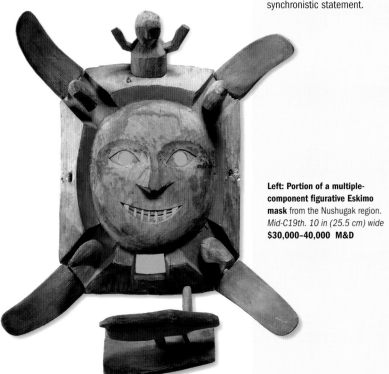

SPIRIT WORLD

The Eskimo's every step was enabled—or hindered—by denizens of a spirit realm very real to them. These frequently became the subject matter for artistic expression.

NUSHUGAK MASK

A complex mask of this sort is likely to represent the *inua* (spirit) of a game animal. It combines elements of both the hunter and his prey in a powerful synchronistic statement.

Left: Portion of a multiple-component figurative Eskimo mask from the Nushugak region. *Mid-C19th. 10 in (25.5 cm) wide* **$30,000–40,000 M&D**

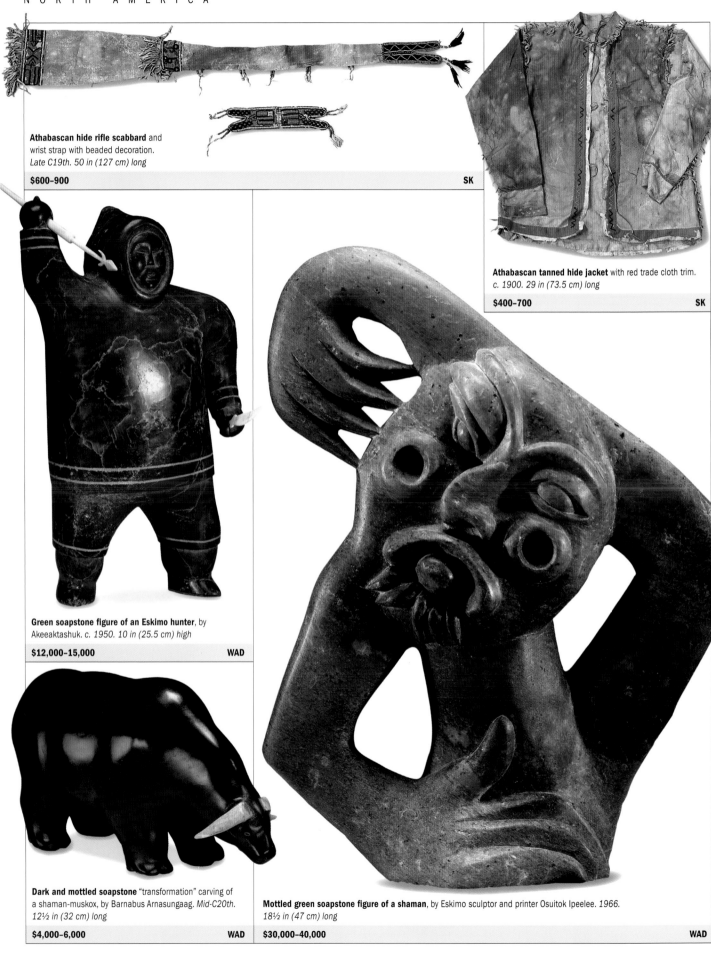

Athabascan hide rifle scabbard and wrist strap with beaded decoration. *Late C19th. 50 in (127 cm) long*

$600–900

SK

Athabascan tanned hide jacket with red trade cloth trim. *c. 1900. 29 in (73.5 cm) long*

$400–700

SK

Green soapstone figure of an Eskimo hunter, by Akeeaktashuk. *c. 1950. 10 in (25.5 cm) high*

$12,000–15,000

WAD

Dark and mottled soapstone "transformation" carving of a shaman-muskox, by Barnabus Arnasungaag. *Mid-C20th. 12½ in (32 cm) long*

$4,000–6,000

WAD

Mottled green soapstone figure of a shaman, by Eskimo sculptor and printer Osuitok Ipeelee. *1966. 18½ in (47 cm) long*

$30,000–40,000

WAD

A CLOSER LOOK

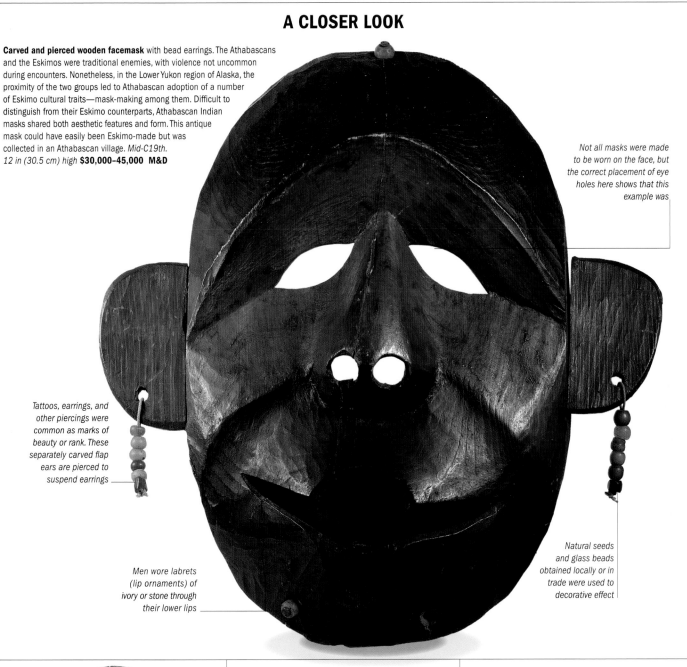

Carved and pierced wooden facemask with bead earrings. The Athabascans and the Eskimos were traditional enemies, with violence not uncommon during encounters. Nonetheless, in the Lower Yukon region of Alaska, the proximity of the two groups led to Athabascan adoption of a number of Eskimo cultural traits—mask-making among them. Difficult to distinguish from their Eskimo counterparts, Athabascan Indian masks shared both aesthetic features and form. This antique mask could have easily been Eskimo-made but was collected in an Athabascan village. *Mid-C19th.* *12 in (30.5 cm) high* **$30,000–45,000 M&D**

Not all masks were made to be worn on the face, but the correct placement of eye holes here shows that this example was

Tattoos, earrings, and other piercings were common as marks of beauty or rank. These separately carved flap ears are pierced to suspend earrings

Men wore labrets (lip ornaments) of ivory or stone through their lower lips

Natural seeds and glass beads obtained locally or in trade were used to decorative effect

Eskimo soapstone carving inset with the ivory hands and face of a spirit. *c. 1950. 5 in (12.5 cm) high*

$10,000–12,000 **WAD**

"Animal Kingdom" felt-tip drawing, by Kenojuak Ashevak. *c. 1960s. 26 in (66 cm) wide*

$1,200–1,800 **WAD**

"Dream" stone-cut print by Kenojuak Ashevak. *c. 1963. 26 in (66 cm) wide*

$5,000–7,000 **WAD**

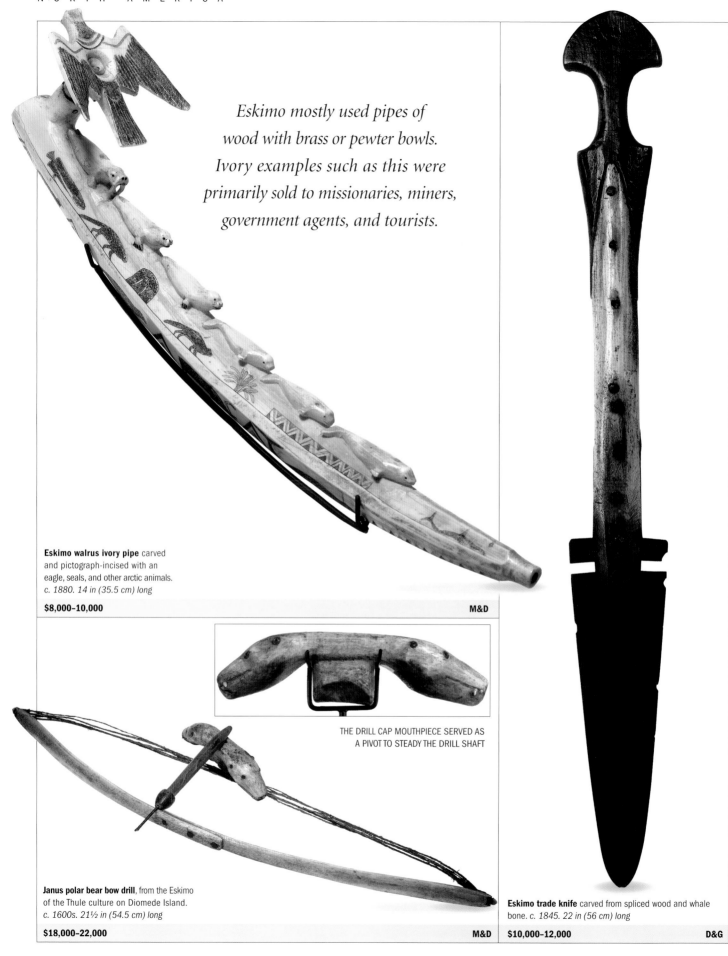

Eskimo mostly used pipes of wood with brass or pewter bowls. Ivory examples such as this were primarily sold to missionaries, miners, government agents, and tourists.

Eskimo walrus ivory pipe carved and pictograph-incised with an eagle, seals, and other arctic animals. *c. 1880. 14 in (35.5 cm) long*

$8,000–10,000　　　　　　　　　　**M&D**

THE DRILL CAP MOUTHPIECE SERVED AS A PIVOT TO STEADY THE DRILL SHAFT

Janus polar bear bow drill, from the Eskimo of the Thule culture on Diomede Island. *c. 1600s. 21½ in (54.5 cm) long*

$18,000–22,000　　　　　　　　　　**M&D**

Eskimo trade knife carved from spliced wood and whale bone. *c. 1845. 22 in (56 cm) long*

$10,000–12,000　　　　　　　　　　**D&G**

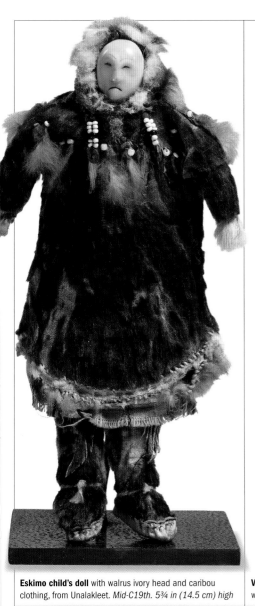

Eskimo child's doll with walrus ivory head and caribou clothing, from Unalakleet. *Mid-C19th. 5¾ in (14.5 cm) high*

$5,000–7,000 **M&D**

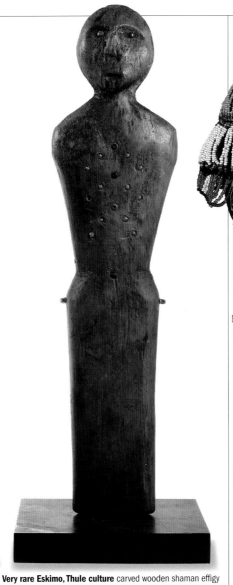

Very rare Eskimo, Thule culture carved wooden shaman effigy with trade bead eyes. *C17th–C18th. 12 in (30.5 cm) high*

$18,000–25,000 **M&D**

Eskimo salmon fishing-net float in the form of a human face, from Point Hope. *c. 1870. 2½ in (6.5 cm) wide*

$2,500–3,500 **M&D**

Male Eskimo dance mask carved and pierced in red cedar, from the Lower McKenzie River. *c. 1855. 13 in (33 cm) long*

$45,000–55,000 **D&G**

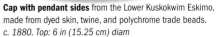

Cap with pendant sides from the Lower Kuskokwim Eskimo, made from dyed skin, twine, and polychrome trade beads. *c. 1880. Top: 6 in (15.25 cm) diam*

$5,000–7,000 **M&D**

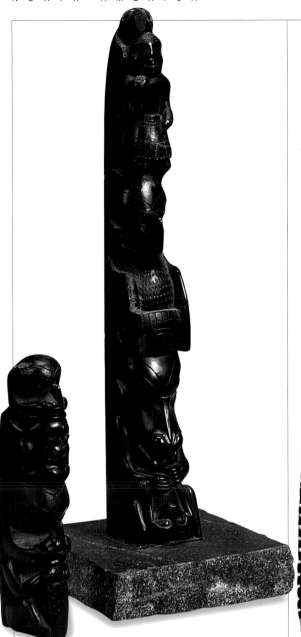

Two Haida totems carved from the shalelike stone argillite.
C19th. Tallest: 14¼ in (36 cm) high

$1,200–1,800 SK

Tlingit cloth wall pocket with beaded flora and fauna motifs.
c. 1900. 20½ in (52 cm) long

$400–700 SK

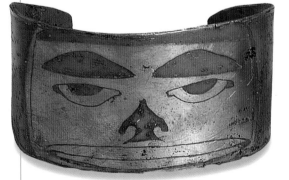

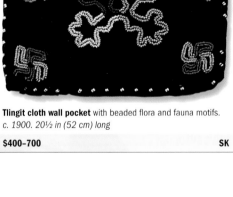

Two copper bracelets, one etched with a
stylized human face, the other with stylized bird
imagery. *Late C19th. 2½ in (6.5 cm) long*

$2,000–4,000 SK

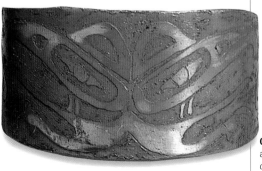

Ceremonial Haida canoe paddle carved
as a fish with additional aquatic imagery.
c. 1890–1910. 17¾ in (45 cm) long

$800–1,000 TSG

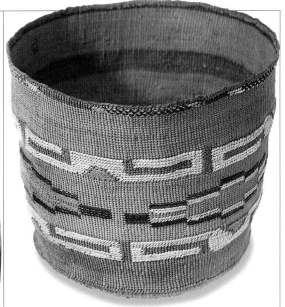

Tlingit tribe basket, finely woven with three central bands of geometric motifs. *Early 1900s. 5½ in (14 cm) high*

$1,000–1,500 ALL

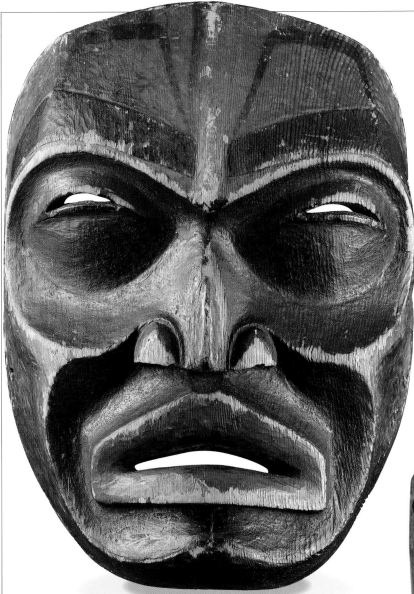

Tlingit tribe carved and pierced wooden male mask selectively painted with black pigment. *Mid-C19th. 10¾ in (27.5 cm) high*

$12,000–18,000 BLA

PATTERNS

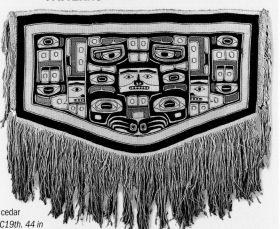

Most patterns used in native Northwest Coast art were conceived as animal images, although floral and geometric designs were also found. Incorporating depictions of the various animal spirits into ceremonial regalia called forth their supernatural powers and abilities for human use. The distinct Northwest aesthetic took delight in the abstraction of body and facial forms, creating a striking final portrait from an array of stylized parts.

***Chilkat* dance blanket** woven from cedar bark and mountain goat wool. *Late C19th. 44 in (112 cm) long* **$20,000–25,000 SK**

One of a pair of Tlingit tribe shaman-in-a-trance necklace pendants carved from cedar wood. *c. 1850s. 3½ in (9 cm) high*

$18,000–22,000 (the pair) M&D

155

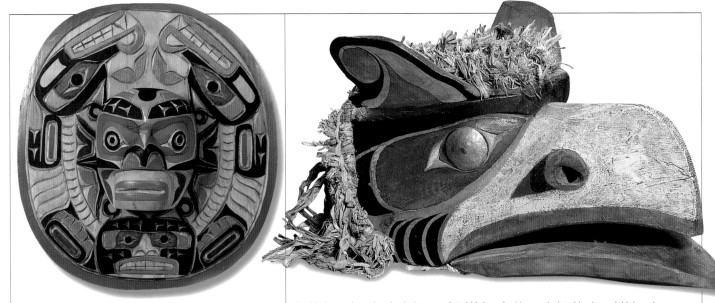

Kwakiutl carved and polychrome-painted moon mask, depicting humanoid faces and mythical seawolves. *Late C20th. 12 in (30.5 cm) diam*

$400–600 ALL

Kwakiutl carved wood and polychrome-painted bird mask with an articulated beak, overlaid domed copper eyes, and a vegetal fiber cresting. *1925–1950. 18 in (45.5 cm) long*

$6,000–7,000 SK

Nootka bone and sinew halibut hook. *C19th. 4¾ in (12 cm) high*

$300–500 PHK

Kwakiutl wooden facemask, carved and polychrome painted to symbolize a wasp. (A similar mask is displayed at the Museum of Natural History in Munich.) *c. 1870. 10½ in (26.5 cm) long*

$30,000–50,000 M&D

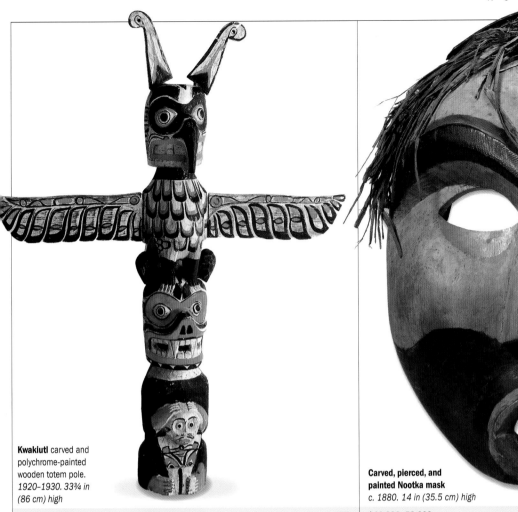

Kwakiutl carved and polychrome-painted wooden totem pole. *1920–1930. 33¾ in (86 cm) high*

$1,800–2,500 **JBB**

Carved, pierced, and painted Nootka mask *c. 1880. 14 in (35.5 cm) high*

$40,000–50,000 **M&D**

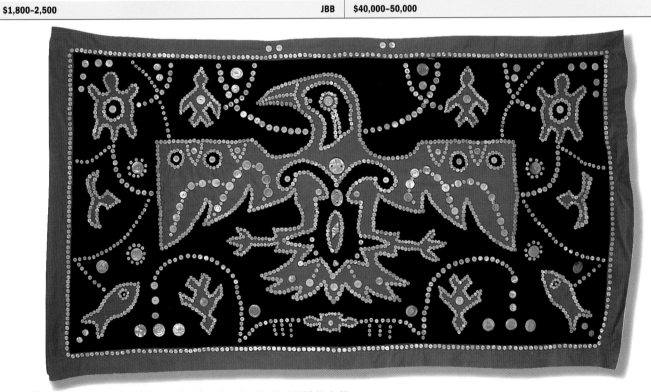

Button blanket with cut-out appliqué bird and animal forms in red, outlined and highlighted with real and faux mother-of-pearl buttons, all contrasted against a black ground. *C20th. 69 in (175 cm) long*

$900–1,800 **SK**

KEY FACTS

KEY FACTS

California tribes include the Hupa, Pomo, Yokut, Western Mono, Maidu, Karok, Panamint, and the various Mission groups. In the Plateau region are the Nez Perce, Yakima, Cayuse, Interior Salish, Klikitat, and Chinook.

A wide range of environments are found across this region: coastland, mountain ranges, desert, and verdant valleys—moderate climates and propitious conditions for a bounty of natural resources.

As hunter-gatherers, the relative ease of sustaining a comfortable life enabled the California Native Americans to develop remarkable talents in basketry.

Influences from the Native Americans of the Plains and the Northwest Coast led to the Plateau tribes' assimilation of a variety of art forms.

California and Plateau

As the last frontier of the Unites States' inexorable westward expansion, much of the traditional lifestyles and art forms of the native peoples of California and the Plateau region lasted well into the 19th century.

In California, the Hupa peoples wove basketry hats for themselves and lidded trinket baskets to sell. Another creative outlet was dance regalia decorated with shells, feathers, and quills. Unlike their baskets, little of this material survives today.

Considered the best weavers of all, the Pomo's most prized baskets were covered with feathers and strung with shell pendants—historically made to be burned in mortuary rites. Small-mouthed "bottleneck" baskets were woven by the Yokuts. Sometimes used to carry rattlesnakes in a ceremonial rite, they were decorated with rows of diamond lozenges in a diamond-back rattlesnake pattern. Rattlesnakes and pictorial motifs were also featured in baskets from the Cahuilla and other "Mission" Indians in the South, reflecting their arid desert surroundings.

In the Plateau, the horse culture adopted from the Plains inspired lavish trappings for the Cayuse's favorite steeds and resplendent attire for their riders. Beaded cradles protected their babies and swaddled them in beauty. The Nez Perce admired geometric decoration while the Yakima tended toward floral designs. Functional basketry became an artistic statement for Salish and Klikitat women, as did the cornhusk bags (*see right*) woven by many of the Plateau peoples.

Wooden-framed hide-, cloth-, and polychrome bead-covered Plateau cradle. *Early C20th. 38 in (96.5 cm) long* **$5,000–9,000 SK**

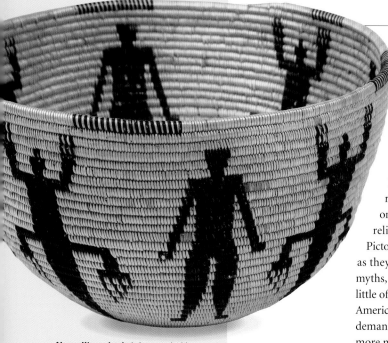

Above: Woven basket decorated with alternated stylized figures of humans and lizards, from the Panamint. *c. 1920. 6 in (15.25 cm) diam* **$15,000–18,000 D&G**

PICTORIAL BASKETRY

The evolution of designs in Californian basketry owes much to the demands and tastes of the marketplace. Basket-weaving was widespread throughout the area, and functional cooking and storage bowls sat alongside gaming trays, cradles, hats, and ritual objects in the weaver's repertoire. Traditional basketry changed once the Native Americans found themselves reliant on a foreign, dominant civilization. Pictorial baskets proved popular among buyers as they purportedly revealed Native history, myths, and heretofore-secret symbols. In reality, little of that was true. Responding to non-Native American tastes, weavers took to satisfying market demand with stereotypical Indian designs often more meaningful to the buyer than the seller.

BASKET WEAVING

UTILITARIAN BEAUTY

While it is unlikely that the people of the Plateau used a word for "art" in relation to their homemade pieces, aesthetics surely played a role in the objects they created for function, fun, and fanfare. Symmetry was the rule for painting the two flaps of a typical parfleche bag (*see right*). Similarly, the softly woven cornhusk bag lined up decorative devices in a balanced composition, but showed asymmetry with a different design on each side. The peoples of the Plateau took great pleasure and pride in displaying the artistic skills of the women (mostly), imbued with brilliant color and clever invention.

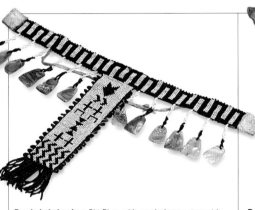

Cornhusk bag of rectangular form decorated with repeat geometric motifs in polychrome woolen yarns. *c. 1900. 22 in (56 cm) high* **$1,000–1,500 SK**

ON THE MOVE

Parfleche container painted with a symmetrical polychrome geometric pattern. Parfleche literally translates from the French as "against arrows." These resistant containers carried meat and other foodstuffs when traveling. *Early C20th. 26½ in (67.5 cm) long* **$1,500–2,000 SK**

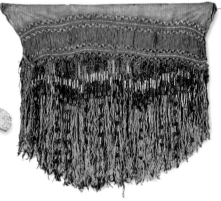

Beaded choker from Pitt River, with a polychrome geometric pattern, beaded fringe, and abalone pendants. *c. 1900. 15 in (38 cm) long*

$300–500 **SK**

Buckskin dance skirt from northern California, decorated with vegetal fiber-wrapped strands of glass beads, and brass thimbles. *Late C19th. 34 in (86.5 cm) wide*

$20,000–25,000 **SK**

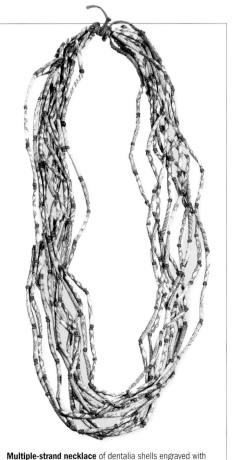

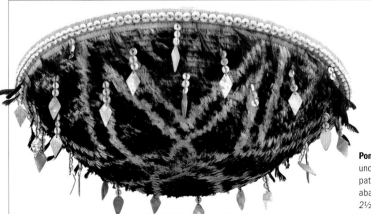

Pomo basketry bowl, the flat underside with a feather star pattern, and clamshell and abalone pendants. *c. 1900. 2½ in (6.5 cm) high*

$4,000–5,000 **SK**

Multiple-strand necklace of dentalia shells engraved with geometric motifs and strung with red glass bead spacers. *Late C19th. 19 in (48.5 cm) long*

$8,000–10,000 **SK**

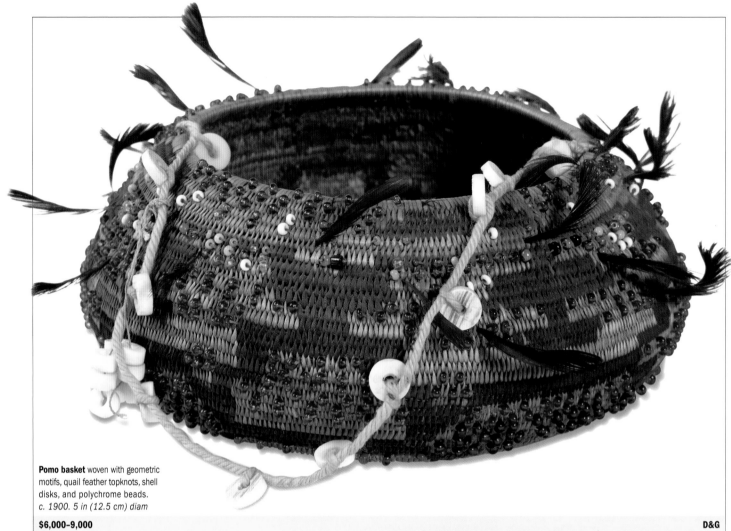

Pomo basket woven with geometric motifs, quail feather topknots, shell disks, and polychrome beads.
c. 1900. 5 in (12.5 cm) diam

$6,000–9,000 **D&G**

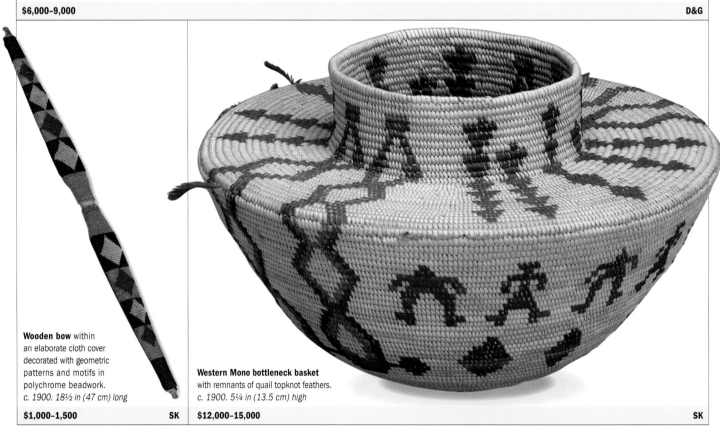

Wooden bow within an elaborate cloth cover decorated with geometric patterns and motifs in polychrome beadwork.
c. 1900. 18½ in (47 cm) long

$1,000–1,500 **SK**

Western Mono bottleneck basket with remnants of quail topknot feathers.
c. 1900. 5¼ in (13.5 cm) high

$12,000–15,000 **SK**

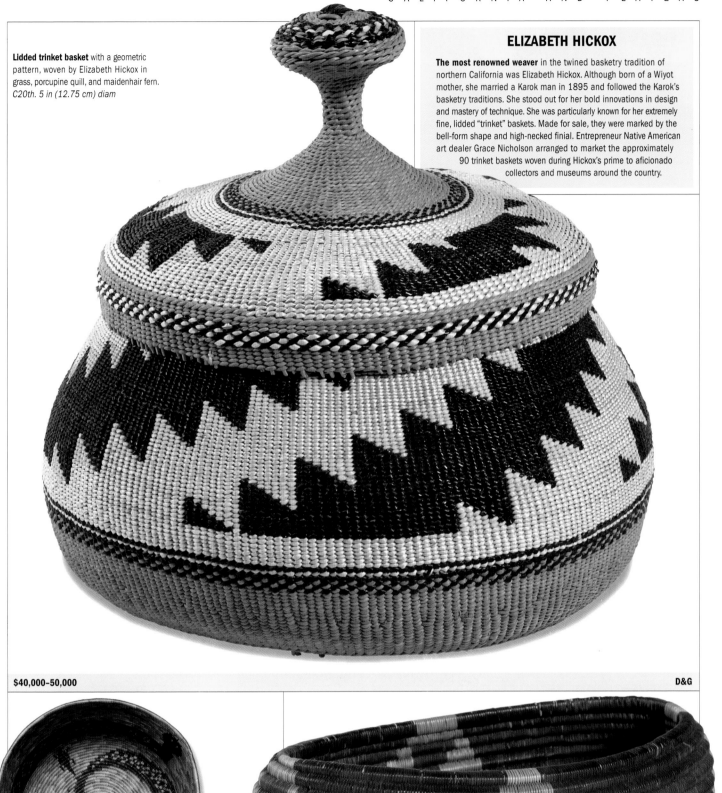

Lidded trinket basket with a geometric pattern, woven by Elizabeth Hickox in grass, porcupine quill, and maidenhair fern. *C20th. 5 in (12.75 cm) diam*

ELIZABETH HICKOX

The most renowned weaver in the twined basketry tradition of northern California was Elizabeth Hickox. Although born of a Wiyot mother, she married a Karok man in 1895 and followed the Karok's basketry traditions. She stood out for her bold innovations in design and mastery of technique. She was particularly known for her extremely fine, lidded "trinket" baskets. Made for sale, they were marked by the bell-form shape and high-necked finial. Entrepreneur Native American art dealer Grace Nicholson arranged to market the approximately 90 trinket baskets woven during Hickox's prime to aficionado collectors and museums around the country.

$40,000–50,000 D&G

Mission basketry bowl with coiled snake decoration. *c. 1890–1910. 14 in (35.5 cm) diam*

$15,000–20,000 MSG

Oval Pomo tribe basket with geometric motifs. *c. 1910. 5½ in (14 cm) long*

$7,000–9,000 D&G

161

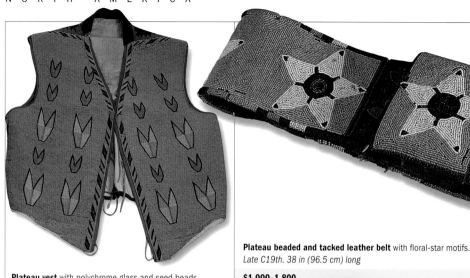

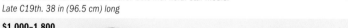

Plateau beaded and tacked leather belt with floral-star motifs. *Late C19th. 38 in (96.5 cm) long*

$1,000–1,800 SK

Plateau vest with polychrome glass and seed beads on canvas. *Early C20th. 24 in (61 cm) long*

$1,200–1,800 SK

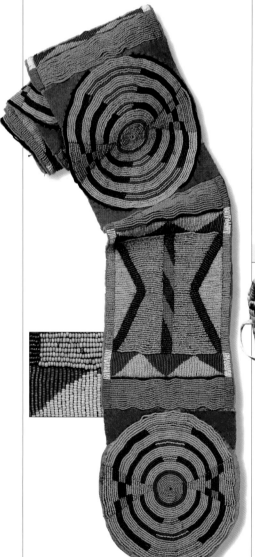

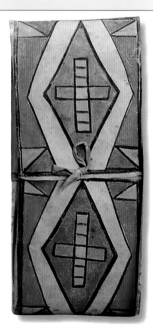

Pair of Yakima tribe hide gauntlets with beaded pictographic decoration. *1920–1930. 12 in (30.5 cm) long*

$7,000–9,000 MSG

Nez Perce tribe prestige blanket strip with a polychrome geometric pattern. *c. 1870. 6 in (15.25 cm) long*

$50,000–60,000 D&G

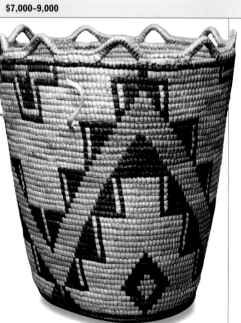

Klikitat tribe imbricated basket with geometric motifs and multiple loop handles. *1910–1930. 13 in (33 cm) high*

$7,000–9,000 MSG

Plateau parfleche envelope with a bold geometric pattern. *Late C19th. 27 in (68.5 cm) long*

$2,000–3,000 SK

A CLOSER LOOK

Infant cradles were carried on the back or on the sides of horses. A mother's love for her child was clearly expressed in the practical construction and beautiful embellishments of the Plateau cradle. Tanned hide was fitted around a flat, dome-topped wood board. The distinct top served to protect the child should the cradle fall head-first. It also served as a "canvas" for the beaded pattern on display. Finally, a soft hide pocket would be fastened to keep the baby snug.

Below left: Wooden framed infant cradle covered in natural and two-tone blue dyed hide. *Early C20th.*
39 in (99 cm) high **$6,000–7,000 SK**

Below right: A Nez Perce infant cradle comprising deer hide and a cloth-covered wooden board.
c. 1870. 46 in (117 cm) long **$90,000–100,000 D&G**

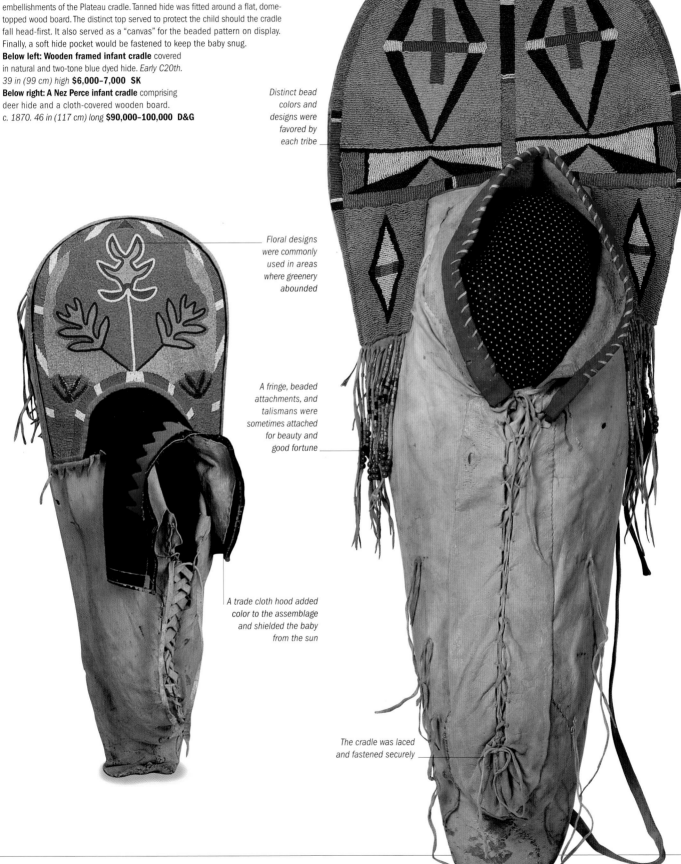

Distinct bead colors and designs were favored by each tribe

Floral designs were commonly used in areas where greenery abounded

A fringe, beaded attachments, and talismans were sometimes attached for beauty and good fortune

A trade cloth hood added color to the assemblage and shielded the baby from the sun

The cradle was laced and fastened securely

KEY FACTS

Tribes include the Navajo, Hopi, Apache, Pima, Papago, and the Pueblo peoples from Jemez, San Ildefonso, Acoma, Zuni, Santo Domingo, and Tesuque.

This is a dry land of rugged mountains, deserts, and canyons, irrigated by the Rio Grande and Colorado Rivers.

Inhabited for more than 7,000 years, the region still holds the ruins of great ancient cities and clifftop villages.

Southwest

The native peoples of the Southwest held on to elements of the ancient customs of their forebears right into the 20th century—probably more so than the peoples of any other region of the country.

It is quite probably the Southwest peoples' determined conservative approach to living in accordance with the wisdom and teachings of generations gone before that has fostered the creation of such an abundance of artistic objects. The Pima and Papago of today, along with their Pueblo brethren, can trace their ancestral lines back to the very first peoples of the Southwest—the Hohokam, the Anasazi, and the Mogollon.

Though their lives were dramatically changed, like Native Americans everywhere, by the incursion of outsiders on their lands in the 17th century, much of the Southwest's indigenous population continued to follow traditional patterns of subsistence. These called for the prolific crafting of pottery, baskets, sculptures, weavings, and jewelry, as well as ceremonial implements, such as dolls and figures for use in their daily lives.

ART STYLES OF THE PEOPLES

The Navajo of eastern Arizona and western New Mexico have gained fame for their textiles. Latecomers to the art of weaving, they learned from their Pueblo teachers and eventually surpassed them, in both quantity and quality. Blankets were the first and only products of their looms until around 1880.

Above: Tesuque tribe seated clay figure, the head painted with yellow and green motifs on a cream ground. *Late C19th. 13¼ in (34 cm) high* **$5,000-7,000 SK**

Below: Navajo polychrome woolen blanket depicting plants and animals. 1925-1950. 81 in (206 cm) long **$10,000-12,000 SK**

PICTORIAL RUGS

From the earliest evolution of simple, striped blankets for wearing, Navajo weaving designs became a complex array of mostly symmetrical, geometric patterns. An exception to that rule was introduced with pictorial weavings as an overture to the commercial market. Though very few 19th-century blankets produced for local use contained human, animal, or plant motifs, later rug production incorporated every image imaginable as an attraction to buyers. Depictions of spirit figures known as *yeis* were popular, as were important elements of the Navajo world, such as corn, birds, livestock, and horses.

Right: Navajo woolen blanket with a polychrome "eye-dazzler" pattern of serrated diamonds. Early C20th. 84 in (213.5 cm) long **$3,000-4,000 SK**

Eventually, they turned to the market economy out of necessity and made rugs for non-Native floors. The Navajo were also unrivaled in working silver. Inspired by Spanish designs and technology brought up from Mexico, the Navajo silversmiths designed "squash blossom" necklaces, silver horse ornaments, and an archer's wrist guard called a *ketoh*.

Pottery, basketry, jewelry-making, and the carving of *kachina* dolls were arts practiced by the Hopi of northeastern Arizona. They excelled particularly in hand-coiling beautiful ceramic bowls, canteens, ladles, and jars of all sizes. The design vocabulary found on Hopi pottery appears to be extensive, but is, in fact, limited largely to abstract bird images, wings, and feathers rendered in geometric fashion. Birds are much represented, as they are of sacred importance to the Hopi, who believe that they carry people's prayers to heaven.

Among the Pueblo peoples situated primarily along the Rio Grande River in northern and eastern New Mexico, pottery was the principal means of artistic expression. The need for functional vessels for storing dry goods, keeping water, and cooking brought forth many similar yet distinct aesthetic styles in form and decorative fashion. Once the railroad opened up this region to tourism, practical pottery evolved into art objects made for sale. Communities such as Acoma, Santa Clara, Tesuque, and Santo Domingo jealously guarded their traditional ways, yet saw a source of revenue in tailoring their pottery production to non-Native American tastes.

The southernmost peoples of this region, the Apache, practiced beadwork, not unlike their neighbors on the Plains. They were most famous, however, for their basketry, which was expertly rendered and featured stylized human and animal figures or dramatic geometric designs. The Pima and the Papago were also known for their skill in basketry.

KACHINA DOLLS

Wooden kachina *figures representing helper deities were carved by the Hopi and Zuni peoples as religious teaching aids for their children.*

ZUNI KACHINA

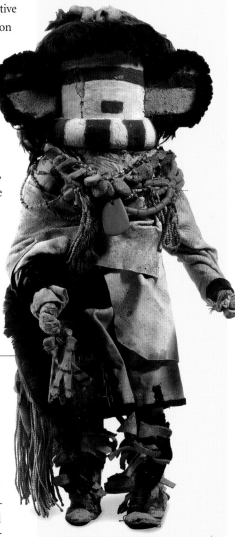

Zuni tribe *kachina* **doll** representing Hututu—a spirit of nature who takes his name from the cry he makes. Zuni dolls differed from those of the Hopi. They were usually more slender and elongated, with articulated arms, and were dressed in cloth garments, leather moccasins, and other regalia. They also represented a related, though distinct, pantheon. *C19th. 15 in (38 cm) high*
$60,000–90,000 D&G

POTTERY REVOLUTION

From the ranks of Southwest potters throughout the 20th century, the name of Maria Martinez became synonymous with this art form in the eyes of the outside world. Born in the New Mexico village of San Ildefonso, Maria was not content to continue producing only the traditional styles of her village. She pioneered an innovative variety of black-on-black ceramics, painting a matte design on a glossy polished surface. She also became the first potter to begin signing her work, on the advice of an Anglo collector. Extremely prolific for decades, her pottery remains highly sought after and valuable.

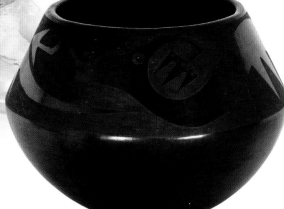

A MARIA MARTINEZ
POTTERY WORKSHOP

Left: Black ceramic bowl with an *avanyu* (horned water serpent) frieze, by Maria Martinez. *c. 1930. 6½ in (16.5 cm) wide*
$5,000–7,000 MED

Navajo

The Navajo, the living heirs of the Athabascan race, did not arrive in the Southwest until around the 15th century. Living a nomadic existence, they initially survived by hunting, foraging, and carrying out raids on the settled villages they encountered. It was not long, however, before the *Diné*, as they called themselves, took up some of the sedentary traits of their Pueblo quarry. They began to practice agriculture and, putting down roots, learned the skills of weaving and pottery. True to their nomadic heritage, they eschewed the notion of a centralized community and lived in small, scattered family bands.

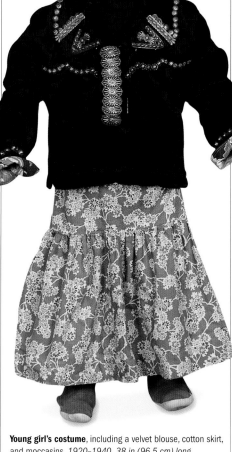

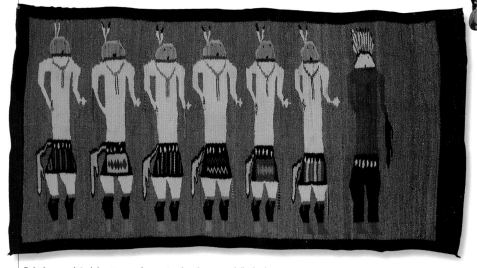

Polychrome pictorial rug woven from natural and commercially dyed homespun yarns, and depicting seven *yei* (holy people) dancers. *c. 1920s. 58 in (147.5 cm) long*

$1,800–2,200 SK

Young girl's costume, including a velvet blouse, cotton skirt, and moccasins. *1920–1940. 38 in (96.5 cm) long*

$2,500–3,000 SK

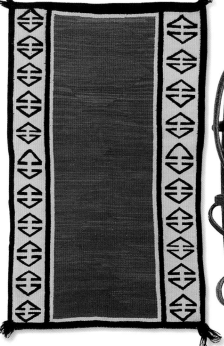

Large woolen rug woven with a polychrome fretwork pattern on a variegated gray ground, within a red and dark brown fretwork pattern border. *Early C20th. 116 in (295 cm) long*

$3,000–4,000 SK

Woolen double saddle blanket, woven with a variegated brown center panel flanked by geometric-pattern borders in black and cream. *c. 1930. 48 in (122 cm) long*

$5,000–6,000 SK

***Ketoh* (wrist guard)** comprising a hide-mounted floral motif in repoussé silver set with three oval turquoise cabochons. *c. 1925. 3.5 in (9 cm) long*

$1,200–1,800 SK

Hopi

For a thousand years or more the Hopi people inhabited their stone-built villages atop a series of *mesas* in a corner of the arid Southwest landscape. They eked out a living through subsistence farming and forged a delicate balance with the unforgiving environment through a never-ending cycle of religious rituals and entreaties to the gods. An essentially pacifistic people, they nonetheless rose up in intensely violent fashion to resist the 17th- and 18th-century incursions of the Spanish—remaining unconquered, and retaining their culture largely intact.

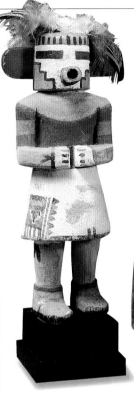

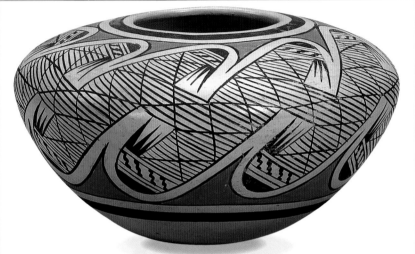

Ceramic jar with a stylized bird-wing frieze in black against a cream and brown ground. *1940–1960. 6.5 in (16.5 cm) diam*

$700–900 SK

***Kachina* figure** carved in wood, with polychrome pigment and a feather headdress. *c. 1940. 7½ in (19 cm) high*

$1,200–2,000 BLA

Flat, cut-out wooden form of a woman in polychrome-painted clothing and carrying a water *olla*. *c. 1900. 15 in (38 cm) high*

$1,500–2,000 SK

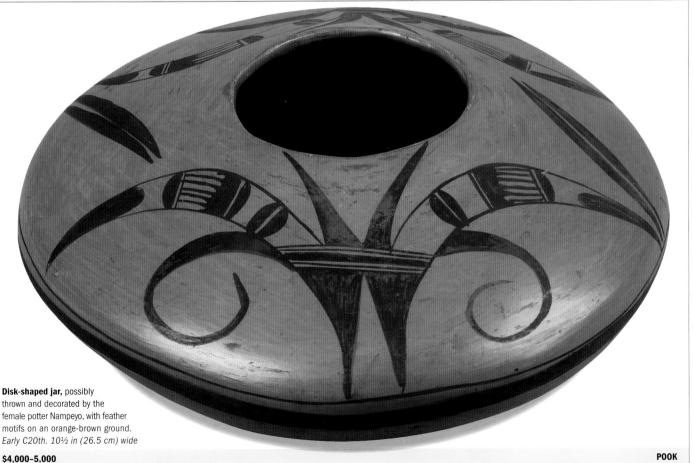

Disk-shaped jar, possibly thrown and decorated by the female potter Nampeyo, with feather motifs on an orange-brown ground. *Early C20th. 10½ in (26.5 cm) wide*

$4,000–5,000 POOK

Pima and Papago

The Pima, and their neighbors the Papago, descended from the ancient Hohokam culture. The Pima's homeland was traversed by two substantial waterways that allowed irrigation farming and the subsequent establishment of permanent settlements. Papago land was less hospitable, forcing them to lead a semi-nomadic, rustic existence. Their basketry is striking, notable for strong geometric patterns and folkloric pictorial motifs.

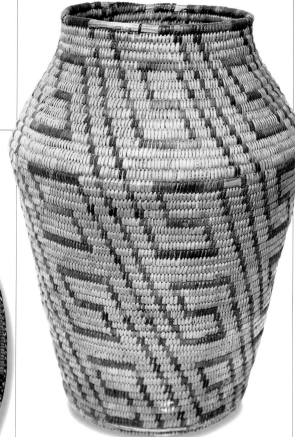

Papago *olla*-shaped basketry vessel with a gently spiraling key pattern. *c. 1930. 14 in (35.5 cm) high*

$700–900 ALL

Pima coiled basketry tray with human and animal motifs. *Early C20th. 16.5 in (42 cm) diam*

$4,000–6,000 SK

Pima shallow basketry bowl with a "man in the maze" pattern. *c. 1920. 15½ in (39.5 cm) diam*

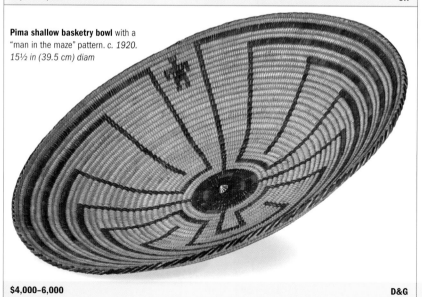

$4,000–6,000 D&G

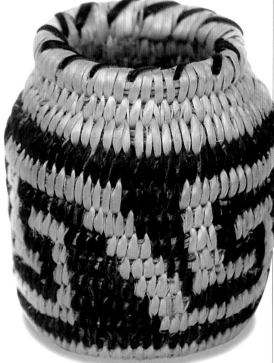

Pima miniature *olla*-shaped basket with a traditional Greek-key pattern around the circumference. *c. 1970. 1¼ in (3 cm) high*

$120–180 ALL

Apache

Legendary for their fierce aptitude as warriors, the Apache were also farmers and traders. They were a proud people, with related bands spread over a wide area of Arizona, New Mexico, and into Texas. Wherever they went, they tended to "borrow" from their neighbors—either ransacking food and provisions in raids, or peacefully learning the ways of the Plains buffalo hunters, the Pueblo farmers, and the Navajo herders. Their basketry designs are similar to those of the Pima, but their beadwork is unlike any other.

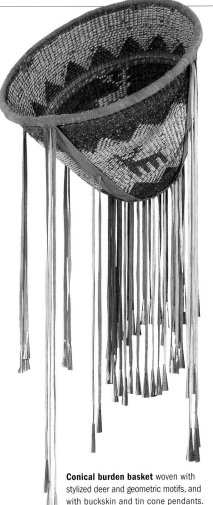

Conical burden basket woven with stylized deer and geometric motifs, and with buckskin and tin cone pendants. *c. 1980. Basket: 17 in (43 cm) high*

$300–700 **ALL**

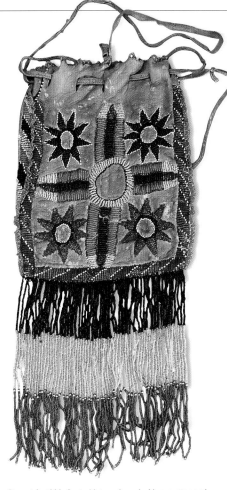

Drawstring hide bag with tassels and with sun, star, and geometric motifs all in polychrome beadwork. *Early C20th. 10 in (25.5 cm) long*

$1,000–1,600 **SK**

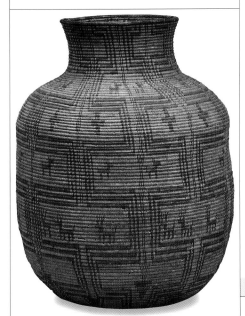

Large, *olla*-shaped, coiled basketry vessel with a trelliswork pattern. *Early C20th. 21½ in (54.5 cm) high*

$15,000–20,000 **SK**

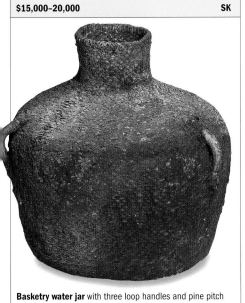

Basketry water jar with three loop handles and pine pitch exterior. *c. 1900. 12½ in (31 cm) high*

$700–1,000 **SK**

High-top hide moccasins with "cactus-kicker" toes and painted motifs in black, yellow, and red. *Late C19th. 41 in (104 cm) long*

$6,000–8,000 **SK**

KEY FACTS

Tribes include the Crow, Hidatsa, Blackfoot, Plains Cree, Sioux, Cheyenne, Arapaho, Comanche, and Kiowa.

A vast territory of grasslands, bluffs, and river valleys, the Great Plains extend from northern Canada to southern Texas and encompass most land east of the Rocky Mountains and west of the Mississippi River.

Immigration into the Plains from surrounding areas after the 13th century resulted in a polyglot mix of cultures from the Athabascan, Algonquian, Siouan, Kiowan, Shoshonean, and Caddoan language families.

Plains

The nomadic warrior horseman and buffalo hunter of the Plains, perhaps more than any other image, symbolizes Native American culture to the outside world. Nonetheless, this way of life had its heyday for only a little over 100 years.

From the 14th to the 17th century, indigenous groups from lands bordering the Great Plains found their way into this sparsely populated area. Along with rudimentary farming and the taking of deer, antelope, and smaller game, they survived by the difficult and often dangerous task of hunting buffalo. This animal was of the utmost importance to the Plains Native Americans, as they used virtually all its parts for food, clothing, shelter, and the manufacture of a variety of implements.

The addition of the horse, which was introduced earlier in the Southwest by the Spanish, completed the equation. Now mounted, the Plains people were able to follow the buffalo herds and enjoy a seemingly inexhaustible supply of vital resources. During the second half of the 19th century, however, wholesale slaughter by nonnative commercial interests led to the near extinction of the buffalo and profound lifestyle changes for the people who depended on it.

ART FROM LAND AND LIFE

Many of the Plains artifacts now found in the marketplace date from the last quarter of the 19th or early 20th centuries. By that time, their decoration had evolved into a busy, ostentatious

Above: Sioux tribe parfleche with painted decoration. *Late C19th. 19½ in (49.5 cm) long* **$2,000–3,000 SK**

ANIMAL-HIDE FINERY

Among the myriad uses Plains people had for the buffalo, the tailoring of functional and handsome robes from the beast's hide was a practical necessity. Winters were harsh, and a thick, shaggy buffalo blanket not only enveloped the user but was also a perfect format for displaying propitious designs and emblems of status. The thinner skins of deer or antelope were used where buffalo were not found for lighter clothing, pouches, saddle covers, and other trappings.

Hidatsa tribe buffalo-hide robe, trimmed with paws, ears, and tail, and painted with a bear amid a shower of red hailstones. *Late C19th. 55 in (139.5 cm) wide* **$150,000–180,000 TB**

Cree tribe hide pad saddle with beaded floral decoration, and bead and fiber pendants. *Late C19th. 22 in (59 cm) long* **$3,000–5,000 SK**

style, though personal items such as ceremonial drums or medicine objects continued to be adorned with images largely perceived in visions. (Earlier examples, such as buffalo robes and painted hides from the Mandan, illustrated a largely unaffected, older, time-honored taste in decoration.)

As important as the horse was for hunting, raiding, and warfare, it comes as no surprise that elaborate and beautiful objects were contrived in its honor. The Plains Cree used what was called a pad saddle and beaded its suspended flaps in showy floral or geometric patterns. Likewise, the Crow lavished remarkable time and talent on the embellishment of horse gear. Bridles, saddles, cruppers, and a horse chest ornament known as a martingale would be beaded in the distinctive stylishly designed and brilliantly colored Crow style.

Art was interwoven with all facets of the people's lives. The Blackfoot and the Sioux beaded blanket strips to adorn buffalo robes

and, later, trade blankets. They and other groups made folded or sewn painted rawhide carrying cases known as parfleche containers. All of the tribes fashioned bags of every sort, the Kiowa gaining distinction for their predilection for using commercial harness leather in their creations. Smoking, whether a social pastime or a sacred rite, called for an assortment of related paraphernalia. The Cheyenne and the Arapaho used these occasions to show off attractive hand-carved pipes, tobacco bags, and a small, hide box flint case (often with tin cone decoration) referred to as a "strike-a-lite."

HUNTING

As with any nomadic culture, the people's seasonal movements were centered on the quest for food. Hunting skills were of immeasurable importance and were taught to children at a young age. When the carbine rifle was introduced, it very quickly became one of a Plains man's most treasured possessions (along with his horse).

RIFLE CASE

Beaded hide rifle case from the Sioux tribe. A Plains man's wife would craft a soft hide rifle case replete with decorative fringe and handsome beaded designs, as would befit a tool of this importance. *c. 1870s. 45 in (114.5 cm) long* **$20,000–25,000 SK**

HIDE PAINTINGS

Plains artistic talents were expressed primarily in three media: porcupine-quill embroidery, beadwork, and painting. The last was found on almost every available surface and served to display highly personal images of power as obtained through visions, or generic designs—usually representational—understood by other members of the tribe. People painted on clothing, utilitarian implements, teepees, and themselves. In ritual use, painted designs took on a special significance, aiding in the accomplishment of desired tasks through invocations of the painted image's magical powers. Drums and shields in particular were effective as portable, visual demonstrations of a man's psychic identity and prowess.

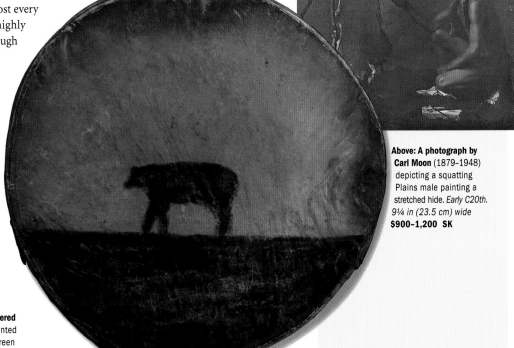

Above: **A photograph by Carl Moon** (1879-1948) depicting a squatting Plains male painting a stretched hide. *Early C20th. 9¼ in (23.5 cm) wide* **$900–1,200 SK**

Right: **Wooden-framed, rawhide-covered drum** with an internal bell and painted with a walking bear in dark blue-green pigment. *C19th. 19 in (48.5 cm) diam* **$60,000–90,000 SK**

Northern Plains

Alongside the Crow, Cree, and Blackfoot, lesser-known tribes such as the Assinaboin, Mandan, and the Gros Ventre were all part of this rich, multicultural melting pot. Though the peoples of the Northern Plains retained well-defined cultural identities, they were artistically influenced by neighboring peoples through extensive trade contact or, sometimes, artifact trophies taken in intertribal hostilities.

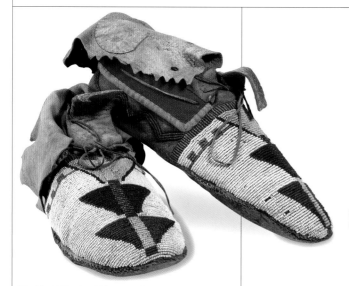

Blackfoot tribe deer-hide moccasins with scalloped ankle flaps, red trade cloth trim, and seed beadwork motifs. *1870. 10½ in (26.5 cm) long*

$20,000–25,000	**D&G**

Northern Plains beaded pipe bag. *c. 1860. 30 in (76 cm) long*

$20,000–25,000	**TB**

Blackfoot tribe fringed hide pouch, beaded with geometric devices (including arrowheads). *Early C20th. 22 in (59 cm) long*

$2,500–3,000	**SK**

Cree or Blackfoot tribe medicine necklace. *c. 1865. 14 in (35.5 cm) long*

$6,000–9,000	**D&G**

Breastplate with hide-strung bone hair pipes, polychrome glass trade beads down the center, and a central glass bead-and-shell disk pendant. *Late C19th. 19 in (48 cm) long*

$1,200–1,800	**SK**

Blackfoot tribe muslin blanket strip with polychrome cloth and beadwork geometric motifs. *Early C20th. 61 in (155 cm) long*

$2,000–3,000	**SK**

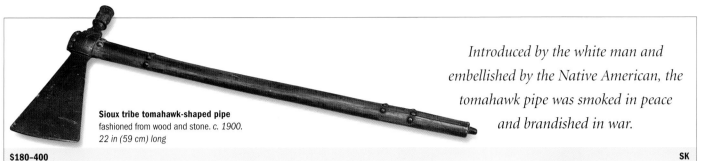

Sioux tribe tomahawk-shaped pipe
fashioned from wood and stone. *c. 1900.*
22 in (59 cm) long

$180–400 **SK**

*Introduced by the white man and
embellished by the Native American, the
tomahawk pipe was smoked in peace
and brandished in war.*

Crow

No one loved a parade more than the Crow people
in the present-day state of Montana, and no parade
displayed more lavish decoration than a festive
assembly of Crow men and women on horseback.
(Both rider and horse would be dressed up for
the occasion.) An important tribal gathering was
an opportunity to show off the beautiful style of
beadwork for which Crow women were justifiably
famous. Stylized and naturalistic floral motifs were
found within their repertoire, but the classic Crow
signature style consisted of outlined box, triangle,
and diamond forms arranged in a symmetry of
brilliant, contrasting colors.

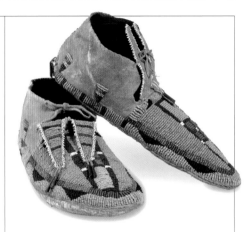

Pair of buffalo-hide moccasins with seed beadwork
and trade cloth decoration. *c. 1865. 10 in (25.5 cm) long*

$15,000–20,000 **D&G**

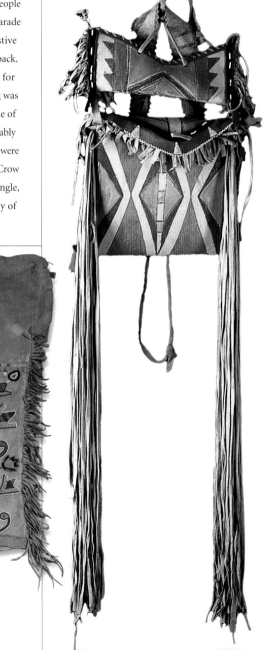

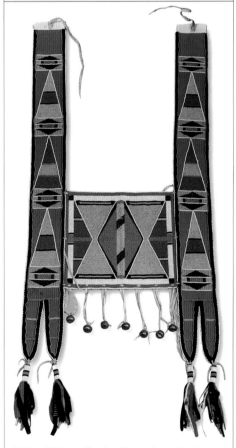

Pair of fringed hide leggings with polychrome beadwork in
floral and geometric motifs. *Late C19th. 22½ in (57 cm) long*

$2,000–3,000 **SK**

Tasseled parfleche double-pouch, with geometric pattern
polychrome-dyed decoration. *1870s. 44 in (112 cm) long*

$40,000–60,000 **SK**

Cloth and hide martingale, with polychrome beadwork,
and hide and hawk bell tassels. *c. 1900. 42 in (107 cm) long*

$9,000–12,000 **SK**

Central and Southern Plains

The Pawnee, Ponca, and Osage joined the Sioux, Cheyenne, Kiowa, Arapaho, Comanche, and other Central and Southern Plains peoples in a cultural unity linked by their equestrian lifestyle centered on the buffalo. Artistically they were a diverse group, from the Sioux preference for heavy beadwork to the Southern taste for sparse, partial beading.

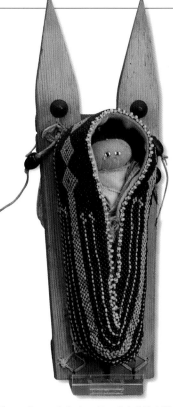

Comanche wood plank and beaded cloth doll's cradle, with a small cloth doll. *Early C20th. 8¼ in (21 cm) long*

$5,000–7,000 SK

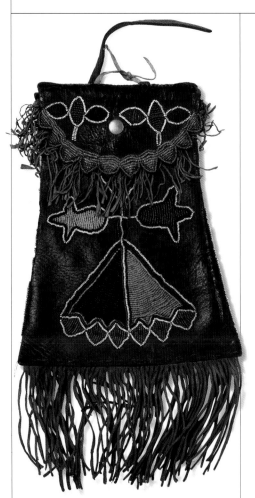

Kiowa tribe dispatch pouch made from boot leather with tassels and beadwork. *c. 1875. 13¾ in (35 cm) long*

$15,000–18,000 D&G

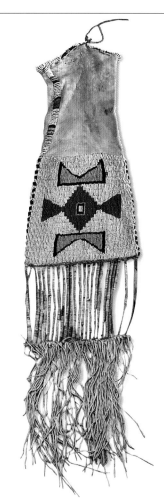

Sioux quilled-hide tobacco bag with beadwork decoration. *Late C19th. 26 in (66 cm) long*

$1,200–1,800 SK

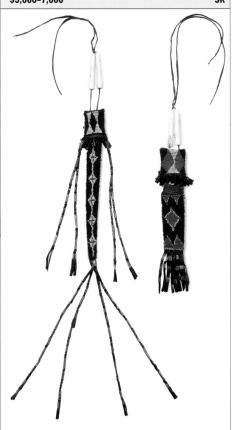

Southern Cheyenne child's yellow-stained hide coat, with bead and bean trim. *Late C19th. 20 in (50.75 cm) long*

$20,000–25,000 SK

Ceremonial hide drum, attributed to the Cheyenne tribe. *1860s. 17½ in (44.5 cm) diam*

$10,000–15,000 TB

Kiowa tribe tasseled leather whetstone case (*left*) and beaded leather awl case (*right*)—both belt-worn. *c. 1875. Left: 18 in (45.5 cm) long. Right: 9½ in (24 cm) long*

$9,000–10,000 each D&G

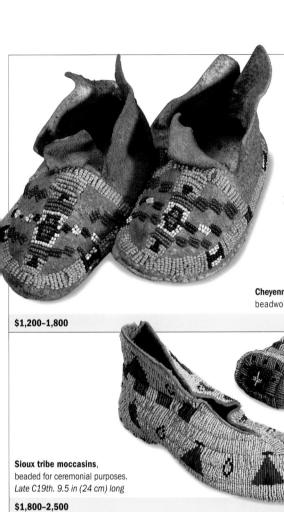

Cheyenne infants about to take their first steps are given new moccasins blessed with sacred herbs.

Cheyenne tribe infant's hide moccasins with polychrome beadwork decoration. *Late C19th. 4¼ in (11 cm) long*

$1,200–1,800 SK

Sioux tribe moccasins, beaded for ceremonial purposes. *Late C19th. 9.5 in (24 cm) long*

$1,800–2,500 SK

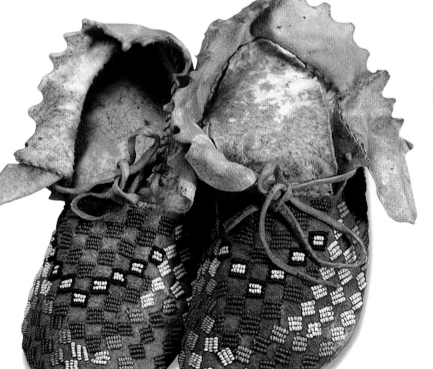

Arapaho tribe child's polychrome-beaded hide moccasins. *Late C19th. 7½ in (19 cm) long*

$1,500–2,000 SK

Arapaho tribe woman's high-top moccasins, in stained yellow and green hide with fringed tops and polychrome beadwork decoration. *Late C19th. 23 in (58.5 cm) long*

$12,000–16,000 SK

FOOTWEAR

The traditional shoes of Native Americans became known as moccasins. Different styles evolved around the country according to local geography and climate. As these variables remained somewhat constant throughout the entire Plains region, moccasin types differed little, at least structurally. Where tribal identities stood out was in the method of adornment. Everyday moccasins had little decoration, but when fashion counted, they became an artistic display of porcupine-quill and glass-bead designs. Each tribal group favored distinct patterns, formats, and even bead colors. In the South, for example, partial beading was prevalent. Among certain groups the women wore "high-top" assemblages of moccasins and leggings. Some ceremonial pairs were beaded even on the soles.

Great Lakes and Eastern Woodlands

The indigenous peoples of the Great Lakes and Eastern Woodlands regions were some of the first encountered by Europeans on the North American continent. Under enormous pressure, those cultures that survived did so by retaining vital traditions and adopting others.

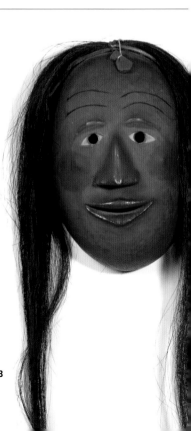

As the French, Dutch, and English began settlements on the Eastern seaboard, their influence was felt immediately through the medium of trade goods. Metal tools and sundry inventions foreign to them changed native peoples' lives irrevocably.

THE IMPORTANCE OF BEADS

The introduction of multicolored glass beads may seem like a trivial development, but it was greeted eagerly by people who took great pride in their personal appearance. Prior to this time, porcupine-quill or moose-hair embroidery and earthen or vegetal pigments served for the adornment of clothing and prized possessions. The peoples of the Great Lakes and Eastern Woodlands developed a deftness of creativity and skill in utilizing beads for beautification. Eventually, beadwork became the most common means for embellishing a special "dress-up" shirt or for beautifying a functional pouch.

By the mid-19th century, new tribal patterns and art styles had evolved in response to the availability of beads, the versatility of their use,

Above: Iroquois tribe doll with typical featureless face (to stop it from turning into the person it represented). c. 1870. 7 in (17.75 cm) high **$5,000–7,000 MSG**

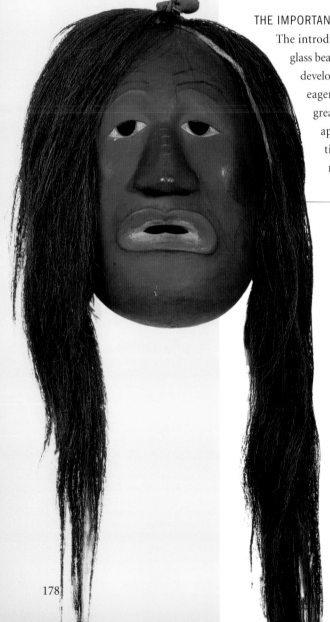

THE FALSE FACE SOCIETY

The five tribes of the Iroquois confederacy shared many cultural traditions. Among the most important was the formation of a popular social medicine organization known as the False Face Society. Initiated members were called upon to perform healing rites whenever necessary. On such occasions, each wore a wood mask, characteristically carved in doleful, fearsome, or grotesque fashion, evoking the forces of the original False Face deity from whom they obtained their powers. The ritual involved specific incantations and dances as were required to chase away the malady. Once cured, the patient was obliged to become a member of the society and assist in the healing of others.

Left and right: A pair of Iroquois male portrait masks, the face carved from basswood, and with horsehair tresses. c. 1890. 8 in (20.5 cm) long **$80,000–100,000 (the pair) TB**

and the influence of the now dominant non-native culture. The Seneca and the Micmac in the far east worked lacelike designs in a curvilinear style that drew inspiration from European decorative arts. Contrary to the starker geometric designs of the Plains people inhabiting the largely barren grasslands farther west, Woodlands people often chose floral motifs, a reflection of their environment. The Ojibwa, in particular, beaded their clothing and accessories in naturalistic sprays of blossoms and scrolling vines. They and other tribes such as the Potawatomi and the Winnebago took great care in the fashioning of rectangular beaded pouches with broad straps sometimes referred to as "friendship bags" or, more commonly, "bandolier bags." These were worn slung across the body and became such an integral part of a man's wardrobe that on special occasions he might wear two or more at a time.

WORKING WITH WOOD

The peoples of the Great Lakes and Eastern Woodlands were surrounded by a rich and versatile resource: the wood from the trees that abounded in the vast forests of their homelands. It served a multitude of functions and was the logical source of housing, furnishings, utensils, weapons, and tools. Skilled carvers made masks, ladles, and pipe stems for the community. The latter were often complemented by a pipe bowl of red, soft stone quarried in parts of Minnesota and called catlinite, after George Catlin, the American artist who documented native life in his paintings. The bark of the birch tree was a particularly remarkable resource—lightweight, yet sturdy. It would be peeled off the tree smoothly in wide sheets and used to build canoes and baskets throughout the Great Lakes area.

FEASTING

The basic agricultural staples of corn, beans, and squash were supplemented by game, roots, berries, and other edibles when available. Responsibility for food preparation fell on the women who, even in this mundane, daily task, favored a spirit of artistic invention.

LADLES

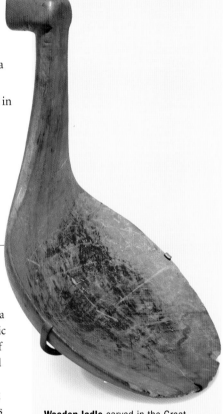

Wooden ladle carved in the Great Lakes, with an animal form on the handle. The ladle became a special object of adornment when fashioned for communal feasts and special occasions. A clever woodcarver would complement the gracefully curving ladle form with a human or animal finial. *Mid-C19th. 10 in (25.5 cm) long* **$10,000–15,000 TB**

SMOKING

The exact origin of the tobacco plant remains a mystery, but the pleasure of smoking its aromatic leaves was well known among native peoples of the Woodlands areas. It was both a private and shared recreational pastime, enjoyed by men and women. Though the simple act of smoking tobacco was often a casual one, on auspicious occasions of a ceremonial or political nature, sharing a tobacco pipe took on deeply meaningful or sacred implications. From symbolizing a pact between two parties, to offering communal prayers, smoking served as a sanctioned, unspoken bond understood by all.

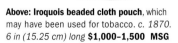

Above: Iroquois beaded cloth pouch, which may have been used for tobacco. *c. 1870. 6 in (15.25 cm) long* **$1,000–1,500 MSG**

Right: Catlinite carved and hollow pipe (on a stand), possibly from the Ojibwa tribe. *Mid-C19th. 9 in (23 cm) long* **$4,000–5,000 TB**

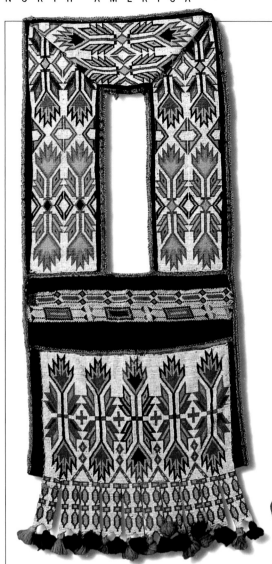

Much native art was a cross-cultural statement, as exemplified by this Ojibwa bag with trade beads, cloth, and a clasp, worked in indigenous floral arrangements.

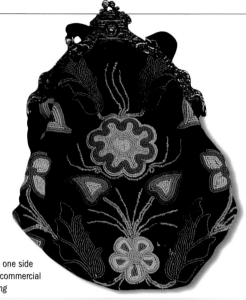

Ojibwa black velvet handbag beaded on one side with polychrome floral motifs, and with a commercial metal clasp. *c. 1910. 12 in (30.5 cm) long*

$400–600 SK

Potawatomi bandolier bag edged with violet silk and decorated with beadwork, and bead and wool tassels. *Late C19th. 36 in (91.5 cm) long*

$4,000–6,000 SK

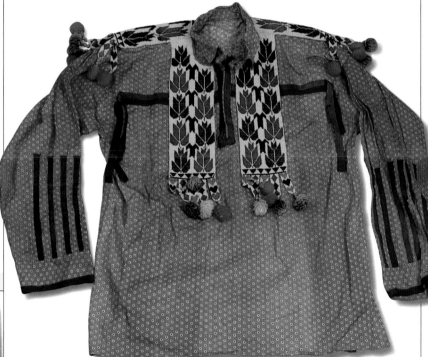

Man's calico shirt from Winnebago, with polychrome beadwork panels and woolen tapes, ribbons, and tassels. *Late C19th. 29 in (74 cm) long*

$2,500–3,000 SK

Eastern Woodlands wooden-framed and birch bark-covered model canoe, with rust red scalloped and floral decoration on the exterior, and a ribbed interior. *C20th. 31 in (79 cm) long*

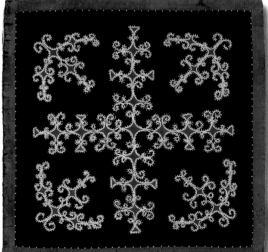

Micmac tribe navy blue, beaded woolen presentation cloth, made to cover a candle stand. *c. 1850. 16 in (40.5 cm) wide*

$9,000–12,000 D&G

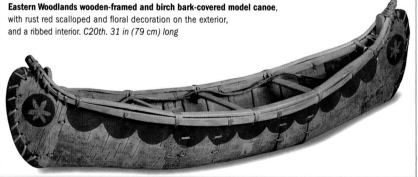

$400–600 SK

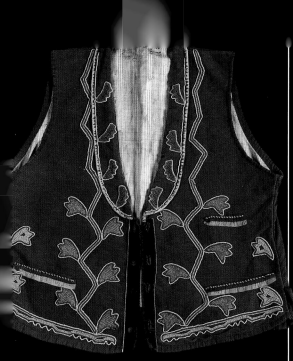

Man's beaded cloth vest of commercially manufactured form with velvet trim, and polychrome floral beadwork, from the Great Lakes. *c. 1890–1910. 22 in (55.6 cm) long*

$1,000–1,500 SK

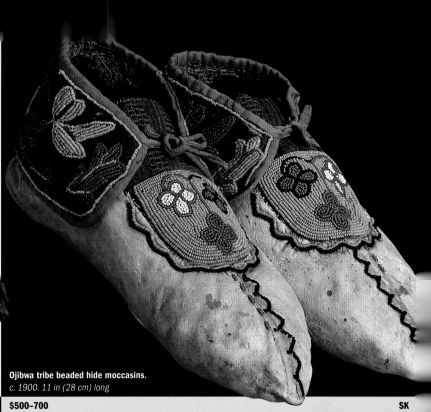

Ojibwa tribe beaded hide moccasins. *c. 1900. 11 in (28 cm) long*

$500–700 SK

Iroquois

It is uncertain how the Iroquois came to live in the region they inhabited, but whatever the path, it led them to an area surrounded on all sides by Algonquian peoples whose language and cultural norms differed in many ways. Perhaps this led to their infamous martial mentality. Yet despite their reputation as warriors, the Iroquois were artists capable of creating graceful tools and adornments that pleased the eye. By the latter part of the 19th century, this talent featured in the manufacture of beaded "whimsies" sold to tourists at Niagara Falls.

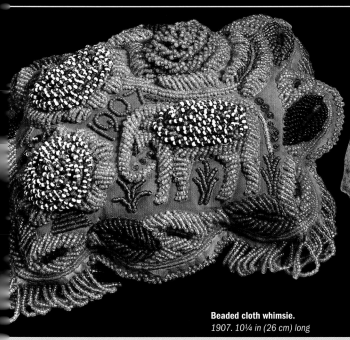

Beaded cloth whimsie. *1907. 10¼ in (26 cm) long*

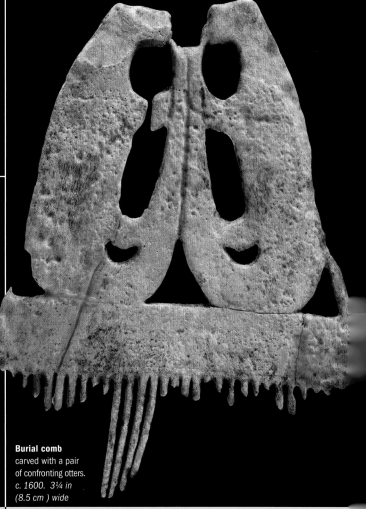

Burial comb carved with a pair of confronting otters. *c. 1600. 3¼ in (8.5 cm) wide*

$250–400 SK

$10,000–15,000 TB

KEY FACTS

Tribes include the Cherokee, Chickasaw, Choctaw, Creek, Seminole, Chitimacha, and Coushatta.

Covering an expanse from eastern Texas to Florida and across the Appalachian Mountains, it was a land of mostly hot or temperate climates and consisted of low mountains, rolling hills, plains, sandy seashores, and swamps.

The peoples spoke dialects of the Algonquian, Siouan, Muskogean, and Iroquoian language families.

Farming staples such as beans, corn, and squash were the principal means of subsistence, augmented by hunting and gathering.

Southeast Region

In a fertile land where agriculture was widely practiced and game was plentiful, the indigenous cultures of the Southeast enjoyed a relatively peaceful and prosperous existence until the arrival of the Europeans.

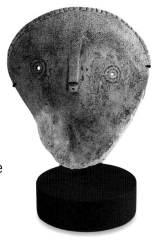

Over thousands of years prior to the Europeans' arrival, local cultures evolved, sharing many similar traits, due to parallels in climate, geography, and the intervention of trade, politics, and religious beliefs. Permanent villages were settled and burial mounds erected nearby. Excavations in the 19th and 20th centuries revealed much to archaeologists about the lifestyles of these ancient peoples.

Religious beliefs in the afterlife provided motivation for much of their artistic material culture. Pottery offerings, for example, played an important role in mortuary rites. Regional styles emerged and are known by the modern-day place names where they were discovered—for example, Taylor (County), Means, Walls, Hodges, and Foster.

By the 19th century, government policies displaced and decimated a large percentage of the population, resulting in a relative paucity of material culture. Still, art thrived, as shown in the beaded bandolier bags, garters, and sashes of the Creek and Seminole. Artists retained elements of the ancient design vocabulary, using spiral, diamond, and double-curve motifs.

Basketry fulfilled a practical function among the Cherokee, Chitimacha, and Choctaw. It was also a source of revenue and has remained a viable art form to this day. Similarly, crafts such as pinecone animals and whimsical effigies are still made by the Coushatta and other peoples.

Above: Mississippian conch or whelk-shell mask.
c. 1350–1550. 8½ in (21.5 cm) high **$3,000–5,000 RAM**

Left: Seminole tribe doll
with palmetto husk head and polychrome cotton cloth costume.
1940s. 9 in (22.75 cm) high
$120–200 RAM

SEMINOLE STRIPES

The Seminole, residing to this day in the Everglades swamps of southern Florida, were one of the only tribes never defeated during the US government's Indian eradication campaign. The civilization evolved in the 1700s as a mix of Creek refugees along with escaped black slaves. Over time, they developed a distinct set of traditions, including a striking and quite novel style of clothing. The women used a technique called appliqué, sewing bands of varicolored cloth cut into geometric shapes in layers of contrasting colors. Bright stripes were the norm for shirts, trousers, and dresses—all crafted from cloth obtained in trade.

Seminole tribe man's jacket made from cotton and synthetic cloth, and with mother-of-pearl buttons.
1940s. 26 in (66 cm) long **$300–900 RAM**

CEREMONIAL CULT EMBLEMS

A sizable proportion of the Southeast art found today is from the distant past. The "Mississippian" cultures of the Southeast used ceramics, bone, and shell ornaments in ancient times as burial items with religious significance. Leaders with divine powers ruled the lands, and cults were formed to foster the faith among the populace. An important emblem of these cults found in archaeological digs were incised shell gorgets, sometimes depicting priests and warriors, sometimes mythical beasts, and often carrying the image of a cross within a circle. This symbol represented the commonly accepted world view of Earth as a floating island crossed by axes from the four compass points.

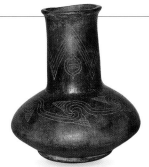

Mississippian culture shell gorget.
1450–1600.
5 in (13 cm) high
$3,000–6,000 RAM

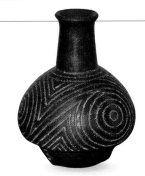

Citico-style engraved shell gorget (chest decoration) from Tibbee Creek, Mississippi. *c. 1350–1450. 4½ in (11.5 cm) high* **$1,200–3,000 RAM**

THE AFTERLIFE

Pottery vessels of remarkable variety and style were made for service in the afterlife. Incised and carved patterns either symbolized mystical phenomenon or were made beautiful simply for art's sake.

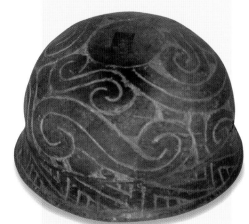

Dome-shaped bowl engraved with scrolls in relief by the Caddoan-speaking Natchitoches people. *1500–1800. 4½ in (11.5 cm) wide* **$900–2,500 RAM**

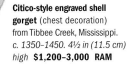

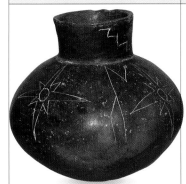

Long-necked Mississippian "Walls" jar with engraved stylized landscape decoration. *1200–1500. 8 in (20.25 cm) high*

$1,800–4,000	**RAM**

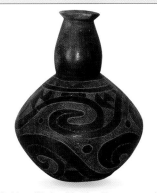

Caddoan "Keno" earthenware bottle with spiral motifs. *c. 1400–1700. 6½ in (16.5 cm) high*

$1,800–5,000	**RAM**

Mississippian "Walls" jar engraved with star, stepped, and other geometric motifs. *1200–1500. 7 in (17.75 cm) high*

$900–1,800	**RAM**

Caddoan "Hodges" bottle with an engraved and pigmented scroll pattern. *1200–1500. 9 in (22.75 cm) high*

$1,800–5,000	**RAM**

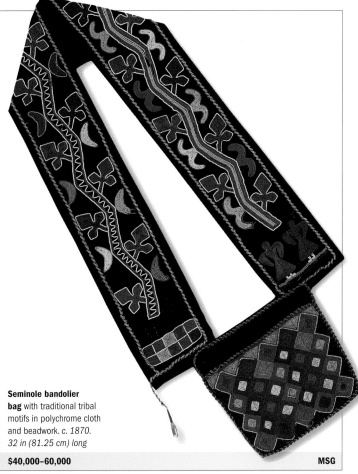

Seminole bandolier bag with traditional tribal motifs in polychrome cloth and beadwork. *c. 1870. 32 in (81.25 cm) long*

$40,000–60,000	**MSG**

Caddoan "Means" engraved tripod bottle from the Ouachita River area of Arkansas. *1200–1500. 9 in (22.75 cm) high*

| $2,500–4,000 | RAM |

Drilled, fine-grained isinglass stone spade head, from the southern Mississippi area. *1200–1500. 7¾ in (19.5 cm) high*

| $1,500–4,000 | RAM |

Caddoan "Taylor" engraved bowl, excavated from the Red River basin. *1200–1500. 4½ in (11.5) high*

| $300–600 | RAM |

Caddoan "Foster" waisted jar, engraved with concentric circles, from the Red River area. *1200–1500. 7¼ in (18.5 cm) high*

| $1,200–3,000 | RAM |

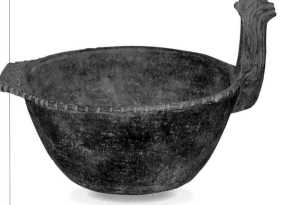

Mississippian "Cat Serpent" bowl, a version of a "Feathered Serpent" bowl. *1200–1500. 6 in (15.25 cm) high*

| $1,200–2,500 | RAM |

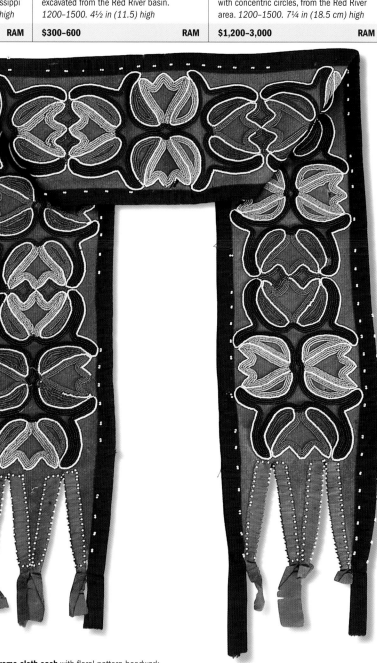

Lidded split-cane basket with polychrome geometric patterns, by the Chitimacha people of Louisiana. *c. 1900. 5 in (13 cm) high*

| $2,500–3,000 | SK |

Polychrome cloth sash with floral pattern beadwork. *Mid-C19th. 55 in (140 cm) long*

| $9,000–12,000 | SK |

BOOGER DANCE

By the mid-19th century, the Cherokee found their population decimated and their cultural traditions in peril. The Booger dance was a reaction. One version had participants wearing masks carved to represent the whites in power, black slaves, and themselves. The ensuing burlesque performances served to release psychological tension through humor and to reinforce the positive values of their own race. More than mere theater, the Booger dance was practiced to drive out the evil influences in the people's lives.

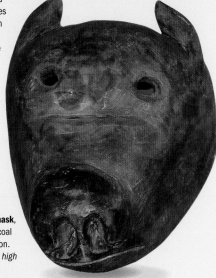

Cherokee buffalo Booger mask, carved from wood with charcoal or black walnut pigmentation. *Early C20th. 11 in (28 cm) high*
$1,800–5,000 RAM

Mississippian variegated, disklike stones originally used for playing the game "Chunkey." *1200–1500. 2–4 in (5–10 cm) wide*
$2,500–3,000 **RAM**

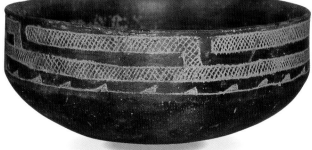

Caddoan "Friendship" engraved bowl excavated from the Ouachita River basin. *1200–1500. 8 in (20.5 cm) wide*

$500–900 **RAM**

Caddoan "Means" engraved seed pot, from the Ouachita River area of Arkansas. *1200–1500. 8½ in (21.5 cm) high*

$4,000–9,000 **RAM**

Fragment of a Mississippian sandstone effigy of a human head. *1200–1500. 3 in (7.5 cm) high*

$400–1,000 **RAM**

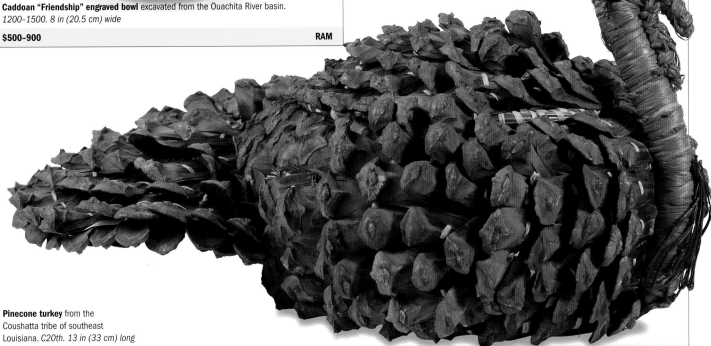

Pinecone turkey from the Coushatta tribe of southeast Louisiana. *C20th. 13 in (33 cm) long*

$900–1,500 **D&G**

MIDDLE AMERICA

Middle America covers an area from northern Mexico to the tip of southern Panama. The need to explore and the desire for trade took its inhabitants outside of their homeland in a pursuit common to peoples the world over—the search for conquests, esoteric knowledge, and precious art objects.

The peoples of Middle America traveled to neighboring lands along the coast, to the next village just over the mountains, and to provinces far away where they could discover something new or obtain goods unavailable at home. The first "collectors" in this part of the world started long before the 20th century. Heirloom items from previous epochs were highly prized by Middle Americans, as witnessed by the special status accorded to Olmec jade carvings found among much later Mayan and Costa Rican archaeological remains.

Art styles and techniques were borrowed as cultures evolved. The technical knowledge required to work gold purportedly made its way up to Mexico from Peru after a journey that took centuries. Some of this education was obtained by force, as was the Aztec custom, adopting the cultural highlights of vanquished foes. Other examples came about out of respect and admiration: figurative incense burners of the exact type made in Teotihuacan of Central Mexico were subsequently made a great distance away in the Mayan highlands, presumably by devotees of a Teotihuacan-inspired theology.

However, other cultures remained isolated, with little apparent interest or need to observe what lay over the horizon. Iconoclasts, such as the Mezcala people in the rugged mountains of the Mexican state of Guerrero, developed an artistic aesthetic uniquely their own. And while they apparently enjoyed occasional trading with lands far afield, the West Mexican cultures of Nayarit, Colima, and Jalisco developed a range of molded and modeled arts with no apparent outside influence. Like the Central American regions of Nicoya, Veraguas, and Cocle, they were never completely overrun by ambitious outside military powers (until the Spanish) and therefore escaped the influence of the expansionist, theocratic city-state empires developing around them.

Seated pottery shaman, with head spout, from Colima, Mexico. *150 BCE–250 CE.* *11½ in (29 cm) high* **$3,000–4,000 BLA**

Our knowledge of these ancient peoples has been pieced together from a few scant writings, surviving oral histories, and an abundance of art and artifacts.

LANDSCAPE AND CULTURE

The landscapes of their homeland were often sacred to the Middle Americans. The nearby mountains, coasts, and jungles were home to the gods and were where mythic history unfolded. Each culture occupied the "center of the universe."

Right: Mountains like the Sierra Madre range of Mexico are a distinguishing feature throughout much of Middle America. It is not hard to imagine that these peaks served as inspiration to the architects and priests who oversaw the building of pyramids and lofty temples to honor their gods.

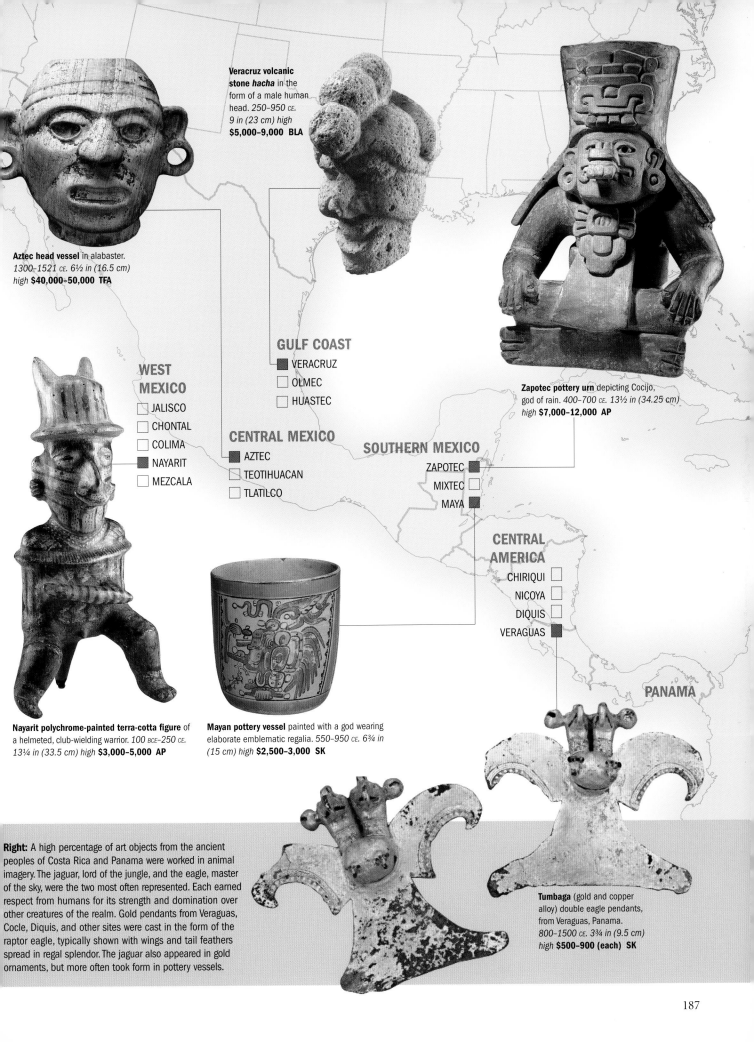

Veracruz volcanic stone *hacha* in the form of a male human head. *250–950 CE.* 9 in (23 cm) high **$5,000–9,000 BLA**

Aztec head vessel in alabaster. *1300–1521 CE.* 6½ in (16.5 cm) high **$40,000–50,000 TFA**

Zapotec pottery urn depicting Cocijo, god of rain. *400–700 CE.* 13½ in (34.25 cm) high **$7,000–12,000 AP**

GULF COAST

☑ VERACRUZ
☐ OLMEC
☐ HUASTEC

WEST MEXICO

☐ JALISCO
☐ CHONTAL
☐ COLIMA
☑ NAYARIT
☐ MEZCALA

CENTRAL MEXICO

☑ AZTEC
☐ TEOTIHUACAN
☐ TLATILCO

SOUTHERN MEXICO

ZAPOTEC ☑
MIXTEC ☐
MAYA ☑

CENTRAL AMERICA

CHIRIQUI ☐
NICOYA ☐
DIQUIS ☐
VERAGUAS ☑

PANAMA

Nayarit polychrome-painted terra-cotta figure of a helmeted, club-wielding warrior. *100 BCE–250 CE.* 13¼ in (33.5 cm) high **$3,000–5,000 AP**

Mayan pottery vessel painted with a god wearing elaborate emblematic regalia. *550–950 CE.* 6¾ in (15 cm) high **$2,500–3,000 SK**

Right: A high percentage of art objects from the ancient peoples of Costa Rica and Panama were worked in animal imagery. The jaguar, lord of the jungle, and the eagle, master of the sky, were the two most often represented. Each earned respect from humans for its strength and domination over other creatures of the realm. Gold pendants from Veraguas, Cocle, Diquis, and other sites were cast in the form of the raptor eagle, typically shown with wings and tail feathers spread in regal splendor. The jaguar also appeared in gold ornaments, but more often took form in pottery vessels.

Tumbaga (gold and copper alloy) double eagle pendants, from Veraguas, Panama. *800–1500 CE.* 3¾ in (9.5 cm) high **$500–900 (each) SK**

KEY FACTS

Cultures prospered from 300 BCE to 250 CE and include Colima, Nayarit, and Jalisco in northwestern Mexico; Chontal and Mezcala in the southwest.

A mostly arid, mountainous terrain, these sparsely inhabited regions remained politically isolated, yet interacted with cultures far afield through trade.

What little we know of these people comes almost totally from their burial customs and related artifacts.

West Mexico

The "preclassic" period in Mexican archaeology refers to a time prior to the development of the great theocratic city-states. West Mexican cultures thrived during this period, independent of outside political, military, or religious power.

Unlike the autocratic rule predicated by the rulers and priests of the Mayan and later Aztec empires, the citizens of this region apparently enjoyed a more benign existence under the leadership of local chieftains. While our knowledge of their daily lives is limited, one clue that suggests this is the lack of deity effigies among a substantial canon of ceramic production. In place of fearsome and omnipotent gods, artists fashioned depictions of men, women, and animals taken from everyday life. They range from restrained, dignified portraits to comic or sexual portrayals that show a lighthearted and confident humor.

Due to the shaft tomb method of burial (*see below*), many of these artistic offerings have survived. In Colima, we find the widest range of figures and the greatest attention to naturalistic detail. Shamans, warriors, dignitaries, and laborers are all shown in accurate and animated poses. Fat dog figures, armadillos, ducks, and even seashells from the coastal areas find representation in their broad corpus of funerary art. An exception to this tendency toward realism is seen in small, stylized figures made in an almost two-dimensional style, and referred to as "flats" or "gingerbread" figures.

Above: Characteristically stylized pre-Columbian carved stone figure from the Mezcala people. *300–100 BCE. 11 in (28 cm) high* **$12,000–18,000 BLA**

SHAFT TOMBS

Approximately 2,000 years ago, peoples spread across the modern-day states of Colima, Nayarit, and Jalisco shared a burial practice, digging what are called "shaft tombs." These not only protected the deceased in the afterlife, but also allowed for the inclusion of offerings for use in the next world. Deep shafts opening into subterranean chambers presented sufficient room for the body and the mostly ceramic grave goods, such as bowls, jars, and figures. The architectural integrity of these tombs has led to the preservation of numerous ancient objects for museums and collectors of the present.

Below: Nayarit terra-cotta female figure with overall black and white pigment decoration and a necklace, from the Ixtlan del Rio region. *100 BCE–250 CE. 14 in (35.5 cm) high* **$1,800–3,000 S&K**

AGAVE CACTUS FIELDS, JALISCO, WHERE MANY SHAFT TOMBS WERE FOUND

ANIMAL FIGURES

The propensity of ancient West Mexican ceramicists to craft effigies of almost everything in their environment naturally led to the depiction of animals. The artistic tradition of these peoples called for naturalism and the results are realistically modeled fish, snakes, felines, and most often, dogs.

Most of the figures from Nayarit are well-dressed standing or seated figures, some as large as 24¼ in (61 cm) high. It is tempting to presume that these must have been high-status, elite individuals, judging by the fine, patterned garments and jewelry the figures wear, highlighted in polychrome pigments. This may be so, but the sheer number of such figures found in museums and collections today indicates a more common origin. Another distinct type of figure is called "Chinesco" and is marked by a broad, round face and slit eyes (*see below*).

Jalisco, like its neighbors, has left numerous, mostly human effigies to posterity. Most figures are pensive-looking individuals with heavy-lidded eyes. A curious Jalisco substyle, however, features a type of figure with a face dominated by a long, tapering muzzle of a nose that has

been dubbed "sheepface" by collectors. The Mezcala and Chontal cultures seemed to work stone almost exclusively and left virtually no ceramic record. To this day, very little archaeological fieldwork has been carried out in the difficult terrain surrounding their homelands. Still, significant quantities of abstract human figures and masks have survived, marked by an austere, minimalist sculptural approach.

COLIMA DOGS

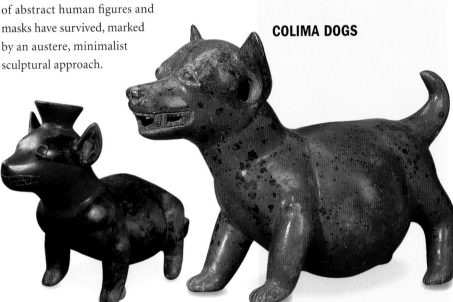

Above: **Burnished terra-cotta dog vessel** from the Colima region. *150 BCE–250 CE. 15¾ in (40 cm) high* **$3,000–9,000 BLA**

Burnished terra-cotta dog figure, characteristically fat and with short legs, from the Colima region. In cultures around the world, dogs have enjoyed special status as faithful companions to their human masters. Colima artists memorialized canines for a grander reason: dogs were instrumental in guiding the deceased through the darkness of the underworld. Typically depicted as grossly overweight, the Colima dog's reward for this talent was to be eaten. *150 BCE–250 CE. 13½ in (34 cm) long* **$4,000–6,000 SK**

CHINESCO FACES

Although a certain artistic homogeneity was the rule within neighboring areas, regional art substyles evolved. In Nayarit, there appeared a peculiar and often beautiful ceramic type that we call "Chinesco." The name is supposed to have been coined by one of Mexico's most famous artists and pre-Columbian art collectors, Miguel Covarrubias. The heavy-lidded, narrow eyes characteristic of these figures were deemed to be similar to those of the Chinese. Of course, since the native people of West Mexico descended from Asian immigrants thousands of years before, the resemblance may have been more than mere coincidence.

Left: **Chinesco-style seated female pottery figure**, Nayarit. *150 BCE–250 CE. 10 in (25 cm) high* **$1,500–1,800 SK**

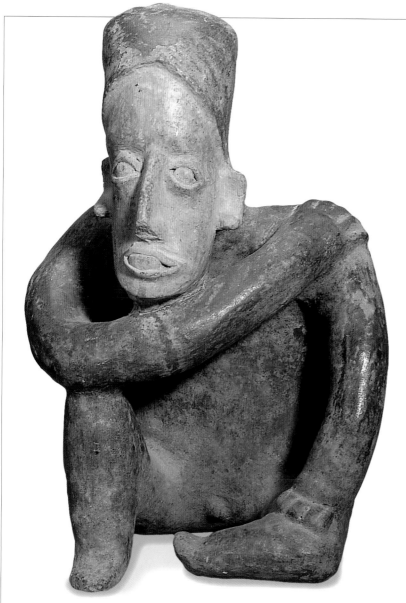

Seated terra-cotta figure with an elongated head and rhomboid-shaped eyes typical of Jalisco sculpture. *150 BCE–250 CE. 13½ in (34 cm) high*

$1,200–1,800 SK

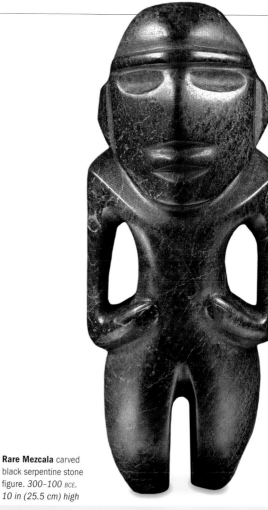

Rare Mezcala carved black serpentine stone figure. *300–100 BCE. 10 in (25.5 cm) high*

$80,000–100,000 TFA

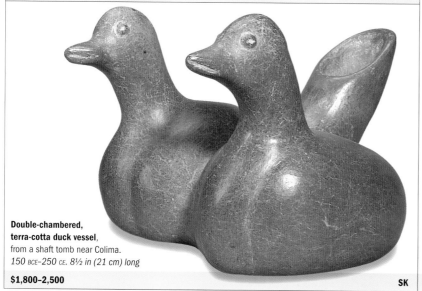

Double-chambered, terra-cotta duck vessel, from a shaft tomb near Colima. *150 BCE–250 CE. 8½ in (21 cm) long*

$1,800–2,500 SK

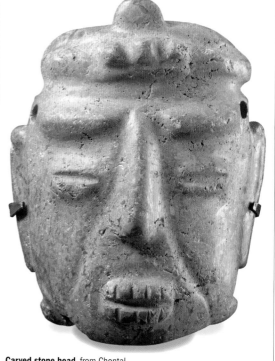

Carved stone head, from Chontal. *300–100 BCE. 6¼ in (16 cm) high*

$2,500–4,000 BLA

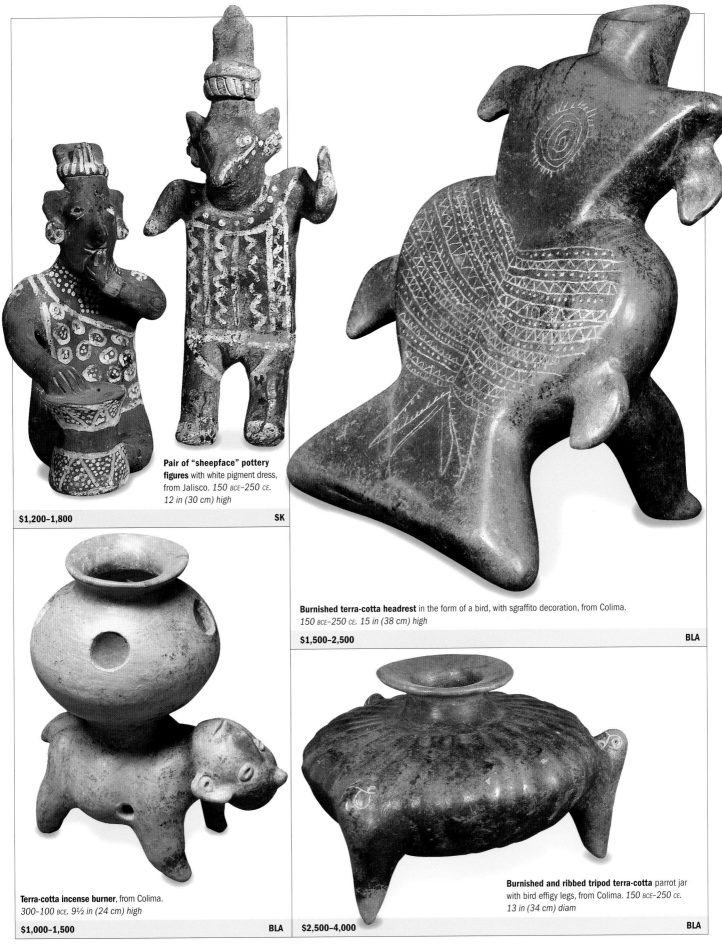

Pair of "sheepface" pottery figures with white pigment dress, from Jalisco. *150 BCE–250 CE. 12 in (30 cm) high*

$1,200–1,800 SK

Burnished terra-cotta headrest in the form of a bird, with sgraffito decoration, from Colima. *150 BCE–250 CE. 15 in (38 cm) high*

$1,500–2,500 BLA

Terra-cotta incense burner, from Colima. *300–100 BCE. 9½ in (24 cm) high*

$1,000–1,500 BLA

Burnished and ribbed tripod terra-cotta parrot jar with bird effigy legs, from Colima. *150 BCE–250 CE. 13 in (34 cm) diam*

$2,500–4,000 BLA

191

Below: **Exceptional stone with iron pyrite mask**, and with inlaid shell eyes, from the ancient city of Teotihuacan. *100 BCE–650 CE. 8½ in (21.5 cm) high* **$200,000–250,000 TFA**

Central Mexico

Central Mexico was home to disparate cultures, from the modest farming communities of Tlatilco to the grandeur of Teotihuacan. There and in the Aztec capital Tenochtitlan arose city-states that rivaled the glories of ancient Rome.

It was in a 20th-century brickyard outside Mexico City that a major find from the Tlatilco culture was discovered. It was not bricks that the ancient peoples of the city had been producing, however, but pottery figures. Depicting mostly women, they were nude, with ample curves and demure, tapering eyes. Today we call these Tlatilco maidens "pretty ladies." Other ceramics from this area included masks, which were probably for use in funerary rites. Also, simple but elegantly formed vessels were made, as well as a small number of inscrutable contortionist figures with apparent influence from the faraway Olmec culture.

Some five centuries later lived a people whose origins and demise remain lost in time. Whoever they were, the priest-rulers of Teotihuacan built an astonishing homage to the gods in a sacred city whose pyramid monuments and temple complexes occupied several square miles. Art was everywhere: from the ornate architecture to the painted murals found within, to a wide range of pottery vessels and figures—all produced for use in a formal religious context. Apart from their architectural statements, the best-known artifacts left were their stone masks.

Above: **Tlatilco pottery mask.** *1150 BCE–550 CE. 5 in (12.4 cm) diam* **$700–1,500 SK**

TEOTIHUACAN, CITY OF THE GODS

A great mystery of ancient Mesoamerica lies on a plain north of Mexico City. The splendid city of Teotihuacan lasted some 750 years before being completely abandoned around 650 CE—no one knows why. It is estimated that at one time its population reached 250,000. Extensive remains include giant pyramids and countless temples constructed to honor their gods. The Aztecs and other later tribes venerated the place but did not dare to occupy this sacred ground. They named it "the place where men become gods."

PYRAMID OF THE SUN, TEOTIHUACAN

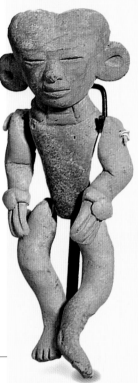

Compelling, lifelike, and possessed of an intensely spiritual authority, these masterpieces of Mesoamerican carving offer high praise to the talents of a people who, by 650 CE, had forsaken their grand city and disappeared without a trace.

AN ARTISTIC MIXTURE

Adroit as organizers and possessed of great military acumen, the Aztecs and their allies controlled Mexico's central valley and far-flung provinces in a tributary bond. What the Aztecs lacked in artistic skills was co-opted from those vanquished. Eventually, the Aztec capital was so richly adorned that Spanish chronicles reported it to equal or surpass the great cities of Europe. Ritual and secular pottery vessels were produced to befit all occasions. A distinctly ornate pictographic painting style was copied from the Mixtecs to the south, and these and other forms contributed to an artistic melting pot. The Aztecs were masters at the arduous task of stone-carving. They gained fame producing small charms, larger altarpieces, and magnificent public statuary.

MOVEMENT

The idea of depicting movement in artistic production did not always appeal to ancient peoples. A rigid, stoic demeanor might have seemed more appropriate when dealing with solemn spiritual concerns and art that represented the metaphysical. In Teotihuacan, however, dramatic exceptions were made to this aesthetic choice.

ARTICULATED FIGURES

Pair of pottery figures with articulated limbs, from the ancient city of Teotihuacan. In Teotihuacan, movement was glorified in both painting and pottery. Particularly telling illustrations were the numerous small, enigmatic doll figures with articulated, separately molded, and movable limbs. *150 BCE–650 CE.* 6¼ in (15.5 cm) high **$1,500–1,800 SK**

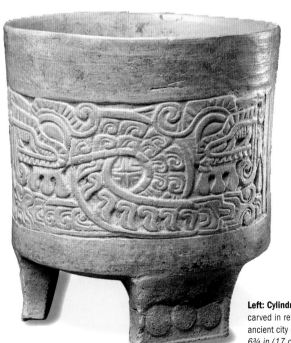

TERRA COTTA

"Baked clay" is the literal translation of *terra cotta*, and it was a medium used widely throughout Central Mexico and the ancient Americas. Utilitarian vessels for daily use were always in demand, but pottery production became an art form when created in the service of ritual ceremonies. Large numbers of terra-cotta "little people" have been found in the Tlatilco area. These small-scale votive figures probably served a role in religious offerings. More sumptuous work came from Teotihuacan (*see left*), famous for its painted stucco and elaborately molded decorative styles.

Left: Cylindrical tripod terra-cotta vessel, carved in relief around the body, from the ancient city of Teotihuacan. *100 BCE–650 CE.* 6¾ in (17 cm) high **$1,500–2,500 BLA**

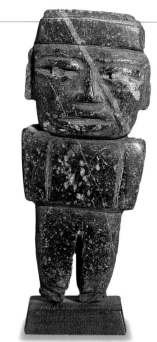

Stone figure from Teotihuacan. *100 BCE–650 CE. 4½ in (11 cm) high*

$900–1,500 SK

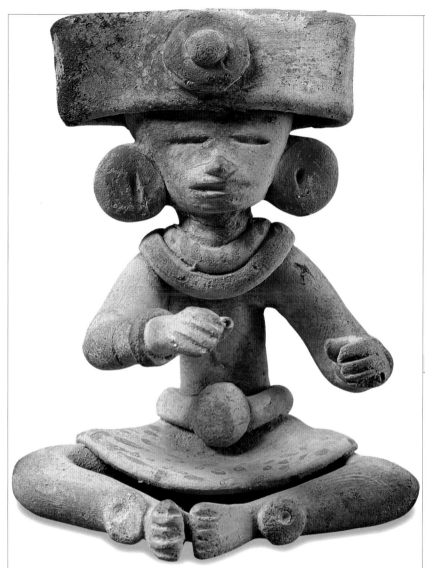

Seated terra-cotta figure, from Teotihuacan.
100–600 BCE. 3½ in (8.5 cm) high

$500–900 BLA

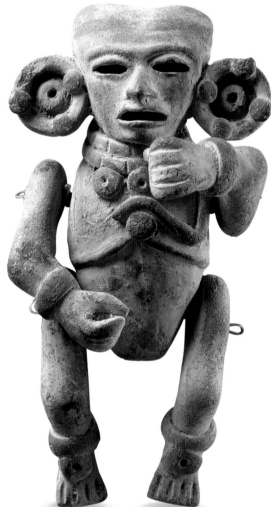

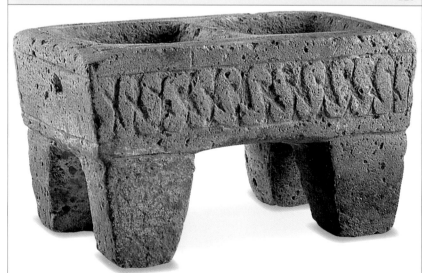

Twin-bowled altar vessel carved with geometric decoration in volcanic stone, from Teotihuacan.
150 BCE–650 CE. 4 in (10.25 cm) long

$300–450 AP

Terra-cotta doll with articulated limbs, from Teotihuacan.
100 BCE–650 CE. 5½ in (14 cm) high

$1,500–2,500 BLA

Three Tlatilco terra-cotta figures. *1150–550 BCE.*
Tallest: 6½ in (16 cm) high

$400–900 (the three)

Aztec

Early in their history, the Aztecs were a loosely knit aggregation of tribes wandering in search of a homeland. Around 1300 CE, they finally settled on an island in Lake Texcoco in the Valley of Mexico. From humble beginnings, they built one of the mightiest kingdoms in the Americas, second only to the Incas of Peru. Great military strategists, they eventually conquered over 30 separate provinces. From these defeated cultures the Aztecs adopted modes of art, learning, etiquette, and even a king of "divine" descent to legitimize their rule.

Tripod pottery censer, with an overall openwork geometric pattern on the bowl, and applied human figure on the handle. *1300–1521 CE. 5¼ in (13.25 cm) high*

$900–1,500

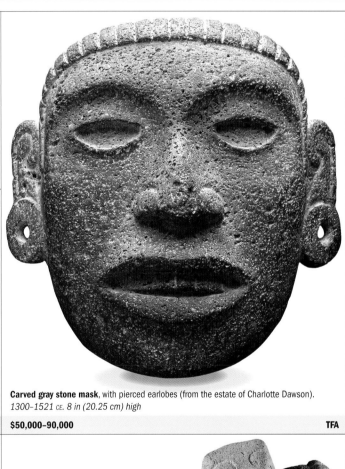

Carved gray stone mask, with pierced earlobes (from the estate of Charlotte Dawson). *1300–1521 CE. 8 in (20.25 cm) high*

$50,000–90,000

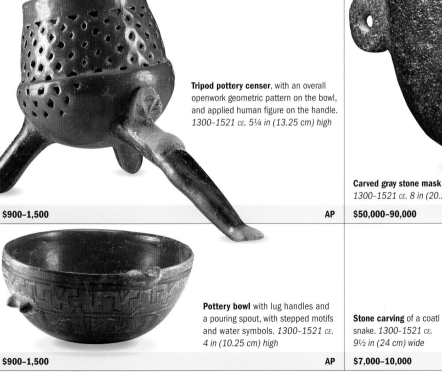

Pottery bowl with lug handles and a pouring spout, with stepped motifs and water symbols. *1300–1521 CE. 4 in (10.25 cm) high*

$900–1,500

Stone carving of a coatl snake. *1300–1521 CE. 9½ in (24 cm) wide*

$7,000–10,000

KEY FACTS

Cultures include the Olmec, (1500–300 BCE; the Huastec (900–1200 CE); and various groups known collectively by their location, Veracruz (250–950 CE).

Low coastal plains distinguish much of the area and lead to mountains in the west and south; a riverine environment predominates, filled with swamps, estuaries, and jungle. The climate is mostly hot and humid.

Inhabitants were subsistence farmers, yet were organized to such a degree that they could support major temple sites such as La Venta and El Tajin.

Gulf Coast

Major cultures of pre-Columbian history took root in the Gulf Coast area. The Olmec were the first true civilization of Mesoamerica, followed by the Veracruz cultures. Both challenged the Maya in artistic and architectural prowess.

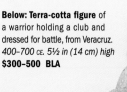

It appears that the Olmec held sway over a sizable area, without the benefit of marauding armies. Perhaps it was their religion, spread with missionary zeal, that captured the minds of the "heathens" surrounding them during that formative period. Whatever the case, Olmec art, which was fundamentally religious, became widespread. The most characteristic traits of Olmec figurative sculpture include heavy-lidded, slanted, or tapering eyes and a down-turned, almost snarling, open mouth—features often compared to those of a jaguar. Monumental sculpture in stone was common, but few examples conveyed the sublime quality of the Olmec's ritual masks.

In Veracruz, religious art was as important as it was for the Olmec. A ceremonial ball game played to symbolically reenact a confrontation between warring deities called for heavy U-shaped stone yokes—mimicking protective gear used by players—and *palmas* (court markers). Ceramic production in Veracruz was prolific, with many figures topping 24 in (60 cm) in height. Typically in a naturalistic style, these portraitlike figures appear to have been ritually smashed before being buried. Heads without torsos have been found in great numbers.

Above: Olmec terra-cotta figure, from Las Bocas, Mexico. *500–300 BCE. 6¼ in (16 cm) high* **$500–900 BLA**

Below: Terra-cotta figure of a warrior holding a club and dressed for battle, from Veracruz. *400–700 CE. 5½ in (14 cm) high* **$300–500 BLA**

DRESSED TO KILL

As cultures developed and as cities, such as the ceremonial city of El Tajin, grew, the need to defend them intensified. It was a fact of life in the Gulf Coast area, and throughout most of ancient America, that wars were frequently fought over natural resources, religion, or the quest for political power. The Veracruz area, in particular, memorialized the warrior ideal and produced significant quantities of stone or ceramic combat figures. A source of fascination for today's collectors of militaria, they are often portrayed in full battle regalia, wearing plumed headgear, armbands, and protective layered clothing, and bearing decorated shields and lethal-looking clubs.

EL TAJIN, VERACRUZ

MOTHER CULTURE

Most scholars believe that the Olmec formed the "mother culture" of Mesoamerica. That is, the Olmec were the first to develop a hierarchical society governed by a ruling elite with powerful influence over surrounding areas in theology, commerce, and aesthetics. Exactly how the Olmec spread their cultural mores so widely has not been determined. But evidence of their artistic influence can be seen plainly in diagnostic Olmecoid traits that appear in statuary from Tlatilco in the Central Valley, to petroglyphs in El Salvador, to stone-carved figures in remote corners of Guerrero.

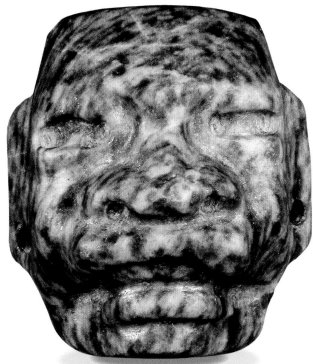

Miniature Olmec facemask, carved from green, black, and gray variegated hardstone. *1500–300 BCE. 1½ in (5 cm) high* **$5,000–9,000 BLA**

SMILING FACES
Terra-cotta priest's head *from Remojadas, central Veracruz. According to some, the wide, beaming smile suggests a drug-induced state of ecstasy. 250–950 CE. 6¾ in (17 cm) high* **$1,500–2,500 BLA**

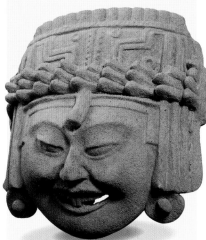

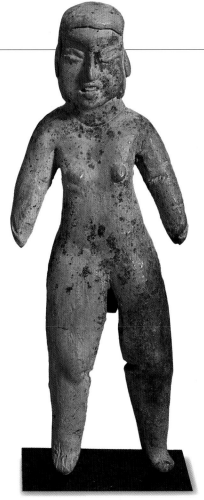

Olmec pottery figure of a standing female. *1500–300 BCE. 5½ in (14 cm) high*

$700–1,000 **SK**

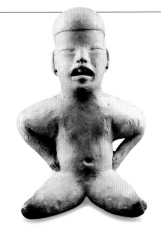

"Baby face" seated pottery Olmec figure. *1500–300 BCE. 9¾ in (25 cm) high*

$3,000–6,000 **BLA**

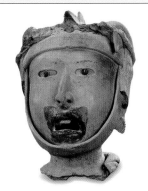

Pottery warrior's head with selective pigmentation, from Veracruz. *250–950 CE. 9½ in (24 cm) high*

$900–1,800 **S&K**

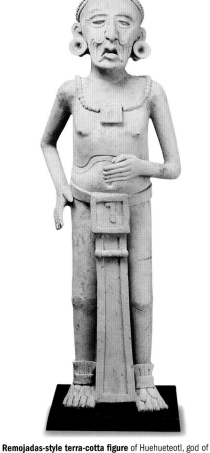

Remojadas-style terra-cotta figure of Huehueteotl, god of the Fire of Life, Veracruz. *250–950 CE. 33½ in (85 cm) high*

$25,000–40,000 **BLA**

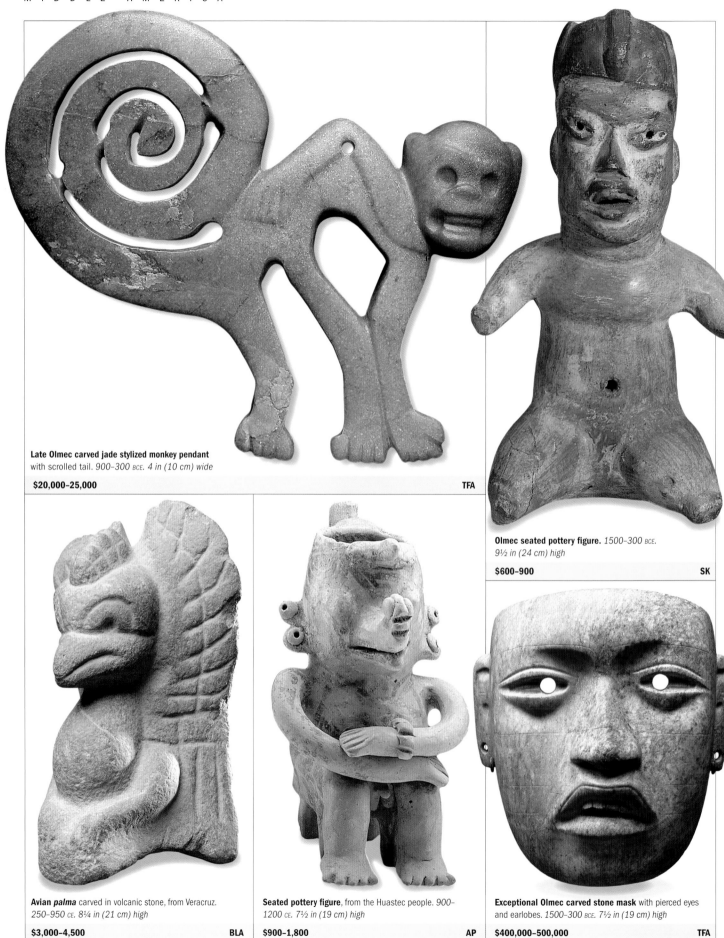

Late Olmec carved jade stylized monkey pendant
with scrolled tail. *900–300 BCE. 4 in (10 cm) wide*

$20,000–25,000 TFA

Olmec seated pottery figure. *1500–300 BCE.*
9½ in (24 cm) high

$600–900 SK

Avian *palma* carved in volcanic stone, from Veracruz.
250–950 CE. 8¼ in (21 cm) high

$3,000–4,500 BLA

Seated pottery figure, from the Huastec people. *900–*
1200 CE. 7½ in (19 cm) high

$900–1,800 AP

Exceptional Olmec carved stone mask with pierced eyes
and earlobes. *1500–300 BCE. 7½ in (19 cm) high*

$400,000–500,000 TFA

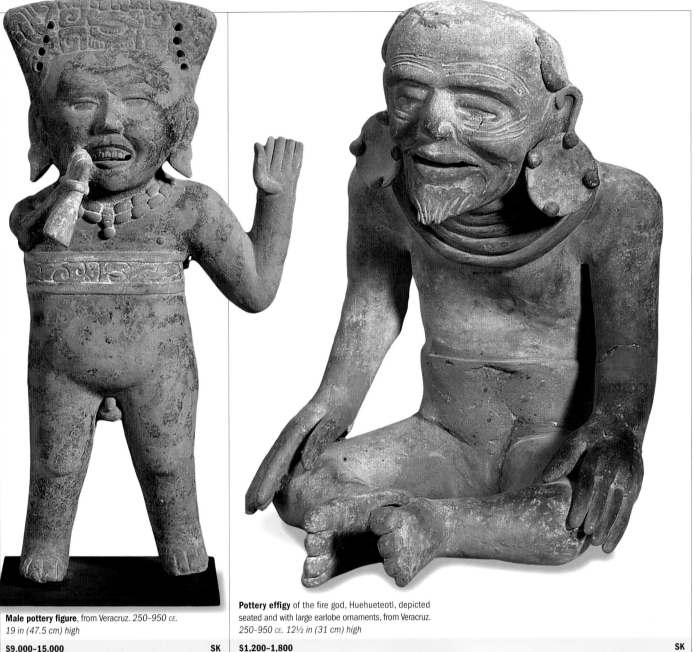

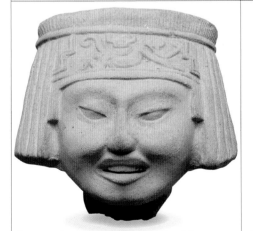

Male pottery figure, from Veracruz. *250–950 CE.*
19 in (47.5 cm) high

$9,000–15,000 SK

Pottery effigy of the fire god, Huehueteotl, depicted
seated and with large earlobe ornaments, from Veracruz.
250–950 CE. 12½ in (31 cm) high

$1,200–1,800 SK

Terra-cotta fragment of a smiling priest's head, from
Veracruz. *250–950 CE. 5½ in (14 cm) high*

$1,200–2,500 BLA

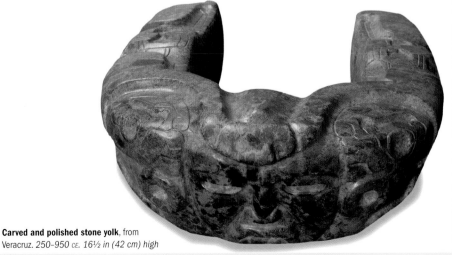

Carved and polished stone yolk, from
Veracruz. *250–950 CE. 16½ in (42 cm) high*

$60,000–100,000 BLA

Southern Mexico

Both the Maya and the Zapotecs reached a cultural zenith paralleled by few others in all of ancient Latin America. They built major temple sites, held widespread political sway, and disseminated their theological and artistic influences far and wide.

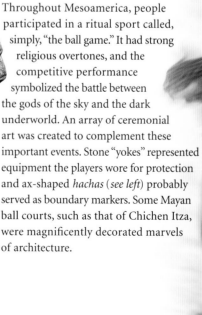

Despite their many accomplishments, the Maya and the Zapotecs both eventually receded from the limelight. The Zapotecs were conquered by the Mixtecs (who in turn fell to the Aztecs), while the Maya, after years of inter-group warfare, abandoned their cities and melted back into the jungle.

Over the course of centuries, the Maya refined their artistic output to produce substantial quantities of fine ceramic ware. Making plates, jars, and bowls, they either carved or painted the surfaces—at times both inside and out. Most of these creations were made in the service of religious or ceremonial practices. The Maya developed a written language of hieroglyphs and, today, specialists have been able to translate much of Mayan history as reported by the original scribes. Artists also produced figures, either mold-made or hand-modeled. The most realistic came from a Mayan cemetery on the island of Jaina. Simpler, less detailed works were done in the outlying provinces, such as present-day El Salvador and Honduras. Shell, wood, stone, and stucco were all utilized to heighten aesthetic sensibilities. Portrait heads of stucco probably served as architectural elements in their original context. Stone took on many forms in artists' hands, becoming splendid

Below: Ceremonial Mayan *hacha* (possibly traded from Veracruz), carved and drilled in stone in the form of a death head. *550–950 CE. 11½ in (29 cm) high* **$10,000–16,000 BLA**

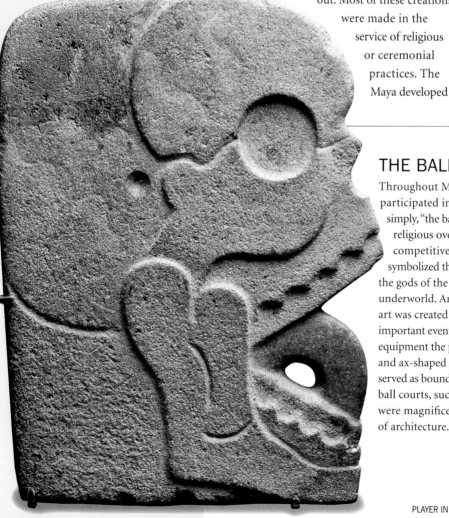

Above: Mayan sculpture of a dignitary, modeled in stucco in typically naturalistic style. *550–950 CE. 10 in (25.5 cm) high* **$6,000–10,000 BLA**

THE BALL GAME

Throughout Mesoamerica, people participated in a ritual sport called, simply, "the ball game." It had strong religious overtones, and the competitive performance symbolized the battle between the gods of the sky and the dark underworld. An array of ceremonial art was created to complement these important events. Stone "yokes" represented equipment the players wore for protection and ax-shaped *hachas* (*see left*) probably served as boundary markers. Some Mayan ball courts, such as that of Chichen Itza, were magnificently decorated marvels of architecture.

PLAYER IN MAYAN BALL GAME

jewelry beads or pendants, ornate vessels, and monumental temple carvings. Stone was also used to produce a peculiarly graceful sort of flint depicting figureheads in profile referred to as "eccentrics."

MONTE ALBAN

On a mountaintop mesa the Zapotecs built their most important religious and ceremonial center, Monte Alban. An awe-inspiring site of tremendous size, the vast courtyard was ringed with constructions decorated in a *talud-tablero* style borrowed from the sacred city of Teotihuacan in central Mexico. This distinctive architectural statement called for a flat, "table" top over slanting, angular sides. The Maya, too, influenced the evolution of Zapotec culture and are said to have introduced the sacred ball game. Portable art, on the other hand, was uniquely Zapotec, at least in the classic period. Although earlier manifestations probably grew from Olmec tastes, with figures and vessels bearing a resemblance to that dominant earlier culture's works of art, by 300 CE a standard type of tomb figure deity had evolved with elaborate, distinctly Zapotec markings.

Following the Zapotec in occupation of Monte Alban, the Mixtecs were known for their architectural accomplishments, pictographic history books called "codices"—a few of which remain in museums today—and a multitude of small, stone figurative carvings and pendants.

DRESSED FOR THE AFTERLIFE
Zapotec funerary offerings in the form of seated figures depicted either gods or their attendants. The specific details of their elaborate outfits— headdresses, pendants, or markings— determined their identities.

ZAPOTEC URN

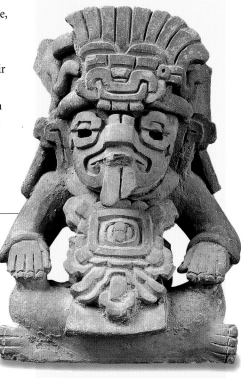

Zapotec pottery urn modeled in the form of a seated Cocijo, from the Monte Alban area. Cocijo was the all-important deity of rain. He was typically represented (*as seen here*) wearing a feathered headdress marked by an undulating water glyph on his forehead, a tripartite nasal mask, and an emblematic "name tag" medallion on his chest. *400–700 CE. 12¼ in (31 cm) high* **$5,000–9,000 BLA**

MAYAN ELITE RESTING PLACE

The island of Jaina, a short distance off the coast of the state of Campeche, served as a burial site for members of the Mayan nobility. Thousands of tombs have been discovered, revealing some of the finest, most naturalistic depictions of classic Mayan fashion in the form of small ceramic figurines. The characteristic style of the Jaina effigies paid great attention to facial expressions, personal adornments, clothing, and accessories. Some figures are depicted engaged in traditional pastimes, seemingly frozen in time.

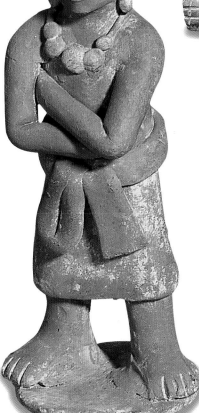

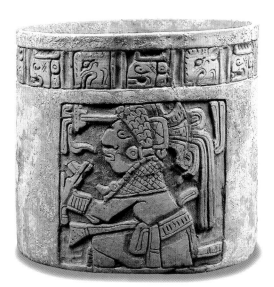

Mayan terra-cotta vessel carved in low relief with human, pictorial, and glyphic motifs. *550–950 CE. 7 in (18 cm) high* **$6,000–10,000 BLA**

Left: Mayan pottery figure of a warrior, from the island of Jaina. *550–950 CE. 6½ in (16 cm) high* **$2,500–3,500 SK**

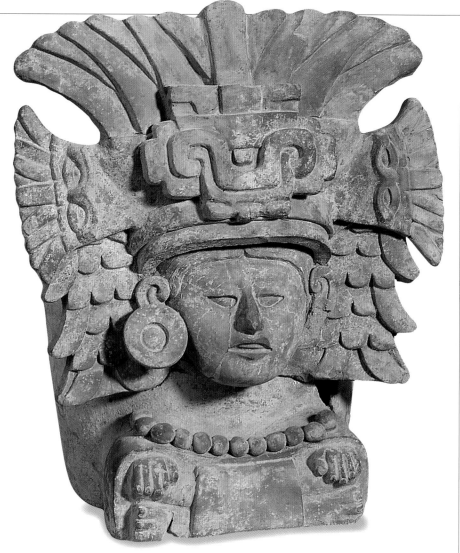

Figurative pottery urn, from the ancient Zapotec capital, Monte Alban. *400–700 CE. 13 in (32.5 cm) high*

$10,000–15,000 SK

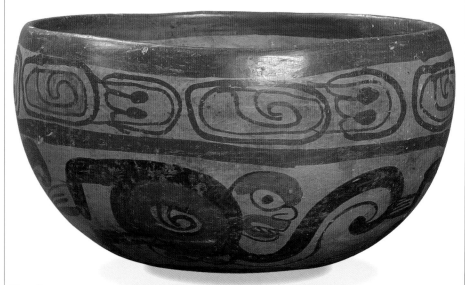

Mayan footed pottery bowl with polychrome stylized figurative and pseudo-glyph decoration. *550–950 CE. 8 in (20.5 cm) diam*

$600–1,000 BLA

Mayan orangeware vessel with incised geometric decoration. *550–950 CE. 8¼ in (21 cm) high*

$400–700 S&K

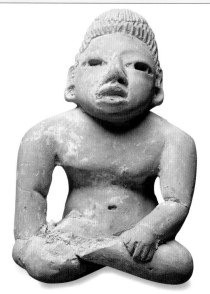

Mayan seated pottery figure from the Itzapa area. *300–100 BCE. 5 in (12.5 cm) high*

$1,200–1,800 BLA

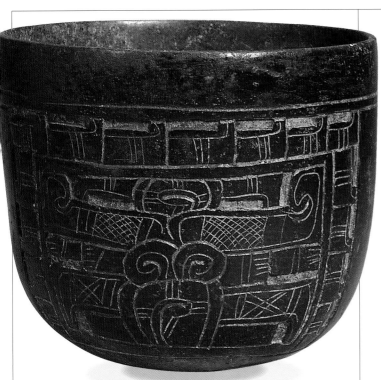

Carved and incised Mayan "blackware" pottery bowl.
550–950 CE. 5¼ in (13 cm) high

$2,000–3,500 SK

Mayan pottery vessel with relief-carved depiction of a seated ruler. *550–950 CE.*
5 in (12.5 cm) high

$1,200–1,800 SK

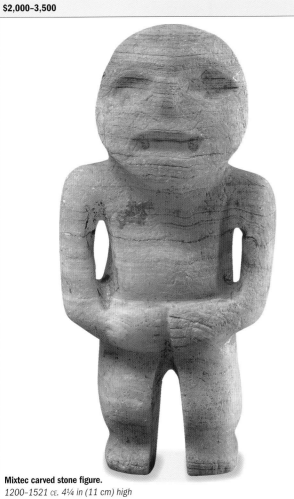

Mixtec carved stone figure.
1200–1521 CE. 4¼ in (11 cm) high

$4,000–6,000 BLA

Mayan pottery vase, with patterns of birds and geometric complements.
550–950 CE. 8¼ in (21 cm) high

$700–1,500 S&K

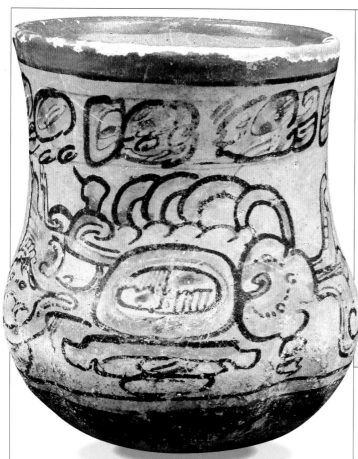

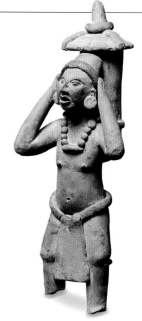

Mayan pottery vessel with incised motifs. *550–950 CE. 6½ in (16.5 cm) high*

$700–1,000 **BLA**

Mayan pottery figure of a man carrying a grain basket. *550–950 CE. 11½ in (29 cm) high*

$6,000–10,000 **BLA**

Mayan terra-cotta vessel, with "codex-style" imagery in black and shades of red on a cream ground. *550–950 CE. 4¾ in (12 cm) high*

$2,500–4,000 **BLA**

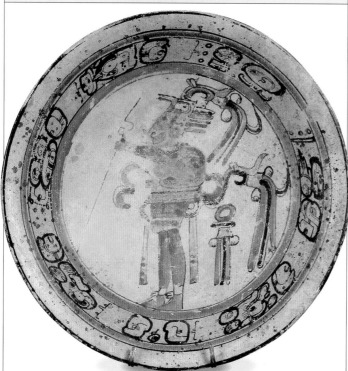

Mayan pottery bowl with polychrome decoration, raised on a tripod base (unseen). *550–950 CE. 13 in (33 cm) diam*

$2,500–4,000 **BLA**

Ceremonial Mayan "eccentric" flint of elaborate form. *550–950 CE. 7 in (18 cm) high*

$9,000–15,000 **BLA**

Mayan bead pendant made from jade. *250–950 CE. 10¼ in (26 cm) long*

$6,000–10,000 **BLA**

A CLOSER LOOK

Mayan ceremonial marble vessel from the Ulua Valley, Honduras. It has a cylindrical body, large effigy handles, an openwork pedestal, and all-over carving in deep relief. This is one of a series of marble vessels carved in the Ulua Valley during the tenth century, marking a highlight in pre-Columbian art production. Only nominally Mayan, the region lies outside the strict sphere of Mayan artistic influence felt closer to the major centers of power. Without any precedent in form or style, a small number of these resplendent art objects appeared, probably from a single workshop or locale, and then ceased. The universal spark of creative genius had left its mark once again. *900–1000 CE. 10½ in (27 cm) high* **$40,000–60,000 BLA**

Painstakingly carved in shallow relief with rudimentary stone chisels, drills, and abrasion techniques, the surfaces of these vessels are almost always filled with wave-like scrolls signifying water

A solid block of marble was hollowed and polished by endless hours of slow drilling. Though probably not meant to be functional as a receptacle or for drinking use, it still needed to be perfect in every way

Twin handles with animal effigy or mask carvings are present in most of these vessels

The finishing touch for this eclectic masterpiece is a string-sawed series of piercings in a stepped pattern evoking the terraced pyramidal form prominent in Mayan architecture

KEY FACTS

Cultural centers include Nicoya, Diquis, and Guanacaste in Costa Rica; Chiriqui, Veraguas, and Cocle in Panama. They flourished from 500 BCE to 1500 CE.

These are lands of rainforest, lush mountain ranges, and many miles of shoreline along the Pacific Ocean to the west and the Atlantic Ocean to the east. They form a land bridge between the great civilizations of Mexico and those of Peru.

Difficult terrain left areas isolated and no empire or single overriding governing power ever evolved.

Below: Pottery vessel with twin-footed handles rising to a jaguar's head, from Nicoya-Guanacaste. *800–1500 CE. 10½ in (25 cm) high* **$1,800–2,500 SK**

Central America

Inhabiting a crossroads between two continents, the people of Costa Rica and Panama felt artistic influence from the north and the south, yet cultivated a variety of their own distinct aesthetic styles.

From around 300 CE to the Spanish conquest in the 16th century, a number of well-defined cultures developed in this region. No military power or pervasive governing force ever ruled more than a limited local area. Artistic tendencies, therefore, were not imposed, but homegrown and, though not without outside influence, enjoyed a unique, flamboyant style.

Ceramic production was widespread, comprising simple plainware vessels for everyday use as well as more elaborate or figurative work for ritual intent. A favorite subject in the Guanacaste area was the jaguar. Jars modeled with this big cat's features often carry rattle pellets in their legs, possibly for rhythmic use in a funerary context. From Veraguas come terra-cottas with otherworldly, almost hallucinatory illustrations. Pedestal plates and bowls show stylized mythic beasts in an ornate and lively style.

The function of the many volcanic stone carvings from the Atlantic Watershed zone in Costa Rica is unknown. Human figures abound, but most enigmatic are the flat-topped metates. They range from simple examples of spare, clean lines to a tour de force of complex yet harmonious abstract figures and geometric accents.

Diquis, Cocle, and Veraguas are famous for their array of gold jewelry, and the production of sophisticated jadeite carvings from Guanacaste points to a long-established patronage system of powerful elite consumers.

Above: Janus bird head jade pendant, from Guanacaste, Costa Rica. *500 BCE–500 CE. 4 in (10.25 cm) high* **$1,200–2,500 BLA**

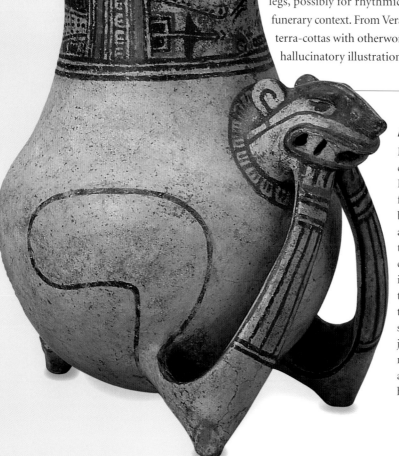

ALL-POWERFUL JAGUAR

Much art from Central America, whether ceramic, stone, or metal, was figurative. Depictions of animals, shamans, and fantastic creatures abounded. But no being was as honored in so many guises as the jaguar. Considered the ruler of the jungle, the jaguar's strength and cunning were coveted by the humans in its domain. Like many Amerindians, the peoples believed in the potential of transformation between species, both spiritual and physical. By portraying the jaguar in ritual pottery vessels, stone mace heads and metates, gold pendants and jadeite celts, a ceremonial participant hoped to share its most desirable attributes.

THE JAGUAR—A SOURCE OF ARTISTIC INSPIRATION

JADE JEWELRY

Ancient artists were called upon to craft fine jewelry and ceremonial objects from jade or, more commonly, jadeite, a related hard stone. Without the benefit of metal tools, they laboriously drilled, sawed, pecked, and abraded this resistant medium—a process requiring days for the fabrication of the simplest bead. Apart from typical jewelry forms, they worked on oblong, tapered pendants called celts or ax-gods. Probably of religious significance, celts were mostly flat, with incised and incut features. They depicted spirit figures and animal totems. Almost always pierced for suspension, they customarily showed a vertical ridge on the reverse— evidence of being sawed from a larger cobble.

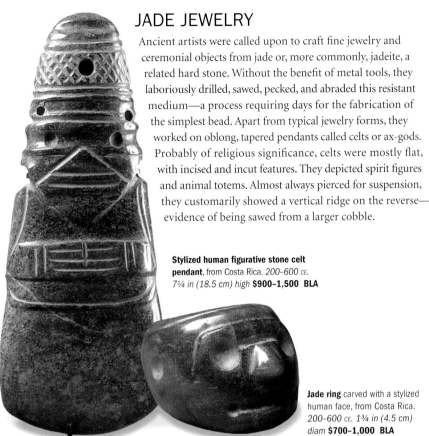

Stylized human figurative stone celt pendant, from Costa Rica. *200-600 CE. 7¼ in (18.5 cm) high* **$900-1,500 BLA**

Jade ring carved with a stylized human face, from Costa Rica. *200-600 CE. 1¾ in (4.5 cm) diam* **$700-1,000 BLA**

THE SHAMAN

Shamans were among the most powerful members of ancient Amerindian communities. Both respected and feared, they claimed control over mysterious forces that shaped people's lives.

SHAMAN ALTER-IMAGE

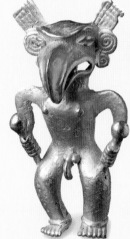

One of a pair of gold pendants in the form of a shaman with an eagle's head, from the Panama–Costa Rica border. *800-1500 CE. 2½ in (5 cm) high* **$25,000-40,000 (the pair) BLA**

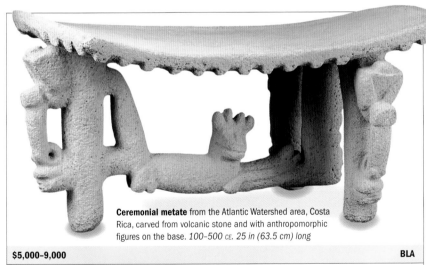

Ceremonial metate from the Atlantic Watershed area, Costa Rica, carved from volcanic stone and with anthropomorphic figures on the base. *100-500 CE. 25 in (63.5 cm) long*

$5,000-9,000 **BLA**

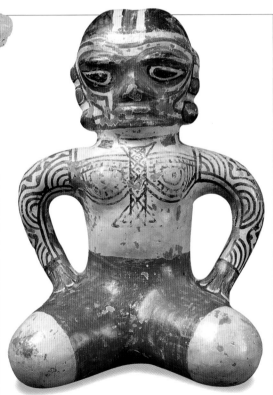

Terra-cotta bowl from the Nicoya region. *1000-1400 CE. 9½ in (24 cm) diam*

$300-700 **BLA**

Seated human figure, in polychrome-painted terra-cotta, from the Nicoya region of Costa Rica. *1000-1400 CE. 6¾ in (17.5 cm) long*

$500-900 **BLA**

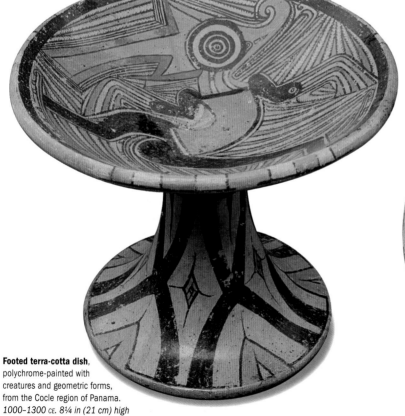

Guanacaste terra-cotta vase, from Costa Rica, with a human face in relief and incised geometric motifs. *1000–1500 CE. 4¾ in (12 cm) high*

$400–600

BLA

GLITTERING GOLD

Gold has long held an allure the world over. The Spanish conquistadors first ventured into the Central American jungle in their unsuccessful search for the kingdom of El Dorado, "The Golden One." In centers of gold production, such as Cocle and Veraguas, they encountered societies, like their own, that prized this scarce metal and afforded status to its owners. Chieftains and others of high rank wore elaborate gold pendants, headbands, and breastplates. Some of these luxurious items were worked by heating and hammering the raw metal, but the most common procedure for the larger, three-dimensional works was the lost-wax method, in which a wax model is made, encased in clay, fired, and subsequently filled with molten gold to replace the wax core (*see p.44*).

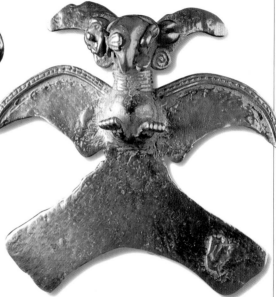

Forged gold eagle pendant, from the Diquis region of Costa Rica. *800–1500 CE. 3¼ in (8 cm) long*

$5,000–9,000

BLA

Footed terra-cotta dish, polychrome-painted with creatures and geometric forms, from the Cocle region of Panama. *1000–1300 CE. 8¼ in (21 cm) high*

$1,200–1,800

BLA

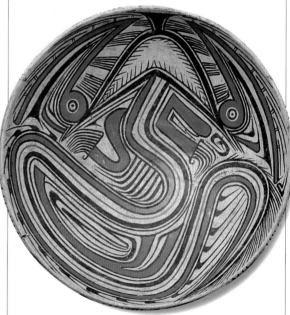

Footed terra-cotta dish polychrome-painted with snakes and other creatures, from Veraguas, Panama. *1000–1500 CE. 11¾ in (30 cm) diam*

$2,500–4,000

BLA

Gold-mounted terra-cotta pendant, in the form of a whale tooth, from the Diquis delta, Costa Rica. *800–1500 CE. 3 in (7.5 cm) high*

$300–700 **S&K**

Gold ceremonial pectoral ornament, depicting a shaman in transformation, from the Diquis region of Costa Rica. *800–1500 CE. 3½ in (9 cm) wide*

$18,000–25,000 **BLA**

Hammered gold headband, from the Chiriqui province of Panama. *800–1500 CE. 21¼ in (54 cm) long*

$300–700 **S&K**

SOUTH AMERICA

From Colombia to Chile, the western side of South America witnessed the rise and fall of legendary societies such as the Chavin, Huari, and Inca. They made the history books with their inventions and empires and also hold high rank in the annals of art for their exquisite textiles, pottery, and goldwork.

The Chavin, Huari, and Inca peoples, and others with whom they had contact, formed a continuum of constant influence, flux, and flow. The art objects they produced were not created in a vacuum, but rather evolved over time, inspired by religious beliefs, personal visions, and, undoubtedly, the latest fashions displayed by their neighbors.

Starting in around 1500 BCE, the Chavin in the north coast region of Peru disseminated a belief system throughout the surrounding area, and with it a wealth of related artistic material culture. The deities depicted on their painted textiles, ceramic effigies, and gold ornaments reinforced the divine message they represented. As the message spread, so did these art forms, until fanged, Chavinoid deities appeared in the art of people up and down the coast and into the highlands. The heritage and early development of Chavin society is unknown, but a pattern of influence had begun and, eventually, almost all of Peru would be affected.

REGIONAL EXCELLENCE

Paracas in the south excelled in the textile arts. Their finest work depicted Chavin-style gods in a dozen or more colors, as brilliant today as when they were first woven, magnificently preserved by the incredibly dry desert climate of that region.

The next culture to dominate that area was the Nazca. They, too, were masters of color, and their slip-painted pottery (*see pp.222–225*) was as beautiful as any to ever come out of the continent. Paracas influences were apparent in these "new" works of art, which, in turn, influenced the art of the highlands Huari. This martial society's empire grew until it eventually encompassed most of the Peruvian coast. Their artists imitated the Nazca painting technique and soon such pottery spread back up into the north. Cross-cultural pollination like this continued from region to region. Similar movements took place in Colombia and Ecuador, though on a smaller scale.

Chancay polychrome-painted hollow terra-cotta effigy figure. *900–1400 CE.*
18 in (46 cm) high **$1,000–1,500 BLA**

From the densest jungles, to the driest deserts, and the highest mountains, the Amerindian people of South America created an astonishing legacy of artwork.

LANDSCAPE AND CULTURE
The relationship between the people and their land is key to these early cultures. The land was sacred to the people, yet nothing could be more cruel than their environment—whatever the land offered, the people accepted. The land defined them.

Right: Macchu Pichu in the Andean highlands is one of the world's great archaeological sites. It has been called "The Lost City of the Incas." To protect the city from the Spanish conquistadors, it was intentionally "lost" by being built on a remote plateau to avoid detection. It was not rediscovered until 1911.

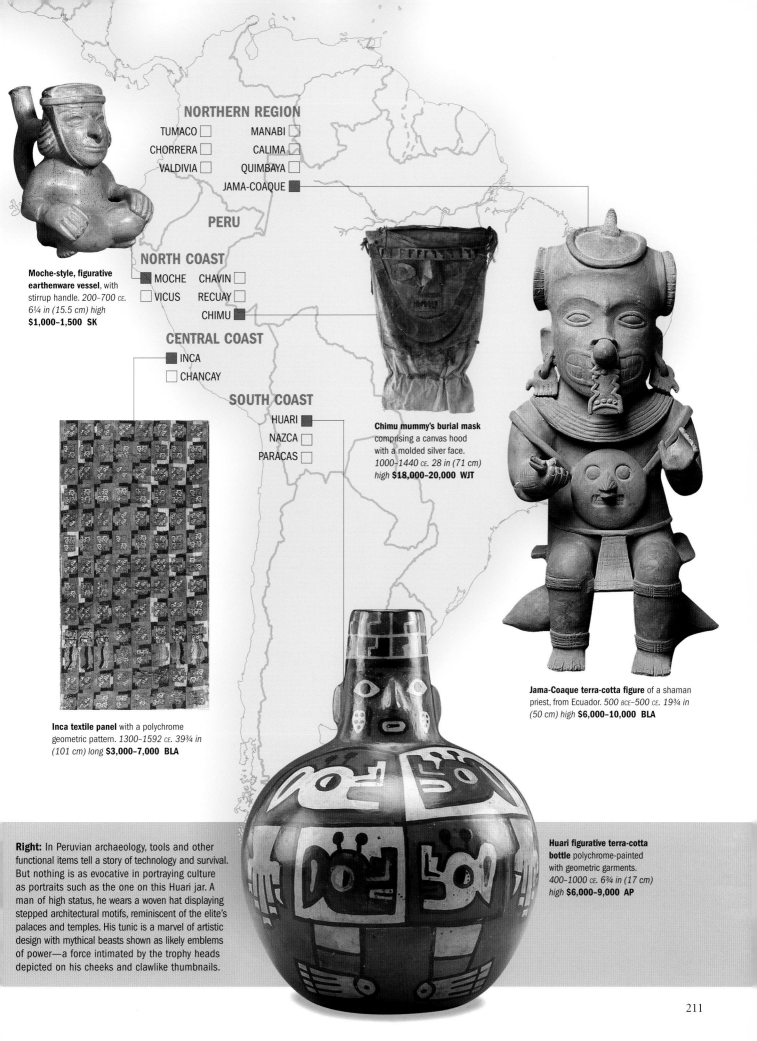

Moche-style, figurative earthenware vessel, with stirrup handle. *200–700 CE.* 6¼ in (15.5 cm) high **$1,000–1,500 SK**

NORTHERN REGION

TUMACO ☐ MANABI ☐
CHORRERA ☐ CALIMA ☑
VALDIVIA ☐ QUIMBAYA ☐
JAMA-COAQUE ■

PERU

NORTH COAST

MOCHE ■ CHAVIN ☐
VICUS ☐ RECUAY ☐
CHIMU ■

CENTRAL COAST

INCA ■
CHANCAY ☐

SOUTH COAST

HUARI ■
NAZCA ☐
PARACAS ☐

Chimu mummy's burial mask comprising a canvas hood with a molded silver face. *1000–1440 CE.* 28 in (71 cm) high **$18,000–20,000 WJT**

Jama-Coaque terra-cotta figure of a shaman priest, from Ecuador. *500 BCE–500 CE.* 19¾ in (50 cm) high **$6,000–10,000 BLA**

Inca textile panel with a polychrome geometric pattern. *1300–1592 CE.* 39¾ in (101 cm) long **$3,000–7,000 BLA**

Right: In Peruvian archaeology, tools and other functional items tell a story of technology and survival. But nothing is as evocative in portraying culture as portraits such as the one on this Huari jar. A man of high status, he wears a woven hat displaying stepped architectural motifs, reminiscent of the elite's palaces and temples. His tunic is a marvel of artistic design with mythical beasts shown as likely emblems of power—a force intimated by the trophy heads depicted on his cheeks and clawlike thumbnails.

Huari figurative terra-cotta bottle polychrome-painted with geometric garments. *400–1000 CE.* 6¾ in (17 cm) high **$6,000–9,000 AP**

211

KEY FACTS

Comprising modern-day Colombia and Ecuador, ancient cultures in this northern segment of the South American continent began as far back as Valdivia in 3500 BCE; 5,000 years later, the Muisca tribe met early Spanish explorers. Other groups include the Calima, Chorrera, Tumaco, La Tolita, Quimbaya, Muisca, and Jama-Coaque.

With lengthy coastlines of swamps and savannas, the region was dominated by mountain chains in the west and jungle rainforests in the east.

Cultures that developed beyond a rudimentary level were mostly coastal or from interior mountainous areas accessible through roads laid out as part of trade networks.

Northern Region

The extant kingdoms of Colombia in the 16th century were conquered by waves of gold-hungry Spaniards. Only a short time before, all of Ecuador had fallen to another dominant military power—the Inca army.

Before the 16th century, the inhabitants of these territories had developed prosperous societies enriched by age-old traditions. In Muisca country, one ritual called for the local ruler to cover himself in gold dust and sail off on a raft filled with treasure. Whether fact or fiction, it gave rise to the European search for El Dorado ("The Golden One"). Gold was relatively plentiful, and across Colombia people used it to create countless decorations. From the Sinu region came delicate filigree earrings; in Quimbaya they cast pendants of shamans and fantastic beasts; the Muisca made flat, multifaceted figures called *tunjas*; and the most elaborate works, including large pectorals and nose ornaments, came from the Calima area.

Ceramics were also plentiful, and many of the most beautiful and exotic examples came from Ecuador. The Tumacos honored their gods with altars depicting startling, composite creatures. Human figures were prominent in Chorrera and Jama-Coaque, and depictions of animated ritual life were common from the latter. The most ancient site in the region, Valdivia, left many stone figurative sculptures whose stylized features could have derived from any modern art school.

Above: **Chorrera figure** of a woman, from Ecuador. *1500–500 BCE. 11¾ in (30 cm) high* **$3,000–4,000 BLA**

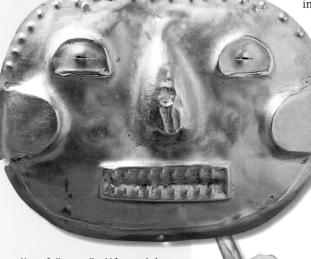

Above: **Calima small gold facemask**, from Colombia. *100 BCE–500 CE. 3¼ in (8 cm) wide* **$5,000–9,000 BLA**

CALIMA GOLD

In the Cauca Valley of western Colombia, two cultures attained great artistic heights in their gold work: the Quimbaya and the Calima. They developed a procedure to produce *tumbaga* (a copper–gold alloy with a golden surface and copper core). With lost-wax castings (*see p.44*) of *tumbaga* or hammered sheet gold, the Calima artisans and their neighbors fabricated quantities of gold jewelry as finery for their chieftains, along with death masks and other burial items.

Right: **Calima gold necklace** with 17 stylized fish-form pendants. *100 BCE–400 CE. 16½ in (42 cm) long* **$600–900 S&K**

Jama-Coaque terra-cotta figure of a shaman. *500 BCE–500 CE. 10¼ in (26 cm) high*

$3,500–4,000 **BLA**

Characteristically stylized Valdivian stone figure, from Ecuador. *3500–1800 BCE. 8½ in (22 cm) high*

$1,200–1,800 **BLA**

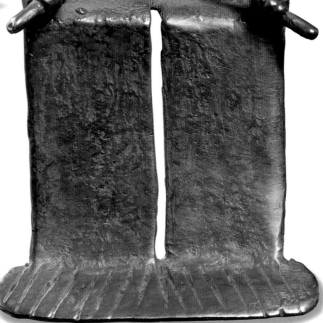

Quimbaya gold pendant depicting a shaman, from present-day Colombia. *500–1500 CE. 2¾ in (7 cm) high*

$4,500–7,000 **BLA**

Tumaco-La Tolita terra-cotta altar with anthropomorphic effigy figure. *600 BCE–300 CE. 11 in (28 cm) high*

$3,000–5,000 **BLA**

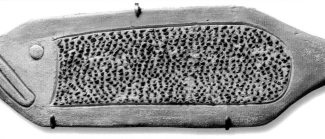

Tumaco painted terra-cotta fish-form vessel, from Ecuador. *600 BCE–300 CE. 11¼ in (28.5 cm) long*

$700–1,200 **BLA**

KEY FACTS

Cultures include Vicus, Cajamarca, Chimu, Moche, Recuay, Sican, and Chavin—covering a time span from 1500 BCE to 1440 CE.

Coastal areas along the Pacific Ocean were arid wastelands penetrated by river valleys; the Andes mountains rose to the east and held intermontane valleys and lakes.

Extremely limited rainfall required the use of irrigation for the cultivation of corn, beans, squash, and cotton.

Much of north coast art was influenced by the widespread dissemination of cultural and religious mores originating from the Chavin area.

Below: **Chimu gold *kero* (beaker)** with a repoussé work design of a noble in full regalia. *1000–1440 CE. 4½ in (11.5 cm) high*
$6,000–9,000 AP

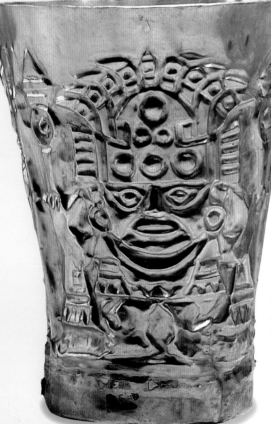

North Coast

Peru's north coast region gave rise to a series of vibrant cultures and a vast array of artistic objects. Textiles, wood sculptures, ceramics, and metalwork have all survived beneath the region's desert sands.

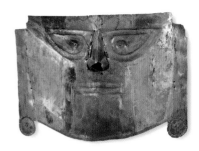

In an area almost without rainfall, stung by ocean winds, and with frequent dense fog, it is difficult to imagine any civilization prospering. The peoples of the north coast of Peru, however, flourished in many ways. They built great towns and elaborate temple complexes. They cultivated fields by bringing irrigation water great distances in canals. Political and religious systems evolved that required a centralized seat of power and an orderly administrative process—all signs of advanced cultures. Trading with the people of the Andean highlands, they mutually expanded their horizons and also their material resources.

POTTERY STYLES

The Chavin culture includes the capital city of that name as well as far-flung, related sites such as Cajamarca, Cupisnique, Chongoyape, and Tembladera. Chavin pottery focused particular attention on the textural decoration of a vessel's surface, usually had a stirrup spout-handle—a form that probably originated there—and was mostly monochromatic. The Recuay and Moche took the opposite approach and painted virtually all of their ceramic ware. A typical Recuay vessel, in two colors on a white background, showed anecdotal scenes of tiny figures set in temples or homes. The variety of Moche pottery is so great that there is no typical theme. Rather, everything under the sun was commemorated in clay. They invented the press-mold process that led to a proliferation of more easily (and

Above: **Sican hammered gold sheet mask** with repoussé stylized human face. *900–1200 CE. 13 in (33 cm) wide*
$7,000–10,000 SK

CHIMU GOLD

The first evidence of goldwork in Peru dates from circa 1500 BCE. The exact origins of this practice are uncertain, but we do know that gold came from the Andes; that the ancient Peruvians found its allure irresistible; and that they developed a multifaceted technology to mine it, smelt it, and work it into decorations. The Chimu probably made more use of gold than anyone before them. It was reserved for royalty and the noble classes in their capital city of Chan Chan, and included drinking vessels, knives, spoons, tweezers, staff finials, jewelry of every sort, crowns, masks, and small platelets used to cover entire garments.

CITY WALL, CHAN CHAN

CHAVIN INFLUENCE

An influential artistic movement spread around 1000 BCE from the city of Chavin de Huantar. Though the name Chavin is synonymous with an aggregation of north coast peoples unified through cultural links, some suggest Chavin was more an art style than a culture. Anthropomorphic deities in the Chavin style were found far afield from its northern highlands homeland. Regardless of prior local sentiment, gods were depicted as fearsome, vengeful-looking beings. This prototype and accompanying belief system served as a direct antecedent for others. The later Moche god, Ai-Apec, was chief among them with his protruding fangs, scowling grimace, and wrathful demeanor.

Right: Moche painted terra-cotta vessel comprising a fortress, the fanged deity Ai-Apec, and fish and animals. *300–700 CE. 8½ in (21 cm) high* **$12,000–18,000 AP**

PORTRAITS

We have learned much about the ancient Peruvians through their pottery. Symbolic or naturalistic, these vessels faithfully portrayed an assortment of deities, humans, and everyday anecdotal events.

MOCHE PORTRAIT VESSEL

The Peruvian ceramics most sought after by collectors are Moche portrait vessels. Accurate in every detail, these lifelike mortuary offerings depicted real human beings as they looked 1,500 years ago.

sometimes poorly) made vessels. Another site, Vicus, favored double-chambered jars, usually with a human or animal figure on the top of the front chamber. Though charming, as a rule they were crudely manufactured.

ELITE ADORNMENT

Gold and other metals in the hands of Chimu, Vicus, Moche, and Sican artists became impressive ornaments and regal implements, truly fit for a king. The rulers of these cultures were properly adorned during their lives, but grew even more splendid when laid out for their final rest with a treasury of gilded accessories.

On a day-to-day basis, textiles kept the elite classes well dressed for any occasion. Although textile production on the north coast was fairly limited compared to that farther south (*see pp.222–225*), remarkably fine and detailed weavings were fashioned. A proper suit of clothes included a finely decorated shirt, loincloth, and headband.

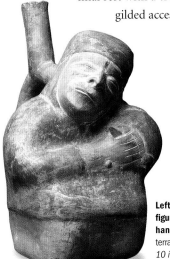

Left: Moche human figurative stirrup spout-handle jar in painted terra cotta. *300–700 CE. 10 in (25 cm) high* **$600–1,000 BLA**

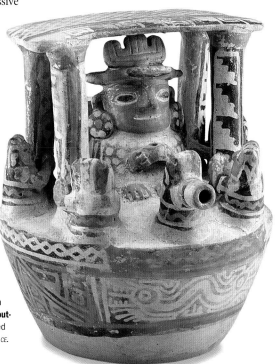

Moche painted terra-cotta portrait vessel with a stirrup spout-handle. *300–700 CE. 11½ in (29 cm) high* **$2,000–3,000 SK**

Left: Recuay painted terra-cotta vessel depicting a dignitary and disciples. *200 BCE–550 CE. 8 in (20.5 cm) high* **$2,500–3,000 AP**

215

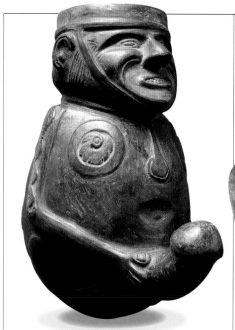

Chimu erotic male terra-cotta vase. *1000–1440 CE.*
9 in (23 cm) high

$1,000–1,800 BLA

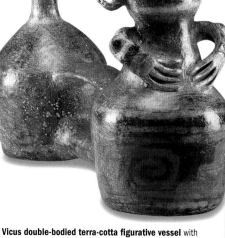

Vicus double-bodied terra-cotta figurative vessel with
black paintwork. *500 BCE–500 CE. 8½ in (21.5 cm) high*

$900–1,500 AP

Chavin painted terra-cotta seated monkey vessel with a
stirrup spout-handle. *1500–400 BCE. 9¼ in (24 cm) high*

$1,200–1,800 AP

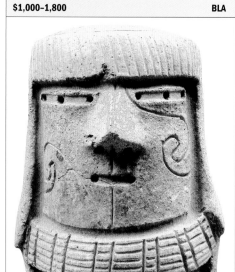

Chavin-style painted terra-cotta deity figure, from
Cajamarca. *1500–400 BCE. 6 in (15 cm) high*

$1,800–2,500 BLA

A CLOSER LOOK

Chimu woven polychrome textile panel with three rows of stylized warriors wearing elaborate
headdresses. The Chimu put tremendous effort and creativity into textiles. Many have survived
due to the remarkably dry coastal climate and their burial method where layers of textiles were
wrapped around the deceased.
For Chimu artists, as in other parts
of Peru, weaving became a sacred
act and the products of their looms
were accorded the highest acclaim, to
be used with respect and solemnity.
800–1200 CE. 17½ in (44.5 cm) long
$1,000–1,800 AP

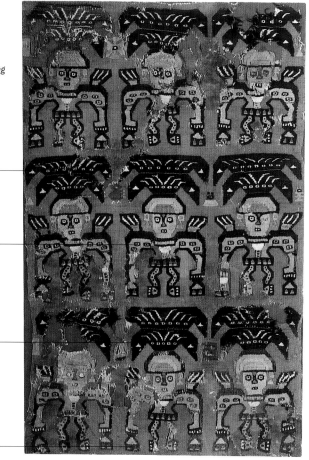

The frontal profile view was the
standard means of depicting
human figures—in this case,
probably a Chimu king

Stylized jaguar or serpent heads
perch on the figures' shoulders.
These are emblematic of the powers
possessed by the Chimu ruler

An elaborate double crescent
headdress befits the image of
royalty and serves as a diagnostic
trait of Chimu iconography

Trophy heads (the severed heads of
defeated rivals) are a grisly leitmotif
seen in many Peruvian artworks.
Here they reinforce the authority
of the king

216

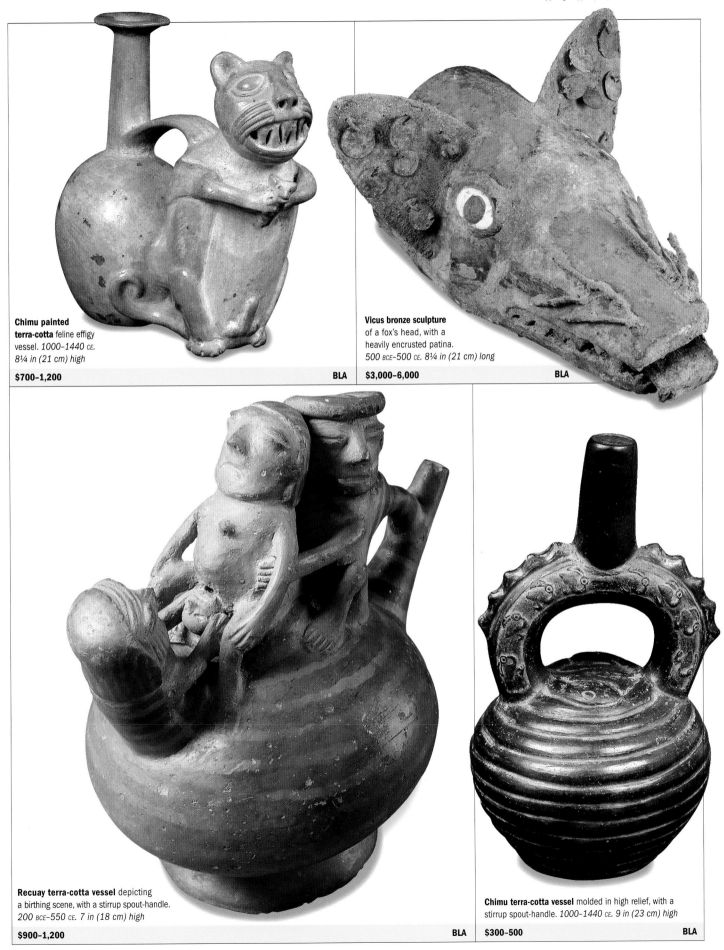

**Chimu painted
terra-cotta** feline effigy
vessel. *1000–1440 CE.
8¼ in (21 cm) high*

$700–1,200 **BLA**

Vicus bronze sculpture
of a fox's head, with a
heavily encrusted patina.
500 BCE–500 CE. 8¼ in (21 cm) long

$3,000–6,000 **BLA**

Recuay terra-cotta vessel depicting
a birthing scene, with a stirrup spout-handle.
200 BCE–550 CE. 7 in (18 cm) high

$900–1,200 **BLA**

Chimu terra-cotta vessel molded in high relief, with a
stirrup spout-handle. *1000–1440 CE. 9 in (23 cm) high*

$300–500 **BLA**

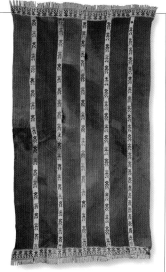

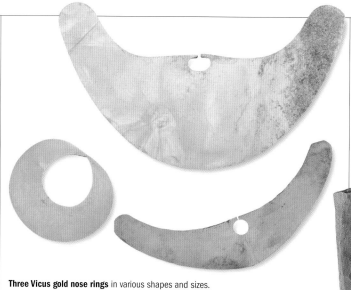

Chimu woven tunic. *1000–1440 CE.*
87½ in (222 cm) long

$2,500–4,000 **BLA**

Three Vicus gold nose rings in various shapes and sizes.
500 BCE–500 CE. Largest: 6 in (15 cm) wide

$300–700 **S&K**

Chimu polychrome textile woven with stylized human figures set within geometric pattern borders.
1000–1440 CE. 47 in (119.5 cm) long

$1,800–2,500 **AP**

**Chimu bird-form
stirrup spout vessel.**
1000–1440 CE.
8 in (20.5 cm) high

$200–400 **BLA**

Chimu monkey-form stirrup spout vessel.
1000–1440 CE. 8¼ in (21 cm) high

$300–500 **BLA**

Huari carved wooden guardian figure
with red and yellow pigment on the face.
400–1000 CE. 34 in (86.5 cm) high

$18,000–25,000 **WJT**

Moche

From its earliest days around 200 BCE to its eventual decline after 700 CE, the Moche culture—or Mochica, after its Moche Valley homeland—celebrated life through art in a prodigious output of ceramics, metalwork, stone, and wood carvings. Textiles were also produced but are scarce today, while the other forms have been found in abundance. The Moche also excelled in architecture and built the largest adobe structure in South America, called Huaca del Sol. The ceramic record, particularly, has given us an insight into the lives of these peoples, with portrayals of ceremonies, military campaigns, everyday affairs, and even sexual acts.

Stone *conopa* (ritual vessel). *200 BCE–200 CE.*
6 in (12 cm) long

$1,000–1,800 BLA

Painted terra-cotta vessel with a stirrup spout-handle.
100 BCE–700 CE. 7 in (18 cm) high

$1,000–1,800 BLA

Terra-cotta portrait-head vessel with a stirrup spout-handle.
200–600 CE. 12 in (30.5 cm) high

$1,000–1,800 BLA

Terra-cotta frog-form stirrup spout vessel. *100–700 CE.*
7¾ in (20 cm) high

$1,000–1,800 BLA

Painted terra-cotta owl effigy vessel. *200–600 CE.*
7¾ in (30.5 cm) high

$1,200–1,800 BLA

KEY FACTS

Principal cultures were the Chancay (900–1400 CE) and the Inca (1300–1592 CE).

The Inca highlands capital, Cuzco, enjoyed a well-watered, moderate environment. Other regions within the empire encompassed most of the various Peruvian climate zones; Chancay, located in a river valley, sat in the arid coastal area.

The Inca empire was the largest of its type throughout the Americas, stretching from southern Colombia in the north to parts of Chile and Argentina in the south.

Central Coast

The Inca empire arose as the result of conquests and accommodations. No other political-military power in the Americas had ever attained such supremacy. In governing, they melded their traditions with those of their subjects.

Inca leaders proved more than just brilliant military tacticians. They were also masterful administrators. They imposed a labor obligation structure that provided workers to fulfill plans for large-scale public art—the building of fortresses and temples. On a smaller scale, the Incas introduced their own style of ceramics and textiles to their expanding world. Outlying local types persisted, but adapted an imperial iconography to distinguish them from earlier traditions. In both wool garments and spectacular textiles covered in feathers, the Inca favored geometric motifs over figurative designs. Pottery took many forms, depending on the location, but the classic Inca vessel was the *aryballos* (a two-handled bulbous jar).

One of the many component parts of the Inca empire was the coastal culture of the Chancay. Artistically, they excelled in producing textiles of numerous types. They wove three-dimensional effigies, clothing, and ceremonial trappings. On these, and most of their textiles, common themes included fish and seabirds, reflecting their dependence on the sea and its resources. They also produced quantities of ceramics and wood sculptures but, as a rule, these were rustic and coarsely finished.

Above: Inca tunic cloth woven in shades of red, green, yellow, and black. *1300–1692 CE. 31½ in (80 cm) wide* **$700–1,200 BLA**

Right: Chancay terra-cotta naked female *cuchimilco* figure, painted over a cream slip. *900–1400 CE. 24½ in (62 cm) high* **$1,800–2,500 BLA**

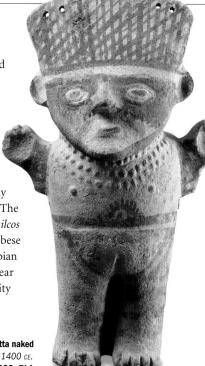

CUCHIMILCOS

Virtually every Peruvian culture included human effigies in its pottery repertoire. Distinct among these were a Chancay version referred to as *cuchimilcos*. According to some, the name means "little moon goddess." Their exact significance is unclear, though they have been found in numerous tomb settings, often in pairs, and were probably some sort of grave guardian or offering. The most distinguishing feature of the *cuchimilcos* is their corpulent build. Not unlike the obese figures portrayed by modern-day Colombian artist Fernando Botero, they bulge to near bursting and may have signified prosperity and abundance.

Right: Chancay painted terra-cotta naked female *cuchimilco* figure. *900–1400 CE. 11½ in (29.5 cm) high* **$500–900 BLA**

Chancay terra-cotta vase of human figurative
form with cream and brown slips. *900–1400 CE.
17¾ in (45 cm) high*

$1,200–1,800 BLA

Fragment of a Chancay sash woven with stylized figurative
decoration. *900–1400 CE. 11 in (28 cm) long*

$300–600 BLA

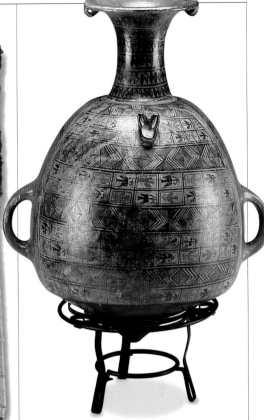

Large Inca terra-cotta *aryballos* with polychrome
figurative and geometric decoration. *1300–1592 CE.
14½ in (37 cm) high*

$5,000–7,000 AP

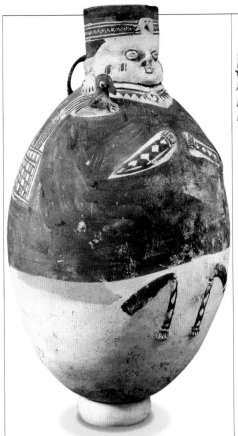

Pair of Chancay wood figures with painted decoration.
900–1400 CE. Both: 12½ in (32 cm) high

$900–1,500 BLA

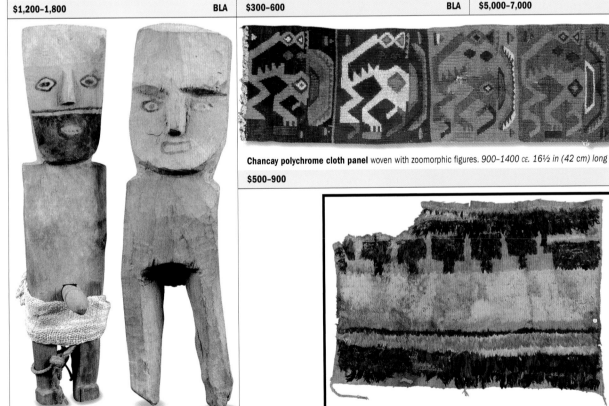

Chancay polychrome cloth panel woven with zoomorphic figures. *900–1400 CE. 16½ in (42 cm) long*

$500–900 BLA

Inca panel with overlapping rows of polychrome feathers on a plain cotton ground. *1350–1592 CE. 42 in (106.5 cm) wide*

$1,800–3,000 S&K

KEY FACTS

Cultures include Paracas (400–100 BCE), Nazca (400 BCE–600 CE), and the Huari Empire (400–1000 CE).

Paracas and, later, Nazca occupied essentially the same strip of barren, desert coastland made fit for habitation only by a series of river valleys. They relied on irrigation for agriculture and the bounty of food offered by the Pacific Ocean.

The Huari empire started near the highland city of Ayacucho and, at its height, encompassed much of Peru.

South Coast

Of all the ancient Peruvian cultures, none surpassed Paracas in the art of weaving, nor the Nazca potters for the quality of their polychrome slip-painted wares. The Huari excelled artistically, too, disseminating influence throughout their empire.

The Chavin artistic and religious influence felt so widely throughout the north coast of Peru also held sway on the south coast. Paracas pottery and textiles frequently showed Chavinoid deities marked by characteristic eye treatments and a fanged mouth. Yet in their overall compositions, use of color, and mastery of technique, they bowed to no one. Woven as mantles to wrap the deceased, some of the most magnificent textiles ever produced were discovered in 1927 in a Paracas graveyard.

Nazca, too, borrowed from other cultures in the evolution of its art styles. Paracas-style personages, traceable directly to a Chavin antecedent, were reborn on the painted walls of polychrome pottery vessels. The figurative tradition so common in the north and central coast areas was mostly rejected in favor of a rich

inventory of two-dimensional imagery. The intensity of Nazca art perhaps stemmed from the struggle for survival in their inhospitable environment. Their culture endured for almost a millennium, but ultimately they were subsumed by the Huari from the east.

From a stronghold in the highlands, the Huari organized a significant military force, and grew in strength and influence. They borrowed the painting style of Nazca ceramics and religious iconography from Tiahuanaco, a site far to the east. On the strength of this pottery tradition, along with their textiles and jewelry, the Huari excelled as both soldiers and artists.

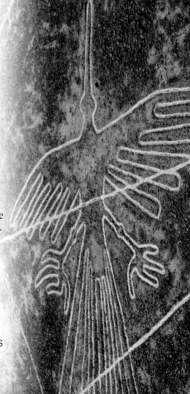

Above: Nazca terra-cotta pan pipe. *400 BCE–600 CE.* *20¾ in (53 cm) long* **$1,200–1,800 BLA**

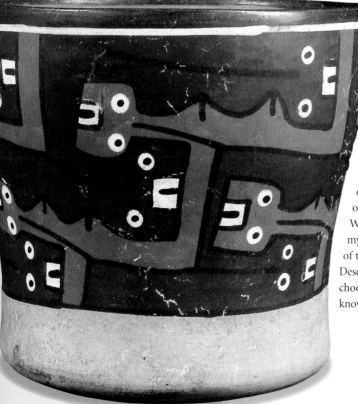

Below: Nazca terra-cotta beaker slip-decorated with a snake pattern. *400 BCE–600 CE. 4 in (10 cm) high* **$300–700 BLA**

ART OR ARTIFACT?

For the Nazca artist who painted this bowl, the rhythmic, positive-negative intertwining of these serpent motifs was perhaps inspired by a vision. Or maybe it was an architectural conceit like the tongue-and-groove fitting of bricks. The significance of the image and the functionality of the object were one and the same for its creator. Was it art? The Nazca also produced lines in mysterious geometric and animal forms, some of them miles long, drawn out in the Nazca Desert. Certainly they had a purpose. However we choose to interpret them, we will probably never know their significance. Were they art or artifact?

NAZCA LINES

TROPHY HEADS

The prevalence of warfare in ancient Peru is made abundantly clear with a study of its artwork. The Nazca, particularly, had an almost obsessive focus on heads taken in battle. Referred to as trophy heads, such depictions are emblazoned primarily on the walls of painted pottery. They are shown worn as pendants, hung as decorative appendages, or even sprouting blossom-style from the stylized figures of anthropomorphic deities and mythical creatures. Yet another indelicate artistic phenomenon was textiles with borders of small trophy heads aligning the sides. They were woven in a three-dimensional, self-stitch technique, lending real character to the faces' glum demeanor.

Below: Proto-Nazca textile border fragment with polychrome trophy heads. *100 BCE–100 CE. 8¼ in (21 cm) long* **$300–700 BLA**

SACRED WEAVING

Weaving was of such importance throughout Peru that it was considered a sacred act. Patterns held religious significance and production was strictly regulated. One particular Inca textile could only be woven by virgins from the temple of the sun god.

Polychrome tapestry from the Huari, with figurative decoration. *400–1000 CE. 42 in (105 cm) long* **$4,000–7,000 BLA**

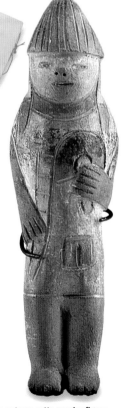

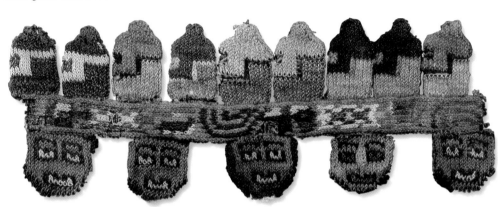

Huari shell and mother-of-pearl headband. *400–1000 CE. 13¼ in (33.5 cm) long*

$900–1,500 **S&K**

Huari gold crown faintly engraved with feline imagery. *400–1000 CE. 21¼ in (54 cm) long*

$300–700 **S&K**

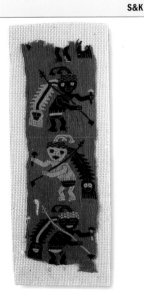

Fragment of a Paracas polychrome textile, with warriors wearing zoomorphic headdresses. *400–100 BCE. 8½ in (21.5 cm) long*

$4,000–6,000 **AP**

Paracas terra-cotta warrior figure. *400–100 BCE. 5¼ in (13.5 cm) high*

$1,200–1,800 **AP**

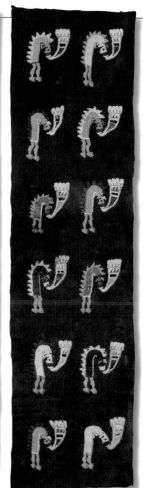

Two Paracas polychrome cloth panels woven with images of shamans in transformation. *400–100 BCE. Both: 13¼ in (34 cm) long*

$3,000–6,000 BLA

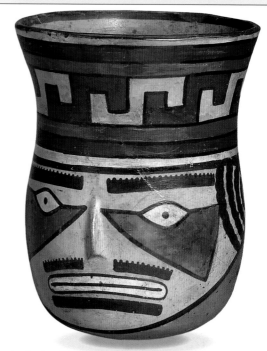

Huari mummy mask carved in wood with inlaid shell eyes. *400–1000 CE. 32¼ in (82 cm) high*

$3,000–6,000 BLA

Nazca pottery beaker with stylized face and geometric decoration polychrome-painted over a cream slip. *400 BCE–600 CE. 6¾ in (17 cm) high*

$400–700 SK

Nazca

A remarkable flourish of art emerged from a relatively small area on the south coast. The Nazca had inherited one of the world's great textile traditions from their Paracas precursors. Eschewing the complex and colorful style of their forebears, Nazca weavers eventually turned to a deceptively simple, bold use of color fields in a limited palette. Nazca potters, on the other hand, were known for the multicolored, slip-painted technique and the complex imagery of their craft. Feather work was also practiced, with garments and trappings strung in colorful Amazonian parrot feathers. And, as elsewhere, there was a predilection for gold ornaments, manufactured for the ruling class.

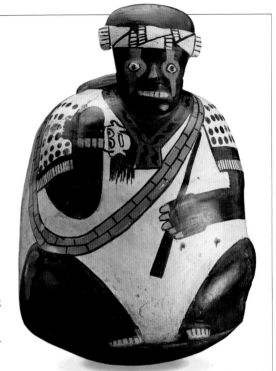

Figurative vessel of a warrior holding a trophy head, with polychrome-painted decoration. *400 BCE–600 CE. 7 in (18 cm) high*

$3,000–4,000 AP

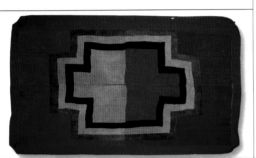

Intricately woven *cushma* **(tunic)** with a geometric pattern in brilliant colors. *400 BCE–600 CE. 86 in (218 cm) long*

$25,000–40,000 EFI

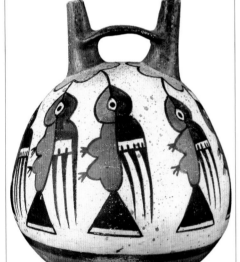

Double spout and bridge vessel with hummingbird and floral motifs on a white ground. *200–600 CE. 6¼ in (16 cm) high*

$600–1,000 BLA

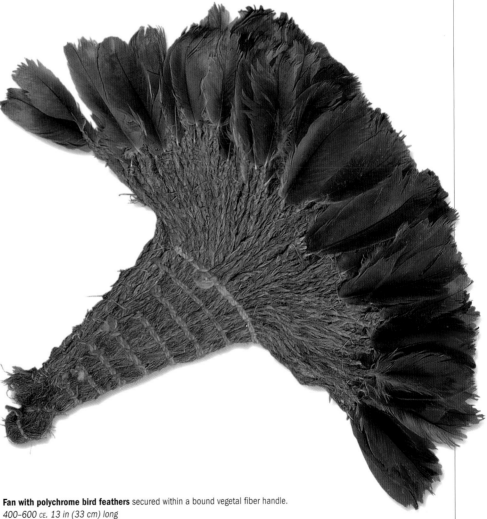

Polychrome cloth panel woven with stylized human face. *200–600 CE. 20½ in (52 cm) long*

$500–900 BLA

Fan with polychrome bird feathers secured within a bound vegetal fiber handle. *400–600 CE. 13 in (33 cm) long*

$500–900 BLA

225

Glossary

Abalone Describes both a type of edible mollusk and its shell, the latter of which has a mother-of-pearl-like appearance and is often employed as a decorative medium. *See haliotis.*

Adz A tool similar to an ax with a blade set at a right angle to the shaft.

Appliqué A needlework technique in which shaped pieces of fabric are stitched onto a foundation fabric to create a pattern.

Anthropomorphic A being or object, most notably a deity or an animal, represented in human form or with human attributes.

Apotropaic A power, usually invested in objects such as statues, that wards off evil or bad luck.

Boreal Pertaining either to the north wind, or to the post-glacial climate of the northern, mountainous regions of the Northern Hemisphere, or to any tree or plant characteristic of that climate and region.

Button blanket A traditional Northwest region blanket decorated with shell, pearl, or other types of button. It is often given as a gift at a Potlatch ceremony. *See Potlatch.*

Cache-sex A French term for a piece of clothing used to cover the sexual organs.

Caribou A North American name for reindeer.

Censer A small container used for burning incense during spiritual-religious ceremonies. Mostly made from either metal or stone that has been suitably decorated, it can be raised on small legs or feet, or suspended (and sometimes swung by hand) from chains.

Chilkat A dancing blanket produced by the Tlingit and other groups of the Northwest coast of North America. It is made from cedar bark and mountain goat wool dyed with natural plant or synthetic dye substances.

Codex style A form of intricate pictorial and hieroglyphic decoration inspired by Classic Mayan folding-screen books, of which only a few have survived to this day.

Coir Coconut husk fiber used to make sennit. *See Sennit.*

Crupper A strap leading from the back of a saddle to the tail of a horse, to keep the harness in place.

Cassowary The second-largest bird in the world, after the ostrich, which it resembles. Black and flightless, it is found in northeastern Australia and New Guinea, where its bones and feathers are used to produce knives and headdresses.

Cephalolmorphic An object shaped in the form of a head or skull.

Champlevé A French term for a decorative technique, often employed in metalwork, in which powdered enamels are used to fill cavities. The process is reminiscent of a wood-carving technique often used to produce decorative shields in Papua New Guinea.

Cicatrice Also, keloid. *See scarification.*

Clan A tribe or group of families with common ancestry.

Coiffure A French term for a hairstyle.

Coptic Of or relating to the Copts, their liturgical language, or their church. The Coptic church is the native Christian church of Egypt.

Divination The art of seeking to know the future or the unknown, by ceremonially consulting supernatural sources.

Effigy A dummy or model, often in the form of a sculpture, representing somebody or something. An effigy can be employed as a monument in, for example, architecture, but more often it represents an undesirable person, spirit, or object, which, in some religious rituals, can be burned or otherwise destroyed to banish what it symbolizes.

Ermine The white fur of the stoat, sometimes used to trim ceremonial garments.

Fetish A term dating back to the 17th century, which was given to African objects believed to have a magical power. It is derived from French and Portuguese words meaning "charm" or "sorcery."

Finial A decorative component that vertically terminates the apex of an object. Typical examples include a spike on the top of a gable spire or a helmet, and a ball- or acornlike projection on the top of the lid of a bowl—which, in the case of the latter, also serves as a handle.

Flange A projecting edge, rib, or rim on an object, used to strengthen the object or for connecting it securely to another object.

Flywhisk An object used to flick or brush away flies and other insects, and traditionally made from woven strands of animal hair attached to a wooden or bone handle.

Frigate bird A popular motif in Oceanic art, the frigate bird (also known as the man-o'-war) is large, about the size of a hen, and has long legs and wings and a red pouch.

Gauntlet A substantial protective glove with a long, wide cuff that covers part of the forearm, and usually made of leather, but sometimes metal.

Guilloche A French term for a repeating form of decoration composed of interlaced curved bands. The latter sometimes form circles, and these can be embellished with other motifs, notably flowers.

Haliotis A genus of abalone mollusk, with a slightly green shell. Maori artists favor this material.

Heishi Literally meaning "shell," this term refers to shell (or other natural material) that has been carefully ground into beads to use in jewelry.

Haus Tambaran Also known as the Spirit House or Men's House. A German term for a large community building in the Sepik River region of Papua New Guinea, characterized by a tall, pointed roof. Initiated men gather there and also use the building to store sacred treasures.

Headrest Sometimes known as a neckrest, this is a portable wooden structure used to support the head while sleeping. The rest lifts the head above the ground, thereby avoiding damage to elaborate hairstyles favored by the men of a number of African tribes.

Imbricated Having regularly arranged, overlapping edges, like roof tiles or slates.

Incised An object that has had a pattern, a motif, lettering, or numerals cut or engraved into its surface with a sharp instrument.

Initiation A ceremony or ritual undertaken by boys or girls to mark their entry to adulthood, or into a particular society.

Janus-headed Twin-headed, from the name of the Roman god of polarities who had two faces.

Kachina A helper spirit recognized by certain native Americans of the Southwest region. Men dress in costumes and masks to celebrate the arrival of the spirits in the springtime with dance and song. *Kachina* dolls represent these spirits and are highly collectible.

Kente From *kenten*, meaning "basket," this iconic, brilliantly colored Ghanaian cloth is characterized by the woven appearance of its design.

Labret An ornament worn in the lip, made from shell, bone, or stone.

Lost-wax technique A process, often referred to in the original French as *cire perdue*, in which an object is modeled in clay, covered in a layer of wax, and then covered again in a layer of clay. When the clay is baked, the wax melts away, leaving a cavity into which molten metal can be poured to create a metal (often bronze or gold) cast of the original object.

Mana Although a near-universal concept, the term originates in Polynesian religion and denotes a supernatural force that can exist within all things—both people and objects—and combines elements of respect, authority, prestige, and power—with the last including spiritual and/or magical.

Martingale A strap used to stop a horse from raising its head too high, typically affixed with a decorative panel. It extends from the reins or noseband to the body of the horse.

Mesa A Spanish word meaning "table," which refers to a flat-topped, natural elevation.

Mesoamerica The American region stretching from central Mexico to northern Costa Rica.

Metate A stone used to grind grains. It has a concave upper surface and forms the base of the millstone.

Maternity figure A figurative sculpture of a mother and child or of a pregnant woman.

Monolithic Originally an object created from a single block of stone, but also any object resembling such and of large or massive proportions.

Monoxylous Made from one piece of wood.

Mortise and tenon A type of joint used in furniture-making, in which two wooden components are securely joined by the insertion of a projecting tongue (tenon) at the end of one inserted into a same-sized cavity (mortise) in the other.

Olla A large ceramic pot or jar, or even a basket of similar form, traditionally used for storing water or oil, but sometimes also for cooking.

Papoose A baby carrier worn on the back, or carried on the side of a horse.

Parfleche A rawhide material originally produced from buffalo. Also the name given to the elaborately painted carrying cases made of this material.

Potlatch A native American gift-giving ceremony, popular in the Northwest region. The large scale of the event reflected the host's great generosity and high status in the community.

Paternity figure A figurative sculpture of father and child.

Patina A surface sheen (usually with a mellow, lustrous appearance) that develops gradually on the surface of wooden (and some metal) objects as a result of exposure over time to a combination of polishing and general handling, dust and dirt, and varying atmospheric conditions. In tribal art, the residue of sacrificial material poured over an object during rituals or ceremonies often accumulatively produces a patina.

Pectoral A chest muscle, and also denotes relating to or located in or on the chest, and worn on the chest.

Pre-Columbian Strictly speaking, relating to the cultures of North, Central, or South America (the New World) before the arrival of Christopher Columbus in 1492, but in practice also used to describe those cultures as they continued to develop prior to being conquered or significantly influenced by Europeans.

Prestige object A piece designed to display the wealth and status of the owner.

Pueblo Both a town or village in a Spanish-speaking country, and a settlement built by native Americans

227

in the southwestern US and Central America. The latter are comprised of at least one, but typically clusters of, stone or adobe dwellings. Also referring to the people of the federally recognized native American communities in the Southwest of the United States.

Reliquary figure A guardian figure that is used to protect sacred containers of relics that link the living to the dead. Sometimes the figure itself is the receptacle for the ancestral material, which may include bones.

Sagittal Relating to the seamlike junction between the two bones that form the top and sides of a mammalian skull. Often used to describe the crest of an African mask or an elaborate coiffure.

Scarification Scarring of the skin. Decorative patterns are burned, cut, or injected into the skin. Sometimes used to describe other decorative cuts—for example, on terra-cotta pots.

Sennit Finely braided coir (see above) used in Polynesia to make cordage for various uses.

Septum A thin membrane that separates the two air passages in the nose.

Serrated Notched like the edge of a saw: sawtoothed.

Shaman A member of certain tribal societies, usually a doctor-priest or medicine man, who acts as a medium between the physical and spiritual worlds, and who has various powers, including divination and healing.

Slip-painted A form of decoration, primarily applied to pottery, in which patterns or motifs are painted with tinted slips (a smooth, creamy dilution of clay and water).

Steatite A type of soapstone, usually dark gray or green in color, and with a soft composition and a soapy texture

well suited to carving figures and other ornaments. In powder form it is a variety of talc.

Stucco Traditionally, a slow-setting plaster designed to facilitate modeling and decoration in relief, but also used to describe any type of plaster used to coat exterior or interior walls.

Talisman Often a stone or a jewel, but in fact any object thought to bring good fortune, or give magical powers to its owner or wearer.

Tapa A strong cloth, primarily used for clothing and made in the islands of the Pacific Ocean from the inner bark of the paper mulberry tree. The bark is stripped from the tree, sun-dried, soaked, beaten, placed on dyed wooden blocks for the application of traditional patterns configured in horizontal bands, then dried again.

Tapu (or tabu) A concept existing in many Polynesian societies, reflecting something that is holy or sacred. Things or places thet are *tapu* must be left alone, and may not be approached or interfered with. The equivalent word and concept in Western societies is "taboo."

Teepee From the Sioux for "dwelling." A conical tent constructed of poles covered with fabric or animal skins.

Tomahawk A lightweight ax used by native Americans as a weapon and tool.

Totem Any animal, plant, or other natural object or phenomena, and any human-made representation of, with iconic status and believed to either embody spiritual or physical power(s), or symbolize a group of people such as a tribe.

Tundra A flat, treeless Arctic region where the subsoil is permanently frozen.

Turquoise A gemstone or mineral ranging in color from sky blue to pale green and often employed in native American jewelry.

Thrummed A term to describe a piece of fabric or weaving in which the thread ends are unfinished and left loose.

Tribe A society or part of a society (which can include a clan, or clans) whose members have common ancestry, leadership, beliefs, and customs.

Yei/yeis Native American Navajo spirit figures, often incorporated as motifs on rugs.

Zoomorphic Either animal-like, or a representation of a deity in animal form or with animal characteristics.

Directory of Dealers and Auction Houses and their Source Codes

Each tribal art piece shown in this book has an accompanying letter code that identifies the dealer or auction house that either is selling or has sold it. It should be noted that inclusion in this book in no way constitutes or implies a contract or a binding offer on the part of any contributing dealer or auction house to supply or sell the pieces illustrated, or similar items, at the price stated.

AC
Ambre Congo
13 Impasse Saint Jacques,
B-1000 Brussels, Belgium
Tel: 011 32 2 511 1662
Fax: 011 32 2 514 0209
info@bruneaf.com
www.bruneaf.com

ALL
Allard Auctions, Inc.
P.O. Box 1030,
419 Flathead St., Ste. 4
St. Ignatius, MT 59865
Tel: (406) 745-0500
Fax: (406) 745-0502
info@allardauctions.com
www.allardauctions.com

AP
Arte Primitivo Gallery
3 East 65th Street, Suite 2,
New York, NY 10021
Tel.: (212) 570-6999
Fax: (212) 570-1899
info@arteprimitivo.com
www.arteprimitivo.com

BLA
Blanchet et Associés
3, rue Geoffroy Marie,
75009 Paris, France
Tel: 011 33 1 53 34 14 44
Fax: 011 33 1 53 34 00 50
info@domasandgraygallery.com
blanchet.auction@wanadoo.fr

D&G
Domas & Gray Gallery
Tel: (228) 467-5294
www.domasandgraygallery.com

EFI
Esther Fitzgerald Rare Textiles
28 Church Row, London
NW3 6UP, UK
Tel: 011 44 20 7431 3076
esther@estherfitzgerald.co.uk
www.estherfitzgerald.co.uk

EL
Elms Lesters
Painting Rooms, Flitcroft Street,
London WC2H 8DH, UK
Tel: 011 44 20 7836 6747
Fax: 011 44 20 7379 0789
info@elmslesters.co.uk
www.elmslesters.co.uk

FRE
Freeman's
1808 Chestnut Street
Philadelphia, PA 19103
Tel: (215) 563-9275
Fax: (215) 563-8236
info@freemansauction.com
www.freemansauction.com

FS
The Frank Steward Collection
P.O. Box 115
Larkspur, CA 94977

JBB
Jean-Baptiste Bacquart
www.africanandoceanicart.com

JDB
Jo De Buck
43 Rue Des Minimes,
B-1000 Brussels, Belgium
Tel: 011 32 2 512 5516
Fax: 011 32 2 512 5516
jdbtribalart@belgacom.net
www.jodebuck.com

JYP
JYP Tribal Art
3 Rue Maurice Poedts,
B-1160 Brussels, Belgium
Tel: 011 32 2 660 0918
Fax: 011 32 2 660 12 67
info@jyp-art.com
www.jyp-art.com

KC
Kevin Conru
8a Rue Bodenbroek,
B-1000 Brussels, Belgium
Tel: 011 32 2 512 7635
Fax: 011 32 2 512 7635
kevinconru@yahoo.com

M&D
Myers & Duncan
12 East 86th Street, Suite 239
New York, NY 10028
Tel: (212) 472-0115
Fax: (212) 472-1665
jmyersprimitives@aol.com

MED
Medicine Man Gallery
7000 E. Tanque Verde Rd.,
Suite 16
Tucson, AZ 85715
Tel: (520) 722-7798
Fax: (520) 722-2783
art@medicinemangallery.com
www.medicinemangallery.com

MSG
Morning Star Gallery
513 Canyon Road
Santa Fe, NM 87501
Tel: (505) 982-8187
Fax: (505) 984-2368
indian@morningstargallery.com
www.morningstargallery.com

OHA
Owen Hargreaves
and Jasmine Dahl
Stall 16, Portobello Antiques Market
(Saturdays)
Corsham St, London, N1 6DP, UK
(by appointment)
Tel: 011 44 20 7253 2669
owenhargreaves@easynet.co.uk
jasminedahl@btopenworld.com
www.owenhargreaves.com

PHK
Philip Keith Private Collection
www.philipkeith.co.uk

PC
Private Collection

PM
Patrick Mestdagh
31 Rue des Minimes,
B-1000 Brussels, Belgium
Tel & Fax: 011 32 2 511 1027
Patrick.mestdagh@marine.be
www.patrickmestdagh.be

POOK
Pook and Pook
463 East Lancaster Avenue
Downington, PA 19335
Tel: (610) 269-4040/
(610) 269-0695
Fax: (610) 269-9274
info@pookandpook.com
www.pookandpook.com

RAM
Ramona Morris
P.O. Box 135
Delaplane, VA 20144
Tel: (540) 592-3873
Fax: (540) 592-3342
rmfineart@earthlink.net

RENO
The Coeur d'Alene Art Auction
P.O. Box 310
Hayden, ID 83835
Tel: (208) 772-9009
Fax: (208) 772-8294
cdaartauction@cdaartauction.com
www.cdaartauction.com

RTC
Ritchies
288 King Street East
Toronto, Ontario, Canada, M5A 1KA
Tel: (416) 364-1864
Fax: (416) 364-0704
auction@ritchies.com
www.ritchies.com

SK
63 Park Plaza
Boston, MA 02116
357 Main Street
Bolton, MA 01740
Tel: (617) 350-5400 /
(978) 779-6241
Fax: (617) 350-5429 /
(978) 779-5144
www.skinnerinc.com

S&K
Sloans & Kenyon
7034 Wisconsin Avenue
Chevy Chase, MD 20815
Tel: (301) 634-2330
Fax: (301) 656-7074
info@sloansandkenyon.com
www.sloansandkenyon.com

SWO
Sworders
14 Cambridge Road, Stansted
Mountfitchet, Essex, CM24 8BZ, UK
Tel: 011 44 1279 817 778
Fax: 011 44 1279 817 779
auctions@sworder.co.uk
www.sworder.co.uk

TB
Trotta-Bono American Indian Art
PO Box 34
Shrub Oak, NY 10588
Tel: (914) 528-6604
tb788183@aol.com

TFA
Throckmorton Fine Art
145 East 57th Street, 3rd Floor
New York, NY 10022
Tel: (212) 223-1059
Fax: (212) 223-1937
throckmorton@earthlink.net
www.throckmorton-nyc.com

TSG
Shand Galleries
Toronto Antiques Centre
276 King Street West
Toronto, Ontario, Canada, M5V 1J2
Tel: (416) 260-9056
Fax: (416) 260-9056
kenshand@attcanada.ca

WAD
Waddington's
111 Bathurst Street
Toronto, Ontario, Canada M5V 2R1
Tel: (416) 504-9100
Fax: (416) 504-0033
info@waddingtonsauctions.com
www.waddingtons.ca

WJT
Jamieson Tribal Art
Golden Chariot Productions
468 Wellington Street West,
Suite 201
Toronto, Ontario, Canada, M5V 1E3
Tel: (416) 596-1396
Fax: (416) 596-2464
wrj@jamiesontribalart.com
www.jamiesontribalart.com

Directory of Museums

AFRICA
Johannesburg Art Gallery
Joubert Park,
King George Street (between
Wolmarans and Noord Streets)
Johannesburg, South Africa
Tel: 011 27 11 725 3130

National Museum of Zimbabwe
National Museums and Monuments
Head Office, P.O. Box 8540
Harare, Zimbabwe
Tel: 011 263 4 752 876
www.zimheritage.co.zw

South African Museum
PO Box 61, Cape Town, 8000, South Africa
Tel: 011 27 21 481 3800
www.museums.org.za/sam

AUSTRALIA
Macleay Museum
Gosper Lane off Science Road,
University of Sydney,
NSW 2006, Australia
Tel: 011 61 2 9351 2274
www.usyd.edu.au/su/macleay

Museum Victoria
GPO Box 666E
Melbourne 3001,
Victoria, Australia
Tel: 011 61 3 8341 7777
www.museum.vic.gov.au

AUSTRIA
Museum für Völkerkunde
(Museum of Ethnology)
Neue Burg, A-1010 Vienna, Austria
Tel: 011 43 1 534 30 0
www.ethno-museum.ac.at
(Closed until spring 2007)

BELGIUM
Ethnographic Collections of the
University of Ghent
Het Pand, Onderbergen 1,
B-9000 Gent, Belgium
Tel: 011 32 9 264 83 05
www.flwi.ugent.be/etnischekunst

Ethnographic Museum
Suikerrui 19
B-2000 Antwerp, Belgium
Tel: 011 32 03 220 86 00
http://museum.antwerpen.be/
etnografisch_museum

Royal Museum for Central Africa (RMCA)
Leuvensesteenweg 13,
B-3080 Tervuren, Belgium
Tel: 011 32 02 769 52 04
www.africamuseum.be

CANADA
Canadian Museum of Civilization
100 Laurier Street, P.O. Box 3100,
Station B, Gatineau,
Quebec, Canada, J8X 4H2
Tel: (819) 776-7000
www.civilizations.ca

The Montreal Museum of Fine Arts
P.O. Box 3000, Station "H" Montreal,
Quebec, Canada, H3G 2T9
Tel: (514) 285-2000
www.mbam.qc.ca

Royal Ontario Museum
100 Queen's Park
Toronto, Ontario,
Canada, M5S 2C6
Tel: 011 416 586 5549
www.rom.on.ca

FRANCE
Le Musée du quai Branly
222, rue de l'Université
75343 Paris, France
Tel: 011 33 01 56 61 70 00
www.quaibranly.fr

Musée des Arts africains, océaniens, amérindiens
Centre de la Vieille Charité,
Marseille, France
Tel: 011 33 04 91 14 58 38

Musée Dapper
35, rue St Paul Valéry
75116 Paris, France
Tel: 011 33 1 45 00 01 50
www.dapper.com.fr

Musée de l'Homme
17, place of Trocadéro,
Paris, France
Tel: 011 33 1 40 79 36 00
www.mnhn.fr

GERMANY
Ethnologisches Museum
Arnimallee 27,
14195 Berlin, Germany
Tel.: 011 49 30 8301 438
www.smb.spk-berlin.de/mv/index

Linden-Museum Stuttgart
State Museum of Ethnology
Hegelplatz 1
70174 Stuttgart, Germany
Tel: 011 49 711 20 223
www.lindenmuseum.de

Staatliches Museum für
Völkerkunde, München
Maximilianstrasse 42
80538 Munich, Germany
Tel: 011 49 89 2101 36 100
www.voelkerkundemuseum-muenchen.de

ITALY
Museo Preistorico
ed Etnografico
(Museo Luigi Pigorini)
Piazza Guglielmo Marconi 14,
Rome 00144, Italy
Tel: 011 39 6 549 521
www.pigorini.arti.beniculturali.it

THE NETHERLANDS
Afrika Museum
Postweg 6, NL-6571
CS Berg en Dal
The Netherlands
Tel: 011 31 24 6847272
www.afrikamuseum.nl

National Museum
of Ethnology
Steenstraat 1, Leiden 2300 AE,
The Netherlands
Tel: 011 31 71 5168 800
www.rmv.nl

PACIFIC

Auckland War Memorial Museum
Domain Drive, Private Bag 92018
Auckland, New Zealand
Tel: 011 64 9 309 0443
www.aucklandmuseum.com

FIJI ISLANDS

Fiji Museum
P.O. Box 2023, Government Buildings,
Suva, Fiji Islands
Tel: 011 679 331 5944
www.fijimuseum.org.fj

SCANDINAVIA

Etnografiska Museet
Djurgårdsbrunnsvägen 34, Box 27140 10252
Stockholm, Sweden
Tel: 011 46 8 519 550 00
www.etnografiska.se

Universitetets Etnografisk Museum
Frederiks gate 2, 0130 Oslo, Norway
Tel: 011 47 2285 9912
www.khm.uio.no

CENTRAL AND SOUTH AMERICA

Museo Nacional de Antropologia
Paseo de la Reforma y Calzada Ghandi
Colonia Chapultepec - Polanco
Delegación Miguel Hidalgo 11560 Mexico, D.F.
Tel: 011 52 55 5286 2923
www.mna.inah.gob.mx

Museo del Oro
Banco de la República,
Calle 16 No. 5-41,
Bogotá 1, Colombia
Tel: 011 57 1 343 2222
www.banrep.org/museo

The Textile-Ethnographic Museum
(Anthropologists of the Southern Andes,
ASUR)
Casa Capellanica. Calle San Alberto No 413
Casilla 662, Sucre, Bolivia
Tel: 011 591 64 53841
www.bolivianet.com/asur

Museo Chileno de
Arte Precolombino
Bandera 361 (w/ Compañia),
Santiago, Chile
Tel: 011 56 2 688 7348
www.precolombino.cl

Museu de Arqueologia
e Etnologia
Av. Prof. Almeida Prado, 1466 CEP
05508-900, Cidade Universitária,
São Paulo, Brazil
Tel: 011 55 11 3091 4901
www.mae.usp.br

Museo Larco
Av. Bolivar 1515, Pueblo Libre.
Lima 21, Peru
Tel: 011 51 1 4611312
http://museolarco.perucultural.org.pe

SPAIN

Museu Barbier-Mueller D'Art
Precolombi De Barcelona,
Montcada 12-14,
08003 Barcelona, Spain
Tel: 011 34 93 310 45 16
www.barbier-mueller.ch

SWITZERLAND

Barbier-Mueller Museum
of Geneva
Rue Jean-Calvin 10,
1204 Geneva, Switzerland
Tel: 011 41 022 312 02 70
www.barbier-mueller.ch

Musée d'ethnographie
Neuchâtel
4, rue St-Nicolas (quart. Château-
Collégiale),
2000 Neuchâtel, Switzerland
Tel: 011 41 32 718 19 60
www.men.ch

Museum der Kulturen Basel
Augustinergasse 2,
4051 Basel, Switzerland
Tel: 011 41 61 266 56 00
www.mkb.ch

Museum Rietberg Zürich
Gablerstrasse 15,
8002 Zurich, Switzerland
Tel: 011 41 44 206 31 31
www.rietberg.ch

UK

British Empire & Commonwealth Museum
Clock Tower Yard, Temple Meads,
Bristol BS1 6QH, UK
Tel: 011 44 117 925 4983
www.empiremuseum.co.uk

The British Museum
Great Russell Street,
London WC1B 3DG, UK
Tel: 011 44 20 7323 8000
www.thebritishmuseum.ac.uk

Cambridge University Museum of
Archaeology and Anthropology
Downing Street,
Cambridge CB2 3DZ, UK
Tel: 011 44 1223 333 516
http://museum-server.archanth.cam.ac.uk

Horniman Museum
100 London Road, Forest Hill,
London SE23 3PQ, UK
Tel: 011 44 20 8699 1872
www.horniman.ac.uk

The Manchester Museum
The University of Manchester
Oxford Road, Manchester M13 9PL, UK
Tel: 011 44 161 275 2634
http://museum.man.ac.uk

National Museums
of Scotland
Chambers Street,
Edinburgh EH1 1JF, Scotland, UK
Tel: 011 44 131 247 4422
www.nms.ac.uk

Pitt Rivers Museum
South Parks Road,
Oxford OX1 3PP, UK
Tel: 011 44 1865 270927
www.prm.ox.ac.uk

Royal Albert Memorial Museum
& Art Gallery (RAMM)
Queen Street, Exeter,
Devon EX4 3RX, UK
Tel: 011 44 1392 665858
www.exeter.gov.uk

Sainsbury Centre for
Visual Arts
University of East Anglia,
Norwich NR4 7TJ, UK
Tel: 011 44 1603 593 199
www.scva.org.uk

World Museum Liverpool
William Brown Street,
Liverpool L3 8EN, UK
Tel: 011 44 151 478 4399
www.liverpoolmuseums.org.uk/wml

USA

The Art Institute of Chicago
111 South Michigan Avenue
Chicago, IL 60603-6110
Tel: (312) 443-3600
www.artic.edu

Autry National Center
234 Museum Drive
Los Angeles, CA 90065
Tel: (323) 667-2000
www.autrynationalcenter.org

Brooklyn Museum
200 Eastern Parkway
Brooklyn, NY 11238-6052
Tel: (718) 638-5000
www.brooklynmuseum.org

**Buffalo Bill
Historical Center**
720 Sheridan Ave.
Cody, WY 82414
Tel: (307) 587-4771
www.bbhc.org

Denver Art Museum
100 W. 14th Ave. Parkway
Denver, CO 80204
Tel: (720) 865-5000
www.denverartmuseum.org

de Young
Golden Gate Park
50 Hagiwara Tea Garden Drive
San Francisco, CA 94118
Tel: (415) 863-3330
www.thinker.org

The Heard Museum
2301 North Central Avenue
Phoenix, AZ 85004-1323
Tel: (602) 252-8840
www.heard.org

**Mathers Museum
of World Cultures**
601 East Eighth Street
Bloomington, IN 47408
Tel: (812) 855-6873
www.indiana.edu/~mathers

The Metropolitan Museum of Art
1000 Fifth Avenue at 82nd Street
New York, NY 10028-0198
Tel: (212) 535-7710
www.metmuseum.org

Michael C. Carlos Museum of Emory University
571 South Kilgo Circle
Atlanta, GA 30322
Tel: (404) 727-4282
http://carlos.emory.edu

Milwaukee Public Museum
800 W. Wells St.
Milwaukee, WI 53233
Tel: (414) 278-2700
www.mpm.edu

Morris Museum
6 Normandy Heights Road
Morristown, NJ 07960
Tel: (973) 971-3700
www.morrismuseum.org

Museum for African Art
36-01 43rd Avenue, 3rd Floor
Long Island City
Queens, NY 11101
Tel: (718) 784-7700
www.africanart.org

Museum of Anthropology
1109 Geddes Avenue
Ann Arbor, MI 48109-1079
Tel: (734) 764-0485
www.lsa.umich.edu/umma

Museum of Fine Arts, Boston
Avenue of the Arts
465 Huntington Avenue
Boston, MA 02115-5597
Tel: (617) 267-9300
www.mfa.org

**Museum of Indian Arts & Culture/
Laboratory of Anthropology**
710 Camino Lejo, off Old Santa Fe Trail
Santa Fe, NM 87501
Tel: (505) 476-1250
www.miaclab.org

National Museum of African Art
Smithsonian Institution
MRC 708, P.O. Box 37012
Washington, D.C. 20013-7012
Tel: (202) 633-4600
www.nmafa.si.edu

National Museum of the American Indian
The George Gustav Heye Center
Alexander Hamilton, U.S. Custom House,
One Bowling Green, New York, NY 10004
Tel: (212) 514-3700
www.nmai.si.edu

**National Museum of the
American Indian**
Cultural Resources Center
4220 Silver Hill Road
Suitland, MD 20746
Tel: (301) 238-1435
www.nmai.si.edu

**National Museum of the
American Indian**
NMAI on the National Mall
Fourth Street & Independence Ave S.W.
Washington, D.C. 20560
Tel: (202) 633-1000
www.nmai.si.edu

The Nelson-Atkins Museum of Art
4525 Oak St.
Kansas City, MO 64111-1873
Tel: (816) 561-4000
www.nelson-atkins.org

Peabody Essex Museum
East India Square
Salem, MA 01970
Phone: (978) 745-9500
www.pem.org

The Philbrook Museum of Art, Inc.
2727 South Rockford Road
Tulsa, OK 74114
Tel: (918) 748-5309
www.philbrook.org

Portland Art Museum
1219 S W Park Ave.
Portland, OR 97205
Tel: (503) 226-2811
www.portlandartmuseum.org

Seattle Art Museum, Downtown
100 University Street
Seattle, WA 98101-2902
Tel: (206) 654-3100
www.seattleartmuseum.org

UCLA Fowler Museum of Cultural History
Box 951549
Los Angeles, CA 90095-1549
Tel: (310) 825-4361
www.fowler.ucla.edu

**University of Pennsylvania Museum of
Archeology and Anthropology**
3260 South Street
Philadelphia, PA 19104
Tel: (215) 898-4000
www.museum.upenn.edu

Authors' Dealer Selection

This list of dealers has been chosen by the authors and is by no means comprehensive. For a further list of recommended dealers and auction houses please see the Directory of Dealers and Auction Houses and their Source Codes (pp.229–230).

BELGIUM

Pierre Dartevelle
Impasse St-Jacques 8-9,
B-1000 Brussels, Belgium
Tel: 011 32 2 513 0175
Fax: 011 32 2 502 0401
dartevelle.p@skynet.be

Bernard de Grunne
Place du Petit Sablon 2,
B-1000 Brussels, Belgium
Tel: 011 32 2 502 3171
Fax: 011 32 2 503 3969
grunne@skynet.be

Michel Koenig
Rue des Minimes 27,
B-1000 Brussels, Belgium
Tel: 011 32 2 511 7507

La Galerie Serge Schoffel
Rue des Minimes 47,
B-1000 Brussels, Belgium
Tel: 011 32 2 503 2847
contact@sergeschoffel.com

CANADA

Jacques Germain
1625 Clark Street, Suite 706
Montreal, Quebec H2X 2R4
Tel: (514) 278-6575
info@jacquesgermain.com
www.jacquesgermain.com

Donald Ellis Gallery
R.R. #3
Dundas, Ontario L9H 5E3
Tel: (905) 648-1837
E-mail: ellisgal@interlynx.net

FRANCE

Galerie Mermoz
6, rue du Cirque,
75008 Paris, France
Tel: 011 33 1 42 25 84 80
Fax: 011 33 1 40 75 03 90
galerie.mermoz@wanadoo.fr

Galerie Meyer Oceanic Art
17, rue des Beaux-Arts,
75006 Paris, France
Tel: 011 33 1 43 54 85 74
Fax: 011 33 1 43 54 11 12
ajpmeyer@aol.com
www.galerie-meyer-oceanic-art.com

Alain de Monbrison
2, rue des Beaux-Arts,
75006 Paris, France
Tel: 011 33 1 46 34 05 20
Fax: 011 33 1 46 34 67 25
courier@monbrison.com
www.monbrison.com

Galerie Ratton-Hourdé
10, rue des Beaux-Arts,
75006 Paris, France
Tel: 011 33 1 46 33 32 02
Fax: 011 33 1 46 33 34 02
rattonhourde@aol.com

Galerie Valluet-Ferrandin
14, rue Guénégaud,
75006 Paris, France
Tel: 011 33 1 43 26 83 38
Fax: 011 33 1 46 33 84 96
v.ferrandin@wanadoo.fr

Renaud Vanuxem
52, rue Mazarine,
75006 Paris, France
Tel: 011 33 1 43 26 03 04

SPAIN

Arte Y Ritual
Valenzuela 7,
Madrid 28014,
Spain
Tel: 011 34 915 227 552
www.arteyritual.com

UK

Entwistle Gallery
144 New Bond Street,
London W1S 2TR, UK
Tel: 011 44 20 7499 6969
Fax: 011 44 20 7290 3683
info@entwistlegallery.com
www.entwistlegallery.com

UNITED STATES

Adobe Gallery
221 Canyon Rd
Santa Fe, NM 87501
Tel: (505) 955-0550
info@adobegallery.com
www.adobegallery.com

**David Bernstein
Pre-Columbian Art**
737 Park Avenue,
New York, NY 10021
Tel: (212) 794-0389
By appointment

**Marcy Burns American
Indian Arts**
525 East 72nd Street, Apt. 26G,
New York, NY 10021
Tel: (212) 439-9257
marcy@marcyburns.com
www.marcyburns.com

David Cook Fine American Art
1637 Wazee Street
Denver, CO 80202
Tel: (303) 623-8181
info@davidcookgalleries.com
www.davidcookfineart.com

Taylor A. Dale – Tribal Arts
401 West San Francisco Street
Santa Fe, NM 87501
Tel: (505) 983-4149
contact@tadtribalart.com
www.tadtribalart.com

Davis Gallery African Art
New Orleans, LA
charles@davisafricanart.com
www.davisafricanart.com

Domas And Gray Gallery
203 Thomas Road
Old Chatham, NY 12136
Tel: (518) 392-3913
info@domasandgraygallery.com
www.domasandgraygallery.com

Economos Works of Art
500 Canyon Rd
Santa Fe, NM 87501
Tel: (505) 982-6347

Ned Jalbert
57 Main Street
Westboro, MA 01581
Tel: (508) 836-9999
ned@njinteriors.com

Lewis/Wara Gallery
615 Boren Avenue,
Suite 11,
Seattle, WA 98104
Tel: (206) 405-4355
Fax: (206) 405-1584
gallery@lewiswara.com
www.lewiswara.com

Morning Star Gallery
513 Canyon Road
Santa Fe, NM 87501
Tel: (505) 982-8187
indian@morningstargallery.com
www.morningstargallery.com

Thomas Murray
775 East Blithedale 321,
Mill Valley, CA 94941
Tel: (415) 332-3445
Fax: (415) 332-3454
tmurray@well.com
www.asianart.com/thomasmurray/

Pace Primitive
32 East 57th Street,
Seventh Floor,
New York, NY 10022
Tel: (212) 421-3688
Fax: (212) 751-7280
info@paceprimitive.com
www.paceprimitive.com

David F. Rosenthal
2158 Sutter Street,
San Francisco, CA 94115
Tel/Fax: (415) 922-8978
dfr@oceanic-art.net
www.oceanic-art.net

George Shaw
515 Holland Hills Rd.
Basalt, CO 81621
Tel: (970) 927-0701
zippy@sopris.net

Paul Shepard
3026 E. Broadway,
Tucson, AZ 85716
Tel: (520) 326-4852

Sherwoods Spirit of America
1005 Paseo de Peralta,
Santa Fe, NM 87501,
Tel: (505) 988-1776
catalog@sherwoodsspirit.com
www.sherwoodsspirit.com

Merton D. Simpson Gallery
38 West 28th Street, Fifth Floor,
New York, NY 10001
Tel: (212) 686-6735
Fax: (212) 686-7573
simpson@inch.com
www.mertonsimpsongallery.com

Stendahl Galleries
7065 Hillside Avenue,
Los Angeles, CA 90068
Tel: (323) 876-7740

Martha Struever
P.O. Box 2203
Santa Fe, NM 87504
Tel: (505) 983-9515
info@marthastruever.com
www.marthastruever.com

Arte Textil
904 Irving St #220,
San Francisco, CA 94122
Tel: (415) 753-0342
SBerg753@aol.com

Throckmorton Fine Art
145 East 57th Street, 3rd Floor,
New York, NY 10022
Tel: (212) 223-1059
Fax: (212) 223-1937
throckmorton@earthlink.net
www.throckmorton-nyc.com

Trotta-Bono
P.O. Box 34
Shrub Oak, NY 10588
Tel: (914) 528-6604
tb788183@aol.com
By appointment

James Willis Tribal Art
1637 Taylor Street
San Francisco, CA 94133
Tel: (415) 885-6736
tribalart@jameswillis.com
www.sftribal.com/James-Willis/

Index

Acknowledgments

PUBLISHER'S ACKNOWLEDGMENTS

Dorling Kindersley would lie to thank Richard Dabb, Lucy Claxton, and Claire Bowers for digital image coordination; Adam Walker for creating the shadows on the images; Caroline Hunt for proofreading; Pamela Ellis for the index; and Sandra Lange at The Price Guide Company for her thoroughness.

The Price Guide Company would like to thank the following for their contribution to the production of this book:

Writers Jim Haas and Philip Keith for their dedication to the project and extensive research.

Photographer Graham Rae for his wonderful photography.

All of the dealers, auction houses, and private collectors for kindly allowing us to photograph their collections and supplying a wealth of information about the pieces.

Kevin Conru, Jim Haas, and Philip Keith for their assistance in organizing photo shoots.

Also special thanks to Claire Smith, Megan Watson, Cathy Marriott, Nicolas Tricaud de Montonnière, Dan Dunlavey, and Sandra Lange for their editorial contribution and help with image sourcing.

Thanks also to digital image coordinator Ellen Sinclair, workflow consultant Bob Bousfield, and contributor John Wainwright.

PICTURE CREDITS

DK Picture Librarian: Richard Dabb.

The Publisher would like to thank the following for their kind permission to reproduce their photographs:
(Abbreviations key: t=top, b=bottom, r=right, l=left c=center)
20: Henning Christoph / Still Pictures; 21: Larissa Siebicke / Still Pictures; 22: Edward Parker / Still Pictures (br); 23: Marcus Rose / Panos Pictures (bl); 24: Kelvingrove Art Gallery and Museum, Glasgow Museums (br); 26: D. Poole / Robert Harding Picture Library Ltd. (br); 27: Jorgen Schytte / Still Pictures (cr); 36: Larissa Siebicke / Still Pictures (br); 37: John Elk III / Lonely Planet Images (cr); 42: Henning Christoph / Still Pictures (br); 52: Friedrich Stark / Still Pictures (br); 56: AFP / Getty Images (br); 60: Hulton Archive / Getty Images (br); 76: Ken Findlay / Dorling Kindersley (bc); 79: Alain Evrard / Robert Harding Picture Library Ltd. (bl); 82: Giacomo Pirozzi / Panos Pictures (br); 84: Ludger Schadomsky / Still Pictures (br); 85: Betty Press / Panos Pictures (tr); 90: Jenny & Tony Enderby / Lonely Planet Images; 91: Friedrich Stark / Still Pictures; 92: Roine Magnusson / Getty Images (br); 93: Ted Mead/WWI / Still Pictures (bl); 94: Hulton Archive / Getty Images (br); 98: John Borthwick / Lonely Planet Images (br); 101: Dorling Kindersley (bl); 104: Tim Rock / Lonely Planet Images (br); 107: Dean Treml / Getty Images (bc); 110: Jean-Bernard Carillet / Lonely Planet Images (br); 112: David Wall / Lonely Planet Images (br); 114: Caroline Penn / Panos Pictures (br); 115: Michael Coyne / Lonely Planet Images (bc); 120: Peter Hendrie / Lonely Planet Images (br); 130: Hulton Archive / Getty Images (br); 132: Peter Hendrie / Lonely Planet Images (br); 136: Mrs Holdsworth / Robert Harding Picture Library Ltd. (br); 142: Hulton Archive / Getty Images; 143: Richard I'Anson / Lonely Planet Images; 144: John Elk III / Lonely Planet Images (br); 146: Michael Sewell / Still Pictures (br); 152: courtesy Myers & Duncan (br); 158: Phil Schermeister / Still Pictures (br); 165: courtesy Mark Sublette, Medicine Man Gallery (bl); 186: Oliviero Olivieri / Robert Harding Picture Library Ltd. (br); 188: Russell Gordon / Still Pictures (br); 192: Richard I'Anson / Lonely Planet Images (br); 196: Ron Giling / Still Pictures (br); 200: Anne Rippy / Getty Images (br); 206: Mike Powles / Still Pictures (br); 210: Angelo Cavalli / Getty Images (br); 214: Tom Cockrem / Lonely Planet Images (br); 222: Chris Beall / Lonely Planet Images (br).

All other images © Dorling Kindersley and The Price Guide Company Ltd. For further information, see: **www.dk.images.com**